THEATRE ECOLOGY

What are the challenges to theatre and the purposes of performance in an ecologically threatened world? Is there a future for theatre as an ethically and politically alert art through environmental action? How might ecological understandings refigure the natural virtues of theatre and performance? *Theatre Ecology* gets to grips with such questions by investigating an eclectic cosmopolitan sample of environments and performance events, in theatres and beyond. It proposes that performance is a peculiarly twenty-first-century addiction at the root of global warming. Encountering this prospect head-on, it searches for pathological hope in historical theatre at the end of its tether and rumbles the contemporary paradigm of performance for signs of eco-sanity. Recognising the future is always before its time, *Theatre Ecology* is a paradoxical tract for survival past the final ecological era.

BAZ KERSHAW is Professor of Performance in the School of Theatre, Performance and Cultural Policy Studies at the University of Warwick. He is the author of *The Politics of Performance: Radical Theatre as Cultural Intervention* (1992) and *The Radical in Performance: Between Brecht and Baudrillard* (1999), and editor of *The Cambridge History of British Theatre, Volume 3: Since 1895*, which was nominated for the Theatre Book Prize in 2005. He has extensive experience as a director and writer in research-oriented radical and community-based performance, including projects at the London Drury Lane Arts Lab., with Welfare State International, plus many freelance creative collaborations.

THEATRE ECOLOGY

Environments and Performance Events

BAZ KERSHAW

CAMBRIDGE
UNIVERSITY PRESS

CAMBRIDGE UNIVERSITY PRESS
Cambridge, New York, Melbourne, Madrid, Cape Town, Singapore, São Paulo

Cambridge University Press
The Edinburgh Building, Cambridge CB2 8RU, UK

Published in the United States of America by Cambridge University Press, New York

www.cambridge.org
Information on this title: www.cambridge.org/9780521877169

First published 2007

Printed in the United Kingdom at the University Press, Cambridge

A catalogue record for this publication is available from the British Library

Library of Congress Cataloging in Publication Data

Kershaw, Baz.
Theatre ecology: environments and performance events / Baz Kershaw.
p. cm.
Includes bibliographical references and index.
ISBN 978-0-521-87716-9 (hardback)
I. Performing arts–Political aspects. 2. Performing arts–Environmental aspects. I. Title.

PN1643.K48 2007
792–dc22

2007032996

ISBN 978-0-521-87716-9 hardback

This book is dedicated *in memoriam* to

Clive Barker
Wilfred Bosence
Dwight Conquergood
Vera Gottlieb
Glynn Wickham

Contents

Illustrations

Acknowledgements

Although this book has only my name on its cover the research essential to its evolution involved a gamut of interlocking creative, scholarly and professional collaborations. The connections between them were manifold and often it was not at all clear where one was ending and another beginning. I was sustained by the energy of countless contributions, some of course of which I was not aware, but all of which surely I was privileged to receive. So the generosity of numerous friends, colleagues and acquaintances influenced what follows here and it is in no way possible to acknowledge them all, even though I exclude people, projects and events that I imagine did not directly influence *Theatre Ecology*. I offer gratitude to all whose names are listed below, and by no means *just* for what you are listed. Many will easily see themselves in others.

Thanks to the editors of journal issues and books where earlier versions of these ecologically oriented essays were first published: Martin Banham, Clive Barker, Marin Blažević, Harry J. Elam, Gabriella Giannachi, Loren Kruger, Jane Milling, Richard Schechner, Maria Shevtsova, Nigel Stewart, Simon Trussler, Joanne Tompkins, and to their anonymous peer reviewers, for improving my originals.

Thanks to the organisers of research gatherings who invited me to present earlier drafts and closely related papers: Christopher Balme, Susan Bennett, John Bull, Victor Emeljanov, Helen Gilbert, Jules Gilson-Ellis, John Golder, Richard Gough, James Harding, Franklin Hildy, Dennis Kennedy, Pirkko Koski, Heike Roms, James Stredder, Joakim Stenshäll, Meike Wagner, Lois Weaver, Phillip Zarrilli, and to all their support staff who lifted the burden of organisation so we could share time together.

Thanks to the conference plenary audiences and session participants who provided always stimulating feedback, but especially to the following joint presentation panel members: Steve Bottoms, Carol Burbank, Laura Cameron, Matthew Goulish, Sonja Kuftinec, David Matless, Gay McAuley, Alan Read, Janelle Reinelt, Greg Whelan.

Thanks to past departmental colleagues for stimulation, support and everyday sustenance through inevitable ups and downs: Adrian Harris, Gerry Harris, Andrew Quick, Stephanie Sims; Sara Jane Bailes, Pete Bailie, Günter Berghaus, Liz Bird, George Brandt, Fiona Chapman, Colette Conroy, Jon Dovey, Debora Gibbs, Angela Groves, Carson Jarvis, Mark Leake, Katie Mack, Jacqueline Maingard, Peter Milner, Lisa Murphy, Colin O'Neil, Helen Piper, Kay Russell, Mark Sinfield, Sarah Street, Kate Withers, and to the porters, cleaners and maintenance staff who laboured to make our working lives more bearable. And to my new colleagues and the support staff at the University of Warwick, thanks for a hopeful future.

Thanks to all staff at the University of Bristol Theatre Collection past and present, especially Sarah Cuthill, Jo Elsworth and Rachel Hassall, for all your friendship, research support and skill in the sourcing of images.

Thanks for six years of challenges and excitement to the research associates and administrators, management group, advisory group and all 600-plus practitioner–researchers who participated in PARIP (Practice as Research in Performance): Ludivine Allegue Fuschini, Laura Cull, Rosanne Jacks, Angela Piccini, Caroline Rye; John Adams, Christopher Bannerman, John Ellis, Simon Jones, Carol Lorac, Robin Nelson, Barry Smith, Janet Thumim, Martin White, and especially all the symposium and conference delegates. Also to Jacqueline Martin and the International Federation of Theatre Research (IFTR) Performance as Research Working Group, many thanks. And to the many non-academic colleagues in the UK who made institutional support systems work to extend the research agenda so that I can 'legitimately' thank another group of collaborators next.

Thanks to all my creative collaborators in four practice-as-research productions who gave their considerable talents to ecological events well suited to the stimulation of audiences: all the remarkable Bristol University and Circomedia Circus Academy students who worked on *The Iron Ship* and *Green Shade* projects; to Gemma Brooks, Misri Deitch Day, Sara Easby, Yvonne Elston, Rona Fineman, Sonika Jain, Bim Mason, Peter Metelerkamp, Jennie Norman, Amanda Price, Jean Rath, Jonathan Smiles, Rod Terry, Jane Tooze, Mike Wright, plus Mike Cannings and all ss *Great Britain* staff, and for the generosity of field-research respondents in Australia and the UK, especially Alan and Jim Crompton; to Andy Bate, Maya Cockburn, Sue Doolin, Alistair Ganley, Neil Puttick, Harmeet Sehambi, Simon Taffel, Pam Tait, Drew Yapp, plus Simon Garrett, Jo Gipps, Xanthe Littledale, Debbie Ward and all

staff at Bristol Zoological Gardens, as well as Sue Hill at the Eden Project and the feedback focus group members. Special gratitude indeed is owed to my closest creative collaborators John Marshall, Sue Palmer and Sandra Reeve.

Thanks are due in abundance to the creative and scholarly colleagues and friends not already mentioned who also contributed directly to the evolution of this book, sometimes in the 'back to the future' way that makes the retrospect so interesting: Sruti Bala, Chris Baugh, Sir John Berringer, Anna Birch, Nerrida Blair, Herbert Blau, Larry Bogad, David Bradby, Jackie Bratton, John Russell Brown, Matthew Causey, Franc Chamberlain, Una Chaudhuri, Enzo Cozzi, Maria Delgado, Paul Dwyer, Peter Eckershall, Penny Farfan, Rachel Fensham, Alan Filewood, Helen Freshwater, Jen Harvie, Wallace Heim, Dan Gretton, Ronald Grimes, Robin Grove-White, Adrian Heathfield, Julie Hollege, Shannon Jackson, Tony Jackson, John Jordan, Sir John Kingman, Anja Klöck, Andy Lavender, Carl Lavery, Jon McKenzie, Jocelyn McKinnon, Michal Kobialka, James Marriott, Susan Melrose, Julian Meyrick, Graeme Miller, Mike Pearson, Brian Pickering, Tom Postlewait, Nicholas Ridout, Freddie Rokem, Wilmar Sauter, Kerry Schaefer, Ed Scheer, Simon Shepherd, John Somers, Bodi Sowanda, Bronislaw Szerszynski, James Thompson, Nigel Thrift, Jane Trowell, John Urry, Mick Wallis, Michael Walton, Claire Waterton, Martin Whelton, Nicholas Whybrow, Rod Whistler, and in particular to Helen Nicholson, Sophie Nield, Dan Rebellato and all the participants of the London Beyond Postmodernism Symposia, 2005–6.

Thanks also to the several hundred undergraduate students who have challenged me to greater intellectual clarity and imaginative effort in the Radical Theatre, Democratising Performance and Ecologies of Performance courses, as well as to the remarkable students of the MA in Cultural Performance, all at the University of Bristol.

To the participants in 'Performance/EcoAction' and to co-tutors at International Postgraduate Programmes, Performance and Media Studies, Johannes Guttenberg-Universität, Mainz. And especially to my recent and current postgraduate research students for stretching my sense of research possibilities: Robert Cross, Dafydd James, Guduz Kalic, Sally Mackie, Nicholas Rowe and Michael Balfour, the last particularly for springing open the distributed archive.

Many thanks for support from a smart and highly professional production team at Cambridge University Press, including Margaret Berrill, Liz Davey, Karl Howe and editor Rebecca Jones. And to the expert

anonymous readers who offered challenging and spot-on advice: Maggie Gale and Rik Knowles. But my most fulsome thanks here must go to Vicki Cooper, who has championed this project well beyond the call of duty. Many Cambridge University Press authors more eloquent than I have chorused her praises before, so what can I best do but turn to paradox for an overriding truth that might amuse her. An adaptation of Baba Ram Dass: If you think you're finished, there can be no end in sight.

Finally, before the formal acknowledgements come up like cinema credits, there are two small groups of people I must risk embarrassing because their contributions beggar the language of thanks. The first are both colleagues and firm friends: Jim Davis, Tracy Davis, John Fox, Viv Gardner, Sue Gill, Robert Hole, Graham Ley, David Watt. The second is my immediate family. Logan has been a model rock star in waiting. Eleanor kindly interrupted her life to source the book's illustrations professionally with aplomb. Thank you, Eleanor. Dr Gill Hadley prepared the index with high professionalism and provided utterly indispensable sustenance of many kinds consistently *and* abundantly when it really mattered most to all four of us. For that, no amount of gratitude is adequate.

And so to the bone-fide artists without whom, perhaps, there would be no theatre ecology to speak of. The ones I write about, dead and living, cannot be thanked enough, as hopefully there's still more of the wonderfully awkward stuff to come. But I must gratefully acknowledge four of them directly. Earth First!, Patrick Hughes, Tess de Quincey and Stelarc have been gracious and generous in providing pictures as well as inspiration. Likewise particular thanks are due to Deborah Snyder at Global Ecotechnics for supplying Biosphere II illustrations, and Rebecca Pilbeam at Out of Joint Theatre for organising the *Shopping and Fucking* image. For further picture credits see the List of Illustrations.

I apologise to any who might have expected to be named above and that I have overlooked, or who are owed formal acknowledgement and are omitted from what follows. Please contact Cambridge University Press for potential inclusion in any future editions. Of course, any errors herein are all my own.

Direct financial support towards the project was provided by: the University of Warwick Humanities Research Fund, the University of Bristol Faculty of Arts Research and Conference Funds, the University of Bristol Alumni Fund, the University of Newcastle (New South Wales) Research Fund, the UK Arts and Humanities Research Board (for *The Iron*

Ship and *Mnemosyne Dreams*), the British Academy Overseas Conference fund, and the UK Arts and Humanities Research Council, in the form of a small grant for *Being in Between* and a Research Leave Grant which was essential to completing this book. Significant in-kind support was also contributed by the ss *Great Britain* Project, Bristol Zoological Gardens, and related agencies. Research presentations outside the UK listed in the Appendix were supported financially by: in Australia – University of Newcastle; University of New South Wales, Sydney; University of Queensland, Brisbane; Monash University, Melbourne; in North America – University of Maryland, USA; Northwestern University, Illinois, USA; University of Calgary, Canada; in Europe – Academy of Dramatic Art, Zagreb, Croatia; Trinity College, Dublin, Ireland; Rikstheatern, Stockholm, Sweden. I am very grateful to all these sources of support for this project.

Acknowledgements for the reuse of writings previously published are due as follows for: 'George Formby and the Northern Sublime', published in *Extraordinary Actors*, reprinted with permission of Exeter University Press; 'Oh for Unruly Audiences! Or, Patterns of Participation in Twentieth-Century Theatre', published in *Modern Drama* under the auspices of the Graduate Centre for the Study of Drama, University of Toronto, reprinted by the permission of University of Toronto Press Incorporated (www.utpjournals.com); 'Discouraging Democracy: British Theatres and Economics, 1979–1999' and 'Curiosity or Contempt: On Spectacle and the Human', published in *Theatre Journal*, reprinted with the permission of the Johns Hopkins University Press; 'Radical Energies in the Ecologies of Performance', published in *Frakcija: Performing Arts Magazine*, reprinted with the permission of Centar za dramsku umjetnost/Centre for Dramatic Art, Zagreb, Croatia; 'Ecologies of Performance: On Theatres and Biospheres', published in *Performing Nature: Explorations in Ecology and the Arts*, reprinted with permission of Peter Lang AG, European Academic Publishers, Bern (www.peterlang.com); 'The Theatrical Biosphere and Ecologies of Performance', 'Dramas of the Performative Society: Theatre at the End of its Tether' and 'Performance Studies and Po-chang's Ox? Steps to a Paradoxology of Performance', published in *New Theatre Quarterly*, Cambridge University Press; 'Eco-Activist Protest: the Environment as Partner in Protest?' published in the *Drama Review*, MIT Press Journals.

During the period of this book's gestation sadly five colleagues died who, to different but significant degrees, influenced its nature. Vera Gottlieb was Emeritus Professor of Drama at Goldsmiths College,

University of London, and a scholar of Russian and British Theatre of high distinction; Glynn Wickham was founding and Emeritus Chair of Drama at the University of Bristol and a pioneering historian of European early-modern theatre who established theatre studies in British universities; Clive Barker was a teacher and scholar of popular and practical performance at the University of Warwick, formerly a member of Joan Littlewood's Theatre Workshop and subsequently an international proponent of radical workshop methods for training performers; Dwight Conquergood was Professor of Performance and former chair of the Department of Performance Studies at Northwestern University, Illinois, a practitioner–scholar committed to community-based participatory performance and a major figure in establishing performance studies as a global 'anti-discipline', as he called it; last but by no means least Wilf Bosence was founder and Head of the Department of Drama at Rolle College, Exmouth, Devon, and a theatre director of notable talent who appointed me to my first permanent post as a lecturer. I was very lucky and highly privileged to have known in varying degrees all five. *Theatre Ecology* grew in the fertility of the widening field that they, together with numerous others, collectively nurtured. It is dedicated to them.

Introduction

Prologue: a kind of storm

As I sat down at my desk in front of a window that overlooks the urban back gardens, pitching to write this first sentence of *Theatre Ecology*, there was a loud thunderclap and rain poured suddenly down. Until that moment I hadn't much noticed the signs of the gathering storm: lowering sky, light fading, air growing heavy with humidity, trees beginning to stir their branches, birdsong quietening, the small flock of pigeons standing perfectly still on the slope of a slightly glistening tiled roof. The storm delivers a single flash of lightning, but all I see is the whole sky for an instant turned to bright silver and it's gone, except maybe the drenched leaves for a nanosecond held a response to its brilliant efflorescence. A couple more thunderclaps and the whole process slips into reverse. The pigeons fly off, the trees become stiller, the air dries out a little, light returns as the sky lifts and there's even a hint of sunshine on a distant sandstone wall. But it will be a while before the birds chirp up again as the usual weather routines return.

What had I just witnessed again for the umpteenth time in a life of over six decades? This was the scene when the doped-up hippie charter-captain of the borrowed million dollar yacht almost ran us onto the Hawaiian coral reef, when the Volkswagen beetle got caught by a Mexican river in full flood that swept us away, when we trudged up the backbone of England as a challenge to cystic fibrosis, when the racing bike lost traction and slid over the edge of the high rocky ridge, when we lay on the bed in the lighthouse hotel with the curtains opened to the raging night. And as I tapped out that last sentence today's storm started up again as if to remind me such dramas are not just a human affair, this time – I swear it – with more energy and vigour than before. Then I pitched: there have also been in my past the high storms of myth and religion and literature and art, of the minds and brains of the brilliant and the insane, of history and politics and wars and genocide and terrorism, of the heart's passion and desire and love beyond all bounds. And so as the storm outside my study window

3

gathered more force I had retreated again to human culture, to seek shelter where there isn't really much at all, where the elements are just as wild and unpredictable, as dangerous and as magnificent and as wondrous in their ways as those of the so-called natural world.

For years now I have been charting a course up the narrowing straits between nature and culture. A decade and a half ago the prospect seemed wide open in an imagined global political synthesis of the red and the green.[1] Seven years on and I was reaching for an ecology of performance by crawling through an utterly blacked-out maze made by a Colombian theatrical wizard.[2] Just recently I was still on my hands and knees, but this time under the broken branches of high-up ancient woodland as a Force-8 gale howled and the torrents of rain hurled down and swirled around ears and splashed up to thighs in a havoc of whipped-up wetness. As the saying goes, the going got tougher, but then as the straits became really dire their hardships paradoxically opened up, if not exactly to a wonderful lightness of being, then perhaps to a bit of a new becoming in ecological pathologies of hope.

The chapters of this book were once in the strictest sense *essays* about that progress, just attempts to read the runes of a planet threatened by a dominant and dangerous species of which I have no choice but to admit to membership. Even in the moments when I ironically think, tapping away at this machine, I'm a born-again cyborg. The chapters were, all but one, written for particular occasions in the weird international trade of my posthuman half-academic life, just as a way of trying to be as fully in touch as possible with whatever broader environments I found myself pulled towards. Now they have been partially rewritten to draw out the senses of that attempted embrace of nature–culture as the straits got narrower, as the state of the planet grew daily more precarious, as the global storm clouds lowered deeply and grew much darker. But still I trust these writings carry some prospects of hope, however tenuously held. Because in welcoming the thunderstorm and its lightning today I note it was far, far more than a metaphor for moments in a life now nearly gone, or for human civilisations at their best and worst. Its silver flash was also, aeons ago, possibly the prompt that startled up all the amazing dramas of life on this enigmatic Earth.

[1] Baz Kershaw, *The Politics of Performance: Radical Theatre as Cultural Intervention* (London: Routledge, 1992), pp. 255–6.
[2] Baz Kershaw, *The Radical in Performance: Between Brecht and Baudrillard* (London: Routledge, 1999), pp. 214–16.

On theatre and performance ecology

ON A MOMENT IN THE WOODS

Water gushes down the trunks of ancient trees in streamlets and the wind whips against them, flinging a spray like needles into squinting eyes. The storm blasts strain even the thickest limbs of the oaks into creaky waving, their early springtime leaves making flittering manic crests. Where the wood has been torn apart and fallen in the past huge broken branches reach to an invisible horizon, tentacles petrified in the moment of death. Best to crawl under them on hands and knees, head down close to the deep mulch to dodge the worst of the swirling lashes. Toes, feet, knees, hands, fingers are sodden and pained with cold as you claw a path across the forest floor, ears numb from the wild drubbing of the gale. Then suddenly you hear it, a high-pitched groaning and a whining of some other animal trapped that you must track down. Hard to locate through the raging air but at last you find its source, right ear pressed to a huge splintered branch jammed upright with its top end in the beech it was wrenched from long ago. As limb grates against trunk in the canopy high above, the old wood vibrates to its core, still singing with life so many years after it died. Listening entranced with cheek against the dripping bark I glimpse a man in the gloomy distance walking his dog. He sees an elderly grey-bearded crazy in a bright orange cagoule hugging a broken tree at the heart of an ancient wood high up on a famous Dorsetshire hill in the midst of a Force-8 gale. Despite the distance and the gloom I see his eyes enlarge and his body shake with laughter and his big dog straining against its leash as it howls and barks at me. Giving a half-hearted apologetic wave I'm thinking: dear God what else will I end up doing for the love of theatrical art!

None of the rest of our group of twenty saw the man, so I may have imagined him. After a shivery and quick debrief of the crawling exercise, the last of the day, a couple came to listen to the singing branch. Then it was back in the Transit van to the warmth of the village hall to work out

what the Lewesdon Hill gale had produced for *Green Shade*, an eco-installation and durational performance we were devising for the Wickham Theatre in Bristol. That city lies in a bowl carved from surrounding hills and connected to the Bristol Channel by the Avon Gorge. At its narrowest point the nineteenth-century Clifton Suspension Bridge spans the deep ravine. The bridge is 78 metres above the median level of the River Avon, which has the second highest tidal range in the world. The very worst-case scenario for global warming puts the water level at high tide just 10 metres below the roadway of the bridge, making Bristol into a toxic lagoon with maybe twenty of its taller buildings becoming concrete islands. The water would also lap, swirl, break, hurl against the gates of the city zoo in utterly unpredictable extremes of weather. Human animals might just about survive in highly specialised groups in geodesic biomes built on the nearby Downs.

We stripped the Wickham Theatre, an old printing workshop now become a flexible black-box studio, back to the walls. Borrowing from Guillermo Gómez-Peña's *Museum of Fetish-ized Identity*,[1] we designated seven areas as habitat-workshops for specialist survival teams, each dealing with water, plants, animals, air, time, energy, filtration. Water had an oil-drum fountain and a splendidly opaque system for processing liquids; plants had a small stairwell with a brightly lit vegetable patch off a food preparation area; animals were squashed into a feather-nested, netted alcove with a window onto an outdoor light-well where sometimes real birds flitted down to eat the scraps placed out for them; energy had a 5-metre-high scaffolding Heath Robinson machine incorporating old bikes where you could lie back and peddle-generate the glow of a small headlamp into life; air survived as best it could in the open middle of the space, an old parachute and Pilates-ball globes its only anchors; and so on. Each of the eighteen performers was in two groups (so thirty-six 'survivors' made up the seven survival teams) and pitched in to make the 'nature' of their habitats and the styles of their work-clothes: no attempt was made to link designs, each team generated its own visual and spatial qualities. The Eden Project in Cornwall provided an understated general framework, the whole space imagined as the experimental engine-room of a much bigger biome community.[2] Three big, suspended, plastic-covered hexagons, plus a few more standing against the walls, suggested work on

[1] Guillermo Gómez-Peña, *Ethno-Techno: Writings on Performance, Activism and Pedagogy* (London: Routledge, 2005); Website – Guermo Gómez-Peña: www.pochanostra.com (18.11.2006).
[2] Website – Eden Project: www.edenproject.com (20.11.2006).

the structure of the larger-scale shelter. A smaller one was hung high up in the fly tower, a continuous video loop of darkly scudding clouds suggesting a skylight window on the devastated postglobal meltdown world outside, a remnant from the storm on Lewesdon Hill. Another was the Toxic Drizzle Dance, a ritual blast performed to boost up energy when the horror of survival got too much. An ironic pop-operatic number, it had all eighteen bodies falling in perfect unison to the ground, writhing and choking like there was no tomorrow.

Spectator–visitors often perched on the edges of the survival-habitats, but mostly they wandered around browsing at will as the show ran for nine hours non-stop during two days. Our practical aim was to devise a performance system that could maintain the same levels of intensity of focus and energy usually found in much shorter shows. All the stuff used in the piece would be recycled and recyclable. We were searching for homologies between the real material conditions and the imaginary world of the production, making the total space a single place. In this sense the project was anti-theatrical, aiming to collapse the differences that theatre by its nature usually works to construct. An environmentally immersive experience was our ideal, like being in a storm on a hill.

The philosophical touchstone for the project was David Harvey's claim that 'if all socio-economic projects are ecological projects, then some conception of "nature" and "environment" is omnipresent in everything we do'.[3] Besides the amazing Eden Project, an early practical inspiration was Biosphere II, the huge glass hangar that replicates some of the Earth's ecosystems in the Southern Arizona desert[4] (see Fig 1, p. 8). These are both remarkable sites, but it could be that they are *pathological* reactions to the degradation that humans wreak on Earth. Biosphere II particularly is a paradoxical intervention in the ecosphere, like its close cousin the theatre holding a mirror up to 'nature' that tends to seal it off hermetically from the 'natural world'. Both Eden and Biosphere II influenced every aspect of *Green Shade* – aesthetic, thematic, ontological – as it aimed to provide an ironic antidote to such ecological desperation. Making a bittersweet anti-theatrical strike against the theatre of man-made biospheres. Trying to use performance like lightning, a destructive force that delivers positive effects.

Lightning figures in *Theatre Ecology* in a number of guises because it is one of the Earth's most theatrical and spectacularly *common* natural

[3] David Harvey, *Justice, Nature and the Geography of Difference* (Oxford: Blackwell, 1996), p. 174. This passage recurs at points throughout *Theatre Ecology*, as a reminder of its self-referential truth.

[4] Websites – Biosphere II: www.biospherics.org/ (25.08.2006); www.bio2.com (25.08.2006).

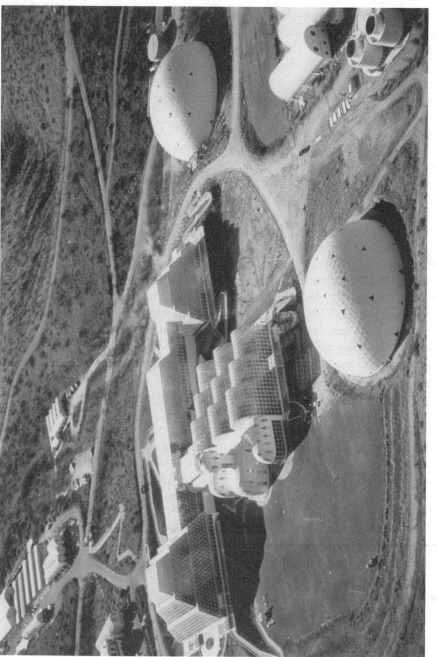

Figure 1 Biosphere II, Arizona, USA – 1991. The giant ecological ark as construction was nearing completion. For scale note the cars in the background. Compare the plan on p. 301. Photograph: Gill Kenny.

performance events. Also, under certain conditions, lightning produces a weirdly paradoxical effect. It creates an instant fossil of itself. Sometimes when it strikes quartzose sand or soil it makes a hollow glass tube that is root-like in appearance, reproducing the branching path of the electrical charge as it travels into the ground. Called fulgurites or petrified lightning, these structures can be 5 metres long or more.[5] What are these instant performative objects, and what might they teach us about theatre and performance ecology? This is a complicated question, but, if you'll forgive the pun, we can short-circuit a long discussion by thinking of the material aspect of fulgurites, the glass itself, as a *negative* trace of lightning, which makes the hollow tube that it enfolds the *positive* remains of the lightning event. The glass is *negative* in that it is *not* the lightning, though it materially shows the parameters of its past path. The tube can be considered a *positive* trace, because it is *not not* the lightning in that it immaterially indicates more fully than the glass the route of the flash. If it were possible to use the tube as a mould by, say, filling it with molten silver then breaking it away, the flash would be manifest. In other words, fulgurites are paradoxical objects, simultaneously *negative-and-positive* in respect of the past performance event that produced them.

This book explores how theatre/performance and ecology may work to the same principles that make lightning and fulgurites interdependent and mutually illuminating. It explores how ephemeral human events – just like lightning-flashes, waves lapping against a beach, trees swaying in a storm – can have lasting effects because they always leave more or less durable traces that frequently are fundamentally paradoxical. So while it was certainly quite mad of the elderly bloke to go hugging a tree in gale, might it yet have been a madness touched by a little flash of eco-sanity?

COMING TO A PRETTY PERILOUS PASS

It may seem slightly odd to begin a book on *Theatre Ecology* with a show about ecological disaster staged in a theatre stripped back to its walls. As the punters came in the back way through the big, sliding workshop doors, having just passed under a powerful air-wash shower, they were usually clearly taken aback by the spectacle of a large, busy, at first sight chaotic, faintly futuristic workshop populated by weirdly garbed drones. All the usual architectural trappings of banked seating, proscenium arch

[5] From the Latin *fulgur*, 'thunderbolt'. See Website – Wikipedia, Fulgurite: http://en.wikipedia.org/wiki/Fulgurite (02.11.2006).

with fire curtain, drapes or flats creating a stage area were gone. Now the superimposed fly-tower and cobbled-on parts of a fixed lighting grid pointed up the fact that the oddly shaped space punctuated by concrete pillars had *not* been built as a theatre. The 'theatre' became skeletal, spectral, no more than fragmented traces of a civilisation that had brought about its own demise.

The ambivalence of theatre in face of a calamity for humanity is a major concern of this book. I am interested in the various parts it has played as a prominent place for public gatherings in the run-down to global disaster that seemed to get steeper by the day in the first decade of the third Christian millennium. In what ways has the theatre been unavoidably embroiled in the ecological mess that is climate change? What could the theatre not help itself doing to stem or strengthen the causes of the environmental calamity that scientists started clamouring about? What was intrinsic to the theatre's myriad links into its social, cultural, political, economic, historical and, yes, environmental milieu? What were the 'natures' of theatre and associated performances in times when influential voices increasingly predicted the 'end of nature'?[6] These are hard questions as none of the main existing methods for the analysis of theatre – semiotics, phenomenology, cultural materialism, feminism, psychoanalysis, historiography and so on – paid much, if any, direct attention to the ecological qualities of the theatre phenomenon. Neither did mainstream studies of ecology, so far as I could tell when I first started seriously groping for answers to such questions in the early 1990s. So the title of this book has a deliberate ambivalence. It references both an object (or objects) of investigation, *theatre* ecology (as in '*human* ecology'), and the processes of theatre's unavoidable ecological engagement and/or disengagement regarding the environment, theatre *ecology*.

Theatre Ecology as a project therefore is broadly *homologous* to the ambivalence of theatre in the environment of the ecological era, sharing similar or related structural qualities. And just as the performances of *Green Shade* were haunted by theatre, so this book is ghosted by its history as part of global events leading to ecological nightmare for humans. This is literally the case, as the originals of its chapters were written, then presented and published internationally, between 1999 and 2005/6. But it is true in other ways as well. Most significant of these has been a continuous involvement with disciplinary debates about the

[6] Bill McKibben, *The End of Nature: Humanity, Climate Change and the Natural World*, rev. edn (London: Bloomsbury, 2003 [1989]).

'natures' of performance and with creative research projects.[7] These were a major context, a crucial milieu for my investigations of theatre ecology, and they have brought the project to a curious and paradoxical pass. My research into *performance* and ecology, some of which is presented as part of this volume, has led to analyses regarding the coming calamity for humanity that provide a testing environment for my arguments about theatre ecology. So it is necessary that a part of this introductory chapter to *Theatre Ecology* take the form of some provisional conclusions about *performance ecology* and the causes of a global addiction to performance on the part of human-animals in the age of ecology.

To cross that paradoxical pass requires five fundamental arguments by way of ecological route maps, which I sketch out in the rest of this chapter. First, concerning the emergence of the 'performance paradigm' in performative societies. Second, on the contradictory qualities of the performance paradigm and the double binds of performance addiction. Third, concerning serviceable definitions of theatre and performance ecology in the search for antidotes to that addiction. Fourth, outlining significant approaches to thinking through theatre ecology. Fifth, concerning the necessity of a paradoxology of performance in getting to grips with the paradoxes of theatre and performance ecology. Those arguments are followed by a brief survey of some analytical writings and creative practices relevant to theatre ecology, and finally suggestions for alternative orders for reading the texts that constitute *Theatre Ecology*. This closing option is fundamental to the reader's freedom in criss-crossing the pass between theatre and performance ecology via paths that, with luck, might lead to a little eco-sanity. For as Heraclitus said: Unless you expect the unexpected you will never find truth, for it is hard to discover and hard to attain.

PERFORMATIVE SOCIETIES AND THE PERFORMANCE PARADIGM

In the final decades of the twentieth century performance became to culture what water is to nature, an element indispensable to life. In some respects this was not altogether new, as ritual performance traditionally had provided a spring for human survival. But by the third millennium new global forms of political, economic, mediatised and technological change together engendered the 'performative societies': societies that are

[7] My principal performance as research projects 2000–5 were: *The Iron Ship*, ss *Great Britain*, Bristol Docks, 2000; *Mnemosyne Dreams*, ss *Great Britain*, Bristol Docks, 2002; *Green Shade*, Wickham Theatre, University of Bristol, 2004; *Being in Between*, Bristol Zoological Gardens, 2005.

crucially constituted through performance. The wholesale diffusion of performance in performative societies establishes a new paradigm of knowledge: the performance paradigm. Every dimension of human exchange and experience is suffused by performance and gains a theatrical quality. All human life is theatricalised and dramatised, including, crucially, its interactions with other species and the environment. The performance paradigm was thus a major generative force of an age of ecology that emerged in the final five decades of the second millennium. In this ecological era historical divides between culture and nature begin to be fundamentally eroded. Non-human species and even the Earth itself acquire new kinds of agency and significance. No longer masters of nature but inescapably part of its force fields, humans become temporary guests on planet Earth as contingency goes global and existence is increasingly under erasure. The paradoxical primate – the human both as object and subject, cause and effect of this potentially devastating evolution – enters an age of profound and inescapable uncertainties and responsibilities. The rest of this introduction will expand on the causes, consequences and crises of these circumstances, touching on other major processes – such as globalisation and terrorism – in the slide towards a calamity for humanity.

This thumbnail sketch of conditions that rapidly became global as the twentieth century closed sets the scene of a new and ubiquitous form of human addiction. A crucial conclusion of my research in performance ecology is that in the twentieth century homo sapiens increasingly became addicted to performance, to the point where the effects of that addiction threatened the survival of the species. There are myriad forms of this addiction, and some are well known, though often they are not recognised as 'proper' addictions. For example, environmentally the Earth's carbon cycle has become subject to a human 'carbon addiction' that focuses on fossil-fuel energy consumption and is possibly the principal cause of global warming.[8] Biologically, a growing improvement in material wellbeing and medical intervention has generated a compulsive global population expansion that may soon be beyond the 'carrying capacity' of the planet.[9] Economically fast-rise or instant millionaires born of, say, dot-com explosions or lottery revolutions and shadowed by legions of

[8] By 2006 the phrase had become fairly common in the UK media. A Google exact phrase search produces 520 hits (20.11.2006). Website – Carbon cycle: http://earthobservatory.nasa.gov/Library/CarbonCycle/carbon_cycle4.html (10.11.2006).

[9] Websites – population growth: www.globalchange.umich.edu/globalchange2/current/lectures/human_pop/human_pop.html (20.11.2006); population clock: www.census.gov/main/www/popclock.html (20.11.2006).

the really obscenely rich, produce cycles of envy, despair and greed that become instilled in the human psyche as an integral part of official fiscal regimes. And so on. These are some of the more obvious signs of performance addiction in the early-twenty-first century, but none of them are its cause. Rather, the addiction was the result of an increasingly pervasive *double bind*.

PERFORMANCE ADDICTION

'Double bind' here describes a negative state of affairs that is irresolvable because there is no escape without deeply undesirable consequences. For example, an immediate major reduction of fossil-fuel energy production would likely cause a collapse of the global economy or other equally dire outcomes. But again this does not get to the nub of the matter. We need to move laterally to achieve that, to indulge in a little *thought experiment*. So considered an argument in 2004 between the British Prime Minister Tony Blair and his Chief Scientific Adviser Sir David King about what is the greatest threat to humanity, international terrorism or global warming.[10] Of course that 'or' operates like a booby trap to an explosion of impossible choices, and maybe it was placed so firmly at the crux of the argument because the consequences of ignoring it open up vistas on a double bind of stupendous proportions. For if the answer is 'both' then extreme intra-species human violence and extreme environmental degradation may be revealed as a vicious circle, one reinforcing the other in a cycle of powerful performance addiction. Think of the appalling events of 11 September 2001 in New York as a performance, as some have already.[11] Think of the Earth's ice-caps speedily melting as part of the *same* performance. At a superficial level this is as simple as the black smoke of skyscrapers torched by aviation fuel adding to carbon overload. More fundamentally, maybe the spectacle burns itself into the human heart and erupts as revulsion against an environment that can be so easily and tragically soiled by terror. Think of the ways in which fear of terror, spoiled freedoms and environmental degradation have already each racked up the ante on the other. Terrorism reduces human rights, requires a war

[10] The debate was sparked by an article and lecture, see: David King, 'Climate Change: Adapt, Mitigate or Ignore', *Science* 303: 5655 (October 2004); Website – Foundation for Science and Technology: www.foundation.org.uk/events/pdf/20021031_summary.pdf (20.11.2006).
[11] Slavoj Žižek, *Welcome to the Desert of the Real* (London: Verso, 2002) pp. 10–17; Richard Schechner, *Performance Studies: An Introduction*, 2nd edn (London: Routledge, 2006), pp. 282–3.

without borders, increasing global energy consumption, fostering the proliferation of destructive technologies, exacerbating international injustice, creating more terrorism ... Think that in some ways, however small, all humans are involved in this global performance system as a double bind. All ways out create undesirable consequences, some of them potentially as horrendous, or even more so, as those it all started with. Think how you personally are integral to that syndrome as you hold this book in your hand or read it on a glowing screen, and that's just a tiny taste of human performance addiction.

Viewed from the extreme perspective of that thought experiment, most humans are in denial that such an addiction exists. This is not surprising, because to resolve such double binds in order to eliminate performance addiction requires a major revolution in how humans relate *both* to each other *and* to the environment. As a now compulsive desire for performance is the motor of the addiction, fresh views of how it might operate in the world are required. Key to this, I think, becomes understanding how performance is an integral part of global ecology and ecosystems, how particular performances operate ecologically as ecosystems, and how humans might arrive at better appreciation of performance processes in Earth's ecosystems through ecology. I call these aspects of the interaction of performance and ecology: 'performance ecology', 'performance ecologies' and 'ecologies of performance', respectively.

There are four main aspects to my arguments about the relationships between performance addiction and performance ecology. First, performance addiction emerged mainly through the 'performative societies' that evolved in the second half of the twentieth century. As already noted, these are societies in which performance is so pervasive that it comes to constitute the human. The performance paradigm is crucially part of that. Second, in these societies many factors, but especially spectacle and spectatorship, shape the 'nature' of human subjectivity so that it is no longer 'at home' in the world. Spectacle and related forms of performance may produce profound 'anxieties of dwelling' on the Earth. Third, to begin resolving the double binds that are integral to such anxieties 'humanity' must sense 'itself' as part of a 'performance commons' that it shares with all organisms, which also share with humans the 'environmental commons' such as air, water and soil. Hence, performance and environment are interdependent in both being essential commons for sustaining life on Earth. Fourth, to improve the interaction of the performance and environmental commons, i.e. to reduce human performance addiction, humans need to evolve and perform forms of 'ecological

sanity'. Successful rehearsals for such forms of sanity can be found in the ways in which radical ecologists performed their ecologies even as performance addiction most virulently took hold of humanity during the second half of the twentieth century.

This last is performative territory that *Theatre Ecology* does little more than gesture towards, as I stumble to set out some of the principles of performance and theatre ecology through other, more direct routes. That study of radical ecologists and other key aspects of performance ecology will be part of a sequel to this book, which here therefore relegates performance addiction to the realms of hypothesis. However, we shall see that the thinking of such ecologists informs the fundamental arguments of *Theatre Ecology*, and that may lead us to glimpse some usable antidotes to performance addiction – which I tag as 'eco-sanity' – through the ecologies of theatre evolved in the pages that follow.

WHAT IS THEATRE ECOLOGY?

The ecologies of theatre and performance, like ecology as a discipline in general, aim to refigure the relationships between 'culture' and 'nature' that all humans inevitably inherit. The starting point for that refiguring here is the modernist traditions of European 'enlightenment' which pitched nature and culture, 'man' and the 'environment' against each other in what has turned out to be a potentially disastrous opposition. Obviously the languages of these traditions are problematic for all ecological projects, as the quotation marks around the key words above have just indicated. In the projects that led to this book it was impossible not to use them, so readers need to be alert to the implications of a deliberate linguistic recycling as I struggle to evolve a language appropriate to a radical agenda in theatre and performance ecology.

I begin with some broad definitions that will seem very basic to experienced ecologists, but which will grow more complicated as my arguments emerge through the chapters. 'Ecology' references the interrelationships of all the organic and non-organic factors of ecosystems, ranging from the smallest and/or simplest to the greatest or/and most complex. It is also often defined as the interrelationships between organisms and their environments, especially when that is understood to imply interdependence between organisms and environments. The terms 'theatre ecology' and 'performance ecology' reference theatres and performances *as* ecosystems. So 'theatre ecology' (or 'performance ecology') refers to the interrelationships of all the factors of particular theatrical

(or performance) systems, including their organic and non-organic components and ranging from the smallest and/or simplest to the greatest or/and most complex. Following uses in ecology, these terms can also refer to the interrelationships between theatres (or performances) and their environments, especially when interdependence between theatres/performances and their environments is implied.

I make further broad distinctions between this group of definitions, and another group produced by the phrases 'ecologies of theatre' and 'ecologies of performance'. These introduce other, differently reflexive dimensions to my arguments, as they reference the study – and the knowledge it produces – of theatres and performances when they are considered as ecosystems. Hence 'theatre ecology' is the subject of 'ecologies of theatre', and likewise 'performance ecology' of 'ecologies of performance'. The main implication in all these definitions is that theatre and performance in all their manifestations always involve the interrelational interdependence of 'organisms-in-environments'. Or, to reformulate that last phrase from a more radical ecological perspective as proposed by 'deep ecologist' Arne Naess, they constitute a 'relational total-field' in which everything is interdependent and cannot always easily be assigned to clear distinctions, say as between 'organism' and 'environment'.[12] For example, as primates perform eating they fundamentally become part of their environment.

Forced to produce soundbites based on these broad definitions I might say: Theatre ecology is the ways theatres behave as ecosystems. Or: The ecologies of theatre are investigations of theatre ecosystems. But I would always want to qualify such statements. Because, for example, the distinction they imply between an 'object' – theatre ecology – and the results of studying it as a 'subject' to produce an 'ecology of theatre' simplifies the *reflexive* dimensions of ecological perspectives. These are integral to the etymology of 'ecology' as it derives from the Greek οικος (*oikos*, 'household') and λόγος (*logos*, 'study'), which implies *both* 'study *of* the house' *and* 'study *in* the house' of nature.[13] Hence 'ecology' fundamentally emphasises the inseparable and reflexive interrelational and interdependent qualities of systems *as* systems, however their components are defined. And included in this is how the word's etymology implies that organisms – including humans – are both a part of and apart from their

[12] Arne Naess, *Ecology, Community and Lifestyle*, trans. and ed. David Rothenberg (Cambridge University Press, 1989), pp. 28, 54–6.
[13] Website – Wikipedia, Ecology: http://en.wikipedia.org/wiki/Ecology (20.11.2006).

environments, more or less reflexively alert to themselves as agents in/for environments. For humans an important quality of such reflexivity is that it can potentially reveal the assumptions or principles upon which actions and thoughts are founded, sometimes paradoxically enabling the correction of errors before they occur, or at least before they produce double binds.[14] As we have just seen through the example from Arne Naess, the more radical ecologists are extremely alert to the complexities of ecology as a reflexively structured 'relational field', but all discussions of ecology engage to some degree in the resultant 'game' of linguistic challenge and transformation. Perhaps the most famous move is James Lovelock's renaming of Earth as Gaia, a vision that the planet is a single living organism.[15]

In approaching such problems of language I have opted to trust the reader, in the interests of both stylistic suppleness and philosophical fidelity. Stylistically it is often awkward to hold to hard and fast distinctions between 'theatre ecology', the 'ecologies of theatre' and so on. So I indulge in some blurring between them as the context allows, hoping that you will become alert to the contextual conditions that produce their various nuances of meaning. Philosophically, this practice has two main purposes. Firstly, it implicitly makes the point that language, including language in theatrical performance, has a kind of 'ecological' dimension in that words adapt to their environments and change their 'behaviour', for example, what they might be doing performatively as part of particular arguments. This is obviously to draw an *analogy* between the processes of language and ecology, treating words like living things. But secondly, and more substantially, that practice reflects the fact that humans can only rarely avoid using and reusing the languages they inherit. So that, in the twenty-first century, ecology – including theatre ecology – *has* to wrestle with the dominant meanings of key words bequeathed by modernism, for example, of 'nature' and 'culture' as separate and oppositional entities.

However, this has a positive advantage for my arguments, because the kinds of *paradox* that that linguistic necessity generates are, I will argue, a fundamental characteristic of most, if not all, performance. To reformulate language in this way is *much the same* as using a theatrical performance, say, to question the 'nature' of theatre in the twenty-first century, as we attempted through *Green Shade* in the Wickham Theatre. Both linguistic

[14] For a useful short discussion of reflexivity, see: Scott Lash and John Urry, *Economies of Signs and Space* (London: Sage, 1994), pp. 31–59.
[15] James Lovelock, *Gaia: A New Look at Life on Earth*, reissue (Oxford University Press, 2000 [1979]).

and theatrical reformulations use the tool of communication to dismantle and reshape itself, or, say, to half-repeat an error in order to know how to avoid it through a stochastic process of trial and error. This is to begin to deduce a potential *homology* between the self-referential, sometimes paradoxical structures of such linguistic reformulation and the often paradoxical, self-reflexive structures of performance itself, theatrical or otherwise, and especially its ecologies. Hence homologies occur when two or more sets of relational components manifest common patterns when they are compared, such as the five digits of the bat's wing and the human hand, or the hyphenation of 'nature–culture' to indicate the environmental convergences leading to global warming. The natures of such homologies are fundamental to my arguments, especially when they are paradoxical. Hence I develop a 'paradology' – a term that references paradoxical homologies – to further my analyses of theatre and performance ecology. This is necessary because paradoxical homologies have extensive implications regarding the causes of a possible calamity for humanity. Engaging willy-nilly with the ecological endgame that is performance addiction/climate change, humans might do much worse than ponder Baba Ram Dass's observation: If you think you're free, there's no escape possible.

TOWARDS THEATRE ECOLOGY

I return to questions of analogy, homology and paradology throughout *Theatre Ecology*, but a brief survey of some other key ecological terms and tropes used in my arguments will provide a more straightforward opening orientation. For example, I sometimes refer to the theatre as a 'niche', a place that sustains theatre-goers because they have adapted to its particular purposes in wider 'cultural' ecologies. Accordingly, theatre is a place of particular 'affordances' in that it has the resources more or less to sustain, to *afford* the practices of theatre-going, in the sense of 'providing something without unacceptable or disadvantageous consequences'.[16] Theatre can achieve this because its levels of 'entropy', or the degrees of random activity in its systems, can be reduced so long as it remains open to incoming energy as a niche with affordances for particular theatre-goers. The more it becomes a closed system the more its entropy will increase in

[16] Encarta World English Dictionary (2006): 'afford'. *Shorter Oxford English Dictionary*, 5th edn, vol. I (Oxford University Press, 2002), p. 37 – 'afford: manage to; able to; have the means; capable of yielding'.

accord with the second law of thermodynamics, just as when hot drinks cool to room temperature, and so the more it will add to the overall disorder and degradation of the universe. Theatre may combat tendencies to closure in many ways, but among the most important is for it to become what ecologists call an 'ecotone', a place where two or more ecologies meet and mingle, such as, say, riverbanks, seashores and deep-sea volcanic vents. Ecotones often produce new hybrid life-forms as a result of the 'edge effects' characteristic of the meeting of ecosystems. Some theatre ecotones are more successful in this respect than others because they have strong 'negative feedback' loops, self-correcting warning systems that ensure no over-use of resource occurs which will make them less sustainable, more prone to entropy. The failure of such loops produces 'positive feedback' and the potential of a runaway resource decline, to the point where the whole system becomes 'unsustainable' and collapses. For example, climate change is the result of positive feedback loops – such as carbon addiction – in the early twenty-first-century global ecosystem.

Of course the application of these terms to theatre, though possibly illuminating, may be regarded as merely an exercise in *extended analogy*. Theatre may operate structurally like an environmental ecosystem in these respects, but it lacks some of the crucial characteristics of environmental ecologies, such as the mechanisms of Darwinian natural selection that produce the succession of species in evolution. Develop the description in that more fundamental direction and the extended analogies, like overstretched ecosystems, start to break down. Hence the biologist Richard Dawkins has been attacked for proposing that genes have an equivalent in the cultural realm. He calls them 'memes', defined as a 'unit of cultural inheritance, hypothesised as analogous to the particulate gene'.[17] He argues that a 'meme should be regarded as a unit of information residing in the brain' and therefore 'should in principle be visible under a microscope'. Just as genes interact with the environment to produce a 'phenotype' – manifest attributes of an organism such as, say, eye colour or body shape – so memes influence the human organism and its environment to produce 'phenotypic effects . . . in the form or words, music, visual images, styles of clothes, facial and hand gestures' and so on. Dawkins argues that memes 'may imprint themselves on the brains of . . . receiving individuals [so that] a copy (not necessarily exact)

[17] Richard Dawkins, *The Extended Phenotype: The Long Reach of the Gene*, rev. edn (Oxford University Press, 1999 [1982]), p. 297. See also: Richard Dawkins, *The Selfish Gene*, 30th anniversary edn (Oxford University Press, 2006 [1976]), pp. 189–201.

of the original meme is graven in the receiving brain'. But even if the meme is not 'localisable on a microscopic slide . . . I would want to regard it as physically residing in the brain'.[18] Hence the transfer of performance, theatrical or otherwise, between generations in, say, commedia del' arte or Japanese Nō theatre becomes a 'memetic' affair. So the longevity of particular artistic genres may be explained by the quasi-scientific 'fact' that some memes passing between human brains are fitter for survival than others.

Occasionally I refer to Dawkinian memes when they provide a helpful analogy for clarifying elements in my analyses of theatre and performance ecology, such as the notion that in theatre economics some types of money may be best thought of as viral when compared to other kinds.[19] But I tend to side with the sceptics of meme theory, not because the 'physical' brain-lodged entity remains unobserved under the microscope, but because I think Dawkins is looking in the wrong place through an inappropriate optic for 'evidence' of the 'cause' of non-genetic phenotype effects among humans and other species. There are many factors embedded in this point, but two are most crucial to the arguments of this book.

Firstly, my arguments accept that phenotype effects occur as between the natural and cultural realms, for example, when the biologically produced blue eyes of particular families witness socially produced typical gestures evoked in response to particular environments which are passed by kith and kin through the generations. But I consider this more likely to be a vector produced by factors of common structural principles shared between varied ecological systems than caused by any specific quasi-physical entity such as a meme. Such principles would include, for example, interdependence of all factors/vectors in a system, such as levels of entropy, negative or positive feedback, species hybridity and diversity, and so on. The sharing of those principles can clearly be seen in environments that include two or more ecologies, such as ecotones shared by humans and other animals. Hence the ecologies of some indigenous peoples' traditional lands or of extended human field studies of primates in the wild show strong evidence of cross-species adaptations over time. These adaptations are best explained by structural similarities between

[18] Dawkins, *Extended Phenotype*, p. 109. For discussion/debates, see: Susan J. Blackmore, *The Meme Machine* (Oxford University Press, 1999); Robert Aunger (ed.), *Darwinising Culture: The Status of Memetics as a Science* (Oxford University Press, 2000).

[19] See chapter 5, p. 157.

systems that effect phenotype transmission and exchange in and between the various species, i.e. through mutual repeated patterns of interaction, which of course may include imitative or mimetic (not memetic) behaviour.[20] I therefore suggest that there are structural ecological principles common to the 'cultural' and 'natural' realms that are *homologous* because they emerge through similar shared or overlapping performance systems, which I call the 'performance commons'. The secret of intra- and inter-species phenotype effects is in homologies resulting from ecosystemic performance commons rather than in analogies based on quasi-scientific physical entities.

Secondly, the conceptual optic for 'observing', i.e. identifying, such homologies needs to be much more sophisticated than anything that can be achieved by binocular instruments. The limitations of Dawkins's memes arise because, for all his commitment to '*selfish*' genes, his theoretical position basically adheres to the nature/culture binary of scientific modernism, and the oppositions between mind/body, animal/human and so on, that follow. That is the meta-message of the distinction between genes and memes.[21] I argue in common with many ecologists that it takes a fundamental erosion of that binary, such as is usually found in radical ecology, to construct a more convincing case for the existence of theatre ecology and its 'cultural' cousins. Of course, this produces the counter problem of creating alternative perspectives on the world, angles of analysis that need to be multi-perspectival and non-reductive, simultaneously 'taking in' the zone of attention from clearly defined and contrasting frames of reference or even paradigms of knowledge. Through such revisioning we might begin to see how the dance of the genes is expressed through fabulous but common structural choreographies shared across and between diverse 'natural' and 'cultural' ecologies in the performance commons.

It follows that the ecologies of theatre and performance, in principle, must take nothing in the share-out of life as between 'culture' and 'nature' for granted. While it is impossible to guard wholly against the freight of historical baggage carried by such words, they must always be qualified by

[20] See: Nancy J. Turner, Iain J. Davidson-Hunt and Michael O'Flaherty, 'Living on the Edge: Ecological and Cultural Edges as Sources of Diversity for Social–ecological Resilience', *Human Ecology* 31: 3 (September 2003); Donna Haraway, *Primate Visions: Gender, Race, and Nature in the World of Modern Science* (London: Routledge, 1989). A famous example of the latter is: Jane van Lawick-Goodall, *My Friends the Wild Chimpanzees* (Washington, D.C.: National Geographic Society, 1967).

[21] Dawkins's position is more complex than this formulation implies, but the point holds especially for memes, which Dawkins claims as no more than '*analogous* to the ... gene'. My emphasis. Dawkins, *Extended Phenotype*, p. 297.

potent surrounding terms as part of the effort to make language responsive to ecological imperatives. Readers have probably sensed this process under way in the last few paragraphs' uses of 'factor' and 'vector'. 'Factors' may be any entity involved in transactions that count in producing significant change, elements that 'make a difference which makes a difference' between varied states of becoming.[22] In this sense ecologists tell stories about the dramas of organic and environmental factors, such as birds in the air or humans on hillsides. 'Vector' adds direction and magnitude to the transactions of factors. So in the case of factors such as a flock of birds or the chorus in a Greek tragedy, say, their vectors are the course they take to reach the flight's destination or to gain bearings on the hero's tragic submission to destiny. Vectors thus provide a sense of tendencies towards the future in particular ecosystems, whether they are considered as primarily natural or cultural or natural–cultural systems. In other words, the language of 'factors' and 'vectors' is useful to the ecologies of theatre and performance, because it can help dismantle the binaries of the modernist teleology that are driving humans compulsively towards eco-disaster in the twenty-first century.

Some erosion of those binaries is therefore a principal objective of *Theatre Ecology*. But it does not attempt to evolve a highly rigorous approach to that objective regarding 'culture' and 'nature'. Such a complex dream of rigour could only be achieved by a wholesale adoption of Derrida's technique of placing words *sous rature* ('under erasure'), thus ~~culture~~ or ~~nature~~, a technique used 'to indicate ... the use of terms the validity of which he denies'.[23] But this would surely become an irritating affectation. More significantly, it would also undermine the varied earlier lives of the chapters that follow, all of which have different genealogies, and whose diversity of topic and style is important to my ecological conceits about sustainability as between both cultural and natural systems. Instead I will highlight the textual variability of the chapters' responses to the mess of the nature/culture binary, sometimes placing the offending words in quotation marks, sometimes hyphenating them, but mostly again trusting that readers will detect through such differences why these writings have survived so far, especially as a result of their

[22] The phrase is from: Gregory Bateson, *Steps to an Ecology of Mind* (University of Chicago Press, 2000 [1972]), pp. 271–2.

[23] Philip Auslander, ' "Just be Yourself": Logocentrism and Difference in Performance Theory', in *Acting (Re)Considered*, ed. Phillip B. Zarrilli (London: Routledge, 1995), p. 66; Jacques Derrida, *Margins of Philosophy*, trans. Alan Bass (Brighton: Harvester Press, 1982), pp. 26–7.

earlier adaptations to new environments. Because these exercises in the ecologies of theatre are an emergent approach that, like any new organism, needs flexibility to survive and grow.

Hence the supple variations of meaning in its key terms are a matrix for adaptations that have drawn on the sustaining energies of diverse environments – whether lecture, seminar, conference, journal, book – to achieve the best possible discursive 'fit' for survival. I hope the reader's memory of my wholesale affirmation of *sous rature* will serve to underline the reflexive and often paradoxical qualities of this prospecting for theatre and performance ecology. This is not a disadvantage, for paradoxes produce multiple perspectives of view on theatrical events in the nature–culture, performance–environment commons that might otherwise be invisible. Possibly as when the 'far side of an eclipsing moon ... absorbs and blocks the sunlight from us and causes us to see the moon as a dark disc. So it is the far side of the moon, not its near side, that we see.'[24]

ON PARADOX AND PARADOXOLOGY

Paradox is utterly crucial to the evolution of theatre and performance ecology. So in many ways paradoxes have shaped the writings included in this book. This is a major reason why the chapters have been only partly rewritten for this new environment, as a tactic to preserve differences and diversities of example, argument, style and so on that bring risky contradictions into play, such as theatre becoming a closed system through interaction with its environment. Yet this tactic is a cautious approach to textual adaptation modelled on the norms of evolutionary selection where – even in the case of some apparent exceptions that have long fascinated biologists, such as male peacocks and birds of paradise – expending too generous an energy on the business of survival is usually a policy for decline and possible extinction. The risks of contradiction set against a conservative adaptive caution tend to create an environment productive of paradox in this book. But paradox can be a positive step that includes but travels beyond the binaries of body and mind, female and male, nature and culture and all the rest that dog ecological wisdom. Another victory like that, said the pyrrhic dodo sitting on the hunter's head, and we're done for.[25]

[24] Michael Clark, *Paradoxes from A to Z* (London: Routledge, 2002), p. 44.
[25] Dodos, of course, could not fly; Pyrrhus coined the paradox.

In deciding which ecologists to learn from I have inclined towards those usually considered most radical, the ones that most challenge the nature–culture binaries up front and head on, so to speak. Gregory Bateson, James Lovelock, Arne Naess, Val Plumwood, Vandana Shiva, Donna Haraway and others have shaded my evolving orientation to ecology like brilliant lodestars, providing, I hope, a cool edge to my sometimes no doubt overheated arguments.[26] I rarely point to them directly – that will be a task for this book's sequel – but they have always been around as I trespassed more deeply into the paradoxical realms of theatre and performance ecology. They have sustained my conviction that the ecologies of theatre are much more than an analogical exercise in drawing imaginative parallels. So that, for example, I discovered they validate my instinctual knowledge as a theatre deviser and director, that there are complicated and unavoidable interdependencies between every element of a performance event and its environment. They lend credence to the craft-based experience that for decades has told me those inter-dependencies ensure that the smallest change to one factor of theatrical performance in some way, however minutely, will effect change in all the rest. They bolster my growing belief that the ecology of theatre is fabu-lously more than a metaphorical enterprise by how they have understood the fine balance of energies that can make or break the life of events. Hence theatre ecology is as much a matter of living exchange between organisms and environments as the ecology of plants or of ants, say. It operates much to the same principles as they do, and for purposes that are much more similar than is conventionally imagined. In other words, theatrical performance is not a system that is different *in kind* from other ecological systems, though of course like them it has its own peculiar characteristics.

Obviously, these claims rest on radical versions of the nature–culture complex. For example, they harmonise with Gregory Bateson's arguments in *Steps to an Ecology of Mind*, where he notes a major shift in twentieth-century conceptions of the 'unit of evolutionary survival' away from a Darwinian focus:

Formally we thought of a hierarchy of taxa – individual, family line, subspe-cies, species, etc. – as units of survival. We now see a different hierarchy of

[26] Bateson, *Steps to an Ecology*, 1972; Lovelock, *Gaia*, 1979; Naess, *Ecology, Community*, 1989; Val Plumwood, *Feminism and the Mastery of Nature* (London: Routledge, 1993); Vandana Shiva, *Staying Alive: Women, Ecology and Development* (London: Zed Books, 1989); Donna Haraway, *Simians, Cyborgs and Women: The Reinvention of Nature* (London: Routledge, 1991).

units – gene-in-organism, organism-in-environment, ecosystems, etc. Ecology, in the widest sense, turns out to be the study of the interaction and survival of ideas and programs (i.e. differences, complexes of differences, etc.) in circuits.[27]

One such circuit in Western civilisation has been commonly defined as 'theatre–society'. From this perspective, the Renaissance notion of the *theatrum mundi* – all the world's a stage and all the men and women merely players – might be considered a kind of early-modern ecological modelling. In related vein, postmodern and poststructuralist conceptions of ecology fundamentally challenge the subsequent evolution of modernism. Deleuze and Guatarri make major contributions to such ecological thinking, for example through their notion of the 'rhizome' as a means whereby cultural forms (with language as the main factor) may 'communicate' with their environment and thus bring about significant 'evolutionary' change.[28] In his discussions of 'ecosophy' Guattari draws an absolute equivalence between the customary objects of ecology – biological species – and what he calls the 'incorporeal species', by which he means in large part 'music, the arts, cinema . . .'.[29] This line of thought, developed further in *The Three Ecologies*, has profound implications for existing approaches to theatre and performance analysis. Yet more substantially, these radical reframings of more conventional ecological views, for example, that 'culture' and 'nature' are major obstacles to global environmental sanity, seem to me ironically to imply an embrace of paradox as a fount of knowledge for ecology itself.

So if the performance paradigm has fully arrived in the twenty-first century, some of the foundational contradictions of theatrical performance take on an exponentially increased significance. For example, that it is both real and not-real, i.e. it exists always in an ontologically subjunctive mode. For example, that it is both ephemeral and durable, i.e. it exists always in a transitive mode where one state implies another to come. Such contradictions are the stuff of strong paradoxes, such as 'At the moment of meeting the parting begins' and 'The future is always before its time.'[30] Performance in many if not all of its manifestations is a paradoxical affair. This accepted, it follows that in the performance

[27] Bateson, *Steps to an Ecology*, p. 49.
[28] Gilles Deleuze and Félix Guattari, *A Thousand Plateaus: Capitalism and Schizophrenia*, trans. Brian Massumi (London: Athlone Press, 1988), pp. 6–8, passim; see also, Daniel R. White, *Postmodern Ecology: Communication, Evolution, and Play* (University of New York Press, 1998), p. 58 passim.
[29] Félix Guattari, *The Three Ecologies*, trans. Ian Pindar and Paul Sutton (London: Athlone Press, 2000), p. 71; see also, Felix Guattari, *Chaosmosis: An Ethico-aesthetic Paradigm*, trans. Paul Bains and Julian Pefanis (Sydney: Power Publications, 1995).
[30] This second paradox was coined by the author.

paradigm a logical means for understanding its most crucial characteristics could be a paradoxology of performance, an approach to theorised analysis that fully recognises and responds to this 'nature' of performance. In this context of performance as a ubiquitous process the human may have little option but to mostly live through paradoxes. Enter the paradoxical primate: the animal that thinks it isn't one, the homo sapiens that is always in at least two minds or body-minds, the human that is absolute only in uncertainty.[31]

COGNATE WRITINGS – COGNATE PRACTICES

The preceding discussion is as much conclusion as introduction to this book, because the following arguments were mostly evolved and published during seven years that spanned the turn of the last millennium. Yet my creative performance projects since the late 1960s often drew inspiration from and were located in non-theatre environments. A scenario for a show in a huge Hawaiian banyan tree put performers up in its branches while the audience wandered among the stilt roots below – sadly never realised, as a spectacle for a hippy festival in Honolulu's Diamond Head Crater won the day! Decades later, in the mid-1990s, I teamed up with colleagues at the Centre for the Study of Environmental Change at Lancaster University for a project investigating theatre, performance and ecology. We planned the first international conference on that conjunction, called Between Nature and mounted in July 2000 to great acclaim.[32] The first pair of books wholly devoted to ecology and performance, *Nature Performed* (2003) and *Performing Nature* (2005), arose from that conference.[33] Those collections provide an invaluable critical panorama of approaches to ecologically practical theorising in this still 'emergent field'.

Una Chaudhuri was a keynote speaker at Between Nature. Her 1994 essay, ' "There Must Be a Lot of Fish in That Lake": Toward an Ecological Theatre', was the first to advance a thorough theorising of the awkward conjunction between dominant Western theatre traditions and ecological thought. Elinor Fuchs's essay 'Another Version of Pastoral',

[31] Colin Talbot, *The Paradoxical Primate* (Exeter: Imprint Academic, 2005).
[32] Website – Centre for the Study of Environmental Change: http://csec.lancs.ac.uk (20.11.2006).
[33] Bronislaw Szerszynski, Wallace Heim and Claire Waterton (eds.), *Nature Performed: Environment, Culture and Performance* (Oxford: Blackwell, 2003); Gabriella Giannachi and Nigel Stewart (eds.), *Performing Nature: Explorations in Ecology and the Arts* (Bern: Peter Lang, 2005).

which defines what she evocatively calls 'landscape theater', was first published alongside Chaudhuri's.[34] Bonnie Marranca's *Ecologies of Theater* (1996) collects together short essays that explore how notions of landscape and nature have influenced mostly American theatre criticism and performance, though the phrase 'theatre ecology' goes back at least to 1987.[35] In that year as well the American journal *High Performance* published a seven-article section on performance and ecology, in an issue which indicated a blurring of lines between ecological activism and the experimental performing and visual arts that were to become increasingly and productively fuzzy.[36] Yet for theatre studies these early writings on the performance–theatre–ecology complex set the terms of a critical strand in which topography tended to mediate ecological critique in dramatic and theatrical analysis, especially in America.[37] In the UK the tendency was more towards a broad social/cultural-studies activist analysis that mostly downplayed serious theorising, perhaps best represented by George McKay's two highly informative books on *Senseless Acts of Beauty* (1996) and *DiY Culture* (1998).[38] Environmental protest was later placed in ritual and performance studies frameworks by Bronislaw Szerszynski's 'Ecological Rites' and my essay on eco-activist practice, reproduced here as chapter 8.[39] This list does not, of course, present an exhaustive survey, historical or otherwise, and there is plenty of scope for a more thorough treatment.[40]

[34] Una Chaudhuri, ' "There Must Be a Lot of Fish in That Lake": Toward an Ecological Theatre', *Theater* 25: 1, Special Issue: 'Theatre and Ecology' (Spring/Summer, 1994); also contains Elinor Fuchs, 'Another Version of Pastoral'; Sheila Rabillard, 'Fen and the Production of an Ecofeminist Theatre'. See also: Elinor Fuchs, *The Death of Character: Perspectives on Theater after Modernism* (Bloomington and Indianapolis: Indiana University Press, 1996), pp. 92–107.

[35] Bonnie Marranca, *Ecologies of Theater* (Baltimore and London: Johns Hopkins University Press, 1996; see also, 'Performance World, Performance Culture', *Performing Arts Journal* 10: 3 (1987), 21–9.

[36] 'Art Environment Ecology', *High Performance* 10: 4 (1987), 22–59. For a key visual arts text, see: Suzi Gablik, *The Reenchantment of Art* (London: Thames & Hudson, 1991).

[37] Una Chaudhuri, *Staging Place: The Geography of Modern Drama* (Ann Arbor: University of Michigan Press, 1997); Elinor Fuchs and Una Chaudhuri (eds.), *Land/Scape/Theater* (Ann Arbor: University of Michigan Press, 2002). But see also: Downing Cless, 'Eco-Theatre, USA: the Grassroots Is Greener', *Drama Review* 40: 2 (Summer 1996).

[38] George McKay, *Senseless Acts of Beauty: Cultures of Resistance since the Sixties* (London: Verso, 1996); George McKay (ed.), *DiY Culture: Party and Protest in Nineties Britain* (London: Verso, 1998); Paul Kingsworth, *One No, Many Yeses: A Journey to the Heart of the Global Resistance Movement* (London: Free Press, 2003). For a US perspective, see: Nina Felshin (ed.), *But is it Art?: The Spirit of Art as Activism* (Seattle: Bay Press, 1995).

[39] Bronislaw Szerszynski, 'Ecological Rites: Ritual Action in Environmental Protest Events', *Theory, Culture and Society* 19: 3 (June 2002); Baz Kershaw, 'Eco-Activist Performance: the Environment as Partner in Protest?', *Drama Review* 46: 1 (Spring 2002).

[40] See: Wallace Heim, 'Performance and Ecology: a Reader's Guide', in Giannachi and Stewart, *Performing Nature*, pp. 405–16.

That would need also to include pioneering work in literary eco-criticism in the 1990s, which spread to screen-based performing art forms, such as film and digital media, in the early twenty-first century.[41] But the extraordinary expansion of creative activities that the theatre- and performance-orientated writings analyse, from scripted drama staged in traditional theatres to improvised performative interventions at sites as varied as genetically modified vegetable fields and an oil-rig in the North Sea, is especially challenging as it reflects the international and centripetal dynamics of ecologically engaged live performance practices.

These blossoming zones of human eco-performance have become ever more extensive since the turn of the millennium. They grew out of decades of radical and alternative theatre practice across many countries.[42] So by the early twenty-first century an international movement of environmental and ecological creative performance groups was emerging to span a plethora of forms, genres, aesthetics, venues, locations, sites, purposes, policies and, last but not least, pleasures. A visit to the only website currently wholly dedicated to theatre/performance and environment/ecology gives an excellent idea of this from a UK perspective. The Ashden Directory combines magazine and database formats.[43] In 'introducing environment and performance' it provides a timeline starting with US Vice President Al Gore's climate change movie *An Inconvenient Truth* (2006) and ending on Ibsen's *An Enemy of the People* (1882), a felicitous though perhaps accidental irony. The 'features' include interviews with environmental author Richard Mabey, ecological activist Vandana Shiva, founder and artistic director of Welfare State International John Fox, a short description of an extraordinary London allotment-based creative community project *Feast*, and more. Links include a changing themed section *special m@rks* that 'currently features . . . productions about rivers and views on water from scientific, activist, and government perspectives'. The directory lists more than fifty companies and two hundred productions that have serious ecological intent, with links to relevant websites, many of which are wonderfully informative and/or imaginative in

[41] See, for example: Lawrence Buell, *The Environmental Imagination: Thoreau, Nature Writing, and the Formation of American Culture* (Harvard University Press, 1995); Cheryll Glotfelty and Harold Fromm (eds.), *The Ecocriticism Reader: Landmarks in Literary Ecology* (Athens and London: University of Georgia, 1996); David Ingram, *Green Screen: Environmentalism and Hollywood Cinema* 2nd edn (Connecticut: David Brown Book Company, 2004); Matthew Fuller, *Media Ecologies: Materialist Energies in Art and Technoculture* (Cambridge, Mass.: MIT Press, 2005).

[42] See, for the UK: Baz Kershaw, 'Alternative Theatres, 1946–2000', in *The Cambridge History of British Theatre*, vol. III, *Since 1895*, ed. Baz Kershaw (Cambridge University Press, 2004).

[43] Website – Ashden Directory: www.ashdendirectory.org.uk (26.08.2006).

structure and content.[44] Here is a 'field' that would take at least half a dozen books to explore properly and it is no doubt variously replicated in many parts of the world, though not with such focused digital elegance. Given the encroaching calamity for humanity and the fact that even Al Gore was in 2006 riding the climate-change wave, it would be surprising if there were *not* many globally spread creative projects using theatre and performance to pursue better prospects for ecological sanity.

Yet despite the pioneer writings noted above serious analysis and fundamental theorising of performance and theatre ecology was still an emergent activity in the early years of the twenty-first century. By the mid-2000s an advanced Internet search using 'theatre ecology' could produce almost 400 hits, with the phrase mostly used as a loose metaphor in documents ranging from national funding council reports to local community newsletters. A more focused search of 'ecologies of theatre' garnered just over sixty listings, the majority of which referenced Bonnie Marranca's book. 'Exact phrase only' searches for both 'theatre ecology' and 'ecologies of theatre' for books and scholarly articles averaged just four or five for each category, almost all by authors already mentioned. However, replacing 'theatre' with 'performance' in similar searches evidenced some very suggestive results.

'Ecologies of performance' generated just over ninety hits, with three university courses in the UK and Singapore being so titled, a UK research seminar on landscape and environment listing it as an important topic, and the majority of the rest referencing essays by Enzo Cozzi, Gay McAuley and others by myself included in this book.[45] Dedicated search results for 'performance ecology' as an exact phrase in books and scholarly articles were significantly more interesting. Forty books were listed on average, most of them on plant and animal ecologies where the two terms simply coincided and were not used as a phrase. It was used as a phrase in two books on architecture and one on morphology. However, around 560 scholarly articles were generated by an exact phrase search, the majority in ecology sub-disciplines where the words in the vast majority of cases simply coincided, suggesting my argument about contiguous environmental

[44] For a representative sample, see ibid.: Dodgy Clutch, PLATFORM, Small World Theatre, Red Earth.
[45] Enzo Cozzi, 'Chilean Sacred Dancers and Western Secular Magicians: Two Paratheatrical Ecologies of Mind', in Ginnachi and Stewart, *Performing Nature*, 2005, pp. 251–68; Gay McAuley, 'BodyWeather in the Central Desert of Australia: towards an Ecology of Performance', in *Théâtre: Espace Sonore, espace visuel*, ed. Christine Hamon and Anne Surgers (Presses Universitaires de Lyon, 2003). Website – de Quincey: www.bodyweather.net/gm_firt_2000.pdf (06.10.2006).

and performance commons may not just be personal fancy. Its use as a phrase appeared in a small minority of essays, focusing in ecology mostly on animal, insect and plant species, and most explicitly of all in morphology studies.[46] It appeared very occasionally also in strategic management, computing, architecture, language education, but most often in psychology where it is an emergent concept in the study of personal relationships. It figures three times in music, with both historical and practical emphases, but just once in theatre studies.[47] A general search for 'performance ecology' produced over 10,000 hits, but the majority of these were coincidental uses, while in theatre and performance studies it seems to have been used mostly in relation to Growtoski-inspired training workshops and somewhat loosely for sessions at performance conferences.[48] Of course such virtual explorations are a very rough and ready way to assess intellectual and creative activity. But still the span of uses ranging across so many disciplines suggests resonant conjunctions between the performance paradigm and the ecological era.

CONTENTS AND STRUCTURE OF THIS BOOK

The following chapters trace a seven-year stop–start stumble towards a biocentric account of theatre and performance. They were substantially influenced in their diversity of styles, modes of address and ways of thinking by their original occasions of public presentation. These were, in order of appearance here: an inaugural professorial lecture in England; seminar papers given at two English universities based on a draft chapter for a festschrift collection; an extended textual exegesis in a regular issue of a UK journal; an essay commissioned for a US journal special issue on 'Theatre and Capital'; a keynote address at a conference celebrating the opening of a new theatre in England; another keynote address at an Australian conference thematically linked to the Olympic Games; a panel paper with two others on political activism at an annual conference of

[46] Website – Topics in Functional and Ecological Vertebrate Morphology: http://webhost.ua.ac.be/funmorph/publications/Aerts_et_al_2002_Topics.pdf (20.11.2006).

[47] For music, see: John Haines, 'Living Troubadours and Other Recent Uses for Medieval Music', *Popular Music* 23: 2 (May 2004); Pedro Rebelo, 'Haptic Sensation and Instrumental Transgression', *Contemporary Music Review* 25: 1–2 (February–April 2006); John Bowers, 'Improvising Machines: Ethnographically Informed Design for Improvised Electro-acoustic music'. Website – www.ariada.uea.ac.uk/ariadatexts/ariada4/index4.html (04.11.2006).

[48] Figures produced using Google general search, plus Google Books and Scholar advanced search, October 2006.

international performance studies researchers in Germany; an opening presentation to a symposium on 'energy' organised by theatre academics, artists, editors and critics in Croatia. Hence six of the nine were originally written as scripts for public performance. All bear substantial traces of their varied emergence into the public realm.

For example, though chapter 10 is the last in the book it was the first to have a public airing as one of a panel of three short papers at a Performance Studies international (PSi) conference in Wales (1999). Several significant environmental transitions followed as it became a 'meditation' published in a regular UK theatre journal issue (2000), then a substantially revised paper for the Between Nature conference (2000), then abstracted as part of a UK university research seminar series on 'Beyond Postmodernism' (2003), then revised again for publication as the lead chapter in the collection *Performing Nature* (2005). Yet still it bears clear structural traces of the thought-experimental nature afforded by its humble birth amid a swarm of presentations at a large international gathering. Together with the eight other chapters, as already noted, it has been partially redrafted again for inclusion here. But I have aimed to preserve the fundamental qualities of the original essays as they appeared in their first public outings, and now they are all more or less obviously striated by their journeys through subsequent environments. They have mutated to become, I hope, fairly distinctive as individual entities, though also they are grouped as trilogies in the book's three parts. The parts overall offer a loopy kind of progression as they move from a focus on theatre ecology and ecologies of performance 'in the present', back through an exploration 'of the past' of those ecologies and their legacies, then to speculations on their prospects 'for the future'. Each part has a preamble written specially for *Theatre Ecology*, drawing out the themes of its chapters and setting them in personal/autobiographical and theoretical/speculative perspectives. The chapters are discussed in some detail there, so here I will briefly preview the nature of the three parts, as their back-draft chronology disguises more conventional types of genealogy. The latter emerged simply because their materials, like the evolutionary lines of natural species, developed historically in parallel with each other.[49]

The focus of Part I is 'in the present' as it explores fundamental qualities in the nature of theatre and performance in the early twenty-first

[49] The Appendix provides a chronology of their development and related events.

century. Its three chapters develop critical perspectives on key questions of theatre history and performance theory in response to claims that in the late twentieth century performance became a new paradigm of knowledge. They interrogate the changing vectors of the theatre's broad social context, of the ephemerality of performance, and of the ethical/political limits of the performance paradigm. Chapter 2 argues that the emergence of the performative society was a major environmental shift threatening the survival of traditional drama and theatres, challenging them to adapt to new reproductive possibilities that would crucially affect their constitution. Chapter 3 searches the traces of popular performance of the past for evidence of its life in the present, suggesting there may be hope for live theatre if the new 'distributed archives' of the twentieth-first century produce 'degrees of ephemerality' through which its future might be reinforced and secured, even if only very tenuously. Chapter 4 advances this argument through an exegesis of key performance studies texts to show how apolitical tendencies in the performance paradigm can be critiqued through a 'paradoxology of performance' that tests the limits of the assumptions on which the paradigm is variously founded, thus uncovering particular ethical and political biases within it.

These chapters in Part I both reproduce and prefigure the structure of the three parts of *Theatre Ecology* as they deal with the present context, the past potential, and the future prospects of theatre and performance ecology as both practice and concept. This creates a broad present–past–future chronological parallel between the constitutive principles of Part I and the three parts of the book as a whole. And that structuring is a textual mimicry of principles of reproduction which are common in environmental ecosystems, where genetic lineages provide a widespread evolutionary order to the chaos of events, as common forms are replicated across vastly diverse organic and non-organic species. As already noted, the question of whether such meta-parallels between 'natural' and 'cultural' phenomena are primarily analogical, homological or paradological – i.e. for the latter, combining analogical and homological qualities – is of fundamental significance to this book and plays through the vectors of its main arguments. For example, the chrono-homology between Part I and the three parts of *Theatre Ecology* was not consciously planned, but emerged as the book was designed and redesigned in response to the publisher's readers. Whether this structural felicity was just a 'coincidence' of similarities (analogy), or the product of some guiding common constitutional 'principle' (homology), or some contradictory but truthful combination of both (paradology) is especially relevant to the issues of

difference and identity as between 'natural' and 'cultural' ecosystems as they figure in my arguments about theatre and performance ecology.

Part II of *Theatre Ecology* shifts focus to concentrate on questions 'of the past', interrogating environmental factors which have shaped theatre and performance as historically significant practices. It explores how the ecologies of theatre and performance might variously produce critical perspectives on the making and writing of theatre/performance histories, primarily in the era of the performance paradigm. To test the value of these methods, particularly for analysing the political and ethical impact of theatre and performance, its three chapters deal with topics that have been relatively recalcitrant for theatre studies: theatre economics, audience histories, public spectacle. It repeats the Part I broadening of focus chapter by chapter from theatre to performance (another unplanned parallel), reinforcing that tactic by extending the periods investigated from a couple of decades through half a century to half a millennium. In each chapter it explicitly introduces historiographic methods informed by ecological principles, further exploring, more or less obliquely, the uses of culture–nature connections in the creation of ecologies of theatre and performance.

Chapter 5 deploys ecological systems-thinking to produce a multi-perspective analysis of British theatre economics (1979–99) which draws largely on the newly created distributed archives, thus revealing a staggering ecosystemic struggle over the democratic potential of theatrical performance in this period. Chapter 6 focuses on the specific practices of British mainstream theatre audiences (1940–2000), treating their evolving relationship with onstage actors as an 'ecotone' – environments where two or more contrasting ecologies meet and more or less healthily mingle – that exposes a wider decline in effective political participation in public life. Chapter 7 interrogates the history of Western spectacle (1500–2000), drawing on ecofeminist theory to argue that a sense of the 'non-human within the human' that spectacle has produced may be a powerful prompt for subjects to engage in spectacular eco-activism against the advancing calamity for humanity. Hence all three chapters add to the ecologies of theatre and performance in their uses of ecologically informed analogical systems thinking, homological catalytic metaphors, and paradological identity creation in historical analysis, thus beginning to evolve an eco-historiography of theatre and performance for the ecological era.

Part III ventures a few thoughts about ecologies of performance and theatre 'for the future', reversing the theatre-to-performance sequencing of Parts I and II to end where *Theatre Ecology* began, with a close focus on

the nature of theatre. It aims to reach past the book's earlier concerns towards a celebration of theatre and performance ecology in times to come, perhaps even after environmental catastrophe for humans. Its chapters are crucially concerned with the circulation of power through performance and theatre in all their interrelations with the environment of Earth and beyond. They aim to foster fresh understandings of ecological performance by fundamentally challenging the nature/culture divide through *thought experiments* that push at the bounds of intelligibility, extending and interrelating the methods of analogical, homological and paradological analysis, thought and theory established in Parts I and II. In this, these final three chapters hope to integrate ratiocination and imagination through a synergy that pays essential respect to the total interdependence in actuality of the environmental and performance commons in the age of ecology.

Chapter 8 draws analogies between two very down-to-earth eco-activist protests and the black holes of space. Chapter 9 explores analogies and homologies that connect energy exchange in lightning strikes and the free radicals of molecular physics to nineteenth-century acting, twentieth-century avant-garde theatre directors, turn-of-the-millennium environmental performance and activist groups, plus a gamut of theatre and performance theorists. Chapter 10 returns us to the opening example of this introductory chapter, through a paradological treatment of Biosphere II in the Arizona Desert, set in the history of nineteenth-century spectacle and framed by the late-twentieth-century theorists of theatre ecology, conceived as a quest to discover a homeopathics of biocentric performance as a start to curing hope as a pathology. Drawing on performances ranging between legitimate theatre and environmental protest, on artists ranging from mainstream actors to desert dancers, on theorists ranging from modernist directors to posthuman cyborgians, on natural ecologies ranging from the cosmic to the microcosmic and from the exquisitely dangerous to the extraordinarily benign, these thought experiments reach for theatre and performance ecologies of survival for the future.

Such ridiculous final attempts at grand gestures, however, should not be allowed to obscure the cobbled together, stop–start try again, muddle-along-till-things-become-clearer qualities of *Theatre Ecology*. As with earlier projects I did not set out to write a book, but somehow one has emerged from my nagging doubts about the value of tree-eating volumes in the age of ecology. So please listen up: if it looks like there's a grand theory lurking in the following pages, like the most dangerous predator you can think of, it would be best to sidle past it as if it's just an

imaginary monster and hopefully it will simply evaporate. To underline that advice, let me provide you with a little detail about this book's publication history. The process of writing and first publication of the three chapters of Part III reached from early 1999 through to 2005, the earliest and the latest in that sequence chronologically being different versions of chapter 10, the final chapter of the book. That chapter therefore paradoxically brackets the substantive work on all the other chapters of *Theatre Ecology* except this introduction.[50] This is significant because the chapters of Part III came to constitute an explicit trilogy of essays on theatre and performance ecology, so in various degrees they influenced everything else in this book. But I did not set out to write a trilogy any more than I set out to write a book. Both evolved almost of their own accord out of a messy passion to make some little sense of the myriad connections between theatre, performance and ecology. So if the preoccupations of Part III's unplanned trilogy seem to grow out of earlier questions of spectacle, spectatorship, participation, activism, democracy, politics, ethics, archives, history, the performative society, the performance paradigm, performance addiction, the calamity for humanity and so on, then probably that is because, like the theory of evolution that was born around the same time as ecology, the book was invented and written backwards, as a playground for readers. As Louis Aragon said: Your imagination, dear reader, is worth more than you imagine.

HOW TO READ THIS BOOK – DIFFERENT WAYS THROUGH

As with all 'Introductions' there were several alternative ways to write this besides the one I eventually chose to use. Like many a proper introduction it has profiled the structure and contents of *Theatre Ecology*, explored its main contentions and arguments, outlined the broader context of its emergent field of research, presented my passion for its subject and so on. But it has done this, primarily and paradoxically, in the form of a response to some of the more fundamental conclusions arising from the following investigations. I risk putting the cart before the horse in this way because humans and other animals, whether they know it or not, are living in an extremely unusual state of emergency. I risk stalling my whole project at the outset because the emergency is so extreme that its full extent cannot be grasped by any conventional means. Hence the strange

[50] The original of chapter 4 was published after the rest in February 2006, but work on it was largely completed by October 2005.

tactic of putting things back to front might make a modicum of sense. It's got to be worth the risk, given a magnitude of current global risk that by definition is greater than itself. 'When you say "hill"', the Queen interrupted, '*I* could show you hills, in comparison with which you'd call that a valley.'[51]

As this introduction is a conclusion of sorts, I tend to think that the best way to read this book is from start to finish then start this introduction again till you get back to this point. Now stop. Put the book back on the shelf, or in the recycling bin. Or maybe, if you are in a masochistic mood, carry on again from here. But also, as with my previous books, this one is structured so it can be read in a number of ways, none of them necessarily better than any other, as that depends on what *you* are looking for. For example, the preambles to the three parts provide discussion of major questions and issues, explanations of methods and details of each chapter's engagement with the overall investigation of each part, so together they can be read as a précis of the whole thing (of course, excluding this introduction/conclusion). Or the parts can be read in any order, as each of them addresses topics of current, historical or futuristic interest but not in terms of any conventional chronological order. Finally, the individual chapters all started life at least with a semblance of stand-alone pieces, and the versions here provide brief reminders of relevant key ideas, materials and methods, so they can still be usefully read more or less independently.

In *The Radical in Performance* I experimented with distinct and contrasting registers of writing and angles of address: autobiography, performance analysis, histories of practices and so on. I continue that experiment here, but largely as far as possible through conserving the key styles of the original seminar and conference papers, lectures, journal articles and book chapters that turned into these ten pieces. As already noted, such adaptations between various presentational environments represent evolutions that to some extent exemplify my arguments about theatre and performance ecology. But I also take the liberty of slipping and switching between registers in the course of a chapter, of a section, or even sometimes of a paragraph. I hope the immediate reasons for this in each case are clear enough, though sometimes perhaps – I can't promise – they will be utterly opaque. But for sure, the path will rarely be even. The

[51] Lewis Carroll, *Alice in Wonderland*, ed. Donald J. Gray (New York: Norton and Norton, 1971), p. 125.

turns and twists of the route may be unpredictable. The landscape could sometimes seem quite bizarre.

These qualities are important because the variations between registers and styles are like environmental diversity in the actual world they aim to engage. As you traverse between them in whatever order, leaping across the gaps they sometimes create, dodging around a caesura or balancing across a bridging phrase or burrowing below a grammatical obstruction, perhaps a process of readerly adaptation will be enacted that, I suggest, is not fundamentally dissimilar to what transpires on travels in the 'material world' by any and all organisms. Such adjustments to differences within and between these arguments, explanations, musings, descriptions, images, puzzlings, imaginings, extended analogies, full-blown homologies, mind-twisting paradologies and absurd thought experiments concerning theatre and performance ecology could be utterly integral to the most fundamental qualities of the world they implicate beyond this text. In the process maybe some useful *experience* of adaptation, evolution, negative and positive feedback, energy exchange, conservation, sustainability and so on might be gained. This may be, in its own reflexive self-questioning conceit, the stuff of an eco-awareness, of an engagement with an actual Earth that is wonderfully dynamic, rich in diversity, multifarious in its interdependencies, strongly alive and yet for humans utterly precarious in its prospects of survival. For this last reason, at least, my fondest pathology of hope is that *Theatre Ecology* will provide a modest training in becoming ecologically sane.

In the present: qualities of theatre and performance

Preamble

The Reception Room of the Wills Memorial Building was set for an audience of several hundred. Laid across the polished woodblock floor of the long rectangular room, red plush institutional chairs in precise rows facing a medium-height stage, an aisle down the centre. Walls of dark oak panelling rising to well above head height, punctuated by portraits of the now dead great and good of this elevated place of higher learning. Functional chandeliers casting a warm glow of even light into all its corners. Behind the stage, deep purple velvet curtains hanging in an untroubled cyclorama of good taste. A little too much to left of down-stage centre the solid lectern with its little private light, sparkling water jug and glass, the institutional crest fixed on the front, an outsize badge of stern approval. Already in place on the slippery lectern top, stacked like fragile tiles in the gutter of a high roof, the pages of my inaugural lecture as the new Chair of Drama. Ready for launch into this austerely subdued firmament, words that were bound to make a difference, even if it turned out to be a feigned indifference.

The idea of an inaugural lecture is a haunting one. This is especially the case in the discipline of drama studies, which even as it emanates from the black marks on the play-script's page cannot shake off the materiality of theatre and the ephemerality of performance. Then with its allusions to ceremony, consecration, sanctification the inaugural resounds with the so-called 'ritual roots' of Western theatre.[1] It also catches at an even earlier time when there was magic in the air as our ancestors took auguries from the flight of birds or the entrails of sacrificial victims, finding in the fleetness of nature or the grim practices of culture omens for the future.

[1] The Cambridge School of Anthropology promoted this as scientific theory, see for example: Jane Harrison, *Ancient Art and Ritual* (London: Williams and Norgate, 1913).

So in harking back an inaugural looks forward. In rooting for origins and genealogies it searches for the shape of things to come.

So much so good if you are confident about the past. But for this particular professor the prospect of pronouncing on the future with eyes fixed on a rear-view mirror was fraught with multiple dangers. I know my Marshall McCluhan: 'We march backwards into the future.'[2] I love Walter Benjamin's image of the angel of history blown helplessly towards the future with its gaze transfixed on disastrous mountains of detritus piling up in the past.[3] And then that troublesome Jacques Derrida, for whom there is no origin or identity outside 'the strange association of the values of effacement and substitution'.[4] How could these inspirations be ignored given the nature of the disciplines – drama, theatre, performance – I profess? Because what is performance if not effacement of being in the interests of becoming in the flux of time? What is theatre if not substitution of one thing for another?[5] And, most depressing of all, what is drama and its study but a word-bound pretence that effacements and substitutions could somehow be rescued and resuscitated?[6] Worse still, in the lecture itself the rear-view mirror of history would have to be on display, prominently attached to my shoulder like an ironic prop from Dada's Cabaret Voltaire. It would be, after all, a performance.

Whatever the lecture argued I would be enacting the paradox of ephemeral materiality that haunts all dramatic performances in theatres. So in prospecting for Derrida's 'strange association of values' in the futures of theatre and performance through ruminating about their pasts in the present, I could not help but show – the word is telling – the play of illusion in their origins and identities. More riskily yet, I had also learned from the artists of Welfare State International to trust my instinct about the name for a show that had yet to be dreamed up.[7] My inaugural's title emerged out of the blue one cold November afternoon in the

[2] Marshall McCluhan and Quentin Fiore, *The Medium is the Massage: An Inventory of Effects* (New York: Bantam, 1967), p. 75.

[3] Walter Benjamin, *Illuminations*, trans. Harry Zohn (London: Fontana, 1992), p. 249.

[4] Jacques Derrida, *On Grammatology*, trans. Gayatri Chakravorty Spivak (Baltimore: Johns Hopkins University Press, 1976), p. 215.

[5] Or 'surrogation', through which 'culture reproduces and re-creates itself'. See: Joseph Roach, *Cities of the Dead: Circum-Atlantic Performance* (New York: Columbia University Press, 1996), p. 2.

[6] For useful discussion, see: Michael Vanden Heuvel, *Performing Drama/Dramatizing Performance: Alternative Theatre and the Dramatic Text* (Ann Arbor: University of Michigan Press, 1993); Hans-Thies Lehmann, *Postdramatic Theatre*, trans. Karen Jürs-Munby (London: Routledge, 2006).

[7] Tony Coult and Baz Kershaw (eds.), *Engineers of the Imagination: The Welfare State Handbook*, rev. edn (London: Methuen, 1990).

year 2000. 'Dramas in the Performative Society: Theatre at the End of its Tether'. Then as I worked on trying to figure out what it might be made to mean I understood I would have to make a drama of the drama of the tale I had to tell.

Unfortunately, though, the story no doubt would be unpalatable to many in my likely audience. I would present them with an acute crisis of drama in a theatre then apparently – at the turn of the third millennium – utterly riddled by crises. I wanted to test performance theorist Richard Schechner's colourful and well-known view from 1992 that 'the staging of drama in theatres ... will be the string quartet of the twenty-first century'.[8] I shared this perspective, but how was that prediction actually and historically being played out in the now nascent third Christian millennium? Schechner's musical metaphor has a witty resonance, but it does not say much about the nature of what might survive of theatre or drama in the paradigm shift to a new dominance of performance. If the quartet stands for the 'drama', what kind of theatre will it be playing in? If it stands for the 'theatre', what will be the qualities of its score?

All these reflections made me chronically alert to the necessity of reflexivity in a lecture event that was so fraught with pitfalls, so susceptible to pratfalls. To convince my audience, I would have to disarm them by exposing the assumptions on which the challenge of my views on contemporary theatre and drama were based. If those views were going to produce a gloomy prognosis, then I needed to show how the cries of crises were a positive response to the conditions that were producing them. The 'performative society' was my general tag for those conditions. So the 'crisis of drama' and the 'crises in theatre' should be seen as sensitive evolutionary responses to a general shift in the environment to performance-dominated societies, and the implication was that drama and theatre *could* adapt to the newly ubiquitous performance ecology. A theatre prepared to look disaster in the face is best placed to pull through the drama of disaster to a healthier ecology. Moreover, if the effacements and substitutions in theatrical and dramatic history were signs of such potential that would underline the hope in my story.

But all that still would not get me out of trouble, because the evolutionary process assumed by the argument implied a peculiar adaptation to the emergent environment. That environment was being fundamentally shaped by the conjunction of capitalism, democracy, technology and the

[8] Richard Schechner, 'A New Paradigm for Theatre in the Academy', *Drama Review* 36: 4 (1992), 8.

media old and new, and the last of these would become the vector of survival for theatrical performance. 'Mediatisation' was the amniotic fluid that would save theatre and drama as they too pulled through to a new emergence. And this was where the very worst trouble lay, because that meant a happy embrace of digital technologies and the powers of hyperreality. Probably total anathema to the devotees and addicts of the live event in my audience, who were sure to be in the majority. To these, my inaugural sources of hope would probably be a recipe for despair. But how could I avoid this double bind and still stay true to my notion of performance and theatre as ecologies?

The flexibility of play is a well-tried response to the horrors of double binds. King Lear's Fool is brilliant at it: 'Prithee, nuncle, keep a schoolmaster that can teach your fool to lie. I would fain learn to lie.'[9] A short warm-up of humour would get my audience going. So anecdotes about actors dealing brilliantly with theatrical disasters would preview my argument that performance was the fundamental source of survival for the theatre they enjoyed and loved so much. But then there could be no joking about the full powers of the threats to that theatre in the performative society. Those were plainly there to see for all who knew how to look for them.

My great hero of such clear sightedness was Raymond Williams, and his inaugural lecture as Professor of Drama at Cambridge in 1974 was a lucid account of the emergent performative society. To honour this fact fully, and to drive home the degrees of potential disaster in store for theatre and the drama, I needed to draw on the mimic power of performance, to suit my action to his words. I must animate my indebtedness to Williams through a theatrical trick. That slim intuition led me to the biggest risk of all. I had to call up his spectre to validate the splendour of his vision. I should at least momentarily efface myself in performing the lecture through an act of substitution that might well offend. But there was no point in playing around pretending all was well with the world. Inaugurals are a deadly serious game. Like King Lear's Fool, I would not insult my masters, past and present, especially present, by implying they were daft enough to keep schoolfellows to teach professors how to lie. It was as transparent as the best crystal wine glasses in the Vice-Chancellor's rent-free residence that this was a powerful university.

[9] William Shakespeare, *The Tragedy of King Lear*, ed. Alfred Harbage (Baltimore, Maryland: Penguin, 1967), p. 60: I.iv.170.

So my knees felt like water as I walked with brisk desperation behind Deputy Vice-Chancellor Professor Brian Pickering – international authority on anatomy – down the interminable aisle of the Wills Building Reception Room at the University of Bristol, his black gown flapping like a winged shroud. The audience was already there and I was surprised by how full the place was. I sat at the end of the front row while he introduced the new Chair, sensing the warmth of his support but not quite able to attach the words as anything to do with me. I climbed up onto the stage to where my lecture lay ready for launch. I looked out into the audience. The previous occupants of the foundation Chair of Drama, the first of its kind in Britain, were there. And the first to warm its virtual leather, the venerable theatre historian Glynne Wickham, was sitting in the front row: an Oxford man, great-grandson of an English Prime Minister, William Gladstone. And there was I, still at heart a Manchester working-class lad, about to self-substitute – if only in a spectral moment – for a Cambridge don, son of a Welsh railway signalman.[10] Feigning confidence and doing my best to disguise a deep intake of air, I began.

ENVIRONMENTAL ADAPTATIONS

That was the environment for the first public outing, in February 2001, of the next chapter. The lecture was subsequently published with only minor amendments by the journal *New Theatre Quarterly* in August of the same year. The version printed here is expanded, though only slightly, to draw out its relevance to theatre and performance ecology. So it still bears all the traces of its journey through the drama of that inaugural moment. It conforms to the conventions of the ritual form as practised in UK universities. Some mild opening jokes, a semi-formal tone skirting round conventional academic styles, a few wide-ranging references, some casual shifts between registers of cultural analysis (in homage to Williams), of dramatic history (out of respect for Wickham), and of contemporary comment on theatre in a stressed environment (for thespian folk, without whom there would be no Bristol Chair for anyone to occupy). The theatre is treated like a hero in the finale of a tragedy, embroiled in a scene it is unlikely to survive. Perhaps this last tactic was too melodramatically flashy for the occasion, a gaudy alien in the spectacular marbled shrine of

[10] Raymond Williams, *Border Country* (Harmondsworth: Penguin, 1960).

the Victorian Wills Memorial Building, caught awkwardly between past and present.

The present is the main focus of this part of *Theatre Ecology*, which aims to jump-start investigations of key topics in theatre and performance studies as a way of coming to grips with theatre and performance ecology. Its three chapters offer critical accounts of performing arts in the early years of the third millennium, responding to the now common notion that performance is a new paradigm of knowledge. So the focus broadens from theatre to performance, considered through questions about their contexts, archives and limits. First, how are performative societies constituted through performance and what problems might that pose for theatre? Second, how might live performance from the past be affected by the nature of the new 'distributed archives' created primarily by the World Wide Web? Third, how can analysis of influential performance theories envisage ethical and political limits for the performance paradigm? Together the chapters aim to make critical inroads into the factors of theatre ecology – plays, theatres, performances and performers – seeking the chief qualities of performance ecology in the early twenty-first century, especially its extraordinary diffusion, its challenging and challenged ephemerality, and its paradoxical limitlessness.

The chapters also aim to suggest analogies and imply homologies between cultural and natural forms by exploring key vectors of theatre and performance in ways that resonate with the evolution of organic species. What can be detected as influencing their continuing survival in this new environment and what kinds of adaptation have they had to make to achieve sustainability? Two main discursive dimensions are most crucial to this conceit. The first is the nature of the chapters' arguments. These were strongly conditioned by the environments of their first appearance in public, which were: a lecture open to all and sundry, two research seminars based on an essay specially commissioned as part of a festschrift for a retiring colleague, a regular issue of an international theatre journal. Now in this new environment their arguments have evolved towards a more explicit address of theatre and performance ecology than they initially had, but that appears mostly in the form of understatement. These adaptations are modest, aiming as seamlessly as possible to bring out what was implicit about ecology in the arguments to begin with, dropping hints and relighting points in a low-key kind of way. There are moments, though, when the more fundamental adaptations to the new environment of *Theatre Ecology* are more obvious, where the evolutionary pressures are strongest and the shift becomes transparent,

as in the early shaded stages of a chameleon's addition of a new colour to its repertoire.

The second discursive dimension of change is wholly homologous to the first, being the modes of address the first versions of the chapters used to position their audiences. This is carried by the styles of implied presentation in their languages, which of course were crucially inflected by the environments that they have traversed. The next chapter, chapter 2, is distinctive in this respect, as it shifted from inaugural lecture through journal article to book chapter. The lecture challenged its audience directly through a live invasion of traditional views of theatre performed from a platform of authority built on the new performance paradigm, while the journal publication distanced its readers from that immediacy by becoming a *script* for staging as part of a ritual of auguries. Now in this book its adaptations implicitly beg a considerate comparison with its nearest neighbours, especially chapter 1, so it becomes a supplicant for equal treatment despite the flashily casual appearance endowed by its earlier environmental niches. The chameleon plays decidedly cool in respect of this total shift of status, appearing hardly to notice that a new ecology is the highest-staked game in the gulch. Even so it is indeed fundamentally adapting to this challenging environment, though the visible bids for a more assured survival may mainly show up as subtle shading.

I speculate, perhaps unwisely, that, viewed from the perspective of performance ecology, adaptation in this second discursive dimension of contextually inflected address is possibly a more *substantial* 'evolutionary' step-change to those required by the first dimension of explicit arguments. The key difference here is between the 'chameleon' finding a place in its new environment where the emergent shades of its adaptations are strongly reflected in its immediate surroundings, so that its appearance of belonging in the new environment may be strengthened, as against finding a space that is more like its older environment where its established colourings predominate and its new shades are therefore less visible. This difference may be seen, from the perspective of environmental ecology, as working in the realm of trade-offs between behavioural – i.e. performative – and genetic vectors in the processes of evolution. So my elaborate analogy of the chameleon is designed to draw out fundamental homologies between cultural-and-natural adaptive events that are simultaneously a part of the performance and environmental commons.

Seen from these multiple perspectives, are the textually performative adaptations as evidenced in the following chapters really all *that* much

different from those performed by living organisms in the 'natural world'? Is it *so* odd to think they have evolved through participation in various discursive environments – as performed lecture, script for performance, chapter for reading – that have their own peculiar and distinctive ecologies with qualities not in principle dissimilar to those found in the 'natural' environments of fruit flies and fishes?

The development of structuralist and poststructuralist theories of textuality may be called on to reinforce this point a little. Consider, for example, the nature of the textual environment before and after Roland Barthes announced the 'death of the author'.[11] In high modernism the agency of the author went largely unquestioned and academic critics had a field-day hunting for his/her intentions on the plains and in the jungles of the text. Barthes did not banish agency from writing, but relocated it in a redistribution that recognised multiple forces playing through a network of vectors intersecting the text from many directions. His most famous definition of this revaluation is especially interesting for theatre and performance ecology. A text is: 'a multidimensional space in which a variety of writings, none of them original, blend and clash. The text is a tissue of quotations drawn from the innumerable centres of culture.'[12] Equate 'organisms' with 'writings' and 'nature' with 'culture' in that passage and one has the beginnings of, if you like, a post-Darwinian, ecological textuality. Perhaps when they 'blend and clash' through these processes of evolution, conventional distinctions between organisms and texts may merge somewhat, as they can be seen to share a world of interconnecting tissue as between plants and animals, including of course the human animal. Words on paper may be fused more fully to living organisms. An ecosystem of the printed text emerges through the dependence of books on trees, or even computers on minerals.

In one utterly typical move Derrida takes Barthes's insight and renders it both more radical and more inescapable. He writes: 'What I call "text" implies all the structures called "real", "economic", "historical", socio-institutional, in short: all possible referents.'[13] This observation counts for 'environmental' as well, of course, which might be considered an especially appropriate inclusion because: 'all reality has the structure of a differential trace, and ... one cannot refer to this "real" except in an

[11] Roland Barthes, *Image – Music – Text*, trans. Stephen Heath (London: Fontana, 1977), pp. 142–9.
[12] Ibid., p. 146.
[13] Jacques Derrida, *Limited Inc*, ed. Gerald Graff, trans. Samuel Webber (Evanston, Ill.: Northwestern University Press, 1988), p. 14.

interpretive experience. The latter neither yields meaning nor assumes it except in a movement of differential referring. That's all.'[14] In other words, no thing can avoid relating to something else, there is nothing outside of 'text', of context, of environment. The 'real' comes into being through a 'differential referring' that implies an environment which does not necessarily already exist anywhere independently, say, but which always appears in the act of referring. Hence, Derrida's characterisation of the 'text' may be taken to posit a radical interdependency of text and context – or perhaps we may chancily say, organism and environment – that always comes into being through action. And of course this text you are reading now operates in that self-same performative dimension. In the realms of textual philosophy perhaps one would be hard put to find a better general account than Derrida's of some crucial qualities of performance ecology.

A MODEST EVOLUTION

Chapter 3, on the archived art of a star popular entertainer, implicitly offers an exploration of the spectral imitation of one text by another, though that implication is probably mostly easy to overlook. This is because the chapter's main purpose is to test how the 'distributed archives' of the twenty-first century might challenge the ephemerality of particular performances as they have been mediated through different processes of disappearance and reappearance. That is to say, as they are *remediated* through various reproductive forms of print, still photography, film, audio recording, websites and so on.[15] Derrida's discussions of 'traces', 'spectres' and suchlike are put to a reflexive use as the chapter distantly ghosts the argumentative structure of his brilliant short book *Archive Fever*.[16] That imitation was appropriate to the first destination that chapter 3 was designed to reach, which stands at the opposite end of the conventional professorial career to the inaugural lecture. For in 2002 I was invited to contribute to the publication of a Festschrift to be presented to a colleague soon to retire. We had travelled closely parallel routes through British higher education during more than four decades.

[14] Ibid.
[15] Jay David Bolter and Richard Grusin, *Remediation: Understanding New Media* (Cambridge, Mass.: MIT Press, 1999).
[16] Jacques Derrida, *Archive Fever: A Freudian Impression*, trans. Eric Prenowitz (University of Chicago Press, 1996).

But, while we were quite near in age, my early career as an engineer and later work in professional performance had fitted us out as from different generations. So the original chapter also bore the marks of adaptation to asymmetries in very particular academic histories and their discomforting political legacies. Even the selection of its subject for study was an archive-fevered choice. A diminutive Northern populist entertainer with bulging eyes and a cheeky grin: the 'ukelele man' George Formby.

The finishing touches to the Festschrift chapter were applied in the deepening global gloom generated by another George. In early 2003 Britain was sucked into the run-up to the war on Iraq laid out by George Bush II and his henchman Tony Blair. In February of that year two million people took to the streets of London to protest the coming barbarism. No direct traces of the horror they hoped to prevent striate the text of chapter 3, though its preoccupation with succession and success in Formby's life ironically refracts the fate of Iraq at the hands of two Bushes, as well as other much more local and trivial struggles of the early 'noughties'. Neither did it originally deal so explicitly with ecology, though its discussion about the eyes of film stars gets directly to grips with fundamental questions of interaction between culture and nature, human and non-human animals. Can we trust anything we learn about our environment and its occupants from the stars' eyes onscreen, or is the seductive sense of sharing something in common just a celluloid illusion? In the twenty-first century this question of mediated fantasy is by no means a trivial one. In 1995 Baudrillard published *The Gulf War Did Not Take Place*, which argues that George Bush Senior's 1993 war on Iraq was just a media construct.[17] In a 2002 essay on the 11 September 2001 terrorist attacks in New York, Slavoj Žižek points out how films like *The Truman Show* (1998) or *The Matrix* (1999) helped to create an environment of virtual unreality for reception of the live television images of the twin towers' collapse.[18] This is why questions of the possibility of the 'live' of an event in the traces of the archives are in urgent need of rethinking. In the twenty-first century they carry an especially profound ethical and political charge.

According to Derrida and the many performance scholars influenced by him, the 'live' cannot by definition be found in the archive.[19] But

[17] Jean Baudrillard, *The Gulf War Did Not Take Place*, trans. Paul Patton (Sydney: Power Publications, 1995).
[18] Slavoj Žižek, *Welcome to the Desert of the Real* (London: Verso, 2002), pp. 5–32.
[19] Derrida, *Archive Fever*, p. 100.

chapter 3 embarks for that destination anyway and passes through different environmental zones – George Formby's family history, biography, films, audio recordings and so on – hoping against hope to happen upon the cherished goal, even if it is only the lightest touch of long gone vitality. In its Festschrift version it toed the conventional line defining the total inaccessibility of the live of the original event in the past, but here the undertow of theatre ecology naughtily suggests a radically different stance. What are the implications for past performances of the 'distributed archives' created by mediatisation and digital technologies in the performative society? Might something of 'liveness' from the past endure through such archives if together their media create 'degrees of ephemerality'? Could the *forms of disappearance* of the live event ensure that some of its vital effects last longer than others? Such heresies ensure the chapter's quest is hedged about with super caution, for it may be founded on a category mistake or two. As though an aquatic biologist were to go looking for aardvarks in deep-sea caves. So the intrepid academic explorer dons some protection from ridicule: on goes the skin-suit of the mock-heroic and the spear gun of paradox is holstered.

A similar movement of questing runs through chapter 4, the final one of this part. The context of its conception was a 2003 conference on 'practice as research' at the University of Bristol. This was organised by PARIP (Practice as Research in Performance), a collaborative project funded by the UK Arts and Humanities Research Board that I directed between 2000 and 2006.[20] PARIP championed and pioneered innovations in research in the performing and media arts that were already pretty widespread in UK universities. These aimed to place creative practice at the heart of some research processes, stretching the bounds of arts disciplines and broadening the notion of knowledge in the academy. So this was a particularly lively UK contribution to the international growth of performance studies. One of the delegates in 2003, Bella Merlin, a professional actress, university academic and journal reviews editor, asked me to assess two recent major books from that amorphous field.[21] The task turned out to be as elusively protean as its topic because of the 'field's' claims to a new paradigm for our times. As successive deadlines passed I took to reciting Ernest Brahmin's ironic quip: He who thinks he is raising a mound in reality may only be digging a pit. By the

[20] PARIP Website – www.bris.ac.uk/parip/ (01.09.2006).
[21] See: Bella Merlin, 'Practice as Research in Performance: a Personal Response', *New Theatre Quarterly* 20: 1 (February 2004).

time the result was published in 2006 the little lamb of the review had mutated into a great ox of an article.

The article's conclusion alluded to ecological disaster and its closing joke nodded towards international efforts to curb greenhouse gases, such as the Kyoto Agreement. But its attempt to devise a way to test the ethical limits of performance studies was fundamentally infused by the greatest ecological conundrum of all. Humans are totally imbued with Earth's biosphere, as they cannot survive without it even when they fly to the moon. So how can they possibly access a critical perspective that is wholly beyond it? How can we solve a problem whose solution is another version of itself? In this particular recursive dilemma, or vicious circle, performance and theatre ecology aligns to an extent with postmodernism. If all totalising master-narratives – such as modernism and its notions of 'progress' – are a lie, then the truth lies in their absence. Enter Po-chang's ox and paradox. Asked about seeking the Buddha-nature Po-chang says: 'It's much like riding an ox in search of the ox!' The quest is a search for itself.

The two halves of chapter 4 argue that this approach is suited to the performance paradigm because its analysis is homologous to the processes in ecological systems. To achieve equilibrium and sustainability all such systems rely on circuits of feedback that self-correct each system. This is called negative feedback because it prevents the system from running out of control through overproduction in one of its parts. Such ecological understandings fundamentally informed every aspect of the original article. Hence the relationships between negative and positive feedback circuits in ecosystems are posited as homologous to the reflexive structure of paradoxes in its analysis. The push-and-pull in feedback circuits, the process of continuous adjustment to produce optimum performance for sustainability, has its equivalent in the yes-and-no of contradiction that constitutes a paradox. Just as the systems built up of such circuits rely for survival on an energy exchange that may never stop, so must the major terms of a paradox remain unresolved for its dynamic truth to abide. Visual paradoxes, such as the Möbius strip or the electric plug inserted into a socket to which it is connected, may be the most accessible way to intuit these evolutionary interdependencies between the material and the virtual realms of experience, between body and mind, nature and culture. It is important to sense that such homologies are not just elaborate, chameleon-like analogies.

Hence chapter 4 suggests that a paradoxology of performance, a highly reflexive system of analysis, is especially appropriate to understandings of

Figure 2 Patrick Hughes, *Short Circuit* – 1971. A witty example of paradox in everyday life.
An electrical extension short-circuits itself.

performance ecology. Its homologies enable a provisional assessment of the tendencies of performance systems as a whole, including of course the theatre, from within. The effectiveness of their ecology can then be judged against established ecological principles. For example, diversity of life in ecosystems is considered an indication of health so long as the system is open and sustained through the positive effects of negative feedback circuits. So systems as diverse as 'performance studies' and 'theatres' can be considered healthy if they show signs of operating according to this principle. If performance studies and theatres fail to do this, if they are so closed that they cannot fundamentally critique their own operations and effects (especially their effects on the environment), they are ecologies potentially in very deep trouble.

Which brings us back to the next chapter, and theatre at the end of its tether. For its structure as a drama about drama stemming from a performance – an inaugural lecture – about performance also works to ecological principles. Reflexivity and feedback, multiple parts interdependently constituting more than the whole, dynamic evolution and sustainability, these are the qualities in which I hope the following

chapters are steeped. These qualities also inform the progression of focus between the three chapters from the specifics of theatre to the generalities of performance as paradigm in this part as a whole. Consider that usually when a vista expands towards the infinite the best view often narrows down to a series of telescopic, or microscopic, nodes. This paradoxical conceit appears in different guises in this part. In chapter 2, like a stage overlooking the auditorium of a theatre that becomes a vanishing point of history at the dispersal of the audience. In chapter 3, like an archive packed with the empty space of past performances trembling on the point of their living reappearance. In the two halves of chapter 4, like a landscape for a quest in search of multiple versions of its own performing of paradoxically invisible truths. So through these reflexive modes of theatre and performance ecology, perhaps, if we are lucky, we might get a glimpse of how a field might best be seen from within the field. Perhaps, with fair winds for speculation on our side, we might just manage to imagine how the wood might appear still in all its splendour through listening to the bark of its trees.

Performance contexts: theatre at the end of its tether

DRAMAS IN THE PERFORMATIVE SOCIETY

I begin, perhaps a little unconventionally, with my subtitle and some straightforward examples of theatre at the end of its tether. In an encyclopaedia of theatrical mishaps they would probably go under the headings of falling scenery, broken machinery, intemperate audiences and botched-up security. Through them I hope to show how at the limits of theatre another kind of performance begins.

Unexpected spectacle – such as falling scenery – is part of every actor's worst nightmare, so it may constitute a kind of theatrical lapse that can open unusual windows on the vista that connects theatre to the world. Consider the mayhem that befell Michael Crawford and Sarah Brightman at a 1986 preview of the mega-musical *The Phantom of the Opera*. Here is Sheridan Morley's version:

> The computer-driven candles had risen through the stage floor as usual, while the hundred plus trapdoors all over the stage were shut. Michael was about to hurl Sarah across the stage when the computers ... went wrong. All the trapdoors suddenly opened, [so] not only did he nearly throw her in a hole, but [they] had to avoid gaping holes in the floor as they carried on singing furiously. [T]he bed from the previous scene ... came lurching back on stage ... the candles began to go up and down, one of them ... going up the gap between Crawford's leg and his trouser leg ... trapping him where he was. Then the candle went on, burning his skin ... while all the time he had to act and sing the deeply dramatic scene ... Finally ... a stagehand used old-fashioned elbow power to pull the bed back off stage ... and the computer glitch sorted itself out, just in time for the denouement.[1]

The mishap triggers an unexpected spectacle of actors excelling themselves by calling up terrific reserves of concentration and fortitude in face

[1] Sheridan Morley, *Theatre's Strangest Acts: Extraordinary but True Tales from Theatre's Colourful History* (London: Robson Books, 2006), pp. 165–6.

of danger and disaster. But even as they struggle along the thin line between tragedy and farce it is the extra-theatrical performer, the out-of-place stagehand, who seems magically to save the scene. His elbow power becomes a sideshow that stretches the tethers of theatre, but seems not to break them, as the thespian computer 'sorts itself out' with immaculate timing.

We might say that Crawford and Brightman's control of spectacular misfortune drew even the stagehand's unrehearsed performance into the imaginative frame of theatre. But my next example, from 1984, is one in which accidental deconstruction produces another type of imaginative poise, as the victim steps neatly over the invisible line dividing theatrical mimesis from other kinds of performance. Giles Brandreth provides a crisp description:

> One night when Judi Dench was playing the title role in Brecht's *Mother Courage* with the Royal Shakespeare Company, the wheel fell off the wagon she was supposed to drag round the stage throughout the play. The mishap brought the performance to a standstill. Miss Dench turned to the audience and craved their indulgence, 'You see, unfortunately we're the RSC not the RAC.'[2]

Here the theatrical tethers are stretched beyond breaking by the wayward wheel, but Judi Dench manages to preserve something of the frame of theatre by performing a marvellous transformation from epic tragedian to stand-up comedian. The bounds of the classic text become embarrassing tatters through technical failure in one of the great theatres of the Western world. But the situation is rescued by a class act that performs a spectacularly transparent switch between contrasting theatrical genres.

Two more examples demonstrate how performance in the auditorium can transform the nature of the theatre experience itself. Consider the riot that erupted on the fourth night of Sean O'Casey's *The Plough and the Stars* at the Abbey Theatre, Dublin, in 1926. This was in response to O'Casey's anti-heroic version of the 1916 uprising against British rule. Peter Hay gives the following, mildly sexist account:

> While part of the audience stormed the stage to attack the cast, another section waged war on the rioters themselves. Lennox Robinson recalled a friend of his hurling her shoe at one of the rioters 'and with unerring feminine aim, hitting one of the players on the stage'.[3]

[2] Giles Brandreth, *Great Theatrical Disasters* (London: Grafton Books, 1986), p. 20. The RAC is the UK's Royal Automobile Club, which runs a breakdown service.
[3] Peter Hay (ed.), *Theatrical Anecdotes* (Oxford University Press, 1987), pp. 263–4.

W. B. Yeats, senior director of the theatre, came out onstage and, referring back to the riot that had greeted Synge's *Playboy of the Western World* nineteen years earlier, bellowed: 'You have disgraced yourselves again, you are rocking the cradle of a new masterpiece.' The arrival of the police restored order and the play resumed, but subsequent performances could only proceed because of their continued presence in the aisles – the pun is intended. The riot and its effects resonated through Irish political history for many years, in a clear case of the audience in performance breaking the tethers of theatre and producing a direct consequence for the practice of power.

A telling historical contrast was supplied – just a year after this inaugural lecture was delivered, and in a new era of global terrorism – by the pop-star Madonna in 2002. Fulfilling a common ambition among megastars to appear on the London stage, she played the lead in David Williamson's play *Up for Grabs* at Wyndham's Theatre. The stage had been raised by half a metre to prevent fans mobbing Madonna, and other security measures were installed. Sheridan Morley was mildly amused by:

> the sumo-wrestler-style bouncers parading in the aisles during a West End drama, earpieces in place, curly cables down their non-existent necks, muttering darkly into invisible microphones throughout the play. On opening night, to add to the chaos all the pop stars and fashionistas brought their own stern-looking security guards, thus causing a traffic jam on the side aisles. When the play got boring, or when the actors were difficult to see because of the raised stage, the entertainment was clearly in the aisles as enormous men bumped into each other, each trying to protect a different star ... [A]lthough I was longing to race to the exit, I didn't dare, in case they had a shoot to kill policy.[4]

Morley's grimly ironic quip deepens the shadowy fears at play in this bleak and blackly comic scene, staged just seven months after the twin towers of the World Trade Center in New York were brought down by terrorists. No riot is needed here to test the tethers of theatre because the spectacle of global war with an invisible enemy simply shreds them at every turn of a bouncer's head. How can the theatre survive when the imaginative reins that give it a purpose no longer have much purchase?

So when the theatre finds itself very near the end of its tether, when the protocols that create the theatrical frame begin to unravel under the pressure of mishaps, disasters or a terrorised world, then performance that in some crucial sense is *not an intended part of the theatrical frame* has to

[4] Morley, *Theatre's Strangest Acts*, pp. 198–9.

be called on to preserve it, restore it, or connect it to some other more urgently meaningful domain. In more melodramatic words, theatre *in extremis* has to draw on extra-theatrical performance to have any hope of making any kind of difference in the world. From this we might deduce that somehow there may be a world of difference between these conventional forms of theatre ecology and the evolving performance ecologies of the wider world.

There is a deep paradox in this for the twenty-first century, because through performance theatre always wants to make a difference, even if it is just to cheer up the audience for an hour or two. But most theatre never wants to be forced to be different *during* performance. Of course from show to show the theatre evolves, but as the show goes on theatre aims to bring about change without having to adapt too much to the unexpected. The production is rehearsed to 'run smoothly' and audiences are encouraged to 'behave' as if all is going according to plan. Yet everyone knows the whole flimsy edifice can fall apart completely at the unintended drop of an onstage hat or an uncontrollable coughing fit in the stalls. That knife-edge challenge to perfection paradoxically is a great part of the theatre's attraction. So in the normal run of theatrical events performance is treated as a 'system' with the potential for total integration, an ecology that can be very finely tuned. Every tiny element of a production, including audience responses, must click into just the right place at just the right time to create a magically complete event.

Of course there are many partial exceptions to this rule of theatrical control: various kinds of alfresco theatre, improvisatory theatre, performance art, participatory theatre and so on. Even these, though, most usually work largely to this exclusionary aesthetic, marking out their own types of safe territory with more or less well-worn conventions. But the theatres that are specially built as a system for making performance are at their peak when the show can just run and run, with minimum maintenance, or transfer from building to building, with minimum adaptation, or be restaged over and over again, with minimum effort. To take just three English examples of these qualities: Agatha Christie's *The Mousetrap*, Andrew Lloyd Webber's *The Phantom of the Opera*, Stephen Daldry's production of J. B. Priestley's *An Inspector Calls*; such shows are the apex of this kind of theatre ecology. This is an ecology in which the unpredictability of performance is tethered and tamed by the predictability of theatre, even at moments when it has to appear unpredictable. A voracious drive to exclude the unexpected tends to sever the 'culture' of this theatre from the 'nature' of the biosphere to produce what, in a sense,

is a quasi-ecology. That is to say, an ecology that appears to be well connected to the world beyond itself, but which in fact is more or less pathologically abstracted from that world, often in ways that make it fundamentally anti-ecological, uncaring about the Earth's ecosystemic health. Looked at through this broader environmental perspective, most kinds of theatre are always chasing an ideal ecology, a utopian ecology. The impossible dream of a perfectly self-sustaining ecosystem, a nightly Eden.

But is it so easy to seal theatre off from the world, to make it as hermetic as a bell jar or a man-made biome like Biosphere II in the Arizona desert? Well, of course not. Theatre has to make a prodigious effort to render the unpredictable predictable, and to make the predictable appear sometimes unpredictable. Some informal rules of theatre in the West suggest weird anxieties about the burden of this extraordinary demand. Never call the 'Scottish play' by its proper name and never work with children or animals. These superstitions about wayward ghostly forces, wonky childish energies and wild animal spirits suggest this theatre abhors the natural. Paradoxically, that makes good sense because there is no such thing as a utopian ecology in the actual environment of planet Earth, which of course includes the theatre! Or to put this conversely: nature is awash with unpredictability, even as humans like to think they have 'mastered' it through science and technology. It is not only in England that nobody really knows what the weather will be tomorrow. The performance of the climate ultimately answers no one's bidding.

And if reports from authoritative sources around the turn of the third millennium can be trusted, theatre and drama in Britain and other parts of the overdeveloped world will continue *in extremis*, in a state of crisis that some believe may possibly prove to be terminal. What is the cause of this sorry state of affairs, in which much of Western theatre often seems to be at the end of its tether? Is it because performance beyond theatre – performance in culture and nature more generally – has somehow usurped or displaced the theatre's historical or traditional purposes? And is this because we live in a historically transformed situation, in societies shaped by new types of cultural, social, political, economic and environmental processes, which are *constituted* through performance? Are humans now mostly the product of performative societies?

THE PERFORMATIVE SOCIETY AND ITS SOURCES

The problems of performance, in any of its many aspects, are now so pervasive that it is difficult to know how best to approach them. The

student of drama and theatre trying to gain a purchase on these problems is in much the same predicament as the adventurer recalled by Edward Bond's Lear: 'I once knew a man who was drowned on a bridge in a flood.'[5] For in the twenty-first century performance has become to culture what water is to nature, an element indispensable to life, a pervasive force. So we are all students of performance now. This is because in the twentieth century performance gradually became the *sine qua non* of human endeavour: think of Neil Armstrong's carefully crafted aphorism as he set foot on the moon in 1969 – 'One small step for man, one giant leap for mankind!' – and you have it in a nutshell. The small step that is a cosmic leap performs a transformation for us all.

So it is hardly surprising that performance is now a subject of studied concern. It arrives in a very personal guise through anxieties about our own performance – in career, lifestyle, love or inaugural lecture. Or we become fascinated by the performance of people we will never meet – in the media, sport, politics. Or we are drawn to more abstract domains of performance – FTSE, GNP, RAE, the hundred best of everything, the ten worst of something, league tables everywhere.[6] The perfusion of performance through public and private arterial networks then generates various pathologies of perception of social process. A jaundiced eye sees us living in an age of inhuman performance indicators. A healthier view focuses on the pleasures of creativity in performance. Either way, performance is becoming an addiction. This ubiquity of performance, around us and within us, suggests, if not a break from the past, at least a radically transformed situation: 'one that I have tried to indicate in my title'.[7]

When I read that quotation out loud during my inaugural lecture I brought, momentarily, a drama of impersonation, a spectral substitution through performance, into the public space of the Wills Memorial Building at the University of Bristol in the year 2001. Twenty-seven years earlier Raymond Williams had used those words in 'Drama in a Dramatised Society', his inaugural lecture as Professor of Drama at Cambridge University. So my lecture's title – 'Dramas in the Performative Society' – paid essential homage to his argument about the 'dramatised society'. His

[5] Edward Bond, *Lear* (London: Eyre Methuen, 1972), p. 19.
[6] RAE was the Research Assessment Exercise, a regular audit of research in UK Universities between 1992 and 2008, used to decide distribution of research funding. Its mention raised a wry laugh from my inaugural lecture audience.
[7] Raymond Williams, *Writing in Society* (London: Verso, 1991), p. 11.

lecture drew a cool contrast between drama in the history of Western theatre and drama in the age of film and television. Drama in theatre he saw as chiefly characterised by the nature of occasion: annual festivals of Dionysus in Ancient Athens, Corpus Christi in Medieval Chester, daily afternoons (plague permitting) in Elizabethan London, evenings in Restoration Patent Houses or the Victorian music halls. The act of gathering conferred a unique quality on the event. But film and television, he argued, infiltrated drama into everyday life. The new media made drama a 'habitual' experience, so that it had come to constitute a 'basic need'.[8] But how should we describe the continuing results of this long historical process at the start of the third millennium, in the age of Walkmans, PCs, DVDs, cellphones, iPODS? Is drama now an unconscious addiction, a programme so deeply ingrained that we do not even recognise it as a need? And is performance becoming an addictive matrix of consciousness, a new kind of paradigm crucially inherent to human ecology, say, in ways that it never was before?

Consider the question of 'lifestyle'. Think of the difference between a life lived through a single career – as miner, engineer, housewife, banker, lecturer – and one that forges a kind of shape-shifting between several mini-careers. The first collapses distinctions between ambition and aging to create a kind of genetic dramaturgy, while the second uncouples the passage of time from personal trajectory to make a dramaturgy more likely to be driven by the fickleness of desire or changes in fashion. The life-long career implies a singular agent, whereas a sequence of careers makes for multiple selves. One might even argue that the first is to natural childbirth what the second is to scientific cloning, so that a shift from one to the other produces a different kind of world. Or, in another register, consider the consumption of speciality magazines and of television channels increasingly devoted to 'narrow-casting'. These media are predicated on the self-dramatising interest of the consumer, who tries out the roles represented for size: expert mountain-biker, capable do-it-your-selfer, sex god or goddess. And if the dream fits especially well, *real* celebrity may be at last within reach. Through such identifications people become ever more uncertain whether they are spectators or participants in the spectacle of reproduction. Andy Warhol, the twentieth-century artist who raised the ambiguities of reproduction to their ironic apogee, pictured the looming anxiety of identity in this self-referential cycle. When

[8] Ibid., p. 8.

the promise of three minutes of fame is held out to everyone it comes with tough ontological strings attached. For we have to decide not only whom or what we might represent, but also which version of that whom or what. Not just Marilyn Monroe or Norma Jeane, but one of the many alternatives that media reproduction has fashioned forth. Thanks, Madonna.

If drama has become a matrix of consciousness through such media-tisation, then theatre has become a datum of everyday social exchange. This has been achieved through an endemic theatricalisation of public and private spaces. The powerful have always known the importance of making public places theatrical. Whether in Whitehall or Nuremberg or Tiananmen Square, the theatre of state elevates particular men through ceremonies that confirm them as world powers. Historically, the public was cast as witness to such proceedings. But in the second half of the twentieth century a shift that had begun much earlier moved towards a transformation. The movement was uneven, but it can be discerned in the small detail of events. The royal walkabout – shaking hands, accepting flowers – aims to humanise majesty, but it also admits, in however token a manner, the people onto the stage of history. Likewise, the politician knocking on your door turns every threshold into a platform for the citizen. Of course, these are the peripheral trappings of a theatre in which the possession of power remains mostly unchanged. But once allowed into the wings the people will always want a place on the boards. The public show of grief at the funeral of Diana, Princess of Wales, was an entirely logical, if surprising, outcome of this invitation to participate, as I argue in chapter 6.[9] So too was the Fall of the Berlin Wall, the occupation of Tiananmen Square, the civic actions of Reclaim the Streets, and more recent protests against international capitalism in globalising cities: Seattle, Berlin, Washington, London, Edinburgh.

The media have grossly amplified this theatricalisation of the public sphere, but a related transformation was occurring at the capillary level of the social. Bertolt Brecht's friend, Walter Benjamin, inspired by Baude-laire, saw in the shopping arcades and department stores of Paris temples for the worship of the commodity as fetish. He also adopted Baudelaire's interest in the *flâneur*, the stroller who eyes the new spectacle of con-sumption with a detached gaze. This potential in the new urban spaces to produce absorption and detachment at street level reproduces the most crucial characteristic of theatre. For the frames that theatre constructs

[9] Chapter 6, see: pp. 196–203.

create a doubled attitude to experience which places the audience as simultaneously a part of and apart from the spectacle of performance. This is a move that paradoxically, as I have already noted, tends to sever theatre ecologies from the wider environment. And the modernist version of this paradigm of theatre more generally pitches culture against nature.

The arcades, museums, urban parks, great exhibitions of the century before last, implanted a theatrical paradigm in the daily lives of millions. In the twentieth century this process became synonymous with progress, making theatre a pervasive model for separating culture from nature through the production of hugely desirable man-made environments, the seductive badlands of anti-ecological modernity.[10] In the public domain, shopping precincts and malls, shop windows and interiors were designed to theatricalise consumption; museums, art galleries, heritage sites theatricalised knowledge; theme parks, science parks, urban regenerations, the myriad 'projects' of the millennium 'experience' reinforced the theatricality of our view on the world. Now in the private sphere likewise: interior design turns homes into sets, fashion turns clothes into costumes, cuisine turns food into edible props, tourism turns travel into scene changes, and – through a neat trick in the positive feedback loop of mediatisation – communications turn social exchange into a self-dramatising set of scenes and scenarios. Consider our mobile phone styles: 'Hello, it's me, I'm on a train.'

A dramatised and theatricalised society encourages an awareness of the sensorium of culture as constructed through performance. Culture tends towards a kind of inorganic anti-naturalism, through which man dreams of totally mastering nature. This is not surprising, given the particular political and economic forces that are at the volatile heart of the performative society. For performative societies are found especially where democracy and capitalism meet. In such societies performance gains a new kind of potency because multiparty democracy continually weaves staged contest into the fabric of society. Especially in highly mediatised societies, performance becomes the key factor of negotiations of authority and power. Moreover, late-capitalist liberal democracies reinforce performance by making the market central to socio-economic organisation. Although the 'performance' of companies, corporations, shares, directors, employees is measured in mundane material and/or statistical ways, the notion that they are players on a commercial or industrial stage is always

[10] The phrase builds on: Kevin Hetherington, *The Badlands of Modernity: Heterotopia and Social Ordering* (London: Routledge, 1997).

implied, and often rhetorically explicit, in the language of markets. Equally from this perspective, how human individuals fare in the competition between lifestyles or the struggle to accumulate depends crucially on their performance. So late-capitalist, multiparty, technologically mediatised democracies produce societies in which performance pervades all cultural processes, making it the main medium of exchange in virtually all spheres of the social. In performative societies culturally constructed performance becomes the defining feature of the human. The paradigm of performance comes to rule the world.

But in a dramatised, theatricalised and performative society what happens to 'drama' in its conventional sense of play-scripts as the blueprints for production, to 'theatre' as a set of buildings with stages, and to 'performance' as what takes place on those stages? How might these places that strive to become utopian ecologies respond to the flood of performance beyond theatre? Might the burgeoning of performance in the performative society drive the drama and theatre to the end of a much more critical tether than those experienced by Crawford, Brightman, Dench and the rest in my opening examples? To grapple with this question requires a paradoxical method, because drama and theatre never state what they mean directly, they always work through metaphor. This is the burden of a utopian theatre ecology, of a theatre which always substitutes one thing for another – as Hamlet did with 'The Mousetrap', that doleful play-within-a-play. So I will search for theatre's response to the ecological world beyond its walls through the ways it staged domestic space. I will look for its reaction to the performance paradigm through what its champions seem most anxious to avoid. By such indirection might we find direction out, as I next explore two continuing dramas of theatre in the performative society.

THE FIRST DRAMA – THE CRISIS OF THE DRAMA

At the start of the twentieth century, serious drama in the West was mostly a matter of rooms. Audiences sat in a large darkened room looking through a hole in the wall into another room. What happened to this onstage room during the course of that century has been used to chart the wider movements of society. One critical line, for example, traces out a process of positive fragmentation, as the drama moved from the oppressive drawing rooms of naturalism, through the shadowy distortions of expressionism and the dream-spaces of surrealism, to the sharply etched panoramas of constructivism and epic theatre, and so on to the

wide-open, almost empty space in which two tramps agree to go but do not move. In this approach, drama is seen as expanding to take on the world, even the cosmos, as always seeking new shapes that would better represent the very form and distorting pressures of the times. The world might be going to pieces, even heading for ecological disaster, but at least the dramas of the utopian theatre ecology know how to cope with it. Loud applause.

A more focused line can be traced through the dramas that featured a reproduced room onstage, as theatre grappled with the changing environment of the domestic world. Such rooms were never entirely comfortable, otherwise dramas would not be happening in them, and so they mutated through many manifestations, from comfortable drawing room to seedy attic with a kitchen sink, to the glamour of five-star hotel suites and millionaire's penthouses. Sometimes the room itself comes under pressure and becomes a hell rather than a haven, even, at the most interesting extreme, to the point of physical collapse. There are just a small number of instances of the latter – the room exploding or imploding – in Western drama, but that rarity makes them all the more significant: they can be seen as an acid test of the drama's limitations in framing events to a familiar human scale. For in all these cases the drama fragments under the impact of growing uncertainty about the value of the human.

The sound of a door slamming as Nora makes her decisive break from the doll's house reverberates down through the century following Ibsen's play, shaking the walls of every domestic and eventually every human certainty, gaining intensity especially following World War Two. In *Huis Clos* (1946) Sartre makes a Second Empire drawing room an antechamber to hell. In *Endgame* (1957) Beckett calls for a bare interior devoid of hope. In Harold Pinter's first play, *The Room* (1957), the seedy setting frames a menace that comes with every knock at the door. In Ionesco's *Amédée, or How to Get Rid of It* (1954) the room is stretched to breaking point by a dead body grown huge and flying out of the window (see Fig. 3 – p. 66). In Sam Shepard's late-1960s *Fourteen Hundred Thousand* the characters finally dismantle the walls of the room they have been decorating, leaving the audience gazing at the theatre's bare walls, while a pair of downstage figures read out a description of a world that has become a series of cities with no space between them. But it is in Sarah Kane's *Blasted* (1995) that this line reaches its high point as the expensive hotel room of the opening – so expensive it could be anywhere, say the stage directions – is reduced by a mortar bomb to a pile of rubble that becomes a playground for extreme atrocity. Dramatic form, and then it seems society itself, falls apart as the room explodes.

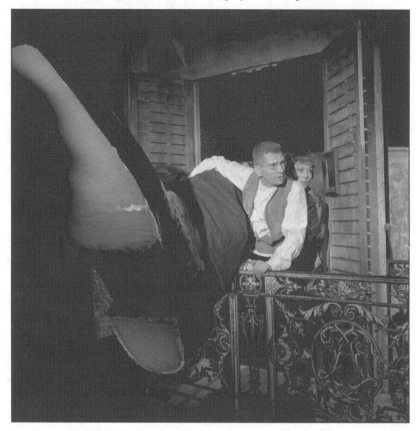

Figure 3 Eugene Ionesco, *Amédée, or How to Get Rid of It* – Théâtre de France Odéon, Paris, 1961. A forever expanding body bursts through the French window and over the balcony's edge, destroying the ease of all domestic bliss for Amédée (Jean-Marie Serreau) and Madeleine (Yvonne Clech).

But there is more than just an onstage crisis in this collapse, because the dramatist has to find a perspective on the drama of a reduced, or even lost, humanity that it produces. The great master of dramatic reduction, Samuel Beckett, secured a serenely cool angle on his creatures through pathos: we are pitifully suspended by the fact that the two tramps stay still even though they have said they are going to go. Harold Pinter took a similar tack with Stanley in *The Birthday Party*. Both playwrights are great humanists in their work, precisely because they will not let go of humanity even when there seems little or no reason to hang on to it. Not

so Sarah Kane, who is pitiless in her portrayal of humans reduced to utter degradation, as if surveying them with an especially detached gaze. It is not so much the events of the drama – rape, murder, baby-eating and all – but rather this *attitude* that is truly shocking. In the final moments of *Blasted* a simple technique to show the passing of days gives us a clue as to why this should be so. The stage flicks back and forth, back and forth from darkness to light in a way reminiscent of a slide show, or of aging silent film. This is the playwright as camera; this is theatre for the posthuman digital age. The tabloid critics found such ethical honesty unbearable and demonised the playwright, conceivably contributing to her suicide in 1999. Equally they could have attacked her contemporaries – say, Mark Ravenhill or Jez Butterworth – who, alongside Kane, have been celebrated for creating something of a renaissance in late-twentieth-century British drama. But if this was a renaissance it was mostly cold-eyed, gazing at the end of humanity, with an absence at its heart.

These are major 'hot spots' in the history of the room in twentieth-century Western drama. They encourage us to review a central convention – the room as sign for civilisation, however troubled – forcefully reminding us, as Raymond Williams argued, that when attention is drawn to a convention it is already starting to break down. They suggest that the great traditions of Western drama are generally failing, falling apart as the world gets intolerably risky and its future full of gloom, as invisible terrorist armies clash by night and the roar of the sea of belief does anything but retreat. For there can be no dominant dramaturgy in an era when belief is subject to relativism, when whole systems of belief can be translated into mere representations of difference, and when some even argue that there is nothing left for us but representations of representations in a hyperreality that makes even history itself inaccessible. Meanwhile a rising clamour of voices insists that the weather is very likely to end up being impossibly atrocious. So the drama becomes prone to acute and continual crisis as the distinctions between image and belief, illusion and reality, stage and society, culture and nature begin to collapse and theatre ecology turns in upon itself. The traditional drama – play-scripts staged in a theatre – hangs on by the skin of its cobbled-together fantasies, but only a decreasing minority of the population are under the illusion that it has the kinds of relevance it once had. There is more than enough drama on radio, video and television, in the computer games and interactive websites, at the multiplex cinemas, in the shopping malls, heritage centres and theme parks, and on the streets – so much so that drama as the staging of a play-script in a theatre may now be coming

to seem, despite its sometimes evident power, hopelessly quaint and inadequate.

This is my first drama of theatre ecology in the performative society.

SECOND DRAMA – CRISES IN THE THEATRE

The British theatres that staged many of these dramas were themselves also in crisis during the final two decades of the twentieth century. And as the millennium approached reports by artists, producers and academics suggested the crisis was nicely maturing into a full-scale calamity. Even the Arts Council of England, normally very cautious in making such claims for fear of losing face, in publishing the 1999 *Boyden Report* on the condition of English theatre, solemnly warned that:

At the start of a new century, a number of theatres are slipping towards financial, managerial and artistic crisis. The process continues to turn too many working lives into a day-to-day recurring crisis ... The 1986 Cork Report concluded that 'theatre in England has reached a critical point which must not be allowed to become a crisis'. Ten years later, ACE's 1996 'Policy for Drama of the English Arts Funding System' raised broadly similar issues. In many cases the crisis is either here or just over the horizon.[11]

The culprit usually accused of causing impending disaster was the state and its economic policies, particularly those of the Conservative Government between 1979 and 1998, which on closer inspection, as we shall see in chapter 5, turns out to be not much more than a half truth. A measure of the power of these predictions at the turn of the millennium, and not just for theatre, can be gained from the Labour Government's announcement in August 2000 of an extra £100 million of state funding for the arts spread over the following three years. This produced a cumulative increase of 78 per cent in total grant for the arts in England between 1998 and 2004 (£189.6 million to £337.3 million).[12] Surely as this was filtered through the Arts Council's new 'National Policy for Theatre in England', published in July 2000, the crises in our theatres would start to abate?

In 2001, as I read out those words, I genuinely hoped that this would prove to be the case, but also I suspected that the problems of theatre at the start of the twenty-first century ran much deeper than the strata in which investment is secured and budgets are balanced. For there were

[11] Arts Council of England, *Boyden Report* (London: Arts Council of England, 1999), p. 10.
[12] Arts Council of England, '£100 Million more for Arts', *Arts Council News* (August 2000), p. 1.

qualities in the complaints of the jeremiahs that pointed towards much more than a temporary panic about making ends meet. Since Goldsmiths College called a conference on the 'Theatre in Crisis' in 1988, there had been a steady stream of publications that suggested substantially more was at risk than the infrastructure of the theatre industry. Peter Ansorge, with many years' experience producing television scripts by writers like Alan Bleasdale and Dennis Potter, was acutely concerned about British play-writing. He ends a long list of reasons to be *cheerful* about the theatre of the 1990s with 'much of this bravura is based on false perception. Our drama is in fact less confident and adventurous than twenty years ago.' And this is just one reason why there is a 'struggle for survival in our theatres'.[13] Peter Hall, in a chapter titled 'Theatre Under Threat' in a book called *Theatre in a Cool Climate*, wrote 'the theatre of the Nineties reveals a failure to respond to society's actual needs', but 'I think the creative madness of the British will ensure that theatre will continue in some shape or form. But this will only be after huge convulsions.'[14] His antidote to such spectacular disease was hardly convincing: a little more subsidy, please, especially for regional theatre.

Observers more attuned to the force of the media in the evolving cultural sensorium sensed a much more profound environmental shift. Michael Kustow, ex-director of the London Institute of Contemporary Arts and first arts commissioning editor for Channel 4 television, as well as producer for Peter Hall and other leading writers and directors in the theatre, claimed that 'Theatre ... may be undergoing life-threatening mutations ... I am therefore warning against endangered theatre, theatre subsumed by webs and networks.'[15] And this in a book entitled *Thea-tre@Risk*. Sir Richard Eyre, in his millenary history of British theatre in the twentieth century, echoed Kustow's anxieties with 'what is at stake today is the survival of theatre itself'. But he seems caught on the horns of an acute dilemma when after 370 pages of arguing for the value of theatre he writes: 'The case for the survival of theatre can only be made by the art itself.'[16] False perception, creative madness, convulsions, subversive webs and networks, a dying theatre having to save itself: these heated phrases

[13] Peter Ansorge, *From Liverpool to Los Angeles: On Writing for Theatre, Film and Television* (London: Faber and Faber, 1997), p. x and 134.
[14] Vera Gottlieb and Colin Chambers (eds.), *Theatre in a Cool Climate* (Oxford: Amber Lane Press, 1999), p. 109.
[15] Michael Kustow, *Theatre@Risk* (London: Methuen, 2000), p. xiii.
[16] Richard Eyre and Nicholas Wright, *Changing Stages: A View of British Theatre in the Twentieth Century* (London: Bloomsbury, 2000), p. 378.

suggest mounting threats in the environment of theatre that are well beyond the purview of the state or its quangos. With even survival in question, the wider performance ecology that the theatre gurus increasingly seem to distrust must somehow be radically changing for the worse.

These were the considered views of the powerful in British theatre, and throughout these writings you can sense extreme desperation hovering over their hearts. Where are the defences? What will save the theatre? The consensus that emerges from these high-profile prophets is that the essential quality of theatre is its *liveness*, the lived exchange between co-present actors and audiences. This is the theatre's strength and its glory, the source of its unique persistence and its guarantee of survival in the future. But always at the moment of celebrating the power of the live event to capture hearts and to change nations, there looms a shadow, or more precisely a chimera. It is just barely submerged in the title of Ansorge's book – *From Liverpool to Los Angeles* – that transparently translates to 'from gritty reality to tinsel town'. It is in Peter Hall's 'The theatre in America is virtually dead … Most of their dramatists – Mamet, Sam Shepard – are off in film. Film is the art of this century.'[17] It is in Michael Kustow's marginally less depressing view that 'In a prefigured response to impending digital culture, arresting visual pieces … have begun to appear in the theatre … Theatre cannot ignore the perceptual changes of the new technology.'[18] The choice of words is telling: the theatre is ahead of – prefigures – the impending digital culture and might even manage to 'arrest' its effects. For these believers in the live event, such digital developments seem to generate deep anxieties. Perhaps this is because the chimera of reproduction – in film and television, then on CDs and DVDs, now in cellphones and iPODS and the rest – is much more threatening to theatre than they really care to admit.

It may be that these eminent addicts of the live event, finely tuned to movements that transform the pulse of a culture's life, sensed an impending generic revolution was well under way at the turn of the millennium, and one that might indeed deliver the end of theatre as we have known it since the Greeks. The new mutation of representation promised by the end of the analogue age was already changing the nature of the live itself. The emergence of radically refashioned technological ecologies, in which the theatre-niche looked ever more precarious, was already well advanced. Given this, it would not be just theatre as an institution that was

[17] Gottlieb, *Theatre in a Cool Climate*, pp. 109–10. [18] Kustow, *Theatre@Risk*, p. 206.

threatened with extinction. But also theatrical performance as an aesthetic form could be transformed utterly beyond recognition. Such, perhaps, would be one outcome of the increasing pressures of widespread and de-centred performance – performance as a profoundly pervasive general ecology – in a highly theatricalised society.

This is my second drama of theatre ecology in the performative society.

FURTHER DRAMAS IN THE PERFORMATIVE SOCIETY

I could speak of further dramas in the performative society. I could outline the exciting challenges to the disciplines of drama, theatre, film and television studies offered by the onset of performance studies. I could explore the interface between live performance and the new digital media for signs of productive symbiosis. I could discuss the precarious status of the body in performance in an age of posthuman uncertainties. And I could discourse anxiously on the uncanny qualities of performance between avatars in the infinite reaches of cyberspace. Whichever theme I chose, though, I would no doubt end up having to deal with the new interactions between digital technologies and live performance. For I think, together with a growing number of contemporary scholars, that there has been a paradigm shift under way in the exchange between technology and performance during the past quarter century.[19]

Of course, technology has always played a part in the history of theatre and performance: the rope tricks of the shaman, the mask that possibly was a megaphone in ancient Athens, the flame and fireworks of hells-mouth in Medieval mystery cycles, and on through gas and electric lighting in the Victorian and Edwardian eras. But in this history tech-nology was always geared to the human actor. Even when the effects were grandly spectacular they were scaled to the human form. At the advent of the reproductive visual media – of photography, film, television, video – this still held largely true. But then a difference emerged in the twentieth century, identified most sharply by Walter Benjamin, in which repro-duction by mechanical media signalled the beginning of the end of the special qualities of traditional arts. Their 'aura' was lost in the inhuman

[19] For example, in various registers: Johannes Birringer, *Media and Performance: Along the Border* (Baltimore and London: Johns Hopkins University Press, 1998); Gabriella Giannachi, *Virtual Theatres: An Introduction* (London: Routledge, 2004); Janet H. Murray, *Hamlet on the Holodeck: The Future of Narrative in Cyberspace* (Cambridge, Mass.: MIT Press, 1997); Stephen A. Schrum (ed.), *Theatre in Cyberspace: Issues in Teaching, Acting, and Directing* (New York: Peter Lang, 1999).

gaze of technical devices. The liveness of the human actor was replaced by flickering shadows, shimmering dots, the uncanny glow of pixels. But also the image of the moving human figure in an instant could be massively magnified by close-ups or shrunk to less than a speck in cosmic infinity. The scale of the human, and by implication any values we might attach to it, was no longer a determining factor in representation and its technologies. So the actor's body in this new ecology is subject to chemical then electronic transformations, making all bodies more open to transmutation. This is the virtual equivalent to experiments in scientific laboratories and medical theatres worldwide, where the limits to re-engineering non-human and human bodies through genetic manipulation shrank like shadows under the midday sun.

The panic of leading theatre artists faced with this second drama in the performative society signalled, I think, a new phase in the still short evolution of the ecological era. The phase is characterised by a single factor – the shift from analogue to digital communication systems – but its ramifications for human culture in the Petri dish of environmental history are innumerable. One key distinction between analogue and digital modes of reproduction is that analogue recording inevitably suffers from a progressive degradation of the original – each time a copy is made some quality is lost – whereas digital reproduction is not significantly subject to such corruption. But digital media have a further immense advantage over analogue forms, because their contents seem to be infinitely open to manipulation; as Anthony Smith says in *Software for the Self*, they can be 'reorganised, remade, enhanced, distorted and presented again on demand'.[20] Moreover, as those contents are at root just strings of numbers they 'require no inspiring or originating reality' – consider the dinosaurs in the *Jurassic Park* films, which ultimately are based on archaeological surmise. Further, digital media can create forms of reproduction that are highly immersive and interactive – computer games, training simulators, virtual-reality systems. So the potential for creativity in the digital age is enormous. But also that age threatens to up the ante in the society of the spectacle, reinforcing the threat of the hyperreal, moving us closer to the era of the posthuman. In this scenario, live performance in theatres may seem like the last bastion of the truly human, which must be protected from reproduction at all costs.

[20] Anthony Smith, *Software for the Self: Culture and Technology* (London: Faber and Faber, 1996), p. 96.

But what if we were to imagine this the other way around: the digital age not as a threat to the live but as a possible source of its rebirth and enhancement in a new kind of sensorium? What kind of digital theatre might place the live event centre stage in every sense? In the twentieth century the Bauhaus artist Walter Gropius envisioned a 'total theatre' that had auditoria and stages which could be radically reconfigured, and which was surrounded by a wall of screens onto which scenery could be projected. Unfortunately his design was never realised, though its influence can be detected even in English theatres built in the late-twentieth century, such as the West Yorkshire Playhouse or the Lowry Centre in Salford, as well as in Imax cinemas. The theatres are still scaled to the human figure, but even more fundamentally their design participates in the cultural binary that separates houses for screen projection from houses for live performance. Here I am not talking about a practical binary – films are often shown in theatres, though cinemas are rarely used for live performance – but about an imaginative one. So how might we imagine a collapse of that binary, to figure forth a space that equally honours the new digital media and the living presence of the performer, while carrying through principles of immersion and interactivity with an infinite flexibility in its treatment of scale? How might we envisage a creative environment that would fully foster the potential of this emergent performance ecology?

Such a space, if it could be imagined and made to work, would most likely make our existing theatre buildings – even the newest ones – seem like much of the drama that still takes place in them, rather dated, somewhat inadequate, if not entirely obsolete. It might even have this effect for cinema, too. And how might we best react to this potential disaster for the cinema and theatre as we know them, and to the possibility that the spectacle of the hyperreal in the performative society will not be a threat to the human, but be crucially productive of its future? In the past the British theatre has risen above many disasters, from total closure in 1642 to the blitz of World War Two. When the environment of theatre gets tougher its artists generally do well in adapting to survive. Surely, that historical perspective makes their millenary willingness to look disaster in the face a cause for hope and celebration. To be sure, the ecologies of their reproductive trade may be subject to life-changing challenges. But if they can deal successfully with falling scenery and broken machinery and wayward audiences and deadhead security they must be especially well prepared to respond to more momentous traumas of an ecological kind.

One of the best-known disaster stories about the theatre may be par-
ticularly instructive for the new theatre ecologies that I am suggesting we
try to imagine. Forgive me repeating it, but perhaps we may find in it a
new resonance for the future. The story concerns one Richard Brinsley
Sheridan, who for thirty years had made London's Drury Lane Theatre a
showcase for his extraordinary talents. Then on 24 February 1809 it
fuelled a blaze that could be seen for miles. Sheridan was sitting in the
Piazza Coffee House in Covent Garden, watching the fire over a bottle of
wine. When he was complimented for his amazing composure in the face
of calamity he replied: 'May not a man be allowed to drink a glass of wine
by his own fireside?'

At this point at 6.15pm GMT on 9 February 2001, when we were mostly
innocent of the gathering storm of global terror, I smiled at my audience
in the Reception Room of the Wills Memorial Building at the University
of Bristol and said: 'Ladies and gentlemen, colleagues, I believe the
University has kindly supplied some wine. I should be delighted if you
joined me for a glass.'

Performance archives: catching the Northern sublime

THE SPIRIT IS A BONE — EXTREMES MEET

It is only when the music stops that I start raising provisos like a palisade around my liking for him. I cannot laugh when he fidgets, gapes and fusses flat-footed across the stage ... and I am unable to accept the theory that a banality or catchphrase acquires wit or philosophy when delivered in a North Country accent. Simplicity and unaffectedness can be carried to extremes. Mr Formby works with what Henry James called 'great economy of means and – oh – effect'.[1]

Fresh and no doubt cock-a-hoop from recently acting First Player to Alec Guinness's Hamlet, Kenneth Tynan was aged twenty-three when he delivered this verdict in 1951. George Formby was forty-seven, turning portly, looking older than his years after bouts of illness, yet still the audiences were raised to a pitch of near-ecstasy as he strummed his banjulele in the musical *Zip Goes a Million*.[2] There were other distances between the rising critic and the fading star. Tynan earns a pittance as a junior reviewer on the London *Evening Standard*; Formby's weekly fee is £1,500, plus profit-sharing from the box-office sell-out. Tynan is just 'down' from Oxford; Formby remembers leaving school aged seven in 1911, to muck-out in racing stables and train as a jockey. Hardly surprising, then, that the review refracts a sundering of sensibilities in the traditional two-way snobberies between a 'common' North and a 'sophisticated' South, still strong in this period of English post-World

[1] Kenneth Tynan, review of *Zip Goes a Million* for the *Evening Standard*, October 1951. Quoted in: David Bret, *George Formby: A Troubled Genius* (London: Robson Books, 2001), p. 190. Much of the biographical information in this chapter is drawn from Bret's lively book.

[2] Formby is often said to have played a ukelele, a small guitar-shaped instrument invented in Hawaii in the late-nineteenth century. The instrument that made him famous was a banjulele, a small 4-string banjo invented by the American Alvin Keech in the early-twentieth century.

War Two austerity, as the general election result of 1950 clearly showed.[3] Note, too, the aesthetic abyss opened up by Tynan's appeal to high art – through that awfully aloof Henry James – against the populist dream-weaving of a West End show revelling in the vulgarity of an enforced spending spree. Even so, in this moment of teetering condemnation there is a paradoxical suturing of artist and critic that suggests a profound vitality in the nature of extraordinary performance.

The paradox of the meeting of these particular extremes seems to turn on Tynan's oddly archaic image of the palisade. His 'provisos' aim to enforce a conventional separation between music and acting, which rests in the Western philosophical traditions on yet more crucial cleavages between mind and body, spirit and bone, culture and nature. Against this I want to risk proposing a *complex singularity* in this ecology of extraordinary performance, taking Formby's practice as a paradigm that denies all such binaries. That is to say, *only* Formby, flat feet and all, could produce the effects of that denial in precisely the way he did. So I shall be rooting for the uniqueness that might make him a member of the sub-species 'extraordinary actors'. Part of my purpose in this cheerful excavation of surfaces is to enquire how such brilliant performers might throw some light on the historical transmission of more mundane theatre and performance ecologies.

Theatre ecology considers every element of a performance as wholly interdependent in, and integral to, the theatrical event. So from this perspective the defensive violence of Kenneth Tynan's metaphor of the separating 'palisade' becomes manifestly self-directed and self-defeating. This is because it aims to split his pleasure in the performance from his horror at the effects that make it possible. It proposes a separation between his desire for and rejection of the self-same organism, George Formby, which produces the event. The futility in this project of raising the stakes between the dramas of love and loathing is suggested by where he locates it, in the moment of silence 'when the music stops'. For the pleasure and the pain – however determined, say, by the critic's 'discrimination' or the artist's 'uneven skills' – cannot be separated in the silence through which they are joined. If anything, the prismatic silence insists that music and acting, mind and body, spirit and bone, culture and nature are one and the same thing. So, ecologically speaking, there can be no denying that Formby's art, his whole extraordinary performance in the

[3] Kenneth O. Morgan, *The People's Peace: British History 1945–1990* (Oxford University Press, 1992), p. 83.

live event that so troubled Tynan, issued through arthritic toes, dodgy lungs and a dicky heart.[4] The paradox of such extremes meeting celebrates one of the common conjunctions in which the sublime can appear. In this ecology even the fatally afflicted creature can still sing some beauty into being.

DISTRIBUTED ARCHIVES AND DEGREES OF EPHEMERALITY

But how can we best judge whether these past events carried such a charge? What has emerged since Formby and Tynan breathed their last in 1961 and 1980 respectively to make such judgements more than wishful thinking? The global environment changed dramatically and the world moved into the performance paradigm. The traces of previous paradigms remained, of course, but everything about the past was altered. This can be measured against the fact that by the twenty-first century the Earth had gained a new kind of archive to match its fossil record. Scattered massively more liberally than fossils all over the globe, the materials of this burgeoning repository were also fabulously more diverse and accessible than the stuff of traditional archives. Those were still lodged in particular places, though they too were gradually recruited more or less into this amazing cornucopia of information and knowledge, ranging from the totally trivial to the utterly profound. I call this new phenomenon of the ecological era the 'distributed archive' because it is so prodigiously spread across material and virtual space in a myriad series of interconnected systems, but especially through the World Wide Web. Inevitably this archive poses fundamental questions about the nature of knowledge repositories. Whether shimmering in cyberspace or gathering dust in a backroom cupboard, its materials might seem very remote from the Earth-bound fossil record. But they and the fossils have homologies that are highly relevant to performance ecology.

Fossilisation is actually pretty rare in any given age, but when dead organisms or their traces end up as mineral remains they draw on a remarkable range of geological media, from calcite to pyrite and from quartz to amber. The distributed archives of the third millennium are also especially media-rich, preserving the past as photographs, film stock, videotapes, audiotapes, recordable disks in many formats, in digital memory chips, hard drives and data banks, as well as on paper, as mass-manufactured objects, and more. So these two archival systems are

[4] Bret, *George Formby*, p. 110.

homologous in their relation to life's diversity, which is strongly replicated in the variety of their materials and forms – a factor less the case in traditional archives. Yet more significantly, perhaps, both systems sport what palaeontology calls 'living fossils'. These are living species that closely resemble the remains of creatures found in the record that were once considered extinct, or which have no, or just a very few, close species relatives still alive. The many examples include mountain beavers, horseshoe crabs and coelacanths, though the last is more accurately classified as a Lazarus taxon, a species that suddenly reappears alive. There are also Elvis taxa, species that are misidentified as having re-emerged, named for the pop star who was frequently 'seen' by enthusiasts after his death in 1977. And by the late-twentieth century the performative society was awash with human 'living fossils', people picking and choosing which avatars to recreate through remediation of the pasts found in the distributed archives. Often they gathered in fan clubs, tribute tribes, retro clans, chat groups, online communes in cyberspace. One group met annually to play banjuleles in the English seaside town of Blackpool. This was by no means an entirely new phenomenon, of course, but its prevalence as the third millennium turned suggests a not entirely trivial question about the interrelationships between archives, memory and time that may have substantial implications for theatre and performance ecology. Can the distributed archives and their effects give fresh access to the 'live' in past events?

The sub-discipline of 'theatre archaeology' raises similar issues in its concern with 'the retrieval and reconstitution of performance'. This 'interdiscipline' was first proposed by artist–scholar Mike Pearson and archaeologist Michael Shanks, the former defining it as follows: 'The term "theatre archaeology" is a paradox. The application of archaeological techniques to an ephemeral event.'[5] This is a reversal of the conventional equation between events and their traces in archaeology, challenging the material 'stability' of remains, including fossils, by insisting on the primacy of performance in their making. It builds on conventional archaeological classification which sees widely scattered traces from the past as companionable, evidence of unique but common events such as hunting, butchering, fire-lighting, eating. Its hunch is that the fossil, archaeological or archival remains of uniquely performed moments in different places – of footsteps, an accident, a birth or a death – might somehow be mutually

[5] Mike Pearson, 'Theatre/Archaeology', *Drama Review* 38: 4 (Winter 1994), 134. More fully elaborated in: Mike Pearson and Michael Shanks, *Theatre/Archaeology* (London: Routledge, 2001).

supportive of the 'live' as a precipitate continuation into the present. But the barrier of the ephemeral remains and only the living human can retrieve and reconstitute a past live event.

My hunch comes at this barrier from a different direction. It responds to the richness of the new distributed archives, reaching for the potential of remediated traces when faced with the *fact* of the past live event. It challenges the new archives of the third millennium to provide a fresh productivity for historical transmission of live events. It asks whether dead traces and previously live events might, under some circumstances, be brought closer to an 'equal footing' – to create a richer sense of the 'live' of the past in the present. Is there anything in the nature of these archives that is akin to fulgurites, petrified lightning? Where the imprint of the event is imminently alive in the present? And is there anything in the ecologies – the diverse media ecologies – of the distributed archive that might trigger that life into action now?

Such questions are bound to be a magnet for super-sceptics, so best to admit that perhaps they are driving at no more than a speculative conceit, a kind of archival necromancy. Hence let's proudly confess to pleasure in tilting at windmills and propose that the twenty-first century's distributed archives profusely secrete *degrees of ephemerality*. These allow, somewhat fabulously, that the different media in distributed archives may vary in their powers of resuscitating the live, or life, of a past performed event. Such degrees also imply that variable intensities of immediacy in those media can trigger this effect, and that their spatial and temporal interfaces could well be designed to enhance the possible reappearance of the past alive in all its glory, or shame. Most fantastic of all, could this interactivity become an open sesame to a performance ecology that reveals the living secrets of dead stars?

Let us be thankful, then, that George Formby's traces *will* provide an absolute test for the quest to discover degrees of ephemerality in the distributed archives. For the man himself sadly is long dead and gone, though not yet beyond living memory. So he hovers in the liminal zone of a promise that is always shrinking. Yet extraordinary actors as a class will usually be richly represented in those archives, and so their resistance to resurrection as live events in the present through different media *might just* act as a measure that such degrees of ephemerality exist. Maybe too the imputation of *shared* uniqueness will beaver them back to life, piqued by the challenge to prove yet again they are top-dog species on the performance mountain. So the fading memories and receding lives of stars may be a paradoxical gain for the distributed archives. They raise the

stakes in the high-flown hope of securing a purchase on the live events of a past performance ecology through its remnants. Distributed archives, degrees of ephemerality, shared uniqueness indeed! How could even a wisp of the energy shaping such weird endurance provide a touch of the live from the past in the present?

ON THE SUBLIME – NOTES ON METHOD

George Formby was a phenomenally successful Northern English popular entertainer in the middle decades of the twentieth century. His records are still available on CD and his films on video and DVD. Even now, over forty years after his death, there are active websites for a fan club as well as a George Formby Society, which meets annually in the Lancashire seaside town of Blackpool.[6] The first full biography, by David Bret, was published in 2001. Sub-titled *A Troubled Genius*, its main theme is the contrast between fabulous public success and a miserable private life. So this particular set of 'fossil' records, appropriately dispersed across the distributed archive of the twenty-first-century media, is currently alive and gradually growing. The ghost of the northern star still twinkles, as memories of him settle nicely into the nostalgic patina of the heritage industry.[7] Even from beyond the grave Formby's catchphrase resonantly echoes: It's turned out nice again!

So in comes I wanting to trouble memories of the troubled genius. And why should I want to do that? Well, justification could be provided through the usual historiographic conventions used to single out the exceptional subject: he was a high-point representative of a long line of novelty popular entertainers, he made a terrifically successful transition from live music hall to mass cinema popularity, he created a unique kind of music that influenced *even* the Beatles, he occupied a singular cultural space in the transition between the mechanical (modernist) and the electronic (postmodernist) eras, and so on; and, oh yes, he was possibly almost as popular as Stalin and definitely more popular than Churchill, etcetera. So Formby was a major organism in the emergent media environments of the twentieth century that, as discussed in chapter 2,

[6] Website – George Formby Society: www.georgeformby.co.uk/ (27.08.2006).
[7] Raphael Samuel reports a telling example from a 1985 revival of the 1937 musical *Me and My Girl*, which included the Formby song 'Leaning On A Lamp Post', not in the original production. Raphael Samuel, *Theatres of Memory – Volume 1: Past and Present in Contemporary Culture* (London: Verso, 1994), p. 398.

posed such a threat to theatre. No wonder Kenneth Tynan, a prescient addict of the live event, felt compelled to put up his palisades.

All this is grist to the conventional mill of a deconstruction aimed at understanding Formby's attraction through specifying his historical trajectory. And of course, that mill must turn in some of what follows. But also I want more playfully to disturb the record, to mess about with the webs of memory that interlace archives like snail-trails on a gravestone, to fly a frail kite of theory in the gaps between documents where perhaps the past truly moves, like eddies of air in the branches of dead trees.

So what might I make of 'extraordinary actors' that could properly compliment the wisdom of the essays in the book where this chapter first appeared, on Richard Burbage, Sarah Siddons, Gertie Millar, Peter Lorre, Morcambe and Wise and more?[8] Individual actors had not been a major interest in my research, so in this department, as the playwright Sacha Guitry said: The little I know, I owe to my ignorance.[9] Fool that I am, perhaps the right task is in honestly trying to grasp something that seems forever beyond reach? For the extraordinary actor as such must surely, somehow have been extraordinary in *live performance*, even if it was done for recording for radio, film, television and the rest. But what kind of methods specifically – patently invoking a seemingly inevitable failure – might be appropriate to making such an attempt on the ephemeral? Fever for the archive in such an engagement – amassing material to provide a 'definitive account', sorting and ordering documents to 'confirm' a cause – is probably a pathology of certain critical doom.

For in troubling any archive to *reveal* an extraordinary act, the uniqueness of which is inseparable from a past forever gone, are we not bound to stretch all marks beyond breaking? As Derrida says of trying to identify the uniqueness of a trace fossil of a footprint in ash:

The possibility of the archiving trace, this simple *possibility*, can only divide the uniqueness. Separating the impression from the imprint. Because this uniqueness is not even a past present. It would have been possible, one can dream it after the fact, only insofar as its iterability, its immanent divisibility, the possibility of its fission, haunted it from the origin. The faithful memory of such a singularity can only be given over to the specter.[10]

[8] Martin Banham and Jane Milling (eds.), *Extraordinary Actors* (Exeter University Press, 2003).

[9] Patrick Hughes and George Brecht, *Vicious Circles and Infinity: An Anthology of Paradoxes* (Harmondsworth: Penguin, 1978), p. 75. All paradoxes quoted are from this source, unless otherwise indicated.

[10] Jacques Derrida, *Archive Fever: A Freudian Impression*, trans. Eric Prenowitz (University of Chicago Press, 1996), p. 100.

Well, then, the exercise in attempted resuscitation of the past live that follows must constitute one of unfaithful memorialising in search of a spectre, a disgraceful intrusion into the realms of the fabulous. This is why I feel compelled to evoke the sublime in my title. It will allow, I hope, for a critical strategy in the ecologies of theatre that may be as slippery as the question it is trying to answer, but one that might rightly take for its motto the words of another great devotee of silence, John Cage: I'm saying nothing and I'm saying it.

Because the sublime, according to Slavoj Žižek's interpretation of Hegel, appears in the renewing collapse of contradiction – apparent absolute binary difference, say between impression and imprint, desire and disgust, mind and body, culture and nature – into the putative truths of paradox.[11] This gives a preview of the next chapter's arguments about the paradoxology of performance, which treat paradox as a means to acknowledge the power of binary analysis yet move fully beyond it. Such paradoxical analysis is fundamental to the ecologies of theatre and performance as method because it accords with some major principles of ecology. For example, that negative feedback is essential to sustainability in all ecosystems, whereas positive feedback destroys it. Predation protects life. Pruning promotes growth. Neutron stars blossom as they implode.

Hence my sub-headings invoke the weirdly paradoxical sites of the sublime as identified by Hegel as reread by Žižek: Spirit is a bone, Wealth is the self, State is monarch, God is Christ. If these appear merely as passing ciphers in my argument, it is perhaps because that is their proper place so far as the traditional archive goes. I can make no apology for this displaced double ghost-writing, as it constitutes a necessary guying of the phantasmal specifics of the task I have unwisely set myself, of trying to resuscitate extraordinary acting through degrees of ephemerality in the distributed archives of the twenty-first century. But maybe, just maybe, in this especially spectral territory for which we are heading, as a specialist in ghostly trading once said, through indirection might we find direction out. Or as George Formby put it in the song 'Believe it or Not' (1934):

> That night at 12 o'clock, just as the light she turned out,
> 'Who's that in my room,' she cried, and started to shout.
> I whispered, 'Shut-up, I'm the ghost I told you about.
> Perhaps you'll believe it now.'

[11] Slavoj Žižek, *The Sublime Object of Ideology* (London: Verso, 1989), pp. 201–31.

WEALTH IS THE SELF — SCENES FROM A LIFE

The Sublime [for Kant] is therefore the paradox of an object which, in the very field of representation, provides a view, in a negative way, of the dimension of what is unrepresentable ... Hegel's position is, in contrast, that there is nothing beyond phenomenality, beyond the field of representation ... the sublime is an object whose positive body is just an embodiment of Nothing. In Kant, the feeling of the Sublime is invoked by some boundless, terrifying imposing phenomenon (raging nature, and so on), while in Hegel we are dealing with a miserable 'little piece of the Real' – the Spirit is the inert, dead skull; the subject's Self is this small piece of metal that I am holding in my hand.[12]

Paradoxical moments of extremes meeting such as that between Formby and Tynan in 1951 can surely seem, as the sayings go, to come out of the blue, emerge from nowhere, materialise out of nothing. Perhaps this is so for most of us. But if the sublime results from a conjunction of wholly contradictory impulses provided for us by an object especially inscribed with radical negativity, then might some artists be able to manifest their selves as such an object? And if so, what gestures and grimaces of the body, what languages of desire or domination might produce such a radical effect? These questions beg a search for the contradictions and paradoxes that make of the biographical subject, in the traces of the distributed archive, a disappearing act. They hanker after an applied paradoxology of performance. Now you see it, now you don't.

So, listen, George Formby's personal life and creative career were riddled with contrasts, contradictions and paradoxes now fossilised in the distributed snatches of his biography, trapped in many media. Just take a few facts from his history as an indefatigable ENSA entertainer and film star during World War Two. The arthritic toes, plus a minor chest ailment, in 1940 caused an army Examining Board to reject him for military service. Yet the social survey Mass Observation found that he was the greatest single morale booster of the war, ahead of the extremely popular weekly radio programme ITMA and Winston Churchill.[13] His public persona was proudly heterosexual: his lifelong business manager, who jealously insisted always on being in the wings of the theatre or on set when he was filming, was his wife Beryl, and his boats were always called

[12] Žižek, *Sublime Object*, pp. 203–7.

[13] John Fisher, *George Formby* (London: Woburn-Futura, 1975), p. 80; ITMA (It's That Man Again) 'attracted up to 16 million listeners', see: Andrew Davies, *Other Theatres: The Development of Alternative and Experimental Theatre in Britain* (London: Methuen, 1987), p. 196; for Mass Observation, see: www.sussex.ac.uk/library/massobs/ (30.08.2006).

Lady Beryl and his houses Beryldene. Yet his 1943 film *Bell Bottom George* had a cast that was almost exclusively, unashamedly gay and was peppered with homoerotic scenes – just watch him singing 'It Serves You Right' surrounded by posing, well-proportioned matelots, and imagine his large following of closet queens swooning in secret raptures. Queer to think that such slippery gestures and grimaces of the body should be part of a production of power that was, in its way, greater than Churchill's. There, in the volatile atmosphere of a megastar.

These types of illogicality in the life-traces might be seen simply as evidence of the kinds of excess that come with stardom, yet they contrast starkly with the way his public persona was created through 'down to earth' social and geographical reference. In the archive he is represented as always carrying his past with him in an especially dense and inescapable manner, like a shark trailing an old net full of many skeleton fish, and much of the detritus is especially marked by the forces of region and class. Referring to himself frequently as 'an ordinary Lancashire lad', he aimed to be completely identified with the industrial North of England. But this apparent stability of identity was, of course, deceptive. The archival environment offers a turbulent ambivalence.

For example, all the Beryldenes (bar one which the Formbys hardly used) were within sixty miles of his birthplace, the industrial town of Wigan in Lancashire, and in a singular respect he was apparently tethered to this town for life through the invention, by his father George Formby Snr, of 'Wigan Pier'. Formby Jnr was fond of referring to this famous feature and it became a corny fixture in his deliberately dire patter: 'Ah'm just an ordinary Lancashire Lad. Ah suppose you'd call me a pup of Wigan Pier.'[14] In 1937 George Orwell helped to ensure its continuing fame through *The Road to Wigan Pier*, though the great writer, having 'set his heart on seeing' it, confesses that 'Wigan Pier had been demolished, and even the spot where it used to stand is no longer certain.'[15] Indeed, not even what it physically was is certain, though it appears not to have been anything like a pier, as it was possibly either an elevated tramway or a 'small iron frame used to tip up coal trucks to empty them into barges on the Liverpool–Leeds canal'.[16] The most iconically powerful mark, passing from father to son, that anchored Formby's identity to locality

[14] Fisher, *George Formby*, p. 14.
[15] George Orwell, *The Road to Wigan Pier* (Harmondsworth: Penguin, 1962), p. 66.
[16] Robert Hewison, *The Heritage Industry: Britain in a Climate of Decline* (London: Methuen, 1987), p. 16.

and class thus evaporates into nothing as the traces across the distributed archive shimmer with absolute uncertainly. And if that impression is untrustworthy in confirming a positive identity of the subject, then all the rest may be as well.

Moreover, the 'ties' to the North and its working-class poor also had an especially complex, perhaps phantasmal, generation through Formby's personal–professional relationship to his father. James Lawler Booth adopted the stage name George Formby around 1897 and developed his onstage alter ego, John Willie, in the first two decades of the twentieth century (see Fig. 4 – p. 86). A semi-destitute childhood had endowed this first Formby with a classic symptom of northern working-class industrial life – pulmonary tuberculosis – which provided John Willie's trademark hacking cough and catchphrase: 'I'm coughing better tonight.' For many years one of the highest paid music-hall and pantomime acts in England, Formby Snr always refused to let his son see him onstage. So it is weirdly prescient in several ways that Formby Jnr saw his father perform just once, a few days before his death from a haemorrhage caused by a coughing fit in the wings of the Newcastle-upon-Tyne Empire Theatre in 1921.[17] What uncanny forces, mostly disguised as good show-business sense, were at play in the next couple of years as Formby Jnr's mother, Eliza, quickly transmuted the shy stable-lad into the very image of his dad? The songs, the make-up, the actual costume, and even on occasion the cough, were adopted for this deferred cloning, this strange resurrection – but not the name. For two years the second George Formby was billed under his mother's maiden name of Hoy, though usually with the sub-billing 'son of George Formby', or sometimes 'A Chip off the Old Block'.

But then the decisive transformation came in 1923, when George Hoy, still in his father's garb and more by accident than design, acquired a banjulele and almost immediate, extraordinary success with the punters. In a double shuffling of identities he jettisoned his father's appearance (except for his last pair of stage shoes, which Jnr kept as a mascot throughout his life) but finally embraced his stage name. George Formby Jnr was thus immaculately conceived through a shape-shifting of the boundaries between body and word, flesh and spirit in a ghostly passing across generations. The son becomes father to the man through negative feedback from beyond the grave. As the name was taken, the body of the father was transformed into insubstantial stuff, an absent presence. But

[17] George Formby, *Radio Pictorial* (16 January 1938); 'Formby Flashback' at: www.georgeformby.co. uk/ (30.08.2006).

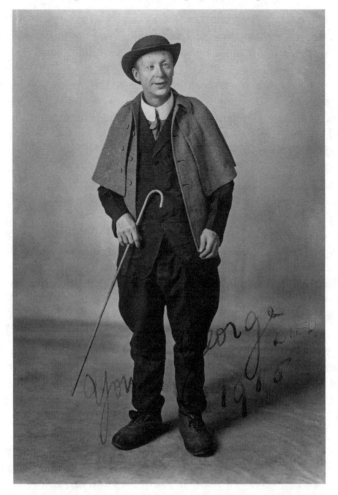

Figure 4 George Formby Snr – 1915. A publicity shot of Formby's
father performing his alter-ego John Willie, possibly wearing the shoes
that the son kept as a mascot throughout his life.

where, if anywhere, was George Hoy Booth in this weird trading between
subjects?

George Formby Snr's photograph had hung over the main mantelpiece
in the various Beryldenes. In his final public appearance on BBC tele-
vision in 1960 Formby Jnr said of his father (the shift of tense seems to
call up his spectre), 'he was certainly a great star. I don't think I'll ever be

as good as him.'[18] By then, Beryl was dying and for many years he had been estranged from his mother Eliza and the rest of his family, seeing them as 'nothing but a load of money-grabbers',[19] yet he had specified in his will that he should be buried next to his father in the family grave. As the funeral cortege slowly trawled through the streets of Warrington on 10 March 1961, with Eliza in the limousine immediately following the hearse, 150,000 people lined the route, paying homage. These and many more had also paid coins in exchange for the pleasures provided by the dead man's extraordinary performances. But who – or more exactly, what – had he been? If the dense social and geographical grounding of the past as figured in the archive cannot provide adequate terms for an answer, perhaps this is because the subject had become a pathology that psychically, socially, economically, environmentally and otherwise, as it were emptied the life of its past, confounding expectations even as they appeared to be confirmed by incessant reiteration. Do the degrees of ephemerality in these biographical traces – from film through photograph to inscription on a gravestone – operate in a paradoxical register: the emptier they become the fuller the impression of an imprint still alive, a fossil still charged by the energy of change? Or is this more like positive feedback in the black hole of super-stardom?

The more we know, the less we think we know.

THE STATE IS MONARCH – THE FILM REAL

Where can the subject who is thus 'emptied' find his objective correlative? The Hegelian answer is: in Wealth, in money obtained in exchange for flattery ... The paradox, the patent nonsense of money – this inert, external, passive object that we can hold in our hands and manipulate – serving as the immediate embodiment of Self, is no more difficult to accept than the proposition that the skull embodies the immediate effectivity of the Spirit ... [If] we start from language reduced to 'gestures and grimaces of the body', the objective counterpart to the subject is ... the skullbone; but if we conceive language as the medium of social relations of domination, its objective counterpart is of course wealth as the embodiment, as the materialisation of social power.[20]

The second George Formby was prolific. At the peak of his career in the 1930s and 1940s he produced records at the rate of about one a month, building to a list that eventually included almost two hundred songs.

[18] Bret, *George Formby*, p. 223. [19] Ibid., *George Formby*, p. 229.
[20] Žižek, *Sublime Object*, p. 212.

Between 1934 and 1946 he made twenty-one full-length films, mainly with the Ealing, then Columbia, studios. For six years from 1938 he topped the touchstone Motion Picture Herald Poll as Britain's leading cinema box-office attraction, receiving 90,000 fan letters a year and with an official fan-club of 21,000. In a 1951 interview he claimed he had earned about £84,000 a year after tax, plus another £20,000 a year for charity; his five-year contract with Columbia alone was worth £500,000.[21] At his death in 1961 his estate was worth around £212,000. Yet he spent much of the war entertaining the troops at the standard ENSA rate of £10 per week, and several of his postwar tours were indeed undertaken for charity. This ambivalence in the financial record was reflected in the purpose of the tours to Australia, New Zealand, Canada, South Africa and Scandinavia in the 1940s and 50s, designed partly to compensate for his flagging popularity in Britain. But the pattern of his international appeal was uneven: he never enjoyed great success in the USA, yet his 1940 film *Let George Do It* ran for a year in Moscow and in 1944, according to John Fisher, 'a Russian poll showed [him] to be the most popular figure in Russia after Stalin'.[22]

Greater than Churchill, not quite so popular as Stalin: the buck-toothed, bulging-eyed, squeaky-voiced lad from Wigan was in dangerous company indeed, raising the stakes on what kinds of ideological trans-action had produced such authority. The archive's ambivalence regarding just who or what this subject might have been then poses another con-undrum about the circulation of power in his performances: was this just another case of render unto Caesar that which is Caesar's, or were some other, fairer kinds of trade under way? Was this, in Hegel's terms, flattery of the monarch who substitutes wholly for the state, totally denying any rights to the people in the moment they praise him, or was some other game in play through which the 'masses' might gain some vestige of power?

Formby's film performances may be the next best place to get a grip on these questions, because there he was most enmeshed in the machinations of capital as the engine of oppression. The films were offered by the industry as pure and simple entertainment, with Formby always playing the guileless and gormless anti-hero ensnared in plots of such risible contrivance that no one could possibly take them seriously. His comical character was invariably caught in an intrigue between stereotypical

[21] Bret, *George Formby*, p. 193. [22] Fisher, *George Formby*, p. 53.

'goodies' and 'badies' which puts him into a spiral of undeserved decline – typically losing face, friends and job – that places the object of his greatest desire, the pert and proper but suggestively sexual 'girl', increasingly out of reach. The denouements virtually always hinged on the girl recognising his innocence and egging him on in a triumphal comeback that ends in sexual promise. The songs intersperse the plot like precious time-out in a busy schedule, and even when they drive on the narrative they are framed as 'something else'. This is particularly the case when Formby serenades the female star, the strumming of the banjulele always rising to an up-beat instrumental climax before the final verse, in patent witness to the sublimation of sex in the song. For all the surrounding flim-flam business gently satirising ethical weakness and economic ambition, this insistent beat of ecstasy is the main undertow in the current of the drama's comic flow. The formulaic plots deliver a fantasy fulfilment.

To twenty-first century eyes uninfected by nostalgia, though, these films almost certainly will look highly contrived and corny. Frequently too they are marred by low levels of aesthetic and technical competence, the result of poor scripts, very uneven acting, clumsy editing, awkward camerawork and more. Ideologically, they are riddled with misogyny, sexism, racism, jingoism and other evils consequent upon their stereo-typical view of the world. A common defence for this syndrome from scholars of popular culture has been that the conventional moral rectitude is required as a trigger to spark off opposing psychic forces, most commonly found in the anti-structures of the carnivalesque, saturnalia, bac-chanalia and so forth, to create what Richard Dyer has described as a 'utopia of sensibility'.[23] From this perspective the sloppy production of Formby's films may even become a vector in understanding how their public was empowered. The list of 'faults' is so easily compiled that one wonders whether audiences even noticed them, or in noticing did not care about them because they were caring more about something else. But if that 'something else' was empowering, then it must still have been so ambivalently, for after the final reel it is back to political business as usual as Formby goes off laughing all the way to the bank. The public have flattered the monarch of performance in paying their dues to the point where perhaps all passion is spent. So these further stories from the celluloid part of the distributed archive unfortunately may serve to make

[23] See, for example: Iain Chambers, *Popular Culture: The Metropolitan Experience* (London: Methuen, 1986); John Fiske, *Understanding Popular Culture* (Boston: Unwin Hyman, 1989); Richard Dyer, *Only Entertainment* (London: Routledge, 2002).

the extraordinary in Formby's performance even more inaccessible. This raises the stakes even higher on degrees of ephemerality as sustained from the live event of filming. But might it still indicate a wider ecology of extraordinary acting, one in which the paradox of shared uniqueness is part of a life still living from the past?

We must look a little more closely and obliquely at these shoddy items, hazarding guesses about their more fabulous resonances, perhaps in the way Formby seemed positively to revel in the denials of his fictional roles – to strength, good looks, manliness, normal physical coordination and so on. He was not afraid to embrace vulnerability. There is a telling description of him at the mid-point of his career, which recognises that he was on a kind of cusp, on the verge of international success in the balance between live and mediated performance.

He is a broad comedian, a knockabout clown ... and still half a variety artist in a strange element. He also has that spark of personality that breeds universal appeal and commands universal affection. His teeth and the dumb grin are his properties, like the clown's red nose and white diamond patch. *But the spirit of Formby is in the eyes.* There is a smile in them that can turn to the most touching pathos, like the eyes of a spaniel. There is also in them an unquenchable optimism that sums up the very essence of his character ...[24]

This appeared in 1937, the year Formby made two films that were highly successful at the box office – *Keep Fit* and *I See Ice* – and in which his character was especially vulnerable. If there is a recognition of some kind of disjunction in the acute view that he is 'half a variety artist in a strange element' – a kind of filmic alien? – then there is another, more stupendous, in the perception that links the 'eyes of a spaniel' with the very 'essence of his character'. This ghosts the idea that the eyes are windows to the soul, but it fails to offset the stress already laid in the impression of an animal spirit. An animal spirit with soul? What kind of creature are we being hailed towards here? What ecological conundrum is in play?

Fascination with the eyes of film stars has a long pedigree, of course. This is partly produced by the technical achievement of the close-up, but also by the ocular structures of film itself: we are looking through two lenses, the lens of the eye through the lens of the camera, into a third lens onscreen, which despite its enormous visual presence is in all other respects absent. This is part of the uncanny 'magic' of film, the paradox of an infinite regression away from the 'real' of the live event now well-and-truly

[24] Leonard Wallace, 'Introducing George Formby', *Film Weekly* (6 November 1937), quoted in Bret, *George Formby*, p. 72; emphasis in original.

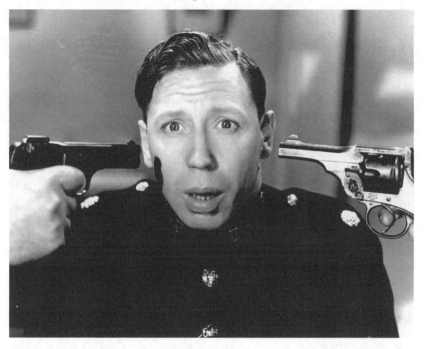

Figure 5 George Formby Jnr, *Spare a Copper* – 1940. The play of the lenses and light gives depth and vulnerability to the eyes of a star and heroic wartime performer.

out of reach, except through the lenses that together seem to bring it ever closer through magnification. In the distributed archive, this is one of the strangest impressions of all, because phenomenally it appears to collapse time – between the then of one seeing and the now of another – while ontologically asserting an absolute distinction between past and present. No wonder, then, that the paradox of seeming depth of the eyes on the flat surface of the screen has attracted some inspiring writing. I am thinking particularly of Roland Barthes's short essay on 'The Face of Garbo', which makes fabulously suggestive contrasts and connections:

Amid all this snow at once fragile and compact, the eyes alone, black like strange soft flesh, but not in the least expressive, are two faintly tremulous wounds. In spite of its extreme beauty, this face ... comes to resemble the flour-white complexion of Charlie Chaplin, the dark vegetation of his eyes, his totem-like countenance.[25]

[25] Roland Barthes, *Mythologies* (London: Granada, 1973), p. 56; see also Bert States, 'The Phenomenological Attitude', in *Critical Theory and Performance*, ed. Janelle G. Reinelt and Joseph R. Roach (Ann Arbor: University of Michigan Press, 1992), pp. 376–7.

Soft flesh, wounds, dark vegetation, animal spirits. Are we here back at the start of civilisation, the moment when, according to Vico, a decisive space was carved out of the forest, a space that led to cities and empires, opening up a distance between books and wild trees?[26] These images certainly call up the vulnerabilities of the space that may have forced a gap between culture and nature, as well as fascination with an ecology that lies beyond it, the energies of another world that civilisation left behind.

So is this where the extraordinary act may have to take place, well beyond the nature of the archive? Somewhere beyond the edge of the human as we have come to know it, where incommensurates meet and mingle, animal and human, nature and culture in a combination of pleasure and pain beyond all reason? This was certainly a dimension of the sublime as conceived by Žižek in his reading of Hegel: the radical negativity of the sublime is achieved in a recognition that not only is there nothing beyond phenomena (representations, impressions), but that each phenomenon itself is constituted through radical negativity. If we are honest, when we look into the other animals' eyes we become aware that we are seeing nothing (not just nothing that we can know); and, as for the human animal, in gazing into each other's eyes we know no essence, however much the warm looks of desire might try to fool us of its presence. Is this the kind of sublime honesty that the onscreen eyes of Garbo, Chaplin, Formby inspired? And are they supremely flattering *us*, turning us each into a monarch of the true state of the ecologically real, where shared uniqueness makes for coherent diversity? Returning us to an ecology where strange bedfellows conjugate in the production of new species?

There were certainly incredible extremes actually at play around the two Formby films of 1937. As with all his leading ladies, Formby aimed to seduce Kay Walsh if he got the chance, spurred on by Beryl's distaste for sex and her incessant policing. Usually Beryl's hypervigilant jealousies prevented any significant contact, but towards the end of the shoot of *Keep Fit* she spent a couple of days in hospital, reportedly for appendicitis. In the distributed archive this negative impression of Beryl is remarkably pervasive, so much so that to say a 'good word for her', as some do, always risks confirming the power of the negative through exception, producing a doubled stamp of condemnation. Such automatic collusions create paradoxes in the gendering of archives that are, for

[26] Robert Pogue Harrison, *Forests: The Shadow of Civilisation* (University of Chicago Press, 1992) p. 6.

example, intensified by other stories surrounding *Keep Fit*: as Formby was sleeping with Walsh, so, allegedly, was Beryl with Gavin Gordon, a young actor in the film who, allegedly, recently had 'bedded Garbo and Dietrich'.[27] Who is worse shod than the shoemaker's wife?

Circumstantial evidence of Formby's success with Walsh can be seen in the final scene of the film, where as the pair are bounced up and down on a stretcher following the climactic fight, she appears to be enjoying him visibly touching her breast, albeit wearing big boxing gloves! Irene Bevan, Gracie Fields's stepdaughter, also claimed there had been a successful liaison.[28] In fact, the operation that 'allowed' the affair to happen was for an hysterectomy, apparently undertaken for extraordinarily ambivalent purposes by Beryl. A childless marriage would ensure that Formby's career always had priority, and he – a confirmed Catholic – might be distracted from other women if she could offer him sex without consequences. Maybe this was a strange conjunction of deferrals, a vital subtraction producing a doubling of tractable benefits. Like negative feedback leading to a life of ecstasy? Or perhaps feedback of a positive kind, a raising of stakes on a hiding to nothing?

GOD IS JESUS – GOING FOR A SONG

the state as the rational organisation of social life is the idiotic body of the Monarch; God who created the world is Jesus, this miserable individual crucified together with two robbers ... Herein, lies the 'last secret' of dialectical speculation: not in the dialectical mediation–sublimation of all contingent, empirical reality, not in the deduction of all reality from the mediating movement of absolute negativity, but in the fact that this very negativity ... must embody itself again in some miserable, radically contingent corporeal leftover.[29]

Descriptions of Formby Jnr performing live refer to how he made audiences feel 'at home' or 'held them in the palm of his hand', as if he had somehow taken them into his confidence, shared a secret with them. The columnist for the *Blackpool Gazette* described a 1940 performance for troops in Quimper, France: 'Half of this young comedian's success can be ascribed to his unaffected intimacy with the audience.'[30] It would be an elementary mistake to assign the quality of this 'unaffected intimacy', these close encounters and exchanges, to the effects of Formby's persona as an 'ordinary', down-to-earth, easy-going Northerner, something with

[27] Bret, *George Formby*, p. 68. [28] Ibid., pp. 66–7.
[29] Žižek, *Sublime Object*, p. 207. [30] Bret, *George Formby*, p. 97.

which audiences might easily identify. It is not through mediation that such inclusion might be produced, but rather through some welcome, unfathomable *deduction* of that which is usually taken as real. The stars' eyes on film seemed to play this trick, while for one critic Formby's smile may have produced a similar movement in the live events, 'a smile of perpetual wonder at the joyous incomprehensibility of the universe and the people in it'.[31] That 'joyous incomprehensibility' moves us closer to the positive negativities of the sublime object in this incredible celestial ecology. But of course, surely the archive is hardly likely to reveal the secrets of the extraordinary in his live performances even through so felicitous a turn of phrase? Its 'corporeal leftovers' stubbornly defy access to the past present and its live effects, especially in their most serially seductive invitations to it in, say, the fading photographs replete with smiles, the real Formby signatures for sale on the World Wide Web. To adopt a phrase from Balzac: They must have the defects of their qualities.

So this is where we must risk really entertaining the spectral, peering for ghosts in our final attempt at an answer to this fool's slippery question. Also this is where archive fever poses its greatest threat, as Derrida has it, 'It is to burn with a passion. It is never to rest, interminably, from searching for the archive right where it slips away.'[32] And where this one slips away, perhaps most excessively, is in the encounter of extremes meeting that we considered at the outset, in the silence as the song ends, yes, but now maybe more so in the silences in the midst of the song. For Formby was not especially competent with the notes – he could not even tune his own instruments – so he might have agreed with the pianist Schnabel's paradoxical view, 'The notes I handle no better than many . . . But the pauses between the notes – ah, that is where the art resides!' Therefore, in the dying moments of this chapter, let us risk all and try to follow Formby's lead when he made his greatest gamble, perhaps hoping to allay the spectre of the father – the origin, the law – by taking on his name.

This is where the distributed archival environment shimmers with utmost uncertainty, where the sub-species 'extraordinary actor' may turn out to be no more than a wisp of the will, where its celestial ecology may be exposed as a foundational myth wholly without substance. In the ecologies of performance as method, this is where analogy must be replaced

[31] Geoff J. Mellor, *They Made Us Laugh: A Compendium of Comedians Whose Memories Remain Alive* (Littleborough: George Kelsall, 1982), p. 30.
[32] Derrida, *Archive Fever*, p. 91.

by homology in support of such existence. It is where associations between the cosmic firmament of galaxies and the structure of human affairs must give way to something more akin to evolutionary evidence of some common ancestry. Having failed to find such evidence in the scenes from a life and the film real, we must paradoxically turn to yet more insubstantial stuff. For if theatre ecology is to encompass the archive as Derrida sees it we must catch the sublime at the point of its birthing, at the moment in which performance most energetically collapses the gaps between mind and body, spirit and bone, books and forests, culture and nature. Only then might we detect inescapable homologies between the most elevated human achievements – in the sublime arts of extraordinary actors, say – and the bloody earthly business of species survival. If somehow that insubstantiality can be given substance, even in just one case, then the exception may be seen as a general rule that can be applied way beyond the stars. Thus shadowing the effects of degrees of ephemerality might lead us to sense how for all species a coherent diversity arises from collective uniqueness through the ecologies of the performance commons.

It is necessary that you listen to Formby singing, first cut on black acetate, now 'remastered' on some CDs.[33] The lyrics of many of his songs have been justly celebrated for the way they capture the spirit of carnival in the everyday, especially as it appears at English seaside holiday resorts. Consider 'With My Little Stick of Blackpool Rock' (1937):

> With my little stick of Blackpool rock
> Along the Promenade I stroll;
> In my pocket it got stuck I could tell,
> 'Cos when I pulled it out I pulled my shirt up as well.

The world they picture has been likened to Donald McGill's postcards, full of the kind of smutty misunderstandings of Formby's personal favourite, which shows a doctor chastising a nurse before an agonised hospital patient: No, I said *prick* his *boil*.[34] But the comparison is misleading, because Formby invested even the clumsiest double entendres with a delicacy of rhythm and timing that was literally breathtaking. Listen to the penultimate line of the fourth verse of 'Auntie Maggie's Remedy' (1941).

[33] *Formby Favourites* (2000) CD, Spectrum Music; *George Formby: When I'm Cleaning Windows* (2002) CD, Pickwick Group.
[34] Bret, *George Formby*, p. 56; for examples, see: Arthur Calder-Marshall, *Wish You Were Here: The Art of Donald McGill* (London: Hutchinson, 1966).

Now I knew a girl who was putting on weight
In a spot where it just shouldn't be,
So I said to Nelly
Now you rub your ... ankle
With Auntie Maggie's remedy.

The minuscule pause, like the tiniest catching of breath, before the ridiculous substitution of 'ankle', is exquisite in its poise as the word is sung with utterly unerring precision on the next beat. This extraordinary control over the moment, a kind of insistent musical cliffhanger, appears in many of the songs as a brief, two-syllable interjected laugh, a 'tee hee' of knowing cod-wickedness, or a 'hee hee' of sheer exuberance. In every instance the timing is brilliantly precise because wholly unforced, apparently as natural as breathing. And here, perhaps, is a key to the success of Formby's performance, because – despite the frequently dreadful lyrics, the monotonous beat, a painfully narrow musical range – the singing is imbued, through the jaunty, upbeat rhythms and the light-footed lilt of the slightly throaty voice, with the rising energy of laughter.

It is in the momentary catching of breath to produce such energy that the special quality of Formby's silence is produced, for the laughter is directed at the world pictured by the songs and in the films, a world of everyday disasters, oddities, distortions, mistakings, excesses, extremes. A radically *ordinary* world in which, in principle and if necessary in practice, anything can be substituted for anything else: ankles for pregnant bellies, Blackpool rock for penises, ghosts for lovers, hysterectomies for love, fathers for sons. In short, a world in which nothing is anything in itself. A world that – because appearance is continually ripe for displacement – amounts to nothing. A world that *is* nothing, a radical negativity even as it is becoming something. But – and here we certainly verge onto the sublime – this is not a matter for despair, but for ridiculously reassuring laughter. The laughter in the voice, whatever the song, is urging us on to smile, to be good-humoured, glad-hearted about this nothingness in all things. So in the moments of caught breath, the tiny silences before each laugh erupts, there is a paradoxical mingling of horror and joy. Yes, that's it. In his performances, Formby produced the sublime for his fans, he became a sublime object, a sublime body. This oh so ordinary corporeal body, crucified on the miseries of a hellish private life in the midst of fabulous success, was, in his way, a god! Perhaps.

There has to be a 'perhaps', doesn't there, George? Because how can we be sure that this raving about nothing is not a delusion brought on by archive fever, a glitch in this performance ecology that births a monstrous

conception? And what is the archive but, as Derrida tells us, a place of commencement, of origin, and of commandment, of law? Hence, in making this writing say thus, do I submit to the impression of the very authority that I have attempted to rubbish by requiring of the imprint to resuscitate the live in your long-gone act. And now, only by calling up the dead, by invoking your spectre – that complex, impossible singularity I dreamed up at the outset – can I move on past it, to leave you behind. You were indeed, according even to the distributed archive, an extraordinary actor, even among the Siddonses, Chaplins, Lorres, and Garbos of this world. But who can believe that in good faith, as they say, from a professor who calls up spectres?

Performance limits: steps to a paradoxology

PERFORMANCE LIMITS

Preamble: a new discipline! a new phenomenon?

In the final decades of the twentieth century performance studies came of age. It had matured as an international discipline very rapidly, fabulously fostered by the performative societies. Such societies constitute the human through performance and, to varying degrees, its forms of reflexivity. So it is hardly surprising that the idea of performance coursed through proliferating networks of institutional vectors in universities worldwide. These extended across the creative arts, social sciences, anthropology, geography, psychology, computing, management studies and other fields of scientific, scholarly and creative research, as well as in politics, economics, industries and cultures more generally. Like a genetic mutation, 'performance' shaped new bodies of knowledge, opened new pathways to action, even revivified long dead genres.

This thumbnail sketch of performance studies' growth pictures 'performance' as a transformative agent, mutating and reproducing phenomenally in many forms and modes as it gains a purchase everywhere. But how best to judge the nature of such a promiscuous factor? What values might performance generally attract, given that both as idea and action it has become profligate in breaching all boundaries to transmission, operating biologically, psychologically, socially, technologically, creatively and otherwise all at once? Hence it might seem useful to consider it a candidate for Richard Dawkins's meme theory, in which mental and cultural phenomena work like genes, multiplying through mimesis.[1] But Dawkins rather reductively sees the meme as a mental

[1] Richard Dawkins, *The Selfish Gene*, 2nd edn (Oxford University Press, 1989 [1976]), pp. 192–201, 322–31; Richard Dawkins, *The Extended Phenotype* (Oxford University Press, 1999 [1982]), pp. 109–12; Susan J. Blackmore, *The Meme Machine* (Oxford University Press, 1999).

replicator, a kind of sophisticated self-copycat, which seems far too restrictive a conception for such a volatile shape-shifter as performance.

This chapter explores a more radical challenge to this conundrum of cultural transmission through an ecologically driven exploration of performance as it has been conceptualised in key texts of performance studies. From the perspective of meme theory this may seem paradoxical, because it is dealing primarily in mental constructs, i.e. with memes. But books may have an especially paradoxical role with regard to the ecological crisis as they can foster fundamental ways to challenge it even as they might increase the likelihood of making it worse because still they rely so fully on organisms – trees – which are utterly crucial in the carbon cycle. In other words, such intimate links between concepts and organisms in texts are extremely important to my arguments about theatre and performance ecology. They may demonstrate, for example, that the crucial coexistence of the environmental and performance commons is not simply a mental conceit. Hence, the book you are holding in your hand draws you into participation in those commons in a paradoxically profound way. Your act of reading may become an example of its arguments concerning how humans perform as being crucial to ecological futures. But of course that outcome depends on the specific ethical and political values you may evolve – or not – through your performance of reading the book, and maybe especially this chapter!

Whatever the specific nature and value of particular performances, though, the general promiscuity of performance as the millennium turned was good news for performance studies as its infectious interpretive powers spilled into the twenty-first century. Everything became available to its explanatory inflections. Like a soft science of the creative impulse, its targets of knowledge were everywhere. A significant flurry of fresh performance studies texts promised sound introductions, explained workable methodologies, laid out long stalls of readings, opened up widening realms for further research.[2] Given this, the mid-point of the

[2] A selection in order of first appearance: Marvin Carlson, *Performance: A Critical Introduction*, 2nd edn (London: Routledge, 2003 [1996]); Patrice Pavis, *Analysing Performance*, trans. David Williams (Ann Arbor: University of Michigan Press, 2003 [1996, as *L'Analyse des spectacles*]); Geraldine Harris, *Performing Femininities: Performance and Performativity* (Manchester University Press, 1999); Julie Hollege and Joanne Tomkins, *Women's Intercultural Performance* (London: Routledge, 2000); Colin Counsell and Laurie Wolf (eds.), *Performance Analysis: An Introductory Coursebook* (London: Routledge, 2001); Jill Dolan, *Geographies of Learning: Theory and Practice, Activism and Performance* (Middletown, Conn.: Wesleyan University Press, 2001); Jon McKenzie, *Perform or Else: From Discipline to Performance* (London: Routledge, 2001); Richard Schechner, *Performance Studies: An Introduction* (London: Routledge, 2002 [2nd edn, 2006]); Philip Auslander (ed.),

first decade of the 2000s (when the essay on which this chapter is based was written) seemed like a good moment to take stock of the qualities of the new 'discipline' and to assess its predominant values.[3] However, a conventional critical survey of this particular 'field' would be caught in a Catch 22 situation. As a 'survey' implies limits, it misses the main point of a project apparently determined to break free of all bounds. By the same token, any attempt to discover the main ethical and political proclivities of performance studies would seem to be a lost cause.

The problem is exemplified by the paradox of Po-chang. Asked about seeking Buddha's nature, he said 'It's much like riding an ox in search of the ox.'[4] The image is intriguing and profoundly disturbing in respect of performance studies. It confirms the magnitudes of performance power that the new discipline set out to engage – they could be universal and/or even God-like. But also it indicates that there will be constitutive blind spots in the knowledge the discipline generates. We would need to get a very firm grip on the slippery ox of performance studies, then steer it in search of its most powerful qualities. So *what* would be the most useful theoretical stance through which to analytically figure performance studies? And *how* could it generate a clarifying focus on examples to reveal the creature's prevailing ethical and political values?

Oddly, the second of these questions could be the easier to answer because performance itself has become, like Po-chang's ox, an expansive and protean and often paradoxical phenomenon. In this it shares some crucial features with the ecological crisis into which humanity blundered ever more deeply in the twenty-first century, sparking off possibly the most acute ethical and political dilemmas in the history of hominids since Early Human species evolved almost two million years ago. That crisis is paradoxical – it is man's highly successful modernist progress that has produced it – and performance is utterly integral to it, through the performance commons and possibly as humanity's current chief addiction, so could a paradoxical investigation into the ethical and political

Performance: Critical Concepts in Literary and Cultural Studies, 4 vols. (London: Routledge, 2003); Michael Mangan, *Staging Masculinities: History, Gender, Performance* (Basingstoke: Palgrave Macmillan, 2003); Erin Striff (ed.), *Performance Studies* (London: Palgrave Macmillan, 2003); Simon Shepherd and Mick Wallis, *Drama/Theatre/Performance* (London: Routledge, 2004).

[3] 'Discipline' is in quotation marks here as performance studies also has been viewed as a number of disciplines, as a field, and as a paradigm. The quotation marks are taken as read in the rest of the chapter.

[4] Patrick Hughes and George Brecht, *Vicious Circles and Infinity: An Anthology of Paradoxes* (Harmondsworth: Penguin, 1978), p 24. All paradoxes quoted are from this source, unless otherwise indicated.

dimensions of performance studies throw some light on its causes? If so, what would such a method entail? We might usefully train our attention on paradoxes in the less slippery dimension of theatre ecology initially to explore these questions. For example, consider the playwright Eugene Ionesco's absurdist dictum as a founding principle for identifying the principal 'object' of performance studies: Only the ephemeral is of lasting value. Or think about N. F. Simpson's 'We can't leave the haphazard to chance' as a maxim for a discipline that refuses to exclude anything, even people who echo Sam Goldwyn's notorious request to 'include me out'. These considerations draw us a little closer to a method through which we might see that paradox could be a significant *a priori* characteristic of performance studies, and perhaps theatre studies as well. They gesture towards strange truths by implying that performance, at least in some of its key characteristics across a wide range of uses, including its uses in theatres, may be inescapably paradoxical. In exploring these possible truths this chapter begins to evolve an emergent theoretical perspective on performance, and on performance and theatre ecology: I call it a *paradoxology of performance*.[5]

This paradoxology suggests that, just as performance is constitutive of humans in performative societies, so paradox may be constitutive of performance in many of its guises, including theatrical performance.[6] If this

[5] I coined the phrase for the original essay, but contradiction, reflexivity and paradox have figured centrally in my analyses of performance for a number of years now. See, for examples: *Engineers of the Imagination: The Welfare State Handbook*, rev. edn, with Tony Coult (London: Methuen, 1990), pp. 200–31; 'The Politics of Performance in a Postmodern Age', in *Analysing Performance: A Critical Reader*, ed. Patrick Campbell (Manchester University Press, 1996) pp. 133–52; 'Cross-cultural Performance in a Globalised World', *Theatre Forum* 8 (Winter/Spring 1996), 67–72; 'Pathologies of Hope in Drama and Theatre', *Research in Drama Education* 3: 1 (February 1998), 67–84; *The Radical in Performance: Between Brecht and Baudrillard* (London: Routledge, 1999). Plus the writings that led to this book: Kershaw, 'The Theatrical Biosphere and Ecologies of Performance', *New Theatre Quarterly* 16: 2 (May 2000); 'Oh for Unruly Audiences! Or, Patterns of Participation in Twentieth-Century Theatre', *Modern Drama* 44: 2 (Summer 2001); 'Dramas of the Performative Society: Theatre at the End of its Tether', *New Theatre Quarterly* 17: 3 (August 2001); 'Ecoactivist Performance: the Environment as Partner in Protest', *Drama Review* 46: 1 (Spring 2002); 'Radical Energy in the Ecologies of Performance', *Frakcija – Magazine za Izvedbene um Jetnosti: Performing Arts Magazine* 28–9 (Summer/Autumn 2003); 'Curiosty or Contempt: on Spectacle, the Human, and Activism', *Theatre Journal* 55: 4 (December 2003); 'George Formby and the Northern Sublime', in *Extraordinary Actors*, ed. Martin Banham and Jane Milling (Exeter University Press, 2003); 'The Ecologies of Performance: on Theatres and Biospheres', in *Performing Nature: Explorations in Ecology and the Arts*, ed. Gabriella Giannachi and Nigel Stewart (Bern: Peter Lang, 2005); 'Performance Studies and Po-chang's Ox: Steps to a Paradoxology of Performance', *New Theatre Quarterly* 22: 1 (February 2006).

[6] Historically the term 'paradoxology' has been primarily used in communication studies and philosophy, though it has key resonances in physics, especially in quantum theory. See, for example: Paul Watzlawick, Janet Helmick Beavin and Don D. Jackson, *Pragmatics of Human Communication: A Study of Interactional Patterns, Pathologies, and Paradoxes* (New York : Norton, 1967).

turns out to be the case it may be reasonable to claim that performance produces the *paradoxical primate*. According to Colin Talbot, it is crucial to this version of the human-animals' primate 'nature' that homo sapiens exhibit complex combinations of behaviour, such as cooperation and competition, selfishness and altruism, aggression and conciliation, and so on. These arise from:

innate instincts which are paradoxical ... and have evolved as a consequence of our (fairly) unique form of social organisation with its combination of fission–fusion groupings and individuality. These paradoxical instincts combine with our truly unique intellectual gifts to produce amazingly adaptable beings and institutions.[7]

The paradoxical primate, fundamentally, would then be a reflexive creature, because paradox is nothing if not self-referential. From this it follows that to identify the lead values of performance and theatre studies would require a method of analysis that somehow matches the qualities of its main 'object' of study, performance itself. That is to say, the para-doxical performances that constitute the paradoxical primate will require paradoxical strategies of analysis. These strategies create what I call a *paradological method* that searches for analogical and homological cor-respondences between the 'thing' analysed and the means of making the analysis. In the ecologies of theatre and performance, paradological, homological and analogical modes of analysis are foundational, as I have argued in earlier chapters. So such methods are necessary for steering Po-chang's ox towards an answer to my second question: how to choose what to analyse in performance studies in order to perceive its most influential and potentially pervasive values?

Now clearly the terrain we are already riding through promises to become mind-bendingly tricky. So perhaps *intuition* is as good a guide as any to a productive direction at this stage of our enquiry. Given that its ultimate objective is to assess value, a paradox about quality should be a suitable opening gambit. So consider Balzac's dynamic observation on the structure of value in the generality of things: They must have the defects of their qualities. Hence, to get a grip on the dominant ethico-political values of performance studies we need examples that are as much unlike as they are alike each other. In sharing the same qualities they must have contrasting defects, and vice versa, where 'defects' is understood both in the sense of 'imperfections' and of 'principled difference'. The latter

[7] Colin Talbot, *The Paradoxical Primate* (Exeter: Imprint Academic, 2005), p. 82.

meaning applies as a person 'defects' when exile is chosen, or allegiances are abandoned on principle, but also when a substance has a principal ingredient that gives it a particular quality. Any texts, say, which we choose to study might therefore be like siblings who do not speak much to each other, at a long distance from their closest kind.

Among the flush of new performance studies books at the turn of the third millennium two appeared within a year of each other that pretty exactly meet this criterion. They are alike in proposing *general* and *full* accounts of performance. They are also especially unlike each other. One offers a 'general theory of performance' to expert readers that will convey them beyond disciplines into a new paradigm of knowledge. The other is an introduction to performance studies as an existing discipline for neophyte students. There are other highly disjunctive homologies between them. The general theory is the first book of a 'newcomer', while the introduction is by a leading 'veteran' of performance studies. Yet both emerged from the same place nearly at the same time: the Tisch School of the Arts, New York, in the first two years of the twenty-first century. But also according to received opinion they came out in different epochs, either side of a human-made disaster that is commonly said to have 'changed the world'. Jon McKenzie's *Perform or Else: From Discipline to Performance* was published by Routledge in April 2001. Richard Schechner's *Performance Studies: An Introduction* was also published by Routledge, in April 2002.[8] The two books symmetrically bracket the terrorist attacks of 11 September 2001 in New York and Washington. They prefigure and refigure the performance of 'global' disaster now metonymically known in the United States of America as 9/11.

There are other pairs and groups of texts that would meet my key criterion. I mention them partly to trouble a foundational myth in which 'two men gave birth' to performance studies, namely, Richard Schechner and Victor Turner.[9] The progeny surely have been more fabulous than the mythical fathers ever foresaw. For example, two other men in 1996 certainly delivered nicely twinned critical analyses of performance, though it was unlikely to have been a planned event.[10] Just a few years later, four women produced a triplet of immaculate feminist conceptions

[8] Routledge, *Performance Studies Catalogue* (London: Routledge, 2002, 2003).
[9] Peggy Phelan, 'Introduction' in *The Ends of Performance*, ed. Peggy Phelan and Jill Lane (New York University Press, 1998), p. 3; see also: Shannon Jackson, *Professing Performance: Theatre in the Academy from Philology to Performativity* (Cambridge University Press, 2004), p. 8.
[10] Carlson, *Performance*, 2003; Pavis, *Analysing Performance*, 2003.

that clearly speak different specialist languages to each other across continents and complementary concerns.[11] The male 'twins' nicely differ between 'cultural studies' and 'semiotic/aesthetic' approaches to performance. The 'triplets' – from North America, Europe and Australia – create a supple set of 'pedagogic', 'aesthetic' and 'cultural' angles on performance, adding substantially to its burgeoning and healthy diversity. However, I risk a ghosting of the foundational myth in preferring the coupling of McKenzie and Schechner's books because I think that their specific positioning *vis-à-vis* the historical moment of 9/11 and its aftermath may make their political and ethical values especially resonant for performance studies as a whole, as maybe it imbues them with a curious environmental resonance. So – like words of wisdom in a global holocaust, like whispered prayers in a local moral maelstrom – the 'terroristic moment' may render them especially significant to explanations of the general evolution of performance and theatre ecology in early-twenty-first-century history. But given that traumatic events make lost causes the last refuge of perfection, how can we best access the defects in the manifest qualities of these two already influential texts?

PART I: ON METHOD AND MATTER

Performance and theatre ecology depend crucially on established ecological knowledge and the methods used to create it, hence my keen interest in paradology, homology and analogy as major factors for detecting vectors in the formation of a paradoxology of performance. For example, homologies within and between the biology and behaviour of species have been fundamental to an understanding of evolution, which of course has had a profound impact on ecological understandings. The same is true for homological defects or, more accurately, disjunctions, such as the roughly 3 per cent difference in genetic make-up as between homo sapiens and the great apes. That small difference raises profound questions about variations between primates in respect of consciousness, intelligence, skills and 'language' acquisition, which in turn have impacted immeasurably on how homo sapiens differ in their uses of the environment in comparison to their closest genetic kin in the 'animal world'. Hence homological convergences and disjunctions between organisms and how

[11] Dolan, *Geographies of Learning*, 2001; Harris, *Performing Femininities*, 1999; Hollege and Tomkins, *Women's Intercultural Performance*, 2000.

they dwell on Earth are crucial to ecological thinking and principles. And the same is true for what organisms produce, even including books.

So besides the similarities between my two chosen texts we need to explore equivalents to that 3 per cent difference between apes and humans. As just noted, *Performance Studies* and *Perform or Else* are broadly homologous in treating performance as key to a new paradigm, or paradigms, of knowledge. But even their sub-titles indicate they are also homologically disjunctive, as the first is 'an introduction' to a discipline already assumed to exist and the second reaches beyond 'discipline to performance' with a 'ruse of a general theory' that aims to be especially original. As with such disjunctions in biological and behavioural studies of animal species, this difference offers multiple challenges to explanation and critique.

A certain obliqueness of approach is often then adopted to meet these kinds of challenge – such as the proposition that chimpanzees may possess a 'folk physics' that indicates they have a 'theory of the world'[12] – and the paradoxology of performance is no exception in this respect. So my paradological method will aim to detect *depth in surfaces, beginnings in endings, truth in contradictions, presence in absences* in the matter of these two books. Before launching into those paradoxical modes, though, I recommend that if you have not read the books at least to consult them as my analysis proceeds, and/or to refer to the synopses of their arguments included in the article that fostered this chapter.[13] Voltaire's shimmering judgement is highly relevant to that recommendation: The superfluous, a very necessary thing.

The following textual exegesis, then, aims to celebrate the sophistications and complexities of *Perform or Else* and *Performance Studies*. My emergent paradoxological theory and paradological method acknowledge that the books are primary exemplars of the 'discipline/field/paradigm' they participate in producing. The method places equal emphasis on the time and place of their appearance as on their main analyses and arguments. Hence, the paradoxology is a version of 'grounded theory' or 'situated theory': theory that is alert to its obligations in the 'material' world, however conceived.[14] 'Grounded' or 'situated' are suited to the two

[12] Daniel J. Povinelli, *Folk Physics for Apes: The Chimpanzee's Theory of How the World Works* (Oxford University Press, 2000).

[13] Kershaw, 'Performance Studies and Po-chang's Ox', 30–53.

[14] Barney G. Glaser and Anselm L. Strauss, *The Discovery of Grounded Theory* (New York: Aldine, 1967); Barney G. Glaser, *Emergence vs Forcing: Basics of Grounded Theory* (Mill Valley, Calif.: Sociology Press, 1992); Donna J. Haraway, *Simians, Cyborgs, and Women: The Reinvention of Nature* (London: Free Association Books, 1991), pp. 183–202.

books' down-to-earth environmental relevance while 'theory' responds to their stratospheric propositions about new paradigms of knowledge. So though my primary focus is on the books as texts, I salute them both as terrific open sesames to the teeming networks of life that flourish on this raucously divergent planet which humans call Earth.

Where's the problem?

But why do we need this somewhat complex and convoluted approach to identify the politico-ethical values of these two texts? Surely they are obvious in their alignment with the great traditions of twentieth-century radical thought designed to bring down the logo-phallo-centrism of Enlightenment-driven systems of oppression? Are they not patently in sympathy with the anti-hegemonic philosophies of feminism, decon-struction, racial equality, democracy, human rights and so on? Where's the problem? Well, in a sense there isn't one, as in broad terms they do sit comfortably with these perspectives on socio-political critique. But it is precisely the *patency* of that fit that should give us pause.

The fit may construct fairly clear political/ethical positions for the two books. But, from the perspective of a paradoxology, that does not answer the question about their more pervasive values. A jaundiced view might see the synthesis of radical philosophies as a ruse to avoid having to be explicit about their own *specific* historical, political and ethical purposes. And this tendency may be encouraged by the drive to inclusiveness of performance studies as a world-absorbing, even a globalising, project. The desire to include everything may build new master narratives out of anti-hegemonic philosophies. The king is dead; long live the king. The *mere possibility* of that risk requires that we do not take their overt alignments with radical values at face value. And it ironically highlights the need for paradox in searching out their ethics and politics.

My paradological method is exemplified in the next two sections. I skim the surfaces of their final pages to excavate the beginnings evoked by their ends. Looking for ethical depth in their typographic design and for political hope in the disasters of their narratives, I draw contradictory conclusions that produce paradoxical views of their designs on the reader. I follow that with a look at the 'nature' of my paradoxology in the light of classical logic and 'dialetheism', a late-twentieth-century revival of an iconoclastic philo-sophical tradition that celebrates the 'truths' of paradoxical constructs. I then demonstrate how dialetheism might strengthen performance theory, using a feral idea in performance analysis: that performance cannot be

translated or transformed into anything else. This augments the previous chapter's arguments about the resuscitation of past 'live' events through degrees of ephemerality in distributed archives, thus adding to the reformist repertoire of the ecologies of theatre and performance.

The second half of the chapter extends the logical advantage of paradoxology by analysing emergent concepts in the arguments of the two books. Concepts created to produce keenly original views about performance, concepts taken as encapsulating an epoch, concepts that displace histories in claiming a new paradigm. My paradological method opens up this emergence to reveal ethico-political values beyond conventional categories of resistance and radicalism. Working against the totalising hail of 'new critical' textual exegesis, I discover partial consonances – which may be paradoxical homologies – in the incommensurable natures of these two texts.[15] Unfold meaning by folding it back on itself, explicate by implication. As Heraclitus said: Unless you expect the unexpected you will never find truth, for it is hard to discover and hard to attain.

Thesis 1: depth in surfaces

What relevance to the fact that *Performance Studies* (2002) and *Perform or Else* (2001) use real death-dealing aerial crashes to end their arguments?[16] Why do such violent conclusions occur in books dedicated to the creative factors of performance? Why should these high dramas suit their ethical and political interests? I address these questions to the two books in their historical order, but note now that there are influences flowing between them in the opposite direction, like water running uphill.

As it nears its point of closure McKenzie's book erupts into spectacle through a mesmerising mix of concrete poetry and photo essay.[17] The text suddenly starts to pull apart: layouts fragment, sentences segment, fonts fracture, images hang apparently haphazardly. It is a risky tactic for ending a disquisition about a 'general theory of performance' in the third millennium, especially as little advance warning is given of such a drastic,

[15] A. Walton Litz, Louis Menand and Lawrence Rainey (eds.), *The Cambridge History of Literary Criticism*, vol. VII *Modernism and the New Criticism*, (Cambridge University Press, 2000).

[16] The following analyses the first edition (2002) of *Performance Studies*. The second edition (2006) does not differ substantially in its contents, though some details of presentation are changed. For example, in the last chapter the final image shows the ruins after the twin towers collapsed on 9/11. Page references for *Performance Studies* and *Perform or Else* given in brackets.

[17] I am grateful to Tracy C. Davis for suggesting these stylistic categories.

textually theatrical move. But we shall see that these qualities are highly relevant to how its arguments may operate regarding theatre and performance ecologies. The break-up of the text refracts a technological disaster that is intimately connected to a performance addiction that theatre/performance ecology might best explain.

The layout of the book's earlier chapters holds to all the usual overt conventions of the traditional scholarly monograph: text, headings, illustrations, endnotes, bibliography, index. But their arguments have developed through complex, recursive networks of intertextuality. Then two supple strands of intertwining reference emerge in the final chapter. The first presents high-flying theory via Derrida, Blanchot and Nietzsche, with nods to Latour, Deleuze and others. The second roots for the imaginative, through Conan Doyle's 1911 science fiction, *The Lost World*, featuring the famous Dr Challenger, plus Márcio Souza's 1990 rewrite, *Lost World II*, whose heroine is Jane Challenger, granddaughter to Doyle's hero. Among the meetings with these theoretical and fictional iconoclasts is a surprise encounter with an eminent Marxist historian, Eric Hobsbawm (254). *The Age of Extremes* (1996) situates author Hobsbawm in the future, the better to strengthen perspective on the most violent century in human history. McKenzie has already mimicked this witty expository tactic through his crucial, stunningly emergent concept of 'perfumance'.

This is variously defined as a kind of atmospheric engine of history: it is 'the citational mist of any and all performances', 'the incessant (dis) embodiment-(mis)naming of performance', 'the [chief] ruse of a general theory' (203). So perfumance, nosing out the temper of the times, is a sniff of the future, a potent tracer of emergent historical trends. The last reference in *Perform or Else* to this 'queer idea' occurs on page 271, where for a *second time* the text is presented as spiralling out of control. A shocking repetition, like Clytemnestra's murder of Agamemnon in Aeschylus' *Oresteia* and the many doubled events of violence in later tragedies. But what causes this recurrent spectacular disintegration? Why does typographic trauma keep happening?

Page 272 provides fragments of an answer. The image of a rocket taking off appears alongside a 'printout' recording two voices called 'ONIZUKA' and 'CARTER [a launch technician]'. A footnote references a book by Richard S. Lewis, *Challenger: The Final Voyage*.[18] It prompts recall that McKenzie earlier dissected the US shuttle spacecraft disaster of 1986.

[18] Richard S. Lewis, *Challenger: The Final Voyage* (New York: Columbia University Press, 1988).

seventy-three seconds after lift-off, *Challenger*'s external fuel tank exploded in the Florida sky. With a mile-high flash and a long plunging fall to the sea,the mission ended with the deaths of the Teacher-in-Space and her six companions, with the loss of spaceship *Challenger*, with its twisting smoketrail disintegrating across the upper atmosphere. (141)

On page 271 the typesetting shows the spiralling pattern of that fall, the alphabet in squiggly descent grasping at technology gone dreadfully wrong. Is this an ironic visual pun on the myth of Icarus? If so, the book's final image (274) apparently provides a profoundly disturbing reminder of the risks that Icarus took, as it shows the long vapour trail of the *Challenger* spacecraft as it *rises* on its way to oblivion.[19] As if to dig down through the horrific depths of this surface impression, the flash of ignition on the external fuel tank that caused the crash is shown close-up in colour on the front cover of the book. Do McKenzie's visual uses of tragedy point up its inescapable place in his arguments for the emergence of performance as a new paradigm of knowledge? The end of the spacecraft *Challenger* was first raised early in part II of the book: 'The Age of Global Performance'. Should we infer that 'global performance' is a matter of impending disaster?[20]

Richard Schechner's *Performance Studies* avoids such sophisticated page designs, but it is peppered with many images and typographic boxes. Small grey boxes give potted biographies of artists, theorists, politicians, and brief definitions of concepts. Larger white ones offer quotations from many diverse authors. Its final chapter, for example, has biographies ranging from Homer to George W. Bush; conceptual definitions include 'colonial mimicry', 'living museums', 'anthrax'; plus quotations from theorists and practitioners too diverse to categorise. The rhythm of reading is usurped by typological objects; hurdles placed awkwardly on a racetrack. Quite an effort of will is required to leap over them, or to take them in then go back to reread Schechner's writing in order to work out how these objects might make sense for his arguments. It presents a game of hit-and-miss for the reader, perhaps well tuned to the radical individualism of neo-liberal democratic times.

This final chapter is called 'Global and Intercultural Performance'. Schechner worries at the meaning of orders of such magnitude: 'If globalisation were treated "as" a performance, what kind of performance

[19] 'Apparently' because this is the only image in *Perform or Else* that does not reference a source.
[20] An inference reinforced by the penultimate image in the book that shows: 'Bumper No. 8, a captured German V-2 rocket, lift[ing] off from Cape Canaveral. This rocket exploded in flight, but was the first to lift off from the Cape', p. viii.

would it be?'; 'Is globalisation "good" or "bad"?'; 'Given the volatile global situation, what should artists do?' (227, 230, 269). These are big questions for the closing pages of an introductory textbook. They imply a global future that is radically uncertain. This is an impression strongly reinforced by the last image in a book of many images. It is a full-page picture of the twin towers of the World Trade Center in New York on 11 September 2001, both of them billowing the black smoke of tragedy. The image dramatically arrests the moments of the towers' collapse, so that premonition – the future of the towers is known to all – and extreme violence are unavoidably linked. Are we to infer that 'Global Performance', again, is best pictured by impending disaster? That it indeed has the deepest defects of its qualities?

So my paradological method as applied through a 'surface reading' of the last chapters of both books raises the spectre of ethical and political pessimism, even postmodern nihilism. The high theatricality of their images of accidental and premeditated tragedy maybe fits us out for much larger disasters – such as runaway climate change – looming on the horizon. These model examples of man-made catastrophes make that future look chronically bleak. There is indeed an extremely poor lookout for human survival, a calamity for humanity ahead. But how does this uni-directional prospect fit with a theatre and performance ecology that is frequently ambivalent, often paradoxical? Could another review of these endings through a paradoxology of performance open up outcomes of greater hope? Might it rescue us from the bleakness crisply captured in the Danish proverb: Bad is never good until worse happens?

Thesis 2: beginnings in endings

How to see these disastrous endings through the glass of a brighter paradox? What could lighten the black hole of such seeming dark designs? Picasso claimed: Art is a lie that makes us realise the truth. What artfulness in Schechner and McKenzie's recourse to disasters would realise a positive spin to their conclusions?

One defence of their typo-tactics and provo-pictures could be that they simply make the books livelier for reading. They animate 'performative writing', to adopt Peggy Phelan's idiom. McKenzie's 'Introduction' uses this phrase, specifically referring to his later chapters (25), while Schechner gives a box to the writerly idea (110). The quotation from his (and McKenzie's) erstwhile colleague at New York's Tisch School of Arts insists on textual action tinged with a playful foreboding.

I want this writing to enact the affective force of the performance event again, as it plays itself out in an ongoing temporality made vivid by the psychic process of distortion (repression, fantasy, and the general hubbub of the individual and collective unconscious), and made narrow by the muscular force of political repression in all its mutative violence.[21]

McKenzie is coy about such dynamics in his writing, and Schechner avoids directly admitting a debt to its seductive styles. But both refract the mesmeric vision projected by Phelan. Both books delight in surprising textual conjunctions and resonant images, as if established scholarly styles are dead ends on a route to nowhere, which seems fair enough. They both aspire to the distortions of an artistry that straightens out a truth or two. But what straight-up truths of a political or ethical kind are their writings rooting for?

The first page of *Performance Studies* points towards performative textuality: 'The boxes . . . help *enact* some of the diversity of performance studies' (1, my emphasis). So they advertise a crucial characteristic of the new discipline: the design provides windows on a variegated, fragmented, contradictory domain. Schechner explains they also substitute for the usual scholarly apparatus of 'quotations, citations or notes'. The purpose of this is both personal to the author and mildly combative towards other researchers: 'Ideas are drawn from many sources, but the voice is my own. I hope this gives the reader a smoother ride than many scholarly texts' (1).

The metaphor is intriguing. What kind of vehicle – or animal – will carry us in such comfort across the boundless, slippery and acutely divergent territories opened up by performance studies? The diversity in the boxes surely demands a special adaptability, a multi-terrain wonder, more versatile even than Po-chang's ox. Or perhaps the vision is more elevated and we will somehow fly to the preferred destination. In visual terms, as we saw, that would be the twin towers of the World Trade Center on 9/11. And, from the perspective of a paradological ox, the particulars of the picture may become profoundly telling. The towers are on fire, but standing still, pregnant with the collapse about to come. So the image performs a common paradox: coming events cast their shadow before. If the choice of the picture implies deep pessimism, could it be one lit by the wisdom of well-founded augury?

[21] Schechner quotes from: Peggy Phelan, *Mourning Sex* (London: Routledge, 1997), p. 12. The force of Phelan's final dependent clause gets a piquant inflection from a misprint in the first edition of *Performance Studies*, where 'marrow' replaces 'narrow'. Repression and violence as an essence of the body politic, as it were.

How does the following un-boxed text, the final words of the book, measure up to this implication? The doomed towers prefigure a discussion of the 'volatile global situation' (269). That discussion ends, like an angel after an alternative immaculate conception, by circling the notion of 'cultural purity'. Reflecting on 'global performance', Schechner writes:

> there is no such thing as cultural purity. All cultural practices – from religion and the arts to cooking, dress, and language – are hybrids. Cultural purity is a dangerous construction because it leads to monoculture, racism, jingoism, and xenophobia. The 'natural' proclivity of humankind is promiscuity – which results in an always changing, if sometimes unsettling, diversity. The work of performance studies is to explore, understand, promote, and enjoy this diversity. (270)

A complicated passage, first denying a vector that it sees as a force in the world, then weaving an ethic out of opposite qualities which attach to it – purity and hybridity, xenophobia and promiscuity, monoculture and diversity – before dismantling the binaries by its double emphasis on diversity. As if a combative certainty based on clear ideas of right and wrong – the kind of conviction that constructs both sides in a global war on terror, say – can be made spectral by a playful vision of infinite difference.

This concluding argument about performance studies seems to forge a bond between the new discipline and the healthy, pluralistic liberalism of postmodernity. A 'live and let live' philosophy is the *modus vivendi*. An innate proclivity for promiscuity is the most likely fount for this in humankind. As the wise vegetarian G. B. Shaw said: The golden rule is that there are no golden rules. But Schechner does not quite fully embrace such paradoxical wisdom. The scare quotes around 'natural' indicate that promiscuity cannot go unqualified, but then it is made defective, unnatural. Despite all, something is wrong with it. Hence the argument balks at an erosion of the nature–culture binary – an ecological rebirth for humans? – as a route into 'healthy', i.e. unqualified, diversity. The moment of sensing performance as a wholly integral part of messy global performance ecologies passes, and an anthropomorphic vision of diversity defined by human 'promiscuity' is all that remains. The motorbike mechanic Robert Pirsig's nicest irony springs to mind: How to paint a perfect painting – make yourself perfect then just paint naturally.

The final pages of *Perform or Else* are much more subtly oblique about positive value in performance, ecological or otherwise. As we saw, they celebrate theoretical and fictional genealogies allied to postmodernism and poststructuralism, but still lead inexorably to the graphic mimicking of the *Challenger* disaster. The last words of the book – 'She was gone' – refer to the disappearance or death of 'disastronaut' Jane Challenger, and the

gloominess is fabulously magnified through a link to extreme ecological crisis, already overtly referenced via a quotation from Souza's *Lost World II* (251–2). A footnote explains that 'She was gone' also refers to the Mother Earth of Conan Doyle's short story 'When the Earth Screamed' (289). Thus the disastronaut's disaster turns into an indirect ecological warning of possibly much worse to come.

These contrasting types of doom – the human and the natural – need to be viewed through the frame of the penultimate gnomic sentence in the book: 'The handle was clicked to number eight' (274). That number figures earlier in the typo-fractured pages, but turned on its side to produce the mathematical symbol for infinity: ∞ (264). The 'handle' that ensures 'she was gone' may not imply just disaster, but also possibly points to eternity. Perhaps this offers a symbolic survival of the human beyond global ecological catastrophe? Or maybe it makes disaster and survival coterminous, the end as a beginning? Is this interpretation a grasping at straws, a self-deluding subtlety that makes my paradology a suitable target for Tom Stoppard's wry comment: 'Eternity's a terrible thought. I mean, where's it going to end?'[22] But, given some truth in this pessimistic witticism, maybe it is not overly pedantic (I wrote, pedantically) to note the paradox produced by the sign for infinity is another version of the not-quite-paradox that McKenzie states is crucial to his whole project. We are here back to the opening of the book's Acknowledgements: that performance can be read as both experimental and normative, risky and reassuring.

Just before the final pages fragment, this opening statement matures into the central paradox of his theory of performance paradigms:

Liminality, disintegration, diversification, fragmentation: while these may harbor forces of resistance and mutation, they may also carry forces of reaction and normalisation ... The paradox: fragmentation can become an identity, disintegration can serve an integrating function. (254)

This reminds us that catastrophe can be positive. The worst that can happen sometimes carries seeds of hope – no guarantees, but a possibility. So there is more than pessimism in the disaster that ends Jon McKenzie's book. It indicates a far-reaching regenerative process that resonates with the fundamentals of ecology, however conceived. The technological Icarus of *Challenger* can also be a philosophical phoenix full of rising promise. That it takes my paradological method to arrive at this point

[22] Tom Stoppard, *Rosencrantz and Guildenstern Are Dead* (London: Faber and Faber, 1968), p. 5.

should by now, I hope, come as no surprise. If paradox is possibly the *sine qua non* of performance, and of its place in ecology more generally, we must engage with such sophistication through paradoxology. Art lies in concealing art.

So I offer clarification of the interdependence of despair and hope in McKenzie's general theory of performance through another quotation, this time a visual one. The quotation references both vicious circles and infinity. The ouroboros, the snake swallowing its own tale, is the prototype of vicious circles – like a challenge that always involves a crash. Note that the switch from ouroboros to infinity between these images is an invisible act of performance. Hey presto! A simple twist in the endless tail enacts a transformation from an evil aggravated by its own consequences to a suggestion of eternal survival against all odds.[23]

STEPS TO A PARADOXOLOGY

Interregnum: notes on paradoxology

So my search through the conclusions of *Perform or Else* and *Performance Studies* for depth in surfaces and beginnings in endings produces ambivalent results. But, of course, this could be the product of my method – close observation simply projecting the angle of the observer on the matter observed. The results are *my* problem, not those of the *texts*. Hence a paradoxology of performance, like quantum physics, must turn the reflexivity of its method back on itself. But then we would be faced by the paradox of a reflexivity that, like the territory traversed by Po-chang's ox, knows no bounds. Trapped for ever in the tropes of the boundlessness of performance studies, with the added aggravation that we've just complexly confirmed that there's no way to get a perspective, ecological or otherwise, on its ethical and political values!

I am not being flippant. A 'discipline' that presents itself as limitless raises questions of research method which call for deeply recursive ways of figuring answers. An ironically paradoxical analogy can reillustrate the point. Playwright Arthur Schnitzler remembers the familiar figure of a man who remembers the whole of his life in detail at the moment of his dying. So part of the act of remembering must be the memory of remembering a whole life in the dying moment, and so on *ad infinitum*.

[23] Hughes and Brecht, *Vicious Circles and Infinity*, figures 11 and 12.

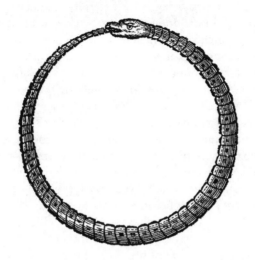

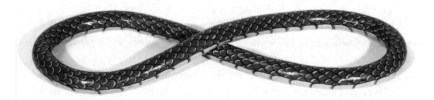

Figure 6 An ancient image of Ouroboros plus *Endless Snake* – 1969 – by Patrick Hughes.
From vicious circle to infinity as the snake devours its own head.

Schnitzler concludes that 'dying is itself eternity, and hence, in accordance with the theory of limits, one may approach death but can never reach it'.[24] John Cage reached a similar conclusion when asked whether he thought there was more than enough pain in the world. He said: I think there's just the right amount.[25] Move into the vicinity of strong paradoxes and this is what you end up with: self-reflexivity trapped forever in a vicious circularity. Neither use nor ornament for anyone, it seems, except maybe logic-chopping philosophers. But if there were any way out of these crucifying conundrums that did not altogether rubbish them then that would be ecologically significant. It might, for example, provide clues to how the vicious circularity of the double binds producing global performance addiction might be resolved, maybe showing how theatre and performance ecology might become routes to greater ecological sanity.

Obviously this is very complicated territory. But a claim that has become something of a basic tenet of performance studies might offer a way forward, as it is a version of this type of paradox. It appears in Peggy Phelan's *Unmarked*:

Performance's only life is in the present. Performance cannot be saved, documented or otherwise participate in the circulation of representations *of* representations: once it does so, it becomes something other than performance ... Performance's being ... becomes itself through disappearance.[26]

This is the doctrine of performance ephemerality that we questioned in the previous chapter, like asking if water can run uphill. Now, exploring the realms of paradoxology further, let's pursue this doubt by reversing Phelan's dictum to test its potential 'truth' values. So: disappearance becomes itself through being performance. We can then deduce that, in this universe of discourse, *performance is disappearance*. And vice versa. Hence, this version of the 'object' of performance studies (the *unrepeatable* performance 'itself') is not just a matter of the magic of paradoxical proof (now you see it, now you don't) but also a matter of faith: now you see it *because* you don't. If you turn on the light quickly enough you can see what the dark looks like. And how paradoxical is that?

Conversely, this paradoxical state of affairs also can be accessed through more time-based, processual versions of performance, which lay emphasis on its repeatability: for example, from Schechner's notion of

[24] Arthur Schnitzler, *Flight into Darkness*, trans. William A. Drake (New York: Simon and Schuster, 1931); quoted by Hughes and Brecht, *Vicious Circles and Infinity*, p. 16.
[25] John Cage, *Silence: Lectures and Writings* (Cambridge, Mass.: MIT, 1966), p. 93.
[26] Peggy Phelan, *Unmarked: The Politics of Performance* (London: Routledge, 1993), p. 146.

'twice-behaved behaviour' (28–9), through Judith Butler's interest in 'reiteration', to McKenzie's stress on 'citationality' (258), and a spectrum of ideas about performances' recombinant possibilities in many other discussions of 'performativity'.[27] Let us take leaves from these texts and rephrase Phelan's nostrum as follows: 'Performance's being ... becomes itself through reappearance.' A similar riff to that in the last paragraph can be played from this formulation. Reappearance becomes itself through being performance; so *performance is reappearance*. Hence, this further version of the 'object' of performance studies (the *repeatable* performance 'itself') is not just a matter of the magic of paradoxical proof (again you see it, again you don't) but also a matter of faith: again you see it *because* you didn't. If you switch to darkness quickly enough you can see what the light looks like. And how – doubly – paradoxical is that?

The doubled paradoxical 'nature' of 'performance' produced here, like the vectors that cause water to run uphill, is a matter of context, or rather, of environment. Hence water *can* run uphill when on a surface that is (a) hot enough to turn it into steam, and (b) grooved in a particular pattern. This has been proven empirically.[28] The 'environment' of the formulations derived above is one of doubled reflexivity, as in Schnitzler's memory of the memories of the memories of a drowning man. Approaching such contradictions through the conditions of their reproduction – the making of strong paradoxes – may enable insight into truths that, as it were, override binaries without denying them. Hence a paradoxology may provide 'environments' for thought-experimental equivalents to water running uphill, revealing qualities that are foundational to any insights to be derived through performance ecology.

Still astride Po-Chang's ox, let's explore this environment a little more thoroughly. In the context of this writing as an attempt to establish the floating foundations of a paradoxology of performance we might risk the formulation of a further strong paradox or two. These can couple the contradictions explicated in the last three paragraphs to reinforce the paradoxes arising from them. First, here is the main contradiction:

(a) performance is disappearance, that is to say, unquestionably ephemeral.
(b) performance is reappearance, that is to say, unquestionably durable.

[27] Judith Butler, *Bodies that Matter: On the Discursive Limits of 'Sex'*, (London: Routledge, 1993), p. 94; see also, for example: Andrew Parker and Eve Kosovsky Sedgwick (eds.), *Performativity and Performance* (London: Routledge, 1995); Dolan, *Geographies of Learning*, 2001; Jackson, *Professing Performance*, 2004.

[28] BBC News Online: news.bbc.co.uk/2/hi/science/nature/4955398.stm (05.09.2006).

These can be compounded into a single contradiction:

(c) performance is unquestionably both ephemeral and durable.

Which can then be rendered as doubly reflexive paradoxes:

(d) performance always endures its ephemerality.
 cf. Only the ephemeral is of lasting value: Ionesco.
(e) the endurance of performance is always ephemeral.
 cf. It is in changing that things find repose: Heraclitus.

Second, the 'truth values' of these doubled paradoxes may be reinforced through further associated paradoxes of performance. Regarding this particular paradoxology it is satisfying to quote again that great devotee of paradox in performance, John Cage, who said: I'm saying nothing and I'm saying it. And for other performances Cage's insight can adapt to produce similar truths about embodied absence/presence: I'm doing nothing and I'm doing it. Or about virtual inaction/action: I'm going nowhere and I'm getting there. And so on. Samuel Beckett, of course, captured all this brilliantly in the ending of *Waiting for Godot*:

> VLADAMIR: Well? Shall we go?
> ESTRAGON: Yes, let's go.
> *They do not move.*[29]

And so, on.

This is not just wordplay or idle catachresis. The status of a discipline traditionally hangs on its ability to render convincing statements about experience in/of the world, in whatever language is appropriate. For example, classical logic evolved as a means of determining the conditions of mutually exclusive truth and falsity for statements, which is why paradoxes are so challenging to its system. This is because they are simultaneously impossibly both true and false, yet they also seem to carry at least a grain of truth 'above and beyond' contradiction. They are contradictions that seem to be true.

Classical logic would challenge the paradoxes I derived from Peggy Phelan's maxim on the grounds that statements cannot be both true and false at the same time. But from another perspective on logic, which philosophy calls 'dialetheism', that problem does not look so disastrous for truth. Dialetheism aims to relieve us of the anxiety of paradox by

[29] Samuel Beckett, *Waiting for Godot* (London: Faber and Faber, 1959), p. 94.

arguing that some statements *logically* can be true and false at the same time.[30] It bases this claim on the rules of classical logic itself, which it uses to show that if a statement is both true and false, then its negation can be both true and false. This opens up the way for recognition of the power of paradoxical truths.

The technical intricacies of the 'paraconsistent' system developed by dialetheism provide counterintuitive, *logical* support for the truths of paradoxes that are foundational to performance theory. This appears, for example, in how such theory defines performance through contradictory elements: it is simultaneously 'real' and 'not real'; a performer in role is both not-herself and not-not-herself;[31] performance 'itself' is limited and infinite (McKenzie: 261). This last clearly rests on the paradox that *repetition ensures the ephemerality of performance*. This chimes with Derrida's clarification of Austin's theory of performativity:

For ... is not what Austin excludes as anomalous, exceptional, 'non-serious', that is *citation* (on the stage, in a poem, or in a soliloquy), the determined modification of a general citationality – or rather, a general iterability – without which there would not even be a 'successful' performative? Such that – a paradoxical but inevitable consequence – a successful performative is necessarily an 'impure' performative ...[32]

If staged performance is 'impure' because it is a repetition of ephemerality then so are all other kinds of performance. Or, to mangle Oscar Wilde a little: Life perfectly imitates art's imperfections.[33] And vice versa.

Such paradoxical qualities inevitably inflect the discourses of performance studies because it is always teetering on the slippery edge between the live event and its mnemonic traces, between the 'real' and its 'representation'. This uncertain, ambiguous realm is where the 'essential' qualities of performance itself flourish: ephemeral, evanescent, refractory, ineffable, enduring, substantial, accessible, intelligible, efficacious and so on. Which is why, at the especially volatile start of the third millennium, the ethico-political values of performance studies are so hard to specify directly. But,

[30] Doris Orlin, *Paradox* (Chesham: Acumen, 2003), pp. 21–36. Philosopher Graham Priest pioneered dialetheism in the twentieth century, see: *In Contradiction: A Study of the Transconsistent* (Dordrecht: Nijhoff, 1987).

[31] Richard Schechner, *Performative Circumstances from the Avant Garde to Ramlila* (Calcutta: Seagull Books, 1983), pp. 94–5.

[32] Jacques Derrida, 'Signature Event Context', in *A Derrida Reader: Between the Blinds*, ed. Peggy Kamuf (Hemel Hempstead: Harvester Wheatsheaf 1991), p. 103. Schechner box-quotes this passage in his chapter on 'Performativity' (111). McKenzie references it in noting the differing treatment of interability as between Austin and Derrida (213).

[33] Life imitates art far more than art imitates life. Oscar Wilde.

ironically, you can safely bet your best philosophical flip-flops that its greatest challenges will be surfing on the emergent in the new world order/ disorder.

This is the spectacle that emerges from focusing on the superficial at the ends of *Performance Studies* and *Perform of Else*. We should not be surprised it features highly contrasting, contradictory, paradoxical intimations of their ethical and political tendencies. One anthropomorphically evades an ethics and politics that refract ecological principles, the other embraces that potential only obliquely and tentatively. So is that the best a so-called paradoxology of performance can come up with through engaging such slippery strata? Exposing contradictions, playing with paradoxes. Like twice-behaved behaviour about the impossibility of twice-behaved behaviour? Thanks Po-chang!

Yet dialetheism still urges a little more riding. Because it aims not just to counter the scepticism of classical logic in face of paradox, but also insists that even the strongest, most recursive paradoxes are amenable to its proofs. So despite the doubts of some logicians about its arguments let us take our paradoxology into even more spectral realms in a search for some overriding truths in the paradoxes of performance.[34] Let's set our sights on the most emergent edges of the two texts' encounters with the emergence of new ethical and political imperatives in the twenty-first century, and especially its impact on Earth's biosphere. As those imperatives are both locally and globally spectral, we need an acute insight to steer our quest, something like Foucault's: All modern thought is permeated by the idea of thinking the unthinkable. So, where do these texts show evidence of thinking the unthinkable? Why, at the margins of coherence in their performance analyses! In the paradoxes they produced as they slid towards the verities of performance addiction. The new age of ecology! When humanity threatened ecological devastation of the Earth.

PART 2: PARADOXES IN TEXTUAL PERFORMANCES

Neither *Perform or Else* nor *Performance Studies* has 'paradox' it its index. Yet Schechner prefaces his Preface with Heraclitus – 'Whoever cannot seek the unforeseen sees nothing, for the known way is an impasse' (ix) – and McKenzie's Acknowledgements open with 'Buried deep within the

[34] Orlin, *Paradox*, pp. 34–6. See also: Patrick Grim, *The Incomplete Universe* (London: MIT Press, 1991), p. 258; R. M. Sainsbury, *Paradoxes* (Cambridge University Press, 1995), esp. chapter 6; Roy Sorenson, *A Brief History of the Paradox: Philosophy and the Labyrinths of the Mind* (Oxford University Press, 2005), pp. 112–15.

writing of this text there lies a paradox *of sorts*' (ix – my emphasis). He is correct to be cautious about what he calls the 'kernel' of his book – ' "Performance" can be read as both experimentation and normativity' (ix) – as it is not quite a paradox. Heraclitus, though, captures the same idea in a proper paradox: It is in changing that things find repose. In other words, experiment seeds the norm to come.

The prominence of paradox in these texts rests in the fact that it is a crucial feature in the nature of performance. So to detect their basic politico-ethical values requires that we 'seek the unforeseen' and the 'experimental', taking a sharp squint at their *emergent* concepts. Particularly relevant will be ideas about performance as dynamically engaged with power, both logically as a feature of their arguments and historically as a potential force for change in the world. For *Perform or Else* this is as easy as falling off a well-oiled ox. Its neologism 'perfumance', as we have briefly seen, is obviously at the forensic cutting-edge of its general theory. For *Performance Studies* this exercise is harder. Its writing reflects a vision of performance as promiscuous, so its concepts often appear as blurry hybrids, both obvious and opaque.[35] However, Schechner's notion of 'dark play' may be homologous to McKenzie's 'perfumance'. If so, my paradoxology will pinpoint homology as a principle of textual exegesis in the ecologies of theatre and performance.

Essential to recognise, though, that we are heading for extra-spectral terrain, a place of mirrors within mirrors, where not only nothing is exactly what it seems – a falsehood – but also everything seems exactly what it is – a truth. So, reader be warned, we shall be picking at pretty knotty stuff to get an untangled line on such refractoriness.

Thesis 1: truth in contradictions

For McKenzie 'perfumance' is ' . . . an atmosphere of forces and intensities . . . the outside of the performance stratum' (25). Somehow that 'atmosphere' always threatens to undermine the normative 'formations' that the repetitions of socio-cultural performance generate as histories, such as, say, the interlocking identities of nation, race and gender in

[35] 'My writings usually exist in versions or variants. My writing isn't finishable. My strategy is to rehearse, rework, revise. I publish at various stages of working, not being too neat about precisely when a constellation of ideas gets into print.' Richard Schechner, *The Future of Ritual* (London: Methuen, 1993), p. viii.

nineteenth-century colonialism. Listen carefully: 'Perfumative resistance . . . destabilises . . . formation[s] through pockets of iterability, self-referential holes [that] are located not only at the limits of social formations but also at their very core' (25). So for McKenzie what seems crucial to historical process is not just the iterations of citationality – or Butler's reiterations of performatives; or Schechner's twice-behaved behaviour – that work to create the 'normal world', but also some other form of self-referentiality which produces a *resistant or radical* strain of performance. It is this 'other' self-referentiality that implies an especially critical edge to the operations of perfumance. It works through contradiction to produce a truth or two.

Hence the descriptions of perfumance in *Perform or Else* emphasise it as unbiddable or especially awkward. But to detect any more specific values it may carry we need to follow McKenzie's lead, to sniff out any other self-referential qualities that it attracts. Two concepts very close to per-fumance in this sense are 'autopoesis' and 'catechresis'. Though complex, they need not detain us long as their functions in the general theory are presented with admirable lucidity. McKenzie explains that in 'chaos theory, the *self-organisation of systems* within chaotic milieus is often called autopoeisis' (200 – my emphasis). He then draws on Félix Guattari's imagistic contrast between normalising structures and a 'machine . . . shaped by a desire for abolition'[36] to produce a paradoxical definition of autopoesis as 'a recurrent passage with no guarantee of return' (200). By this he seems to mean the ways in which '[s]tructural systems may attempt to master difference, but self-referential incorporation opens them to catastrophe' (201). The pearl oyster is a good example of this process as its successful response to one invader – a piece of grit – literally opens it to catastrophe in the form of a second, the human oyster-pearl harvester.

Thus 'autopoesis' encompasses both the provisional stability and the potential chaos of all systems, including, of course, ecosystems. Forces for resistant change may be incorporated in host systems as they generate their normative structures (grit becomes a pearl); but also the same forces, in other structures, can bring about further structures for radical change (a gritty grindstone hones the oyster knife); and different resistant forces in those other structures can create catastrophically radical effects (the clamped shell rejects the knife which slices an artery in the harvester's wrist). In any event, radical change is effected by more or less disruptive

[36] Félix Guattari, *Chaosmosis: An Ethico-aesthetic Paradigm*, trans. Paul Bains and Julian Pefanis (Sydney: Power Publications, 1995), p. 37.

transformations of normative structures – so there's nothing much new there! Such encounters provide the basic conditions through which per-formance–perfumance may operate simultaneously as contradictory sta-bilising and destabilising factors in the creation of value. But are those crucial differences in effect produced because *performance* can be 'read' in these contradictory ways, as McKenzie's not-quite opening paradox says? Or does the pong of *perfumance* attract a less ambivalent politico-ethical gloss, a kind of innate 'taste' for radicalism, or maybe a greater para-doxical 'truth'?

To nose this out we need to get downwind of 'catachresis', McKenzie's other key example of autopoesis, which he defines as 'the misuse of words: as a: the use of the wrong word for the context, b: the use of a forced figure of speech, esp. . . . strong paradox' (210–1). Let's fix on the moment where he breathes new life, as it were, into catachresis through another neologism.

the catachrestics practiced by Derrida and Butler highlight the social efficacy of what many have dismissed as mere frivolity and wordplay . . . Puns, acronyms, anagrams, numerologies, alliterations, rebuses . . . In our ruse of a general the-ory, the strategy of what I will call *catachristening* (catastrophic naming) engages the interminable death and birth of performative referentiality . . . (212)

So the non-sense of paradoxes, say, can be socially (therefore also ethically and politically) efficacious, not just as provocative mind-fodder but also through some profoundly engaging process that touches directly on matters of life and death: catachristening. Not surprising, then, that McKenzie's next sentence feels like it would have needed a very deep breath to write: 'The name becomes an event: catachristening is the detonation of discursive alterity through holes of autopoetic self-referentiality' (212). Phew! But here comes the pay-off from the pong – in the theatrical sense, of course[37] – produced in those holes: 'Its catastrophic effects register the inherent ability of performatives to fail and misfire, and, in misfiring, to link up with other referents, other contents, other performances' (212). This statement emphasises processes ('link up') through a mixing of metaphors.[38] But the qualities of radically transformative performance as McKenzie sees them through 'perfumance' seem clear enough: 'fail and misfire', 'detonation', 'catastrophic'.

[37] Martin Harrison assigns two meanings to 'pong': 'to *pad out* in both its senses of *ad libbing* to cover for forgotten lines and extending a role by supplying extra lines'; in *The Language of Theatre*, rev. edn (London: Carcanet, 1998), p. 201.

[38] 'Misfire' is what guns or engines do, while 'link up' is what chains or phone-lines achieve.

So here apparently is a vision of ethical or political change through performance as more-or-less accidental disaster, in which perfumance garners feedback always already tainted by fear or despair born of catastrophe. As if the playfulness of any performance that offers positively resistant or radical 'social efficacy' is always bound to turn sour, like a children's picnic in the shadow of nuclear missiles with their warheads ready to go.[39] Or whatever the hopes carried by future *Challengers* they will *always* be piloted by disastronauts. In this general theory, does performance automatically operate like a free radical in molecular physics, attacking the DNA of history to produce ethical and/or political carcinogens and cancers?

From this perspective 'perfumance' is true to its contradictory nature, for any 'positive' historical truth it reveals as a force for change – reduction in world warfare or poverty or greenhouse gases – will also be false because it cannot happen without a 'negative' effect in violence and suffering of some kinds. Then would my paradoxology be unfair in placing this powerful theory of performance in the politico-ethical tradition of Dwight D. Eisenhower, who famously claimed: We are going to have peace even if we have to fight for it?

Thesis 2: presence in absences

A similar deadly serious quip can be made for intertextuality's potential yield in my paradological method: We are going to have homologies between texts even if we have to coin them! How else could we be sure to hear Schechner and McKenzie's theories singing discordant descants? So now the principles in my choice of books come most forcefully into play, where the defects of their qualities may emerge most starkly as they think the unthinkable of the twenty-first century. I begin by looking for presence in the absences of *Performance Studies*.

Schechner's chapter 5 opens with 'performativity is everywhere' (110). He frames this claim with boxed quotations from the usual suspects (Austin, Searle, Derrida, et al.), so his view of *how* performativity is so pervasive is potentially of major consequence.

In performativity, the 'as if' consists of constructed social realities – gender, race, what have you – all of which are provisional, are 'made up.' At another level, performativity is a pervasive mood or feeling – belonging not so much to the

[39] The image is from Martin Amis, *Einstein's Monsters* (Harmondsworth: Penguin, 1988), p. 18.

visual–aural realm (as performances do) but to the senses of smell, taste, and touch. 'I smell something funny going on' ... (142)

So 'mood or feeling' is the principal operative distributor. This down-plays the productivity of performatives in creating normative identities and admits realities beyond the social and human into the world. In this regard, Schechner's performativity seems to follow yet exceed McKenzie's perfumance as it becomes an environmental agent, 'something ... going on' over and above what the human animal might have 'made up'. By contrast, in *Perform of Else* perfumance is paradoxically both more evasive and pervasive than this, because it is pictured as always already engaged, however unpredictably, with the strata of performance and therefore ultimately always with human 'history'.

But 'performativity' is not the closest Schechner gets to 'perfumance', despite their seeming almost identical. Unlike, say, 'twice-behaved behaviour', he did not coin the term. Neither does he overtly link it to ethics or politics; quite the contrary, as we have just seen. The nearest he gets to *that*, ironically, is in chapter 4 on 'Play'. There he argues that play constitutes 'ways of establishing autonomous social orders and hierarch-ies, of exploring or exploding the limits of power' (108). That is from the chapter's final section, which focuses on 'dark play', a phrase Schechner invented in 1987 and first presented publicly in an inaugural address to the American-based Association for the Study of Play.[40]

'Dark play' derives from anthropologist Clifford Geertz's development of Jeremy Bentham's notion of 'deep play'.[41] Schechner starts with Geertz's definition: playful activity that 'amounts to a life-and-death struggle expressing not only personal commitment ... but cultural values' (106). He takes this on a step by arguing that 'dark play' is produced through 'games' in which not all the participants know the rules or even that a game is being played. Hence 'dark play is truly subversive ... [its] goals are deceit, disruption, excess, and gratification' (107). Examples of dark play involving adults are provided, but the crux of the discussion focuses on children. The key passage imagines them using dark play as a means of 'resisting the adult world that apparently so dominates them', and specu-lates that 'Some ... grow up to be spies, police, colonels, conmen and crooks – all with *sensible reasons* for making dark play' (108 – my emphasis).

[40] Schechner, *Future of Ritual*, p. viii; Website – The Association for the Study of Play (TASP): www.csuchico.edu/kine/tasp/ (03.06.2007).
[41] Clifford Geertz, 'Deep Play: Notes on the Balinese Cockfight', in *The Interpretation of Cultures* (London: Fontana, 1993 [1973]).

In the previous chapter Schechner has argued that social stability is achieved through evolutionary or genetically driven ritual, which is inherent for homo sapiens because 'Human ritual is a continuation and elaboration of animal ritual' (77). His vision of dark play strengthens this phylogenetic line through the parade of figures linking power and violence (physical, perceptual, ethical and so on) as an outcome of human maturation. At several points *Performance Studies* indicates clear distaste for such power, signalled above in the faint irony of 'sensible reasons'. But Schechner of course recognises the double-edged nature of dark play. It reinforces the powers that be just as it can subvert them, and often – always? – there is an horrifying pleasure in its processes. In dark play, 'dancing on the edge, one leaves behind the mundane, hears it screaming and begging, and soars into a realm of spirituality . . . There is something excitingly liberating about this kind of playing . . . More than a few have died on a dare' (109).[42] This makes the mundane into a 'victim' of a 'spirituality' that is linked with death and points up a fabulous ambivalence towards the ethical and political factors of performance. It would seem that, in this thinking of the unthinkable through performance, seeing a presence through absence, there is no gain without pain. Or as Pyrrhus more darkly said: Another victory like that and we are done for.

The force of this paradox is further reinforced by Schechner's coupling of dark play with 'the feelings of being caught in the toils of fate or chance' (106). There is an appeal to inevitability in these particular processes of performance, giving them the qualities of perfumance in McKenzie's theory: unavoidable challenge, disruption, violence, catastrophe. But is there in *Performance Studies* an equivalent to 'catachristening' that would clarify still more the political and ethical values in its views on the nature of performativity and performance? We have noted that several times Schechner explicitly associates performance studies with anti-capitalist global movements. But at this ethical and political crux in his analysis the implications of inevitable violence raised by ritual and dark play are not subject to the reflexivity that comes with catechristening. On this point there is a remarkably tactful absence in Schechner's theorising of performance studies.

Like all absences, this one is difficult to grasp. But the publication year of *Performance Studies* and the placement of the image of the burning

[42] The gendering of dark play through example in *Performance Studies* is interesting; three of the four dark-play stories quoted are by women (108).

twin towers suggest its qualities. As does an utterly stunning example of dark play's subversive potential:

wherever the eyes of authority gaze down on them – kids find ways around the rules ... They form clubs, gangs, and cliques. They even develop careful strategies in order to shoot up a school.

All these activities – the pleasant, the provocative, and the terrifying – can be understood as playing, as ways of establishing autonomous social orders and hierarchies, as exploring or exploding the limits of power ... (108)

Given the clear qualities of 'these activities', it is remarkable that the list of dark players that ends this sentence – spies, police, colonels, conmen and crooks – omits the terrorist. The Columbine School massacre becomes a 'shoot up'; the Oklahoma City bombing is not mentioned. But in the United States of America, in 2002, perhaps this is as close as one dared get to the kinds of overriding truths in which a paradoxology must try to engage. 'Remember', says one of N. F. Simpson's characters, 'to them it is us who are the enemy'.

On paradoxes and paradigms

Let me make it absolutely clear that I am not condoning terrorism. While I might deplore fundamentalist beliefs, religious or otherwise, I would defend people's rights to hold them. At the same time, I think no one has a right to impose any beliefs on others. My paradoxology creates an analytical system that aims to engage with the contradictions produced in practice by ethical and political complexity. So it will sometimes create uncomfortable results, such as the possibly jaundiced views of *Performance Studies* and *Perform or Else*'s political and ethical orientations arrived at above. But – I admit it – perhaps my approach suffers from a fatal flaw, because its interpretations derive from what is *not* directly asserted in the texts. My paradological method here, at best, is a kind of inverted guesswork. Yet if performance studies teaches us anything crucial about performance, textual or not, it is that performance always means more than it intends. If you think you've seen everything, look again. Ironically, sniffing out such meanings is part of the licence that perfumance grants the nosy textual detective.

One obvious objection to this method of deriving values from the absences in texts is that its findings – about 'catastrophe', about 'fate' in dark play and so on – are not indicators of an ethics or a politics but simply responses to reliable rhetorical gestures. They mis-take performatives aimed just at livening-up more mundane truths, i.e. that the more complex a

performance-system – *Challenger* spacecraft had 'over one million parts' (144) – the more unpredictable the precise nature of its potential futures. Such textual gestures are just a glittery surface that invites us into the truer depths of an argument. But a paradoxology – in line with Derrida's teaching – gives the lie to the convention of treating texts as archaeological sites. What you get is what you see, however hard or obliquely one looks. Or, as Marshall McCluhan more pithily put it: The medium is the massage.[43] Textuality's depth is always on the surface. Its presence lies in absence. Such paradoxes direct analysis towards *fugitive*, always *provisional* general truths because their 'true contradictions' prompt a doubly reflexive awareness, a questioning of one's own reflexivities.

This is why I suggest that the arguments of *Perform or Else* and *Performance Studies* are crucially informed by some of the constitutive paradoxes of performance in the performative societies. So from my perspective their *relative* lack of explicit address of ecology and its relevance to performance is curious indeed. Yet that, paradoxically, makes them both potentially paradigmatic in the limitations of the paradigms they propose, as well as influential attractors for performance studies as a whole. This is why it is so important to locate how their politico-ethical values relate to the specifics of early twenty-first century 'history' – 9/11 and all that. What are they saying through their near silence regarding the practical implications of their thinking for a third-millennium future that, from an ecological point of view, is anything but promising?

It is such seeming reluctance to become overtly reflexive about its own reflexivity that admits ethical and political lacunae into the historical analysis of *Performance Studies*. So its closing celebration of diversity is unqualified by any explicit address to the question of diversity for whom or what in the preceding 269 pages. Diversity becomes a generalised universal good. Paradoxically, then, a highly specific geo-political absence flourishes with this strategy, as it appears to cede to the United States of America's neo-liberal democracy as a global norm, simply because its author is a citizen of that country. Similarly, despite reiterated claims to anti-capitalism, the book nowhere offers a serious critique of liberal democracy's burgeoning addiction to global capital. In its absence, ecological crisis starts to look like the unchangeable given of a messed-up 'human nature'.

[43] Marshall McCluhan and Quentin Fiore, *The Medium is the Massage: An Inventory of Effects* (New York: Bantam, 1967).

Hindsight cruelly highlights such reflexive deficits in the only section of the book that deals directly with politics, under the heading of the 'problems of poststructualism' (129–30). Diversity is stressed as a 'success' of poststructuralism, though an appropriate historical doubt is voiced:

> be careful about confusing 'tolerance' and 'good management' [of diversity] with actual change. In the United States, at least, the diversity of behaviour and opinion has not yet been tested against a serious economic recession or depression. Not to mention large-scale war. (130)

The post-9/11 'war on terror' is referenced in the final chapter of the book, as is the 2001 bombing of Afghanistan (267). The 2003 US/UK attack on Iraq added another key point to the global 'axes of evil' engaged in a war that could never be won because the 'enemy' is by definition, at least in some part, invisible. When such a new global paradigm meets the performance paradigm that fostered it, there is bound to be an inconceivable disturbance. So it is saddening that *Performance Studies*, despite its overt alignment with radical philosophies, appears finally to embrace the capitalist–democratic–technological global fix. This reflects its lack of a sufficiently reflexive take on 'performance studies' as a possible symptom of that wider ethical and political pathology.

The greater levels of generalisation in the argument of *Perform or Else* make its interpretation of emergent history at the millennium's turn even less transparent. But still there is ethical and political force in its core insights, such as the processes through which 'norms become mutant [and] mutations become normative'. Hence, its witty realisation of: 'The paradox: fragmentation can become identity, disintegration can serve an integrating function' (254). That in turn leads to stimulating guesses about the paradoxical characteristics of third-millennium futures: 'Infinite finitude, recombinant diversity, unlimited permutation of limited components, these are the modes of being emitted from the future' (261). How's that for a quality profile of cyberspace and its contents; or, for that matter, of invisible enemies? The book also offers an acute sensitivity to the fragility of such paradoxical truths in a world that might crash, ecologically or otherwise, just as momentously as the *Challenger* space-craft did.

It is remarkable, then, that the application of these insights to the twenty-first century is not carried through *as* paradox, but as a sniff of implied progress followed by catastrophe. McKenzie even seems to essay a modernist extension: 'On this emergent formation, the biology of organisms is displaced by the biochemistry of genetics, the industrial

economics of coal and steel give way to the information economy of silicon technologies, the linguistic signifiers disperse in literary agrammaticalities' (261). Thankfully the argument pulls back from this hint of teleological quiescence, but only to plunge up like *Challenger* into a vision of a global future going badly wrong, leaving just a vapour trail of warnings behind. Even McKenzie's figment-hero of the performance paradigm may be sucked into the strange scenarios of twenty-first-century disaster. 'In short, is Nietzsche's superman falling victim to an all-too-American faith in "good performance" and his futural promise coming to pass as the age of global performance?' (263).

And it is at this point that the text on the page really starts to pull apart: layouts fragment, sentences segment, fonts fracture, images hang every which way with no apparent spatial logic between them. 'What then', said Nietzsche, 'in the last resort are the truths of mankind? They are the *irrefutable* errors of mankind.'

Postscript

So in divergent but homologous ways, what seems most to be *risked* by *Perform or Else* and *Performance Studies* is a significant ontologic–historical bet against the survival of hope in the third millennium. Hence, perhaps, the paradox of pleasurable horror that haunts the refreshed 'grand narratives' that both books seem desirous to achieve through their promotion of performance as discipline and paradigm. Is this why a pact on the dubious side of 'diversity' in capitalist-driven neo-liberalism comes to seem like the best deal in town? Or why it is so strongly implied that any presumption of long-term action for a better world is likely to be a lost cause?

However, and finally, my paradoxology would be inconsistent not to point out that these querulous views of their politics and ethics might still be subject to Emerson's principle that the field cannot well be seen from within the field. From this perspective, surely they do much more than play into the vision of business as usual that is usually fostered by postmodernism? For a start, are they not splendidly alert to the *implications* of their arguments for history, ironically via a distrust of established historiographic method? Do they not demonstrate this, among other tactics, by each quoting Eric Hobsbawm on, respectively, inventing traditions and the volatility of the past?[44] So *surely* they would recognise that the

[44] Schechner, *Performance Studies*, p. 73; McKenzie, *Perform or Else*, p. 255.

human-animal of the third millennium, the paradoxical primate, may not, ethically and politically, have the affordance of luxury in denying the gruesome *environmental* history of the twentieth century and the longer one of modernity's 'progress'?[45]

In the next part of this book I investigate some implications of performance and theatre ecology for such historiographic perspectives, prospecting for new approaches to the project of creating histories. Because the coming collapse of the Earth's eco-system prompts an urgent need for fresh reviews of the past in the future, perhaps for the better of further times to come. So as we ride along on Po-chang's creature maybe a paradoxology could provoke an ethics and a politics that add in some small way to ecological sanity. However, let's not get so po-faced that we forget the fun of the paradoxical progress that Po-chang's ox may make. Indeed, my paradological method insists I come clean about the final destination of this chapter. Maybe somewhere like Lewis Carroll's vision of the cleanest of worlds: that mythical island, whose inhabitants earned a precarious living by taking in each other's washing.

[45] Eric Hobsbawm, *The New Century*, trans. Allan Cameron [from the Italian of Antonio Polito], (London: Abacus, 2000), p. 7: 'It is true that in some ways the [late-twentieth-century] war in the Balkans has been truly a war with all the hallmarks of a bygone era. It is a *continuation* of the ... wars produced by the international system of powers in the twentieth century, and before that, in the nineteenth. [It is] the last by-product of the Great War.' My emphasis.

Of the past: histories of theatre and performance

Preamble

On the wide dockside the punters stroll about between the lifeboat-stalls selling sea-themed local produce. Here and there scenic entrées erupt into energetic life: a high-seas Captain struts around asking everyone to join him at his table for dinner; the Purser hovers by a luxury liner built as a sidecar to his classic motorbike, inviting groups of three in strictly descending order of class to climb aboard; a mummers-style three-men-in-a-boat crashes into an Iceberg Queen and promptly sinks. Suddenly a monster yellow crane arrives. The crowd gives way, excited as it trundles to the water's edge and slowly extends its boom way out over the grey still surface of the dock. A seaman in a tiny boat heaves a big loop onto its lifting hook. And the whole monstrous assembly shudders with the strain of hauling out from the deep a massive scaffold-skeleton wreck, cranking it up to a steep angle towering twenty metres above the heads of the audience crowding along the water's edge. Water pours from seaweed-strewn portholes, gunwales, smashed lifeboats and one huge battered funnel hanging almost horizontal just above the surface of the watery depths, the other three easily imagined down below. The Titanic dance-band strikes up a jaunty tune, the Captain and Crew usher the audience back to a big bank of seating, and the show that calls up the dead to witness the end of Western Civilisation beats into extravagant life.

Welfare State International's *Raising the Titanic* was staged at the Limehouse Basin in the East End of London, where the Regent's Canal meets the River Thames, in August 1983.[1] It was an apocalyptic allegory that followed hard on events marking a major turn in British society and

[1] Tony Coult and Baz Kershaw (eds.), *Engineers of the Imagination: The Welfare State Handbook*, rev. edn (London: Methuen, 1990), pp. 207–16; Baz Kershaw, *The Radical in Performance: Between Brecht and Baudrillard* (London: Routledge, 2002), pp. 8–12; John Fox, *Eyes on Stalks* (London: Methuen, 1990), pp. 76–80.

culture. Just two months before Margaret Thatcher had been re-elected Prime Minister with a hefty majority, still flying high on the triumphalism of victory in the Falklands War of 1982. A January 1983 public lecture at the National Theatre by internationally eminent economist J. K. Galbraith attacked Thatcher's monetarist mission, but already it looked like a rally for a lost cause. For the first time in years the economy was revitalised and inflation was falling. By the time the *Titanic* was raised by Welfare State its ironic parallels with the bloody South Atlantic saga were greeted with wry smiles. I worked as an engineer and bit-part director on that astonishing spectacle, sleeping in a condemned and filthy flat in a 1960s tower-block, reopened by the local council to house some of the many artists mounting the show. It was an impossibly fraught place to live, pickled in poverty, awash with desperation – the deep downside of neo-conservative dreams. All night the police sirens howled like wolves in for the kill.

The extravagant scale of the *Titanic* project fostered some strange distortions. I was one of a four-person team of engineers making the massive mock-up of the long-gone ship. Plan one: build it around a sinkable dredger barge that would rise slowly to the surface to expose the majestic wreck. A borrowed barge was duly sunk and air pumped in but it stayed put on the bottom of the dock. More air was delivered and suddenly up it came, jumping clear of the water to produce a sizable tsunami. A long finger-wide crack on a lateral weld forced a switch to plan two and the scaffolding skeleton lifted by the big yellow crane. Rumours were spreading around the frantic site that the company would be bankrupt by the end of the show. As the spending soared the cost-cutting tricks got more bizarre. Two sets of toilets in big portacabins were jacked 2.5 metres in the air to get them to empty through the dodgy on-site drains. But how would audiences rise to the occasion? A gang was despatched to a warehouse fantasia of stage sets that looked priceless. For the two-week run of Welfare State's show the audiences climbed to their ablutions up wide flights of ornate mahogany stairs, last used by Wagnerian choruses in full flood. Thanks to the Royal Opera House, and grist to the mill of Oscar Wilde's dictum that 'Life imitates art far more than art imitates life.'

ECONOMICS AND THE ARTS

The first chapter of this part opens with an account of Galbraith's 1983 lecture on 'Economics and the Arts'. By the late 1990s it was a subject I knew a little about from years of hands-on practice at juggling with

budgets large and small in professional theatre, arts-funding bodies and university faculties. So when in 1999 Chicago scholar Loren Kruger asked me to write about the economics and politics of postwar British theatre I felt fairly well qualified for the job. But how best to quickly research the most recent fiscal past for an in-depth, up-to-date history? Suddenly I was a trainee diver facing an endless free fall down a deep-sea trench. Luckily, a splotch of money – let's call it 'sloppy dosh' – floated into view. It was a left over from the 'pump-priming' grant that came with my becoming in 1998 the University of Bristol Chair of Drama. Most of the grant had disappeared in a refurbishment overspend, research travel magically turned into ugly shelving and hard seminar chairs. The sloppy dosh surfaced at a serendipitous moment when a former doctoral student called, looking for work. He quickly grasped the needs of the job: detailed documentation from the capillary levels of economic processes shaping the adaptations of British theatre to the severe environment of socio-cultural change in the 1980s and 1990s.

Two months later a very fat file of assorted papers adorned my desk, mostly filtered from digital sources in a swathe of public institutions – Arts Council, Office of National Statistics, Lottery Fund, national and regional newspapers and more – rich pickings from the distributed archive. The dense diversity of this feedback from the recently gone past fascinated me, but its messy complexity was utterly frustrating. How could it possibly indicate any sure direction of drift in the political health of a nation via the optic of its theatre? I took to leafing randomly through its reams, desperate to get a fix on how economic forces had flowed through British theatres. The years of poring over budget sheets turned the trick. What was most volatile in the flux of theatre money? Production costs and pay packets for short-term employees. These expand and shrink in response to the faster fluctuations in a nation's economy. Generally bad luck for designers, actors and sundry other 'casual' staff, but the gold of flexibility for executive directors anxious to shape-up their theatres for success. Those parts of theatre budgets are like the central flow of a glacier, shifting along fastest hence somewhat rough and tumble.

So what is closer to the edges? What gives directors nightmares, being hardest to control? On one side there are inflexible outgoings, such as regular spending on the physical estate and other major recurrent fixed costs, including the salaries of directors! On the other side there is unpredictable income: takings at the box-office and profit from commercial activity, plus (especially for not-for-profit theatres) business sponsorships and/or grants in the form of subsidy. All these monies are

sluggish compared to the ones that pay for the making of performances. Hence they exert enormous force in the economics of theatre, like the slow-motion side streams in the ecology of glaciers. And the fat file on my desk showed that in the 1980s and 1990s British theatre buildings increasingly were hemmed in by expensive health and safety regulations and subject to strongly rising maintenance costs. The pressure was on to *make* audiences grow to fill every empty seat, using grants and sponsorship as the mulch of state and commercial approval.

This is how in theatre ecology the three great fiscal flows – capital, expenditure and revenue – rub up against each other. They interact in all vectors of its systems, including the edge effects where stage and auditorium meet, especially on opening nights. From that spot the theatrical glacier most dramatically trails its history, in the crevasses that regularly open up between delivery and expectation, between shows and publics, between fixed and fluid assets and so on. But also the friction between budget streams creates complex historical areas of tension, a bit like those tracked by glaciologists judging the passing behaviour of ice, marking the surface, taking out cores, down-loading satellite images. Similar multiple measures are needed to catch the complexity of theatre ecology. This translates into devising several perspectives of analysis on an unstable evolution, thus creating an overall method homologous to the qualities of the vectors of the system studied – in this case theatre economics, with its very marked behavioural variables between budget streams. Make comparisons between the results of those multi-viewpoint angles and other major historically shifting aspects of the system – such as programming patterns and audience demographics – then economics, aesthetics and politics may begin to come into focus for each other in the general theatre ecology. Potential outcome: improved access to interpretation of the changing cultural, social and political health of theatre and performance systems as part of wider environmental movement, larger historical change.

As for new hands-on methods in theatre historiography, my finger flipping in the fat file was just an adaptation of a well-worn archival trick. No doubt, though, that many larger benefits were lubricated into life by that little dollop of sloppy dosh. The fat file eventually led to the idea of the *distributed archive*, proving again that money can beget concepts. It also, more weirdly, led to seeing how multi-viewpoint perspectives might picture an economics of theatre ecology through the techniques of glaciology. Could this be a cool opening-pitch for an eco-historiography? And, who knows, the speculative histories that follow in this part of

Theatre Ecology could well have been provoked by Welfare State's *Titanic* spectacle. The show ended as the burning skeleton ship was lowered back down sizzling into the black depths of a watery grave, cued by the drift of an enormous floating iceberg made of silver fireworks.

HISTORY AND MEMORY

The first public outing of the next chapter was as an article in a special issue of *Theatre Journal* on 'Theatre and Capital' in the final year of the second millennium. 'The economic importance of the arts' had become a buzz-phrase of British cultural pundits in the monetarist 1980s, and the increasing availability of statistical data-sets about the arts fuelled pioneering research in the new fields of cultural policy and management, which mostly dealt with contemporary developments and issues.[2] But theatre economics was a dog of an academic trade in theatre studies compared, say, to gender and performativity or intercultural performance. By the late 1990s very few scholarly attempts had been made to tease out in historical detail how British theatre, let alone performance, might have been affected by the miasma of economic systems that flourished in the second half of the twentieth century. More scholarly work had been done by the mid-2000s, but economics was still a recalcitrant topic in theatre studies.[3]

Recalcitrant topics are a characteristic of this part as a whole. Chapter 6 deals with the history of British theatre audiences during five decades after World War Two. Chapter 7 is an analysis of public spectacle over five centuries in the last millennium. None of these topics were of mainstream interest in theatre studies in the 1990s. Until the middle of the decade 'audience' and 'spectacle' did not have entries in major reference works in English, and it was the early 2000s before 'finance', a weak substitute for 'economics', made an appearance.[4] This reflects the lack of prominent

[2] For representative texts, see: John Myerscough, *The Economic Importance of the Arts in Britain* (London: Policy Studies Institute, 1987); Marian Fitzgibbon and Anne Kelly (eds.), *From Maestro to Manager: Critical Issues in Arts and Cultural Management* (Dublin: Oak Tree Press, 1997); Jim McGuigan, *Culture and the Public Sphere* (London: Routledge, 1996).
[3] For example: Loren Kruger (ed.), *Theatre Journal: Theatre and Capital*, 51: 3 (October 1999); Tracy C. Davis, *The Economics of the British Stage, 1800–1914* (Cambridge University Press, 2000); Website – American Society for Theatre Research, Cost of Taste: www.astr.umd.edu/conference2004/Seminars/Cost_of_Taste.pdf (15.09.2006); Susan Bennett, 'Theater/Tourism', *Theatre Journal* 57: 3 (October 2005). An early partial exception: John Pick, *The West End: Mismanagement and Snobbery* (London: John Offord, 1983).
[4] Dennis Kennedy (ed.), *The Oxford Encyclopedia of Theatre and Performance* (Oxford University Press, 2003), p. 458.

objects of study for these topics, such as plays and buildings are in drama
and theatre studies. It not only suggests relevant data would be scattered
widely in traditional archives, but also that there was a high chance as well
of masses of stuff being lodged in the realms of the distributed archive.
That suited my project. Tricky questions of methods for collection, cri-
teria for selection and angles for analysis could interestingly stretch
existing research protocols, especially in theatre historiography.

Economics, audiences and spectacle all raise the ante on key questions
of history posed by the paradigm of performance, putting theatre his-
torians very much on the spot in a still radically unmapped territory. For
example, the pervasiveness of performance makes them like policemen at
the scene of a perpetual crime where nothing can be ignored as insig-
nificant evidence. Performance ephemerality turns them into haunted
shadow-hunters, always caught in the flickering light of now-you-see-it,
now-you-don't. The paradoxology of performance has them gazing on
mirrors-within-mirrors in fundamental doubt that the essential limits
needed for a fix on the subject to be grasped will ever be within reach.
Such conundrums always threaten to trap the historian in a capitulation
to the extreme postmodernist position that history is a fool's illusion.
They might even imply an embrace of the capitalist attitude crisply
caught in Henry Ford's claim that 'History is bunk.'[5]

These troublesome factors resonate with the categories of what already
counted as problems of theatre and performance history. W. B. Worthen
briskly spelt out a number of these when introducing a major collab-
orative project on theatre history. They include: the diverse and pluralistic
'nature' of theatre historiography as already practised; challenges to
objectivity rising from doubts about the possibility of 'disinterested
neutrality'; issues of continuity and discontinuity in the 'periodisation' of
the past; the inevitability that such histories will be built on 'absences',
animated in particular by the trope of vanished 'improvisation' in per-
formance. Worthen is also extremely alert to a common protocol in
performance studies that gnaws at the joints between performances and
texts: 'theatrical performance has everything to do with everything that is
beyond the text'.[6] Yet for all but two of his contributing historians the

[5] Website – Henry Ford: www.answers.com/topic/henry-ford (24.07.2006). Ford actually said,
'History is more or less bunk', but subsequent history has preferred the more outrageous side of his
equation.
[6] W. B. Worthen, 'Introduction: Theorising Practice', in *Theorising Practice: Redefining Theatre
History*, ed. W. B. Worthen with Peter Holland (Basingstoke: Palgrave Macmillan, 2003), pp. 1–7.

primary sources of historical knowledge turn out to be texts, the documentary record. Of course texts are usually indispensable sources even in histories of performance, but the evolution of an eco-historiography demands an exploration of their changing status in light of the electronic glow of the distributed archive. Do its messy riches generate new kinds of interaction between texts, memory and forgetting in the transmission of histories?

Memory is not a through-line concern in Worthen's book, nor was it for a prominent 1980s collection on performance historiography.[7] This is unsurprising, as the dominant traditions of Western history writing for more than a century were document-based. Yet until well into the nineteenth century professional historians had freely drawn on non-documentary sources. They would have been familiar with Samuel Johnson's claim of 1745 that oral history '...was the *first* kind of history'.[8] The performance paradigm makes even that debatable. 'Prehistoric' early humans passed bodily skills through many generations, for example through flint-tool styling, particularly of hand axes, which 'for over a million years...remained effectively unchanged as the most advanced form of stone tool available'.[9] The performance of such tasks is conventionally excluded as 'history', but it is highly likely the shaping of axe-heads was coupled with prelinguistic vocal sharing. The musicologist John Blacking proposed music as a universal proto-language among the ancient ancestors of homo sapiens.[10] Steven Mithen extends this argument, suggesting continuities between prehistoric and historic eras that may be hard-wired in the human brain.[11] Thus various systems of historical transmission combined physical, cognitive, emotional and other channels of communication, making it impossible to accurately mark where 'history' began. But no such system could have emerged without the play of memory, forgetting and states in between over time.

Paul Ricoeur calls memory and forgetting 'the median levels between time and narrative'.[12] They took on new degrees of historical significance

[7] Thomas Postlewait and Bruce A. McConachie (eds.), *Inventing the Theatrical Past: Essays on the Historiography of Performance* (University of Iowa Press, 1989).

[8] Quoted in: Paul Thompson, *The Voice of the Past: Oral History* (Oxford University Press, 1978), p. 19.

[9] Steven Mithen, *The Singing Neanderthals: The Origins of Music, Language, Mind and Body* (London: Phoenix/Orion Books, 2006), pp. 163–4.

[10] John Blacking, 'Music, Culture and Experience', in *Music, Culture and Experience: Selected Papers of John Blacking*, ed. Reginald Byron, (Chicago University Press, 1999 [1986]).

[11] Mithen, *Singing Neanderthals*, pp. 274–5.

[12] Paul Ricoeur, *Memory, History, Forgetting*, trans. Kathleen Blamey and David Pellauer (University of Chicago Press, 2004), p. xv.

in the twentieth century, especially in the wake of the Nazi holocaust and the bombing of Hiroshima and Nagasaki. Related doubts about the authority of the document and the archive later added to widespread efforts to democratise knowledge, from oral history through post-structuralist philosophy to performance studies. And if the document is thus demoted what happens to the median levels, the margins between time and narrative? Now I will more explicitly engage those levels briefly to practise a historiography that models a rebalance between memory, forgetting and texts, in part through the global aurora of the distributed archives. This is just one way in which a homological match between method and materials might throw light on the nature of theatre ecology. So here come I with some memory-work about memory-work in performance.

NOSTALGIA FOR THE FUTURE

A community theatre company I co-directed over three decades ago in 1976 invented a new genre. We called it 'reminiscence theatre'. Our Board member Dr Gordon Langley, specialist in geriatric mental illnesses, was well up to date on research that showed long-term memory improved with age for many elderly people.[13] This is a paradox of memory, as the bodily deficits of aging are coupled to the potential benefits of early life more fully recovered. Our hybrid theatrical innovation aimed to enrich that paradox through a straightforward process: collect reminiscences from the elderly residents of local-authority care homes and turn them into loosely structured episodic entertainments designed to nurture further reminiscences and create a feedback loop of oral history. This would challenge the prejudice that reminiscence is an exercise in nostalgia, by strengthening the self-esteem of the elderly people in the homes through the pleasures of conviviality. During five years of experimentation we evolved reminiscence theatre into a highly accessible, participatory and engaging minor genre. It was subsequently adopted and adapted by many groups worldwide, as the distributed archives attest.[14]

[13] Dorothy Langley, with Gordon Langley, *Dramatherapy and Psychiatry* (London: Croom Helm, 1983). Langley was later elected Fellow of the Royal Society for his psychiatric work.

[14] The first was the London-based group, Age Exchange, founded in 1983 by Pam Schweitzer following a workshop run for her by Gordon and Dorothy Langley and myself at the community venue Action Space in London, 1980. See: Baz Kershaw and Gordon Langley (eds.), *Reminiscence Theatre*, Dartington Theatre Papers, 4: 6, 1982; Baz Kershaw, 'Reminiscence Theatre: New

These several decades later I can remember a remarkable moment of reminiscence performance with great clarity. In a south Devon care home a very elderly woman who had seemed almost totally uninvolved in the show suddenly smiled broadly and commented loudly on a scene. The actors responded in role as they had been trained to, drawing her into a short conversation that moved the scene on. As it continued she beamed at her companions, eyes twinkling. When the show ended, surprised and delighted care-staff were keen to tell us it was the first time Ethel had spoken since coming into the home four years earlier. Now I recall earlier, widely varied scenes produced the same effect for other individuals. Those moments of breaking long silences proved the power of memory-work in performance to somehow spark a re-engagement with the world, even a kind of rejuvenation. Did such profound effects result because the participatory, culturally democratic genre of reminiscence theatre could trigger biologically embedded or genetically determined processes in the performance of memory? Had we happened upon a powerful prompt for reproductive memory-work that even now, thirty years on, is continuing, in however pale a fashion, through this brief description?

Research in autobiographical memory has identified a 'reminiscence peak' for many elderly people, though debate continues on whether this is primarily a biological, cultural or some other kind of phenomenon.[15] From a radical ecological perspective, though, there may be *no* primary vector as others will always be working interdependently to sustain the living complexity of memory systems. Theatre ecology would be no exception to this rule of multiple flows, as we saw for its economics. Hence the powerful memory-work of reminiscence performance could result from an energising of synaptic networks of natural, cultural,

Techniques for Old People', *Theatre Ireland* 2 (February 1983); Pam Schweitzer, 'Dramatizing reminiscences', in *Reminiscence Reviewed: Perspectives, Evaluations, Achievements*, ed. Joanna Bornat (London: Taylor & Francis, 1994); Pam Schweitzer, *Reminiscence Theatre: Making Theatre from Memories* (London: Jessica King, 2006). For an American perspective, see: Anne Davis Basting, *The Stages of Age: Performing Age in Contemporary America Culture* (Ann Arbor: University of Michigan Press, 1998). A Google exact phrase search for 'reminiscence theatre' lists 706 references (24.08.2006). However, this myth of foundation for reminiscence theatre elides other types of revaluation of age by theatre. For the USA in the early 1970s, see: Basting, *Stages of Age*, pp. 26–7; an earlier UK example was OATS (Old Age Theatre Society) founded in 1969 by Interaction, London.

[15] Martin A. Conway, *Autobiographical Memory: An Introduction* (Milton Keynes: Open University Press, 1990), pp. 149–57; Joanna Bornat, 'Reminiscence and Oral History', in *The Oral History Reader*, 2nd edn., ed. Robert Perks and Alistair Thomson (London: Routledge, 1998), pp. 457–73; Gillian Cohen and Stephanie Taylor, 'Reminiscence and Ageing', *Ageing and Society* 18 (1998): 601–10. See also: Mike Bender, Paulette Bauckham and Andrew Norris, *The Therapeutic Purposes of Reminiscence* (London: Sage, 1999); Bornat, *Reminiscence Reviewed*, 1993.

social, scientific, technological and other historical processes. Was the reawakened voice of Ethel an animation of such complex causalities working through common evolutionary factors in this particular theatre ecology? Might the basic paradox of reminiscence by the elderly have triggered a convergence of cross-generational memories between participants and performers? Did the young performers so powerfully elicit long-past memories in a pleasurable transmission of history because the excess of performance in the moment of exchange combined many vectors of recall?

If the answers are mostly 'yes', we might hypothesise that, as an adjunct to the human-animal's median levels, the floods of mnemonic material in the distributed archives could have fantastic implications for setting such processes in motion, which are as much involved in what's to come as what has gone. And from this perspective it would certainly turn out that we were somewhat half-witting in the name we gave our reminiscence theatre company: Fair Old Times. In retrospect its work refracts the paradoxical powers of nostalgia for the future.

<div style="text-align:center">THE THREE CHAPTERS OF THIS PART</div>

Nostalgia for the future was a potent by-product of the dynamics of postmodernism and ecology in the second half of the twentieth century.[16] Together the postmodernist and ecological movements produced crucial paradoxes for humans in the processes of global history. Key to this effect was their highly contradictory impact on the human sense of a past or pasts. Some severe simplifications will serve to briefly explain this point. First, postmodernism reduces the past to compulsive recycling of materials in the present and an inevitable experience of loss. History becomes little more than pastiche of, and pining for, worlds that are totally gone for ever. So in postmodernism the history of memory is a decorative lost cause.[17] Second, ecology always engages the past because evolving ecosystems incorporate the chains of events that have produced their current state. Whether 'memory' in organisms is permanently imprinted by genetics, and/or is established by traditional behavioural routines, and/or is a

<hr>

[16] The Iranian–American futurist FM2030 (F. M. Esfandiary) is credited with coining this phrase. See: Websites – F.M.: www.fm2030.com/ (03.10.2006); http://en.wikipedia.org/wiki/F.M._Esfandiary (03.10.2006).
[17] Jameson's 'disappearance of a sense of history'; see: Frederic Jameson, 'Postmodernism and Consumer Society', in *Postmodern Culture*, ed. Hal Foster (London: Pluto Press, 1985), p. 125.

function of symbolic languages, it is always constitutive of ecology as history. For ecology, history is memory in action through the past in the present.[18]

Such condensed accounts beg many questions of course, but I hope they suggest the scale and nature of the historical factors and vectors that the chapters of this part explore. I evoke the idea of nostalgia for the future to imply that hope may be never entirely forlorn in the age of ecology. Nostalgia remains an inauthentic negative when it plays only over the past, but in the early twenty-first century it promises to become a potential positive when it paradoxically engages the future. The potential emerges because, as Susan Stewart claims, 'the prevailing motif of nostalgia is erasure of the gap between nature and culture'.[19] As I have argued in earlier chapters, that erasure may be complete as an effect in certain performance practices, but the contradictory 'gap' between nature and culture will always exist in principle, hence the need for paradoxical formulations to determine any overriding truths arising from its closure. This dynamic was a vector well known in Leningrad and St Petersburg, where freezing point is called melting point.

The point is that to see environmental truths through paradox may be a step towards more sustainable ecologies and provide a greater analytical grip on the ethical and political dimensions of nostalgia for the future. Hence the following chapters are designed to take health-checks on British cultural democracy, democratic participation, and progressive activism through theatre and performance in history. They aim to show that theatre ecology is in no way a retreat from questions of freedom, equality and justice – in a word, from democratic values. Indeed, quite the contrary. Through an inclusive ethic forged by critical engagement in particular environments, theatre ecology may profoundly reinforce the politics of performance and the radical in performance.

'Discouraging Democracy' was the title of the article that is the source for chapter 5. It described a web of economic forces shaping British theatre in the late-twentieth century, in large part transforming it from a state-subsidised, public-service cultural sector to a market-oriented, venture-financed entertainment industry. The chapter partially reframes that conventional narrative through a theatre ecology explanatory mode, to

[18] Bateson's 'the processes of any ongoing ecosystem are the outcome of multiple determination'; see: Gregory Bateson, *Steps to an Ecology of Mind* (University of Chicago Press, 2000 [1972]), p. 508.
[19] Susan Stewart, *On Longing: Narratives of the Miniature, the Gigantic, the Souvenir, the Collection* (Durham, N.C. and London: Duke University Press, 1999), p. 23.

show how environmental challenges of an economic kind infiltrated theatres in deeply uneven and contradictory ways, throwing the majority into continual crisis, as we saw in chapter 2.[20] The richly chaotic qualities of the distributed archives, which provided most of the data surveyed for this revision, demanded a multi-perspective analytical approach in order to make anything like coherent sense of those economic impacts. 'Theatre ecology' becomes the tag for a mode of historical explanation thoroughly inflected by ecological-systems thinking: we are talking networks, inter-dependencies, various forms of feedback shaping modes of survival. This indicated a clear overall reduction of creative flexibility and diversity in British theatre, and therefore of its democratic potential in the general environmental drift to the commodity-driven and consumerist market economies of neo-liberal disorganised capitalism in the 1980s and 1990s. So the research and its results are nuanced to suggest a sense of the eco-logies of theatre as a potent approach to creating histories that multiply reflexive perspectives in their political analyses.

Chapter 6 zooms in to focus initially on a highly specific element of theatre ecology: applause. My attraction to this strange phenomenon was fed by discomfort at being in any theatre building, whether as jobbing director, researching academic, or curious spectator. I nurtured a habit of attentive listening to applause in the hope of finding some clue as to why I was there. Ironically, then, the chapter's genesis was a keynote paper at a celebratory conference called for the creation of a new venue at the end of the last millennium, the Arena Theatre in Wolverhampton. So I started my presentation by asking the assembled delegates for a wholly gratuitous round of enthusiastic applause. They clearly enjoyed that. Next: desultory applause. Rather more interesting fun. And so on. The responses were astonishing in their accuracy and confidence, even as I tried out the exercise on several continents. Yet no one in my audiences could really explain how they had learned the trick of spontaneous, collective, uni-fying intimacy in public. The force of that mystery produced a journal article about one of the greatest conundrums of theatre ecology, the audience.

Starting with applause as a measure of ephemeral participation in live performance, the chapter traces a history of audience identities in British theatres during the second half of the twentieth century. Judged by changing patterns of participation, a pathology of advancing political

[20] See, for comparison: McGuigan, *Culture ad the Public Sphere*, pp. 51–74; Robert Hewison, *Culture and Consensus: England, Art and Politics since 1940* (London: Methuen, 1995), pp. 209–94.

dispossession seems to have been widely enjoyed, perhaps reaching an apex of endemic standing ovations in London's West End theatres as the millennium turned. But how could this paradoxical shadow of a grand narrative of democratic decline be explained through theatre ecology? The macro-story leads to a detailed case study that offers a microanalysis of a very particular moment in performance. The punch of a notoriously provocative play had been pulled through a small but singular change to its text. The staging of this tiny amendment gives a passing glimpse of a positive feedback loop that magnifies a profound deficit in British public life as a whole. This conjunction of macro-narrative and micro-dissection extends the method of multi-perspective historical analysis derived from theatre ecology as tried out through the topic of theatre economics in chapter 5.

It also tempted me into an overt nature–culture analogy, a catalytic ecological trope that posits homologies between general historical theatre trends and specific performative events. Theatres are proposed as an equivalent to environmental 'ecotones', areas where two or more distinct ecologies rub up against each other: river and banks, stage and auditoria, seashore and sea, actors and audiences. In this conceit the pulled punch of the scandalous play becomes an 'edge effect', an event restricted to a specific kind of ecotone but which may be ecologically resonant for many cognate environments. Hence in environmental ecology the state of similar ecotones – say, shrinking rainforest perimeters – articulates fully with much wider processes, such as global climate change. Likewise in theatre ecology, perhaps the edge effects of applause may be telling of a nation's democratic health.

Chapter 7 broadens the perspective from theatre to performance ecology through a look at Western spectacle in the second half of the second millennium. It indicates four major types of spectacle and explores how they propagate the burgeoning factors of human power. To establish a quasi-stable element across that panoramic quagmire it imagines the 'human' at the 'heart' of spectacle – theatrical, cinematic, environmental and so on. It asks: when 'humanity' is subject to extremes of pressure from the greatest of powers (political, physical, cultural, natural, etc.) what might survive? Hence spectacle is proposed as a major factor in the constant reconstitution of 'human nature' since mediaeval times. It became especially pervasive as the digital revolution of the late-twentieth century finally detached it from a sense of scale set by the human form. This poses the conundrum of how to refigure the 'human' in the eco-logical era. Hence my trope for envisaging the subject at the heart of

spectacle through theatre and performance ecologies is 'the non-human in the human', gesturing towards those vectors of existence that embed homo sapiens inextricably *in* the biotic sphere and beyond, as atoms, as fluids, as organisms, as animals and all the rest. This extraordinary ecological ambivalence is truly the realm of the paradoxical primate.

This chapter originated as a keynote paper at the annual conference of the Australasian Drama Studies Association (ADSA) in July 2000. It was timed to reflect on one of the most spectacular performance events regularly staged by twentieth-century humans, the Olympic Games, which were held in September of that year in Sydney. In May I had devised and directed a large-scale, site-specific spectacular on a Victorian ship that had taken 14,000 people to Australia. The ss *Great Britain* had become a heritage site at the dry dock in Bristol where it had been built and launched in 1846. There were echoes of Welfare State's *Raising the Titanic* in the show's styles and themes, as the ship's designer Isambard Kingdom Brunel battled with Poseidon over its place in the histories of colonialism, Empire and environmental pollution.[21] In 2001 I was back in Australia interviewing descendants of the ship's Victorian passengers in preparation for a second onboard production, this time a one-woman durational show that played with memories of memories of its ambivalent past.[22] The ADSA keynote paper was subsequently rewritten during 2002 at the invitation of Harvard University professor Harry Elam for a *Theatre Journal* special issue on 'Activism'.

I note this 'historical background' to chapter 7 because writing it was a process of accretion that involved creative practices, theoretical reflections, thematic emphases and oceanic obsessions in my personal life trajectory. This was another of my ways to participate in a broader historiographic embrace of materials previously shunned by theatre historians as unreliable or marginal, including infusions of Antipodean family memory. For example, Tracy C. Davis uses close analysis of Victorian etchings to tease out feminist insights into the gendering of theatre management; Jim Davies and Victor Emeljanow use street censuses and transport timetables to trace the meandering flows of London audiences between theatres; Jacky Bratton uses anecdotes about theatrical mimicry and the genealogies of theatre families to draw out subtle structures of

[21] Baz Kershaw, 'Performance, Memory, Heritage, History, Spectacle: *The Iron Ship*', *Studies in Theatre and Performance* 22: 3 (2002).
[22] Baz Kershaw and PARIP, *Mnemosyne Dreams: An interactive document and investigative research resource*, DVD (Bristol: PARIP, University of Bristol, 2004).

stylistic influence.[23] These and other theatre historians together success-fully juggle a productive jumble of historical vectors to enrich their his-toriographic methods.

I gratefully followed their innovative example (and that of others) in the chapters of this part, piecing together analyses that concertina in their temporal span from three minutes of highly focused drama to five cen-turies of extravagant spectacle. My ecological bent is sometimes overtly stated, sometimes slips in by implication, sometimes seeps through in the paradoxical nature of its case studies. For instance, in chapter 7 film star Buster Keaton survives a cyclone by giving in to it; body artist Stelarc is Superman and strung-up meat above the rising waves; Latino perform-ance provocateurs Coco Fusco and Guillermo Gómez-Peña become human-animals by caging an imaginary culture. These strange conjunc-tions are local encounters that aim to crystallise the irregular global transitions I try to trace in these three chapters. Further connective cusps are under construction in the gaps between their recalcitrant topics – economics, audiences, spectacle – and the astronomical billows of documents and other mediations that gathered in traditional archival collections and fabulously filled out the distributed archives as the last millennium turned. As memory plays so richly in the unprecedented mnemonics of these highly networked systems, perhaps they have already produced fresh degrees of ephemerality that will improve the future of the past as history. In *this* paradigm shift maybe an eco-historiography of theatre and performance might make nostalgia for the future a state worth entertaining.

[23] Davis, *Economics of the British Stage* (2000); Jim Davis and Victor Emeljanow, *London Theatregoing: Reflecting the Audience, 1840–1880* (University of Iowa Press, 2001); Jacky Bratton, *New Readings in Theatre History* (Cambridge University Press, 2003).

Economies of performance: theatre against democracy

If all economists were laid end to end, they would not reach a conclusion. (George Bernard Shaw)

A society is democratic to the extent that its public citizens play a meaningful role in managing public affairs. If their thought is controlled, or their options are narrowly restricted, then evidently they are not playing a meaningful role: only the controllers, and those they serve, are doing so. The rest is a sham, formal motions without meanings. (Noam Chomsky[1])

AN ERA ENDS

In January 1983, two leading liberals, one American one English, shared a stage at the National Theatre in London. The American, J. K. Galbraith, one of the world's great economists, was here to lecture on 'Economics and the Arts', a gesture which was generously aiming to reinforce the political hand of the Englishman. This was Sir Roy Shaw, champion of equal educational opportunity for all, advocate of the democratisation of culture, and currently – as the then Secretary-General of the Arts Council of Great Britain – the most powerful arts mandarin in the land. Galbraith's argument, as usual, was urbane, subtle and marked by the kind of modesty that only international celebrity provides. He spoke of the interdependency of economics and the arts, of the responsibility of artists to speak out on matters concerning the national wealth as well as the national health, of artistic achievement as essential to industrial development. The underlying theme of the lecture was the need for a mutually respectful partnership between cultural producers and money-makers,

[1] 'Discouraging Democracy', the title of the essay on which this chapter is based, echoed: Noam Chomsky, *Deterring Democracy* (London: Vintage, 1992), p. 6.

between creative artists and business people. This meant eliminating the traditional suspicions shared by the two sides, which in turn implied recognition of equality of knowledge and expertise. And to prove the point by example, in a characteristically self-effacing move, the American visitor paid a cheerfully oblique and, in this particular year, suitably stunning compliment to his host: 'Let us not . . . believe for a moment that there is some supervening financial wisdom to which those who guard our artistic treasures should be subject.'[2]

From the perspective of theatre ecology, this is a profoundly telling claim. Galbraith's caution about 'financial wisdom' implies that other values than the economic may have at least equal right to definitions of global 'goods'. His lecture focuses on human economic goods as expressed through the arts, but his formulation does not rule out other possibilities, such as ecologically ethical actions and processes. His judgement also crucially calls into question the dominance of standard economic measures of a 'healthy' society, in particular the Gross National Product, its monetary accumulator. This was clear flattery of his audience, the great and the good of the British arts scene. It also applauds the immediate environment of the lecture as a quintessentially cultural one, not just any theatre but a *national* theatre. Yet the metaphor that Galbraith uses to characterise both setting and audience has, from an ecological point of view, a resonance that is ultimately sinister. 'Artistic treasures' transforms the National Theatre into a vault for the storage of cultural capital and his auditors into functionaries for its protection. The theatre ecology implied by the famous economist's account turns out to be still in thrall to the progress of capitalism, albeit one tempered by the good grace of a liberal gentility.

Galbraith's liberal vision certifies a mutually beneficial system of checks and balances between art and money, culture and commerce, creativity and industry all working towards a 'civilisation' in which the rapacity of the market may be paradoxically tamed by the general rise of an affluence more or less shared by all. We can securely surmise that he still believed such a system would have to be reinforced by the good offices of the state, in the form of subsidy or tax breaks for art – after all, this was an Arts Council lecture, and Galbraith's *The Affluent Society* had been recently reprinted by Penguin Books for the eighteenth time – but he did not explore this increasingly unpopular theme in the lecture. Instead, he

[2] John Kenneth Galbraith, *Economics and the Arts* (London: Arts Council of Great Britain, 1983), p. 4.

referred to its chief enemy in 'the exuberant enthusiasm of Mrs Thatcher and Mr Reagan for the economics of Professor Friedman' and added an ironic coda about their supporters: 'It is a well-established feature of the free enterprise system that fools and some other people will be separated from their money.' You can almost hear the soft rustle of affluent asses as they shift uncomfortably in the plush seats of the Olivier Theatre.

Meanwhile, behind the scenes of Britain's arts bureaucracy, Galbraith's kind of thinking was being separated from policy. Not long after the lecture Roy Shaw retired, to be replaced by Luke Rittner, champion of business sponsorship of the arts. As Rittner's appointment was made, despite much internal opposition at the Arts Council, by Sir William Rees-Mogg – who in 1982 had been made Chairman of the Council by the Conservative Minister of the Arts, Paul Channon – we can safely assume that Prime Minister Thatcher approved of the change. Public support for Thatcher was rising in the jingoistic wake of the Falklands War of 1982, and six months after Galbraith's lecture she won a surprise victory in the general election of 1983 for a second term of government. The 'free' market was reinforced at the top of the economic agenda, the post-World War Two political consensus entered its final death throes, and the numbers of homeless bodies lying in the streets of Britain's major cities began climbing to epidemic levels. The monster of monetarism had been fully unleashed.

THEATRE ECONOMICS AND DEMOCRACY

This chapter explores the impact of changing economics on British theatres, especially those subsidised by the state, in the final twenty years of the twentieth century. It is a particularly fertile territory to traverse because the period was characterised by extreme shifts in the cultural complexion of the nation, fostered in large part by the programme of 'radical' neo-Conservative economic and social reforms instituted during eighteen years of Tory government, first under Margaret Thatcher and then John Major. As we shall see, the 'radical' nature of cultural change in the period throws the relationships between economics and the arts into high relief, which in turn raises crucial questions about interactions of the ecology of theatre and democratic processes. I address these questions through an investigation of developments in government cultural policy and its impact on theatrical practice – on audiences, programming, and the relationships between regional and metropolitan theatre sectors particularly – and through this I will show how the economics of theatre

as a cultural form can be analysed as a useful test site for the democratic health of a nation. As a highly visible, and often expensive, social practice, theatre makes manifest the consequences of state policy in ways that, say, the literary or visual arts do not.

Many factors, of course, contribute to the well-being – or not – of democracy, but I propose that changes in how democracy defines its citizens in any particular period is key to any prognosis of its health. It follows that one useful way into the analysis of democratic vitality – or lack of it – would be through a multi-faceted account of the forces flowing through the vectors of theatre as a physical entity, as a cultural practice, and as a social institution. These environmental forces significantly contribute to the evolution of theatre audiences – through their niche behaviour as individual and collective organisms – as they more or less autonomously respond to and influence changes, including economic changes, in both the theatre's specific practices and its general constitution. That view of the audience as a dynamic element of theatre ecology strongly informs this chapter, and is investigated more fully in the next. My approach proposes that a theatre ecology can, in a sense, make citizens who are more or less effective; in environmental ecology terms, organisms more or less well adapted to their milieu and therefore contributing to its sustainability as an ecosystem. This translates in theatre ecological terms into citizens – audiences, actors, directors, writers, designers and the rest – who are participants that use the privileges of the theatre niche to benefit the living diversity and other ecological 'goods' of its own and the wider environment, including the 'natural world'. Hence theatre economics is just one of many modes of energy exchange in those environments that, viewed as one ecological element interacting with others, can indicate the health or ailments of the system as a whole. So from a theatre ecological perspective Alexis de Tocqueville gave intriguing advice when he argued that: 'If you would judge beforehand of the literature of a people that is lapsing into democracy, study its dramatic productions.'[3] In this chapter I investigate how a retrospective study of the changing environment of 'dramatic production' might throw light on a nation's 'lapse into', or a falling away from, democracy.

[3] Alexis de Toqueville, 'Some Observations on the Drama Among Democratic Nations', trans. Henry Reeve, in *The Theory of the Modern Stage*, ed. Eric Bentley (Harmondsworth: Penguin, 1968), p. 479; see: Alexis de Toqueville, *Democracy in America*, vol. II, ed. Phillips Bradley (New York: Alfred A. Knopf, 1945), p. 79.

In Britain during the forty years following World War Two there was a general strengthening of democracy. One small but highly significant sign of this was a gradual increase in state subsidy for the arts.[4] This trend was the direct result of a left–liberal philosophy adopted by the postwar Labour government (1945–55) that saw culture as a democratic right for all citizens, along with universal education, healthcare and housing. The principle of a cultural franchise was enshrined in the first two objects of the Royal Charter, which empowered the new Arts Council of Great Britain, founded in 1945, to distribute state aid to the arts:

1 To develop and improve knowledge, understanding and practice of the arts.
2 To increase accessibility of the arts to the public throughout Great Britain.[5]

The money distributed ensured that much of British theatre was largely protected from the subsequent growth of the Western capitalist market and the cultural ascendance of the consumer. But the 1980s witnessed major modifications to this policy for cultural provision, and theatres became subject to increasing marketisation and commodification. In effect, British theatres were forced to incorporate into a service-oriented economy and so to compete with other attractions in the burgeoning media, heritage, tourist and related industries. The relatively well-protected niche of theatre arts was faced with increasing challenges to survival as its environment became more pervious to adverse pressures in a larger, more crowded ecology of cultural forms.

This assimilation was part of a much wider trend towards a pervasive 'spectacularisation' of culture that Debord, Baudrillard, Lyotard and other cultural analysts identified with the late-capitalist postmodernisation of Western societies.[6] As I argued in chapter 2, this was an integral aspect of the production of the performative society, in which human transactions are complexly structured through the growing use of theatricalised modes of behaviour and frames of reference. The economics of such a society promotes a struggle that could be called epic, were it not for the fact that it is mostly fought out in the realm of the everyday, at

[4] John Pick (ed.), *The State and the Arts* (Eastbourne: John Offord, 1980), p. 15.
[5] Ibid., p. 3.
[6] Guy Debord, *The Society of the Spectacle* (Detroit: Black and Red, 1977); Jean François Lyotard, *The Postmodern Condition: A Report on Knowledge*, trans. Geoff Bennington and Brian Massumi (Manchester University Press, 1985).

the capillary level of the social. Many cultural theorists have identified this struggle as between the processes of commodification – in which the human is objectified by, and becomes subject to, irresistible market forces – and the sources of subversion in the performativity of human agency – in which the commodity is always open to transformation into a weapon of radicalism.[7] In this kind of context, the theatre is an especially telling phenomenon, because as a collection of public *buildings* – theatrical real estate – and as a cultural *institution* it has to conform significantly to the disciplines of the state and the market in order to survive. But also as an arena for *creative performance* it always offers the potential for a radical critique of the social (and its economics) as a general disciplinary apparatus. This tension is another reason why theatres are especially relevant to our understanding of struggles about the nature of democracy in any particular time and place.

Theatre ecology can add fresh dimensions to historical analysis of theatrical performance and politics because it encourages multi-perspective views of the environmental conditions that influence the evolution of staged shows and their audiences. It affords an approach that can discriminate the dynamic milieu of interactions between, for example, theatre as real estate and as cultural institution. A specific focus on the economic forces that flow through theatre ecologies in any particular period also has the advantage of rich sources of fiscal research and debate in the field of green economics, which treats the survival and sustainability of cultural forms and natural organisms as inseparable from and integral to each other.[8] Green economics thus provides a reminder of vital perspectives on the processes of a theatre ecology created as between (a) a general system of exchange within environments through which conventional distinctions between 'natural' and 'cultural' elements are questioned; (b) a more specific array of networked or rhizomatic interactions between, say, the maintenance of the theatre estate and the patterns of performance programming as mutual sub-systems of energy exchange; (c) a field of energetic experimentation between, say, individual

[7] John Fiske, *Understanding Popular Culture* (Boston: Unwin Hyman, 1989); Dick Hebdige, *Subculture: The Meaning of Style* (London: Methuen, 1979); Michel de Certeau, *The Practice of Everyday Life*, trans. Stephen Rendall (Berkeley: University of California Press, 1988); Henri Lefebvre, *Everyday Life in the Modern World*, trans. Sacha Rabinovich (London: Harper and Row, 1971).

[8] See: David Pepper, *Modern Environmentalism: An Introduction*, London: Routledge, 1996), pp. 61–91; see also: *Ecological Economics: The Journal of the International Society for Ecological Economics* (Amsterdam and New York: Elsevier, 1989–).

and collective bodies sharing the stage–auditorium niche considered as more or less integral to the 'body politic' of the wider public domain.

The rest of this chapter engages with all these dimensions of British theatre ecology through analysis of the extensive economic adaptations it underwent in response to state policies between the early 1980s and the turn of the third millennium. One underlying analogy that emerges from its modes of explanation may be seen as between economic crises in the theatre system and chemical crises in the natural environment. For example, state fiscal policies in this period in some respects were to theatre culture as pesticides are to rural ecosystems, corrosive and potentially catastrophic for more species than those targeted, but also pathologically productive for some select others. From the viewpoint of the ecologies of theatre, it is worth noting that such parallels were not a research hypothesis, but arose inductively through a historiographic method that privileges the *intrinsic* relational qualities of trace materials from the past in traditional and, especially, distributed archives.

However, the chapter's arguments are framed from the perspective of an 'environmentally alert' economics, as this gives access to a meta-view of theatre as more or less engaged with wider ecological processes and paradoxes. The theatre cannot altogether avoid the consequence of its pervious public nature even as it forecloses on challenges to its environmental niche, narrowing its flexibility of response. A partially rephrased reiteration of David Harvey's radical claim is an appropriate reminder of this: if all cultural projects are ecological projects, then some conception of the forces of 'nature' and 'environment' is omnipresent in everything humans do.[9]

A SHORT DIGRESSION ON ANGELS

The potential efficacy of a meta-view on theatre ecology informed by green economics can be illustrated by asking a curious question: What was money in the general ecosystem of British theatre in this period? In the complexities of that system, money shapes up as a number of entities, such as subsidy, sponsorship, box-office takings, productions costs, salaries and fees and so on. To see how these might operate ecologically a focus on particular theatre niches is required and, as this chapter is concerned with economics and democracy, an example from popular

[9] David Harvey, *Justice, Nature and the Geography of Difference* (Oxford: Blackwell, 1996), p. 174.

commercial theatre in the 1980s is apt. One key term in the 'world' of modern mega-musicals and related types of commercial production computes strongly in the economics–democracy equation. Financial backers of such shows are called 'angels', an adaptation that stems from democratic America in the 1920s, when it was used to describe the rich financial supporters of political campaigns.[10] In Britain in the 1980s and 1990s production costs of spectacular musicals often amounted to millions of pounds sterling, so theatre angels – like Lucifer – were generally betting on very high-risk odds in their investments. Mostly this was money in pursuit of money as the pay-off depended on profits, a process liberal green economist Paul Elkins describes as 'a debilitating virus in the economic system' because, in his view, it is divorced from 'productive activity or real wealth creation'.[11] In this analysis money is identified as operating much like the memes that Richard Dawkins sees as the gene-equivalents of culture.[12] This kind of money is integral to advanced capitalism, and so the 'virus' is endemic to the spread of commercialism, consumerism and commodification.

When a general theatre culture incorporates that 'virus', or even from some perspectives 'pesticide', it may create an ecology that is ironically sickening, as its high consumption of resource can have the effect of reducing diversity in the whole theatre system. Put crudely, high-profit musicals in a system constrained from overall growth, say, will take up a growing proportion of overall programming. This effect is fundamental to a basic principle of mega-musicals as a species of event, because their best chances of survival rest on the exact replication of shows that run simultaneously in major cities around the world. But even more fundamentally, their heavy energy use becomes integral to the consumptive cycles creating environmental ecological crisis on a global scale. *Phantom of the Opera*, for example, provides a direct measure of how thorough-going the symbiosis between cultural and natural environments can become. According to Sheridan Morley: 'When it moves to a new theatre, the touring production needs 27 articulated lorries to transfer the set.'[13]

[10] *The Cassell Companion to Theatre* (London: Market House Books, 1999 [1994]), p. 18.

[11] Paul Elkins, *Wealth Beyond Measure: Atlas of New Economics* (London: Gaia Books, 1992), p. 26; quoted in Pepper, *Modern Environmentalism*, p. 86.

[12] See Chapter 1, pp. 19–20.

[13] Sheridan Morley, *Theatre's Strangest Acts: Extraordinary but True Tales from Theatre's Colourful History* (London: Robson, 2006), p. 164.

THE BIG TWO: CAPITAL AND REVENUE

Money as a 'virus' in this sense features in at least one other surprising way in the following discussion, as British subsidised theatres were challenged by government policy to prove the state's investment would produce 'value for money'. As we shall see, the required 'value' was not considered primarily as cultural, nor ethical, and certainly not environmental, but financial. The state-funded parts of the theatre system came under enormous pressure to increase other sources of income more or less in inverse proportion to subsidy levels, producing greater integration into market environments. Subsidy became 'challenge' money aimed at attracting other types of profit-driven money. From the Government paymaster's perspective, the less subsidy, the more potential value. Hence the story of British theatres in the 1980s and 1990s is one of hard-line ideology upsetting a delicate balance between culture and economics that had been achieved since the 1940s, mostly under Labour governments, through rising general prosperity in the country as a whole. It is a deeply ironic story, as the political party – the Tory party – that claimed to put money and the market first, produced a crisis in the economics of the theatre because it failed adequately to understand (or wilfully ignored) the particular relations between capital investment and revenue turnover that was crucial to that balance.

This broad distinction between capital and revenue monies is important to an ecological understanding of the theatre system from a green economic point of view. First, because it helps to discriminate how finance may affect the balance as between non-organic and organic aspects of the system, broadly speaking as between buildings and performances, the material environment and the live event. Second, because it can facilitate seeing how money may operate in theatre ecologies in other ways than as a 'virus', or even a 'pesticide'. Hence, money that pays for training a growing diversity of performers, say, might be considered to operate as a 'vitamin' or, if that analogy seems strained, as 'seed' funding. Third, because it will aid an increasingly systemic view of the theatre, so that the complexity of the interactions between theatre as estate, institution and performance can be better understood. Through these means, more nuanced and ecologically revealing interpretations of politics as a force in theatre ecologies can emerge.

This last point is especially significant to British theatre in the long run-up to the end of the last millennium as, broadly speaking, government

policy in the 1980s was successful in stimulating an increasing spread of revenue sources for subsidised theatre and an increased general level of income overall. But that emphasis of policy also succeeded in all but destroying the capital base on which revenue success rested. So the physical estate of theatre suffered a severe decline, dragging down with it the general health of theatre as an art form contributing to democratic processes. Further success was achieved in placing London theatres on the map of global tourism, partly through new partnerships between subsidised and commercial production companies. But, in acute contrast, state-supported theatres in the regions, including Wales and Scotland, suffered from increasing financial difficulties and crises. This chapter provides a detailed focus mostly on theatres in England, though what happened to them was largely replicated in Scotland and Wales.

When in the first half of the 1990s the state finally woke up to the unintended vandalism of its policies (and not just in the realm of theatre), it introduced the National Lottery (1994) which quickly 'produced' many billions of 'new money' to be distributed to the nation's good causes, among them the arts and theatres. As if in guilt at the wreckage it had wrought in the infrastructural environment of the arts, the government decreed that lottery money could only go towards capital investment, mainly in the form of equipment and buildings. Hence, many subsidised theatres were renovated and some new theatres and arts centres built where previously there were none. But the recession of the early nineties undermined the revenue-earning power of subsidised theatres, and income for theatre overall remained static as the real costs of production steadily rose even as the recession receded into history, with the net result that the newly revitalised estate of theatre was increasingly starved of the productions it needed to justify and maintain the new capital investment. This ironic inversion of the problems produced by growing state intervention in the economics of the arts generally, and theatres particularly, might best be seen as a see-saw between crises in which no one – but least of all the rising generation of talented new theatre artists – could enjoy anything remotely resembling a comfortable ride. The see-saw symmetry might even raise a wry smile, until one recalls that the state-produced crises were engineered in the name of freeing the arts from dependence on the state, and of giving audiences, through their spending power, greater control over the national theatrical evolution. In other words, the crises were produced by an attempted 'democratisation' of theatre through the mechanisms of the market.

THE PRACTICE AND RHETORIC OF CULTURAL POLICY

Since its inception the Arts Council of Great Britain (ACGB) had sub-sidised producers, largely through grants to theatre companies. Its policies were based on the modernist liberal–humanist view that the artist offers society works that transcend any particular political or economic regime. Art puts people in touch with 'universal' values, so it should be protected both from market forces and state interference since, like education, health and social security, it is an essential ingredient in the effective citizen's life. This cultural philosophy had its economic corollary in the theories of John Maynard Keynes, so it is hardly surprising that he was instrumental in setting up the Arts Council and briefly became its first Chairman before his death in 1946. His legacy, though, can be traced clearly in the fact that between 1945 and 1964 state aid to the Council grew from £175,000 to £2,730,000,[14] and the latter year is significant because Prime Minister Harold Wilson appointed Jenny Lee as the first ever Minister of the Arts in Britain, a symbolic moment of marriage between Keynesian economics and official cultural policy. The severe fiscal and social vicissitudes of the 1970s – ranging from the international oil crisis of 1973 which threw the world economy into near chaos, to the British 'Winter of discontent' in 1978 which culminated many years of acute industrial strife[15] – undermined confidence in Keynsian theory, and by the early 1980s J. K. Galbraith's ideas about the role of the state in the economy had supplanted Keynesianism as the favoured economic line of the liberal-left, so it was fitting that Sir Roy Shaw should invite Galbraith to give the Arts Council lecture described at the start of this chapter. However, as Secretary-General of the Council from 1975 to 1983, Shaw – who was fond of quoting Iris Murdoch's dictum that art is 'a training in the love of virtue'[16] – represented the tail end of this liberal tradition in the management of British culture.

In the 1980s this tradition waned and, as the Conservative Party under Margaret Thatcher consolidated its power following the general election of 1979, British subsidised theatre was subject to a fundamental shift in the ideology and economics of the funding agencies that revolutionised its relationships to the public sphere. This 'revolution' can be described in a

[14] Pick, *State and the Arts*, p. 15.
[15] Alan Sked and Chris Cook, *Post-War Britain: A Political History*, 2nd edn (Harmondsworth: Penguin, 1984), pp. 279–81 and 321–2.
[16] Roy Shaw, *The Arts and the People* (London: Jonathan Cape, 1987), p. 23.

number of ways, each of which raises key issues about how we might understand theatre as contributing to democratic processes. Such descriptions are a crucial method for developing multi-perspective systems analyses of theatre based on ecological principles, thus creating potential homologies between accounts of natural and cultural phenomena. For example, the tectonic ideological shift in the funding agencies was multi-faceted in its impact on British theatre ecology in the following ways:

- It partly undermined the types of elitism which were founded on a valorisation of 'high art' traditions – e.g. opera, Shakespeare – through the encouragement of populist theatre programming designed to appeal to a widening range of people; this consumerist populism democratises access to the theatre while reducing the theatre's potential for stimulating social critique and democratic debate.

- It can be conceived as a struggle between modernist and postmodernist aesthetic values, through which the claims of art to present universal truths is crucially questioned by a relativism which celebrates difference and pluralism; this cultural shift profoundly destabilises the ethical foundation of democratic human rights to justice, equality and freedom, while giving greater weight to the democratic demands of previously oppressed minorities for fairer treatment in the future.

- It may represent a move from essentialist to instrumentalist views of the functions of theatre in society, so that theatre may be claimed to serve a widening range of purposes beyond, say, its celebration of the unchanging human soul; this move towards social pragmatism may place theatre at the service of democratic processes through an emphasis on its progressive educational powers, say, but by the same token its use in systems of commercial exploitation that are utterly anti-democratic is validated.

- It can be described in terms of a new *rapprochement* between state subsidy and market economics that reinforces theatre's place in the cultural economy as a whole; this suggests a financial marriage in which a mixed economy may enhance the general level of theatrical activity, thus democratising its overall availability, but also leading to a market stratification or segmentation which is anything but democratic.

As these alternative descriptions suggest, the changes in the British theatre system were very complicated systemically and ideologically, and constituted a decidedly mixed blessing in respect of democratic processes. To keep this complexity in focus I will investigate it primarily through the most pervasive politico-economic project of the eighteen years of

Tory rule, namely, an attempted general transfer of authority, if not power, from producers to consumers.

The Thatcher 'reforms' of the 1980s demanded greater 'accountability' and 'value for money' in public institutions, and imposed a steady reduction, in real terms, of total subsidy to theatre.[17] The so-called 'arm's length' principle that underpinned the 'independence' of the funding agencies, which was supposed to stop state interference in the 'freedom' of the arts, was gradually amputated.[18] Hence, in 1984 the Council issued its first ever general strategy document, *The Glory of the Garden*, which proposed a major redistribution of its funds in order to redress an acknowledged imbalance of support between London and the regions and, yet more crucially from an economic point of view, to increase funding 'partnerships' between its 'clients' and both private sponsors and local authorities. The redistribution was to be paid for by total cuts in grant to some forty organisations, including a number of leading left-wing theatre companies and, ironically, several regional repertory companies, while the drive for partnership funding was to be stimulated by Council schemes to increase management efficiency and business acumen in the arts sector as a whole.[19] The new policy met with so much resistance from the arts community, from the regional funding bodies, and from the local authorities, that within a couple of years the scheme was totally 'botched'.[20] But its underlying purpose became *the* main element of state funding policy for the next fourteen years: economic 'realities' – particularly as figured by the 'spending power' of the consumer – were to drive the engine of theatrical and other cultural change. Thatcherism sanctioned a more interventionist role for the Arts Council in order to open up the subsidy system – and all the subsidised theatres – to 'free' market forces. British theatre ecology as a whole was forced to integrate into a wider, much less hospitable environment in which questions of survival, particularly for small to medium-sized theatres in the regions, became ever more acute as money became increasingly viral.

The rhetoric of this process slavishly echoed Thatcherite doctrine. Hence the high-Tory former editor of *The Times*, William Rees-Mogg,

[17] Andrew Feist and Robert Huchison, *Cultural Trends in the Eighties* (London: Policy Studies Institute, 1990), tables 1.9 and 1.11.

[18] Robert Hutchison, *The Politics of the Arts Council* (London: Sinclair Browne, 1982), pp. 27–40.

[19] Arts Council of Great Britain, *The Glory of the Garden: The Development of the Arts in England: A Strategy for a Decade* (London: Arts Council of Great Britain, 1984)

[20] Robert Hewison, *Culture and Consensus: England, Art and Politics since 1940* (London: Methuen, 1995), p. 261.

whom in 1981 Thatcher appointed as Chairman of the Arts Council, by the middle of the decade was arguing that:

The qualities required for survival in this age will be the qualities of the age itself. They include self-reliance, imagination, a sense of opportunity, range of choice, and the entrepreneurial action of small professional groups. The state should continue to help the arts but the arts should look first to themselves, and to their audiences, for their future and their growth.[21]

Rees-Mogg urges this as a necessary consequence of an all-pervasive historical abandonment of 'the great twentieth-century thesis ... [of] collectivism and mass forms of production and power'. The end of communism/socialism is signalled by the emergence of a new class – the 'affluent and technically qualified ... electronic middle class' – that will dominate the social structure. Through them the Arts Council was to become a singular force in the state's drive to establish a new economic base for Britain in the service and information industries. Hence, in-built financial inequalities become the motor of growth in the Gross National Product. Ironically, the Conservatives took over the economism that is central to classic Marxist theory while of course totally rejecting its source.

Moreover, underlying Rees-Mogg's arguments is an assumption that the mechanism for achieving healthy growth in the markets of the cultural sector was, paradoxically, to control money supply from the state, a strategy recommended by the so-called neo-classical economics of Milton Friedman.[22] In practice, this meant that any increases in overall state subsidy for the arts in real terms should not produce significant growth in the arts' share of total government expenditure, in order to reduce 'dependency' on the state. (In fact, state subsidy to the arts grew by only 0.04 per cent of total expenditure between 1979 and 1989.)[23] Thus policy for the cultural system aimed to bring it into harmony with the government's desire to put a general curb on inflation while promoting competition. Hence, the recommendations of *The Glory of the Garden* fully echoed the new economic orthodoxies of monetarism, and reflected its in-built contradictions. So Rees-Mogg promotes an old-Tory emphasis on the importance of excellence and traditional standards (*The Glory of the Garden*), while professing a new-Tory belief in open access through the market as the final arbiter of value. The theatre fish in the widening

[21] William Rees-Mogg, *The Political Economy of Art* (London: Arts Council of Great Britain, 1985), p. 8.
[22] Milton Friedman and Rose Friedman, *Free to Choose* (Harmondsworth: Penguin, 1980), pp. 316–9.
[23] Feist and Hutchison, *Cultural Trends*, table 1.7.

river of culture were expected to become fat and juicy by fighting for their monetary feed.

A major by-product of the new monetarist-led policies of the Arts Council, augmented by a Conservative Government policy which progressively reduced both the political and spending power of local authorities, was a major general decline in the physical estate of the theatre. Most new theatres built by local authorities in the sixties and seventies were founded, in financial terms, on agreements that provided continuing revenue from the public purse of local and/or national government for companies to work in them.[24] One crucial matter overlooked by the new Tory policy line was the complex ways whereby capital investment, and its maintenance, had been dependent on *secure* revenue streams in British subsidised arts. If this steady source of income is undermined, then the principle of the capital is also eroded: in concrete terms, quite literally, the buildings gradually fall into disrepair. This trend in the 1980s can also be traced by an overall steady decline in the Arts Council 'Housing the Arts' new-build, rebuild and maintenance fund to a third of its original size.[25] One telling outcome of this trend is provided by a northern English theatre, which by the early nineties was handing out blankets to audiences for its winter productions because a failing heating system was too expensive to repair.[26] This cold back-draught of monetarism, as we shall see, was to impact on cultural policy in the 1990s in ways that produced a worsening of the very pathology it was aimed to cure.

In the 1980s, though, the pathology was disguised by rising claims about the economic power of the arts, and the rhetoric developed by the Arts Council to promote this idea was, again, straight out of the Book of Thatcher. For example, a 1986 pamphlet from the funding body heralded 'a great British success story', and offered itself as a 'Prospectus' spelling out the advantages of embracing 'An invitation to the nation to invest in the arts'.[27] This glossy panegyric employed the language of big business and the stock exchange to outline the 'Dividends' which would derive from a new combination of state grant-aid and private sponsorship, including: (i) low-cost job provision (at £2,070 per head per annum 'a

[24] George Rowell and Anthony Jackson, *The Repertory Theatre Movement: A History of Regional Theatre in Britain* (Cambridge University Press, 1987), pp. 99–114 and table 1.
[25] Feist and Hutchison, *Cultural Trends*, table 1.8.
[26] This was the Dukes Theatre in Lancaster, Lancashire.
[27] Arts Council of Great Britain, *A Great British Success Story* (London: Arts Council of Great Britain, 1986).

bargain price'); (ii) regeneration of depressed inner-city areas; (iii) vital creative stimulus to the wider (commercial) entertainment industry; (iv) substantial tourist income; and so on. The arts are framed generically as 'the arts industry', and their operations particularised through a metaphorical transformation into a business company, thus: 'The arts have an excellent sales record, and excellent prospects. *Customers* are growing in number, and with increased leisure one of the certainties of the future, *use* of the arts will intensify' (my emphasis). The pamphlet claims that the arts may provide a society with 'vision', but its main argument carries the clear implication that they are essentially the same as other types of consumer product and, significantly, 'pleasure' for 'millions of people' comes at the end of the list of benefits. Hence, the potential of theatre to strengthen cultural democracy through increased access is rhetorically downgraded to a populism that hinges on the (unequal) power of customers to buy into a 'business' tinged with elitism. This represents a 'dumbing down' of the theatre system that effects a reduction in its diversity. From an ecological perspective, as we shall see in the next section, it is analogous to the use of pesticides in agriculture during the 1950s and 1960s, when the decimation of particular agricultural 'pests' led to a systemic reduction of many other species.

The economic orthodoxies of monetarism were given vigorous impetus in the late-1980s by John Myerscough's impressive report on *The Economic Importance of the Arts in Britain*. The report drew on extensive empirical evidence to provide ammunition for a claim that the arts are central to industrial restructuring for an information-led service economy. So:

The success of cities in the post-industrial era will depend on their ability to build on the provision of services for regional, national and inter-national markets ... The arts fit *naturally* into this frame ...[28]

Theatres and other arts facilities become cultural magnets to attract 'footloose senior executives' in search of lucrative locations for the new industries, and they can be used to tool-up civic systems by becoming a 'catalyst for urban renewal'. Again theatre and concert audiences, museum- and gallery-goers are transmuted into 'arts customers', and the mighty stamp of empirical authority 'proves' that theatre is best seen as a service commodity – but it is an especially superior one because it can trigger off huge transformative forces in the process of social restructuring

[28] John Myerscough, *The Economic Importance of the Arts in Britain* (London: Policy Studies Institute, 1987), p. 2. My emphasis.

for the postindustrial/postmodern age. In these ways theatre as a system is recruited into the general ecology of a global 'progress' leading to ecological crisis and, possibly, catastrophe.

And what of the political implications of this environmental short-sightedness? The idea of the 'public' enshrined in the Arts Council Royal Charter, which was clearly linked to the Old Labour notion of the 'people', is swept aside by the dual tide of rhetoric and statistics, to be replaced by the atomised customer with individual spending power – and in the process a key interactive link between theatre and democracy is broken. From this position it is then but a short logical step to conceive of the theatre-consumer, rather than the theatre-producer, as the fulcrum of 'success'. Thus in the 1987/8 Arts Council annual report Chairman Rees-Mogg suggested that:

We are coming to value the consumer's judgement as highly as that of the official or expert ... The voice of the public must ... be given due weight ... [and] the way in which the public discriminates is through its willingness to pay for its pleasures.[29]

By the end of the 1980s, then, British cultural policy (as represented by the ACGB) had been refashioned by monetarist ideologies which favoured the commodification and marketisation of art; and, at least at the level of rhetoric, this discursive realm relocates power and authority away from the public and invests it in the image of the consumer as sovereign queen or king. In this system, patronage is replaced by sponsorship, and state funding as a whole becomes 'challenge money' which can only be gained if it is matched by other sources of income, especially support from commerce and industry. In theatrical terms, the box office becomes more important than the stage, and the public – the body politic of democracy – is assumed to be incapable of calling the cultural tune. Money becomes a virus that debilitates the species it was supposed to benefit.

THE IMPACT ON THEATRICAL PRACTICE

During the eighties subsidised British theatres reconfigured their patrons as 'consumers' through major modifications to the various protocols required for the construction of audiences. Stimulated by a variety of Arts

[29] Arts Council of Great Britain, *43rd Annual Report and Accounts* (London: Arts Council of Great Britain, 1988), pp. 2–3.

Council schemes to improve business performance, theatres encouraged audience members to position themselves as 'customers', especially through advertising, at the point of sale, and in front-of-house services. Marketing policy climbed the administrative agenda, producing promotional material that was aggressively designed and copy-writing which often indulged in extravagant hype – thus 'the English Shakespeare Company makes Shakespeare the hottest ticket in world theatre' – implying a certain distinction for those who bought into the product. Most theatres assumed quasi-corporate identities, complete with obligatory logos aiming to promote a sense of 'unique' identification with the producing company. Box-office computerisation and credit-card payment made ticket-buying much easier, and pricing policies reached out to untapped markets through subscription and discounting schemes: theatre attendance became more 'accessible', provided you could afford the ticket. The idea of the theatre building as a (more or less) classy cultural drop-in centre gained currency, foyer areas were redesigned to make them more 'welcoming', bar and restaurant services were added or improved, bookshops and other merchandising outlets livened up the moment of arrival: theatre-going was gradually transformed into an 'experience' to be consumed.

Monetarism forced subsidised theatres to become increasingly populist, in two complementary senses. Firstly, some of the traditional 'snobbishness' of theatre was eroded as the volume of 'bums on seats' became more important than who they happened to belong to, so 'popular' became primarily an indicator of box-office success. Secondly, changing programming patterns produced an overall repertoire of shows that aimed to appeal to non-traditional, 'popular' constituencies. Hence in the first half of the eighties there was 'a decline in the presentation of classical drama ... and a rise in musicals ... and comedies by Alan Ayckbourn.'[30] By the end of the decade it was clear that fewer new plays were being staged and in their place adaptations grew from 5 per cent of the repertoire in 1981–5 to an astonishing 20 per cent in 1985–9.[31] In the first half of the nineties modern musicals continued to increase their share of the repertoire of subsidised theatre (from 5 per cent to 9 per cent, compared to an average of 46 per cent for West End commercial theatres), while modern drama (including adaptations) fluctuated between

[30] Sir Kenneth Cork, *Theatre is for All* (*The Cork Report*) (London: Arts Council of Great Britain, 1985), p. 8.
[31] Paul Barnard, *Drama* (London: National Arts and Media Strategy Unit, 1991), tables 1.1 and 1.2.

21 per cent and 25 per cent, indicating a slight increase in new 'play' production overall. But these figures need to be set against a continuing high dependence on Christmas season pantomime and children's shows (average 23 per cent); the small growth of new work obviously was dependent on this type of popular programming.[32] In ecological terms these trends indicate a negative adaptation in performance programming overall as the diversity of generic 'species' is eroded. Like coral in a cooling sea, the theatre estate is pushed towards becoming a crumbling monument as the live interactions that sustain it are drained of the means to survive.

The encroaching populism of programming patterns was reinforced by other developments in the structuring of British theatre as an 'industry' catering for 'customers'. The growth of the theatre 'package tour' – a coach trip (usually, but not always, to London), a meal, a show, a hotel room at an all-inclusive bargain price – successfully turned mainstream metropolitan commercial theatre-going into an accessible 'outing'. Also, the economic barriers between the commercial sector and the subsidy system had been significantly eroded during the 1980s, most spectacularly signalled by the two musicals produced by the National Theatre (*Guys and Dolls*, 1983) and the Royal Shakespeare Company (*Les Misérables*, 1985) which transferred to West End theatres, but also in an increased cross-over of productions and, crucially, performers between theatre and film, TV, video, radio (especially through well-known names and faces), all of which undermined the theatre's traditional exclusiveness. But it would be mistaken to view this as the development of a mixed economy producing creative diversity; commercial enterprise gained cultural power, and the entrepreneurial few – such as Cameron Mackintosh, who co-produced *Guys and Dolls*, and Andrew Lloyd Webber, who owned the theatre to which *Les Misérables* transferred – grew very rich, in no small measure through the investment seeding provided by taxpayers' money. In this ecology the symbiosis between resource-hungry genres and the 'fat cats' of theatre commerce is profound. However, such high-profile blurring of the historical distinctions between commercial and subsidised theatre sectors served much more than an economic purpose, as it played out the postmodern capitalist challenge to the aesthetic authority of the most elevated theatre institutions in the land. Paradoxically, this further confounded established ideas about the constitution of audiences.

[32] Sara Selwood (ed.), 'The Performing Arts', *Cultural Trends, 1995: Cultural Trends in the '90s, Part 2* 26 (1995), tables 1.4 and 1.9.

The cultural distinctions of British theatre in Bourdieu's sense of the term, in which particular sectors of theatre appealed to particular classes of people to produce differences between Parisian boulevard, bourgeois and avant-garde theatre,[33] were also probably undermined by its growing articulation to the wider processes of consumerism. Audiences as 'customers' were increasingly assaulted, seduced or distracted by a remarkable proliferation of performance-related commodities: T-shirts, badges, hats, posters, pennants, play-scripts, cassettes of show music, videos of the making of the show – if it could carry an image and/or title of the production it was pressed into service. The performance itself might become a fading memory, but its traces could be registered in countless objects, the consumption of which could magically recapture the moment of gazing at the stars onstage. Some especially successful shows acquired their own logo – there was (still is) the half-mask of the *Phantom of the Opera* or the waif-face of *Les Misérables* – which through a kind of semiotic condensing 'becomes' the show. Such markings are not just adverts of power but also serve to demarcate territory as they spread from their source.

Susan Willis succinctly notes that, partly because of their proliferation in contexts separate from what they signify, 'the logos become essentialised in relation to the de-essentialisation of the commodity itself'.[34] This process reinforces the cultural de-differentiation fostered by consumerism, via which the boundaries between different kinds of art (high and low, commercial and subsidised), and between art and everyday life are blurred, thus opening the way to the aestheticisation of the ordinary, which Lash maintains is central to postmodernism.[35] Performance related sales-lines might also be seen as particularly potent signifiers in Baudrillard's characterisation of the 'hyperreality' of consumer societies, since their signifieds are simply vanished fictions.[36] These developments in the semiotic environment of theatre parallel the increasing cross-over of performers and scripts, say, between the different media, further confusing cultural distinctions, making theatre itself seem less 'special', and so, theoretically, creating easier access for more people. But did these trends towards postmodern populism undermine or reinforce an ecology that fostered the democratic potential of theatres?

[33] Pierre Bourdieu, *Distinction: A Social Critique of the Judgement of Taste*, trans. Richard Nice (London: Routledge, 1986), pp. 234–5.
[34] Susan Willis, *A Primer for Daily Life* (London: Routledge, 1991), p. 60.
[35] Scott Lash, *Sociology of Postmodernism* (London: Routledge, 1990), pp. 172–98.
[36] Baudrillard, *Simulations*, 1983.

AUDIENCES REDEFINED

Paradoxically, the shrinking repertoire of British theatres was probably enjoyed by audiences which increasingly became pluralistic between the early-1980s and mid-1990s. The historical middle-class domination of theatre, and especially subsidised theatre, seems to have been challenged by a growing heterogeneity of 'customers'. This is most marked for London, where throughout the eighties there was sustained growth in the proportion of tourists and day visitors using the National and West End theatres, until they constituted over half of the total attendances. Figures for the regions show a much smaller proportion of tickets bought by non-residents, but a much higher proportion of C2DEs (blue collar workers) than is commonly supposed by critics and historians who claim a continuing middle-class hegemony for theatre.[37] This trend towards heterogeneity probably was reinforced both by the collapse of the traditional aesthetic hierarchies under the pressure of populism and by the erosion of boundaries between theatre and the other so-called cultural industries. Hence, as cultural barriers diminish theatre becomes the subject of a widening range of uses. Its place in the big business entertainment account is matched by its contributions to the heritage industry, while the once homogeneous local audience is infiltrated by the domestic version of what Urry, following Feifer, calls 'post-tourists': people for whom there is no correlation between *particular* cultural zones and self- or group-identity.[38] From this perspective, the growing opportunities for 'secondary consumption' of performance crucially reinforce theatre's place in the realm of the hyperreal: wearing a *Phantom of the Opera* T-shirt and/or a National Theatre peaked cap may gather more cultural status than an evening in the stalls watching the show, but it also stimulates desire for the fantasy of participation in the source of the artefact. Hence, the new heterogeneity of the audience for theatre may be seen as a democratising force, involving a wider range of participants in a previously privileged cultural domain. But to determine if increasing consumerism actually leads to a 'lapse into' democracy, we need to look more closely at its effects on the distribution of power, and for theatre ecology this involves making different kinds of distinction from the sociological ones of Bourdieu, most

[37] Feist and Hutchison, *Cultural Trends*, p. 37; Myerscough, *Economic Importance*, p. 25.
[38] John Urry, *The Tourist Gaze: Leisure and Travel in Contemporary Societies* (London: Sage, 1990), pp. 100–2.

notably between audience authority and cultural power, i.e. the privileges of niche locations and availability of energy sources.

The likely effects of the consumerist trends on British theatre in the last twenty years of the twentieth century, *vis-à-vis* audience authority and cultural power, are paradoxical. For example, theatre's place in the whole cultural realm may have been enhanced. We can identify this empirically, perhaps, in ticket sales and yield. While there was a decline of 13 per cent in attendances in the subsidised sector between 1986 and 1995, the total number of attendances for commercial and subsidised theatre combined held steady through the second half of the 1980s, dipped significantly in the general recession of the early 1990s, but recovered to the higher levels of the eighties by the middle of the decade. It is notable, though, that this general level of recovery masked a significant redistribution of attendances between London and the regions, a factor I will look at more closely in the next section. Nonetheless, the overall stability is remarkable, given that throughout the period the rise in average ticket prices easily outstripped the rate of increase of average earnings in Britain.[39] Clearly, the high levels of attendance by tourists was a major factor in this economic stability, though in terms of the share-out of cultural power their presence may be interpreted as *de*stabilising for the home audience (at least in London), introducing a global vector which can be seen as undermining any local democratising trends. Though the detailed statistical evidence for the 'consumption' of theatre in this period is relatively sparse and difficult to interpret,[40] these trends may give more credence to the argument that the theatre came to rely less on an established audience returning for several visits, and so was used overall by a growing number and range of people from both the UK and abroad. For example, these would, on average, pay less each, because the differentials between top and bottom seat prices widened, as if in response to the growing economic inequalities in British society as a whole under the pressures of monetarism.[41] In terms of theatre ecology, though diversity in the generic

[39] Feist and Hutchison, *Cultural Trends*, p. 4; Rachael Dunlop and Jeremy Eckstein, 'The Performed Arts in London and Regional Theatres', *Cultural Trends* 22 (1994), 2; Andy Feist, 'Consumption in the Arts and Cultural Industries: Recent Trends in the UK', in *From Maestro to Manager: Critical Issues in the Arts and Cultural Management*, ed. Marian Fitzgibbon and Anne Kelly (Dublin: Oak Tree Press, 1997), tables 1.3 and 1.4.

[40] Feist, 'Consumption in the Arts', p. 258.

[41] Some measure of the extent of this drift away from a culturally democratic economic system is suggested by the trends in average ticket yield between 1986 and 1995, which for home-based productions of subsidised repertory theatres grew by just over 25 per cent, while that for operas produced by the Royal Opera House in London rose by almost 100 per cent. Ibid., table 12.2.

'species' of live performance onstage was reduced, improvements in the accessibility of the theatre niche tended to ensure an increasing diversity in the collective organisms of their audiences, adding energy to the system as a whole. But what was the living constitution of these collectives with regards to their likely influence on the survival rates of the aesthetic 'species' that kept them coming, and what implications did that carry for the prospects of sustainability for this particular theatre ecology as an energetic system of democratic diversity?

These developments indicate a rising *status* overall for theatre as a symbolic commodity, an improvement reinforced by the growth of secondary consumption. Consumers of theatre – both primary and secondary – stood to gain more authority from this enhanced general status. On the other hand, the lack of cohesion brought by the expanding heterogeneity of actual audiences, the separation of theatre generally from any particular social formation, suggests a dispersal of power – except perhaps in relation to the metropolitan elite enjoying the opera.[42] It becomes even more difficult to employ Bourdieu's concept of 'distinction' without significant qualification, or to claim that Rees-Mogg's 'electronic middle classes' were using theatre to consolidate their position in the social pecking-order. Instead, we have the spectacle of a fragmenting populist democratisation, a growth in access through which the power of the actual audience collective as part of a social formation – middle class or otherwise – is supplanted by the authority of the individual consumer, with those possessing the greatest spending muscle possibly using the 'highest' of arts – opera – for a display of opulence as a way of buying into increasingly centralised power. Differentiation between niches fostered a new hierarchy of species. Thus, through its audiences, British theatre was reshaped in the paradoxical image of a highly hierarchical 'democratised' estate. Hence we may say that generally the British theatre ecology had successfully adapted to the tectonic shifts of political and economic forces in is wider environment, but at the price of increasing instability for the majority of its users, who were consequently faced with a widening range of threats to its and their survival as a more or less effective political entity. A near perfect outcome, perhaps, for a general human ecology seemingly bent on collaborative doom. Do postmodernist relativism, capitalist accumulation, liberal democratisation and the other

[42] Royal Opera House ticket prices rose by more than twice those of any other theatre between 1990 and 1994, while average attendance capacity remained high at 88.8 per cent of available seats. Selwood, 'The Performing Arts', tables 1.11 and 1.16.

'goods' of early-twenty-first century globalism become a combination of unaffordable luxuries when together they produce such a paradoxical ecological pathology?

INTO THE NINETIES

In 1988, after almost a full decade of Thatcherite monetarism, Goldsmiths College in London convened a national conference under the title 'Theatre in Crisis'. The conference declaration took a robust line on the economic question:

- a free market economy and private sponsorship cannot guarantee the necessary conditions for theatre to fulfil its many functions
- the foundation of its funding at a level adequate to its basic needs and future development must be public, and ... the management and distribution of that funding should be democratically organised and devolved.[43]

The direct linking of money and a *lack* of democratic political principle indicates the extent of the mistrust of the then current government felt by many working in British theatres. That the declaration was signed by practitioners from the top of the theatrical tree – Harold Pinter and Peter Hall among them – as well as by younger academics and theatre workers, shows just how serious the crisis was felt to be. While at the time such local cultural discontents were properly overshadowed by international events, including Tiananmen Square and the fall of the Berlin Wall, in retrospect they provide part of an ironic British counterpoint to the global struggle for democracy. Continuing its contradictory commitment to centralised state control, in 1989 Thatcher's government forced the deeply unpopular Poll Tax onto Scottish ratepayers despite the fact that Scotland had less than a handful of Tory Members of Parliament, following up – in face of widespread protests and rioting – with its imposition in England in April 1990. Five months later the Iron Lady was compelled to resign by the party she brought to power.

Her successor, John Major, was thought to have a kinder attitude to culture – after all, his wife Norma was an enthusiast for opera – and signs of an economic policy more friendly to the arts emerged in 1990, strengthening in 1992 when David Mellor became the first Secretary of

[43] Andy Lavender, 'Theatre in Crisis: Conference Report, December 1988', *New Theatre Quarterly* 5: 19 (August 1989), 213.

State for the National Heritage (a new government department covering the arts, sport, the built heritage and more). However, while there was a real growth of 3.4 per cent overall in government subsidy to the performing arts (dance, drama, music) in the first few years of the decade, the total theatre subsidy actually reduced by 1.8 per cent and in 1993 a further cut of 18 per cent was imposed, followed by several years of standstill funding levels and a growing price resistance at the box office, particularly in the regions.[44] So in the first half of the nineties the signs of a collapsing system appeared everywhere, ranging from the Royal Shakespeare Company closing the Barbican Theatres for six months in a desperate attempt to reduce its growing deficit, to the Liverpool Playhouse appearing in court under the threat of receivership.[45] Yet the economic misery was not evenly spread, as an acute contrast in financial performance between London's commercial theatres and the regional subsidised theatres demonstrates. There was a drastic 25 per cent drop in total attendances at regional theatre (12 to 9 million) between 1992 and 1995, while those for London's West End rose only slightly, but produced a 6 per cent growth in box-office revenue.[46] In this sector, government policies that 'freed' the market seemed to be working. But despite efforts by the Arts Council to prevent it, the deterioration of regional theatre continued throughout the decade, prompting even the ultra-conservative *Whittaker's Almanac* to pronounce in 1997 that 'The days of a repertory rooted in its community and producing work which reflects that community appear to be numbered',[47] and leading Sir Peter Hall to claim in 1999 that 'We're going to end up with almost no regional theatre except for one or two centres, say Leeds and Birmingham.' [48] To both theatre practitioners and audiences, the price of systemic adaptation to the superheated instabilities of this new economic environment was proving far too high. Not surprisingly, from a radical green economic point of view, its contradictions are straightforward evidence of its overall lack of sustainability.[49]

The Conservative government's main response to this worsening crisis was the National Lottery, which was introduced in 1994 to produce funds

[44] Selwood, 'The Performing Arts', p. ix.
[45] John Bull, *Stage Right: Crisis and Recovery in British Contemporary Mainstream Theatre* (London: Macmillan, 1994), pp. 24–5.
[46] Selwood, 'The Performing Arts', tables 1.2, 1.4 and 1.7.
[47] *Whittaker's Almanac*, 'Theatre' (London: Whittaker and Sons, 1996/7), p. 1127.
[48] Dan Glaister, 'ACE Rhetoric, Pity about the Grants', *Guardian* (16 February 1999), 15.
[49] Pepper, *Modern Environmentalism*, pp. 88–91.

in support of five 'good causes': charities, sport, heritage, the arts and a Millennium Fund. However, applications to the arts fund could only be for capital investment, not for revenue costs. The Arts Council was responsible for managing the new fund, and in the first year of operation it distributed £228.3 million to 338 organisations, but the pattern of awards caused continuous controversy as 61 per cent was given to four companies – the Royal Opera House, Sadler's Wells Theatre, the Royal Court Theatre and the Shakespeare Globe Theatre – all of which were based in London.[50] In addition, the tabloid press created a 'dosh for toffs' scandal as £13.25 million was given to Cambridge University for the purchase of the Churchill papers, £3 million went to pay for a local authority athletics centre to which the leading public school, Eton College, would have rights of access, and the biggest grant of all – £78.5 million – went to the Royal Opera House for a major rebuilding plan. By 1996 many of the subsidised theatres outside London were also enjoying major refurbishment schemes or even total rebuilding. But ironically the lottery windfall further worsened the financial performance of these theatres as the increased costs of running updated buildings – typically, environmentally aware building policies were not much in evidence in this period – coupled with falling grant revenue simply inflated their cumulative deficits. Typical examples from 1997 include the experimental Greenroom Theatre in Manchester and the Cambridge Arts Theatre, both of which had to reduce their programming significantly, further lowering income and thus risking a downward economic spiral.[51]

The acute contrast of economic out-turn in the 1990s between the London commercial and regional subsidised theatres can be seen as an effect of the global 'success' of late capitalism. The commercial theatres of the West End of London could flourish in this environment because, particularly through the appeal of modern musicals, they were 'positioned' on the international tourist map as an attractive element of global culture. The National Theatres (the Royal Shakespeare Company and Royal National Theatre, particularly) could partly benefit from this restructuring, but primarily by incorporation into it, either through the marketing of complementary products (the classics as heritage plays), or through coproduction arrangements with the commercial sector

[50] Luke FitzHerbert, Cecelia Giussani, and Howard Hurd (eds.), *The National Lottery Yearbook* (London: Directory of Social Change, 1996), pp. 33–5.
[51] Paul McCann, 'The Trouble Starts with a Million-pound Windfall', *Independent on Sunday: Focus* (24 August 1997), 13.

(especially of modern musicals), or through international touring to other global cities. But the majority of regional theatres could only participate, quite literally, on the margins of this system, so that its financial rewards grew increasingly remote. With overall state subsidies held almost at a standstill in order to force a partial privatisation through increases in sponsorship and box-office, and with its physical fabric generally in process of serious deterioration, the regional theatre and its audiences were placed in a Catch-22 situation. For them the policies that aimed to reap the economic benefits of globalised late capitalism for the whole of British theatre had precisely the opposite effect. Hence the majority of British people were subject to worsening theatrical opportunities locally at the same time as the globalisation of the media brought them news of the cosmopolitan triumphs of shows produced in their capital city. Hardly surprising that fewer and fewer of them bothered to attend, even as lottery money made the theatres more comfortable and welcoming. The values of theatre to the local community, especially as a component of democracy, were being replaced by the dubious pleasures of individualised consumerism, while its standing in the national cultural agenda was significantly compromised by the homogenising effects of globalisation.[52] As the millennium neared, the capitalist economics of the global cultural marketplace had forced 'British theatre' into a state of serious structural instability, significantly undermining its role in the fostering of a healthier democracy. The overall theatre ecology in Britain was in great trouble, paradoxically because of its success in adapting to the harsh environment produced by liberal capitalist democracy. No wonder that there were mounting cries of crisis.

ENTER NEW LABOUR

Where economics are concerned, as Bernard Shaw's epigram dictates, there is never likely to be a conclusion, and this is particularly the case when a new government declares a totally new approach to the business of state – so the prognosis for any neat rounding-off of this chapter is exceedingly poor. When, after eighteen years of Tory rule, Tony Blair's New Labour was elected on 1 May 1997 in a landslide victory that produced an overwhelming Labour majority in Parliament, a new type of politics seemed to be born. New Labour's 'third way' style of government

[52] For useful early discussion of the homogenising vectors of global culture, and counter tendencies, see: Anthony D. King, *Culture, Globalisation and the World System* (London: Macmillan, 1991).

aims to steer, in Anthony Giddens's phrase, 'beyond left and right', but in the process it colludes with globalising economic forces which ensure that 'Keynsianism falters and Soviet-type economies stagnate.'[53] The language of New Labour's cultural policy, which emerged in the wake of this soft revolution against its historical roots, enunciates a genuinely coherent social vision, or shows signs of acute ideological insecurity – depending on your point of view.

Hence, in the speeches which the new Secretary of State for Culture, Media and Sport published as *Creative Britain* in 1998 we find some familiar monetarist themes about the fiscal functions of culture married to an enthusiasm for the positive – and democratising – social powers of art. In Secretary of State Chris Smith's version of the cultural economy, wealth-producing industry encompasses art, which becomes just another factor producing the pleasures of 'Cool Britannia'. Hence, he presents the interrelationships between very different sectors of cultural activity – popular music and theatre, for example – as homogenous in economic terms, part of a 'Summary Map of the Creative Industries'.[54] The state needs to work in partnership with commerce and industry to make the market more civilised; while art needs to buckle down still further to the realities of management efficiency and properly balanced books. Just as political differences between left and right are seen as a false dichotomy, so culture and cash, art and big business, theatre and commerce tend to collapse into each other. We may see this as yet another manifestation of postmodernisation: the elimination of hierarchies of value, a fantasy flattening-out of the mountainously rough terrain of inequality and injustice that Thatcherite monetarism had made of the social. Or it may seem to be what Chris Smith claims, a heart-felt effort to balance the demands of artistic excellence with a desire for universal access to theatre and other cultural institutions in an attempt to eliminate the evils of social exclusion and create a more robust democracy.

But the story of theatres and economics in Britain during the last twenty years of the twentieth century seems to demonstrate the ideological symbiosis of culture and general commerce, as division and inequality prospered in both. Paradoxically, that story would be more reassuring if it had shown straightforward causal effects in operation, in, say, state fiscal policies producing structural economic change in the

[53] Anthony Giddens, *Beyond Left and Right: The Future of Radical Politics* (Cambridge: Polity Press, 1994), p. 67.
[54] Chris Smith, *Creative Britain* (London: Faber and Faber, 1998), pp. 151–65.

theatre sectors. But from an ecological perspective everything is part of a complex interdependence that renders nothing straightforward, so it becomes increasingly difficult to identify primary controlling factors – whether in the theatre or the economy – with any confidence. This is why an analysis that deploys theatre ecology is useful, because it can produce a multi-perspective, non-reductive historiography that pays due respect to the systemic complexities of theatre and its environment. That in turn has the advantage of showing how economic, cultural, political, aesthetic and other vectors combine as they play through particular theatres and performances in their multi-faceted interactions with other ecologies.

In the late-1990s, as the cusp of the millennium approached, it was not at all clear where New Labour's 'third way' was likely to lead theatre in Britain politically, to a more democratic or a more hierarchic dispensation. The Secretary of State for Culture, Media and Sport may well have agreed with Ruskin that 'There is no wealth but life',[55] but economics seems, as Galbraith so clearly saw, to have ways of insinuating itself into the very heart of a culture. And, as we have seen, there is probably no theatre ecology that is impervious to its more viral elements. So just as in the free market we can be sure that some of the rich may be parted from their money, in New Labour's 'third way' it was by no means certain that the poor would not be parted from the most sustainable emergent cultures. The rhetoric of a fresh democratic dispensation was everywhere in the brave new world beyond left and right, but the structures of the British cultural environment created in the previous twenty years – and those of its theatres in particular – seemed ill-designed to contribute to a weakening of the political and economic forces that act as a deterrent to democracy.

[55] Ibid., p. 149.

CHAPTER 6

Audiences of performance: declining participation

THE PROBLEM OF APPLAUSE

At the turn of the third millennium applause, apparently, was not what it used to be. In a brief report on London's first-night West End audiences Lyn Gardner, theatre critic of the *Guardian*, noted a certain increased hyperactivity of response. These audiences for a couple of decades had been known often to applaud at the first entrance of the star actor (especially if she or he was elderly), at Shakespeare's soliloquies, at the sets of modern musicals. Such outbursts surely indicate the audience's sense of itself as part of the occasion of the show, but it was the nature of applause at the curtain call, implied Gardner, that may tell us most about the general health of the theatre.

> What is new is audiences' increasing fondness for the standing ovation. In the past two years theatre-goers have become more determined than ever to make their stand ... Returning the favour, actors themselves are increasingly prone to applauding their audiences. This suggests a disturbing lack of confidence in both the play and their own abilities – as if they are astonished that we are there at all.[1]

Of course, there is a methodological debate to be had about the value of such information in the making of generalisations about the theatre in any particular period.[2] Is the first-night audience, as Gardner argues, 'an entirely different breed from normal theatre-goers'; or is it the theatrical equivalent of litmus paper, a reliable indicator of the cultural toxicity – or vitality – of the event in its whole environment; or are its reactions so fickle and fleeting that generally they are best ignored by theatre scholars,

[1] Lyn Gardner, 'Just Sit Down and Shut Up', *Guardian Saturday Review* (14 October 2000), p. 4.
[2] See, for example: Jackie Bratton, *New Readings in Theatre History* (Cambridge University Press, 2003); Thomas Postlewait and Bruce A. McConachie (eds.), *Interpreting the Theatrical Past: Essays in the Historiography of Performance* (University of Iowa Press, 1989); W. B. Worthen and Peter Holland (eds.), *Theorising Practice: Redefining Theatre History* (Basingstoke: Palgrave Macmillan, 2003).

or at least relegated to the odd footnote in histories of the art? And if such uncertainty attaches to the generality of audience response, what hope is there of making any useful sense of applause itself? Yet Gardner's perception of a sea-change in late-twentieth-century audience behaviour, even if only in the refined niche of the first-night aristocracy of London's commercial theatre, prompts me to think that the range and styles of theatrical applause may be worth dwelling on. This is for the same kinds of reason that a geneticist, say, may pay attention to a protein that seems marginal: might this matter be an index to the health, or disease, of a whole culture?[3] So to put the larger issue of method addressed by this chapter into a nutshell query: in what ways can theatre ecology, and particularly its political dimensions, be better understood through thinking of its applause?

'Applause!' indeed. So let words be like proteins in the world of geneticists, crucial information-carriers for the evolution of the total system of a culture or an organism. Both proteins and words help to bring living systems into being. Hence the verb 'applaud' entered the English language in 1536, just forty years before James Burbage built the first Theatre in Shoreditch, but it took another twenty years or so after that monumental event before the noun 'applause' itself was coined.[4] Both words were adaptations from the Latin (applaudere, applausus), so it comes as no surprise that the playwright who was especially proud of his classical learning should be moved to exclaim, in his 1623 dedicatory poem to Shakespeare's First Folio, 'The applause! delight! the wonder of our stage!'[5] Thus Ben Jonson recognised with characteristic perception that applause and the English secular theatre were coterminous. And from the perspective of theatre ecology, the productive capacity shared by proteins and words suggests that applause itself might constitute theatre in much the same way as waves define the shore, or as prevalent winds sculpt the edges of a forest. Taking that speculative conceit as a starting point, this chapter explores how comparisons between cultural and

[3] Steve Jones, *In the Blood: God, Genes and Destiny* (London: Flamingo, 1997), pp. 363–5.

[4] *Shorter Oxford English Dictionary*, 3rd edn (Oxford University Press, 1970), p. 85. The *Shorter Oxford English Dictionary*, 5th edn (Oxford University Press, 2002 [1993]) is more circumspect about giving year dates. It reverses the chronology between verb and noun and places their advent a century or so earlier, when the transition from religious to secular theatrical performance in England was well under way. In this chronology the morality play replaces the opening of the Theatre, perhaps, but the substantive point remains. I retain the *SOED* 3rd edn dates for the dramatic point about the Theatre.

[5] William Shakespeare, *Mr. William Shakespeare's comedies, histories & tragedies: a facsimile of the first folio, 1623*, intro. Doug Moston (London : Routledge, 1998), p. xx.

natural forms with specific structural similarities might be understood as deeply analogous, or even as substantively homologous, through the analysis of ecologies of theatre and performance.

Given that applause could be paradoxically fundamental to theatre in this way, it is a curiosity of relatively recent scholarship that standard reference works in English such as *The Oxford Companion to the Theatre* (1967) and *The Cambridge Guide to Theatre* (1992) carry informative entries about Adolph Appia or G. B. Shaw's *The Apple Cart*, about Apollodorus or the apron stage, but devote no space at all to applause. Even more remarkable, the same is true of influential studies of audiences in theatre and performance by, for example, Susan Bennett, Herbert Blau, Jill Dolan, Nicholas Abercrombie and Brian Longhurst, none of which list applause in their indexes nor treat it as a distinct topic.[6] Patrice Pavis's *Dictionary of the Theatre* (1996) does have an entry which suggests that applause 'is a fairly universal phenomenon', while *The Oxford Encyclopedia of Theatre and Performance* (2003) offers a neat qualification with 'applause may be ... universal, but it is not universally the same', citing examples ranging from the waving of toga flaps in the Roman theatre to clicking of the tongue in appreciation of classical Indian dance.[7] Hand-clapping in the theatre has been widespread historically and geographically, but its styles are still very much specific to its cultures. The standing ovations enjoyed in West End theatres were not globally ubiquitous. In contrast, the general scholarly silence surrounding applause is, as they say, deafening. But what might such silence, such a dominant lack of interest in a crucially defining feature, at least of Western theatre, signify? Or, to turn the question on its head, why do theatre scholars appear to take for granted our knowledge about what applause may be for?

This is a complicated question, because the scholars' assumption that we, the audience, know what applause *is* implies an intimacy with the making of applause that is in some sense difficult to deal with, theoretically awkward, maybe even embarrassing. Perhaps most theatre analysts

[6] Phyllis Hartnoll (ed.), *The Oxford Companion to the Theatre*, 3rd edn (Oxford University Press, 1978 [1967]); Martin Banham (ed.), *The Cambridge Guide to Theatre*, rev. edn (Cambridge University Press, 1992); Susan Bennett, *Theatre Audiences: A Theory of Production and Reception*, 2nd edn (London: Routledge, 1997); Herbert Blau, *The Audience* (Baltimore: Johns Hopkins University Press, 1990); Jill Dolan, *The Feminist Spectator as Critic* (Ann Arbor: UMI Research Press, 1988); Nicholas Abercrombie and Brian Longhurst, *Audiences* (London: Sage, 1998).

[7] Patrice Pavis, *Dictionary of the Theatre: Terms, Concepts and Analysis*, trans. Christine Schantz (University of Toronto Press, 1998 [1996]), p. 28; Dennis Kennedy (ed.), *The Oxford Encyclopedia of Theatre and Performance*, vol. I (Oxford University Press, 2003), pp. 69–70.

have not wanted to acknowledge applause in the context of serious scholarship because it is perceived to be incidental or marginal to performance. Or perhaps applause – like sex and laughter – is in itself a thoughtless act, maybe a response arising from a basic impulse or reflex action, over which, in the end, we have little control. Hence applause may be thought of as a biologically given that fits us out for hegemonic submission. In this interpretation, applause seduces us into the 'logic of private obedience' to dominant ideologies that Slavoj Žižek sees Brecht uncovering in the *Lehrstücke*,[8] which in turn links applause to the Lacanian concept of the 'phallic signifier' through which 'loss as such attains a positive existence'.[9] Applause therefore celebrates the loss – the lack – it tries, impossibly, to mark; for perhaps it can never fully recover the events it appreciates, except perhaps in the spectre-like quality of an encore, which itself intensifies the immediate irrecoverable quality of the rest of the show.

Or, to offer a sociological interpretation instead of a physiological or psychoanalytic one, applause is the moment in which the collective aims to assert itself over the individual, through which an imagined community is evolved. So the pitch of applause – whether it is a standing ovation or a desultory clap – indicates different types of consensual abandon, a giving-up of individual judgement. We lose something of ourselves in putting our hands together with others in public. This notion of applause as a conservative theatrical force has profound implications for theatre ecology that deepen the issue of how audiences are caused to applaud. Is it more like tears, perhaps genetically driven, than like nodding, a matter of choice?

The ecological resonance of that question may become resounding if applause is viewed as an elemental vector of feedback in the creation of a theatre ecosystem, a literal transfer of energy that crucially drains or sustains it. A standing ovation could be storing up energy for the future, as *outside* the theatre it becomes negative feedback that draws more vital applauders to this successful niche. Or might it be, as Gardner suggests, a process of excessive wasting, a blast of positive feedback *within* the theatre that ratchets up the odds against survival as it attempts to compensate for more crucial wastage elsewhere in the system?

Given such considerations, the paucity of knowledge about applause, even regarding how audiences know how to do it, is profound. In the

[8] Slavoj Žižek, *Enjoy Your Symptom* (London: Routledge, 1992), p. 175.
[9] Slavoj Žižek, *The Sublime Object of Ideology* (London: Verso, 1989), p. 157.

Western tradition the practice is certainly not a result of formal teaching. It is a discipline not on the syllabus; there are no professors of applause. So, while virtually every act of theatre is in some sense defined by applause, we seem to be too mystified or even ashamed by the way we have acquired the habit to want to talk about it openly, or to study it. Maybe it confirms the paradox dreamt up by French playwright Tristan Bernard: 'In the theatre the audience want to be surprised – but by things that they expect.'[10] So is applause, whatever its temper, a signal that all is exactly as it should be in the theatre ecology – reassuringly self-satisfying?

THE SHAPE OF THE ARGUMENT

The continuing low status of applause in scholarly debate is paradoxical, because applause became more important to Western theatres in the second half of the twentieth century, as other forms of audience engagement were reduced. This reduction was integral to a theatre ecology that often discouraged democracy in the final two decades of the twentieth century, as discussed in the last chapter. So in this chapter I extend the period of investigation back to World War Two in order to trace out a longer history of permissible response. This shift in most Western theatres can be characterised as an evolutionary adaptation to an environment in which audiences were transmuted from *patrons*, to *clients*, to *customers*. I will argue that this historical drift indicates an intensifying acquiescence in audiences, an increasingly pervasive relinquishing of cultural power. I will add qualifications to this overall story, because of course audiences were more complexly constituted than its plot implies and the evolution was by no means uniform, but my main purpose is to sketch out dominant trends.

I will then take a close look at an especially telling case of audience conformity in the staging of a play that aimed to outrage the audience, and which caused something of a critical storm. This was Mark Ravenhill's *Shopping and Fucking*, and my analysis focuses on a report by an audience member – the academic Dominic Shellard – of a particular performance at the West Yorkshire Playhouse in Leeds, in 1997. Despite this play's shocking determination to provoke a riven response it was largely neutered by the disciplines of a British theatre ecology heavily influenced by the transmutation of theatre audiences into a relatively docile sub-species, especially when compared to, say, football fans. My measure of this trend

[10] 'Tristan Bernard' in John Daintith (ed.), *Biographical Quotations* (London: Bloomsbury, 1997); Website – www.Bloomsbury.com/ARC/detail.asp?entryid=118251&bid=3 (10.06.2006).

will be the ways in which audiences increasingly were prevented from becoming unruly. Or, to put this ecologically, the ways in which they were discouraged from introducing creative energy that would reduce the entropy of mainstream theatre ecology in the UK. In conventional critical terms, the theatre environment produced a political weakening of audiences and, by extension, the communities from which they were drawn.

In contrast to the meta-systemic focus on economics in the previous chapter, here I address issues about the health of theatre ecology in the practices of actual performance, in the exchange between actors and audiences. And I want to try to shed some light on the draining of audience energy by framing that exchange in two main ways. Firstly, by raising general questions about how audiences in late-twentieth-century Western theatre were determined in the practice of their role through an increasing severance from the wider environment (cultural, political, ecological) as a critical flexibility of response was discouraged. And secondly, by posing questions about how audiences might have made the theatre more effective as a community-forming and political process through disrupting the theatre's critical disengagement from that wider environment. There is, of course, an implied paradox in this tension between audience and theatre: the audience may want what the theatre withholds. Hence in the second half of the twentieth century the protocols of audience membership in most Western theatres, but particularly in so-called mainstream theatres, undermined participation in more general performance ecologies.[11] As a result, British theatre in particular became increasingly irrelevant to communities and to politics, and this fuelled the sense of theatrical crisis at the turn of the millennium discussed in chapter 2. So a reconnection of performance, community, politics and environment through theatre in the twenty-first century would require an understanding of how and why the audience became disempowered. I suggest that the growing importance of applause, as other forms of participation diminished, was index to a systemic pathology in twentieth-century Western theatre ecology.

[11] John Bull has pointed out a tendency among theatre academics to use the term 'mainstream' in an undifferentiated manner. In this chapter I am taking 'mainstream' to mean the West End theatres, National Theatres (Royal National Theatre, Royal Shakespeare Company, Royal Opera House) and regional repertory theatres in the UK, and their equivalent in other Western (or Westernised) capitalist democracies. John Bull, 'The Establishment of Mainstream Theatre, 1946–1979', in *The Cambridge History of British Theatre*, vol. III, ed. Baz Kershaw (Cambridge University Press, 2004), p. 326.

My main method, therefore, will be to describe how audiences were constituted as an ecosystemic factor in the evolving British mainstream theatre. I will trace the unavoidable interdependence between the systemic functions of audiences as patrons, clients and customers as they were largely shaped through the behavioural protocols set by artistic policies, auditorium conventions, styles of publicity and so on. This type of interdependence prospects for an integrated fine-tuning of the theatre system, so that, for example, all the offstage activities on the auditorium-side of the ecology work more or less in concert with the onstage and backstage routines of production to establish its specific micro-environment as, potentially, a sustaining niche for theatre folk. Clearly, as many observers before me have remarked, historically these systems have been especially, and perhaps increasingly, complex. So to bring this complexity within reach of analysis in this chapter I shall concentrate on the main theatrical equivalents to what ecologists call 'edge effects'.[12]

Edge effects, as noted in chapter 1, occur where two or more distinctive ecosystems rub up against each other, such as river-banks, forest perimeters, urban boundaries and so on. Ecologists call these areas 'ecotones' – a word deriving from *eco*(logy) plus *–tone*, from the Greek *tonos* or tension – hence, places where ecologies are in tension. The consensual view in ecology argues that ecotones tend to produce an especially dynamic diversity of life processes, so their vectors at any time may indicate the current and future general health of the wider environment. But also particular ecotones can exhibit edge effects pulling in a variety of ecological directions in sub-environments that are more or less stable, a quality especially pertinent to the rarefied zones of theatre ecology. Again this throws the question of the ecological 'nature' of theatre ecology into high relief. As explored in earlier chapters, the analysis of 'edge effects' and 'ecotones' of cultural forms may be analogical and/or homological and/or paradological, depending partly on complexity in how the cultural–natural factors are compared. In all three methods, theatre ecology (culture) may articulate to environmental ecology (nature) through both structural (ecotone) and processual (edge effect) systemic factors.

The obvious theatrical instance of this general ecological model, often claimed as the defining feature of theatre and/or performance, is actor–audience or performer–spectator interactions. Viewed from this perspective, theatre ecology is constructed as an ecotone that would seem to

[12] 'Edge phenomena' occasionally replaces 'edge effects' in ecology; it is more frequently used in parapsychology, physics and ophthalmic surgery.

be at least structurally homologous to many natural environments, and possibly the species behaviour they encourage in, for example, display, disguise, herding and so on in the 'animal world'. The rest of this chapter will explore theatre from this structural perspective through analysis of the specific conditions that produce edge effects in theatre ecologies, particularly in the relationships between spectators and performers, stages and auditoria, and audiences and theatres. This view of theatrical edge effects will also be used to assess the significance of theatre to its wider environment, especially regarding the relationships between performance, politics and community.

It is a commonplace of theatre and performance studies that actor–audience interaction is the major key to whatever efficacy theatre may have, whether for community, politics or the environment more generally. But it is equally patent, as we have seen in earlier chapters, that the phenomenally fleeting and ephemeral nature of that interaction makes it particularly recalcitrant as an object of study. However, if we view theatre as dependent on performance ecology as described above, then we may legitimately infer that a change in one element will have an effect on all the others. So historical developments in, say, the ways in which audiences were encouraged to construct their role will have had an effect on their behaviour, on their processes of reception, on the attitude of the actors towards them and so on. Thinking of actor–audience interaction in terms of ecological edge effects may enable us better to see how the changing disciplines of audience membership, including those of applause, can be an index of the general health of the theatre.

My primary political purpose in taking this approach is to try to determine the ways in which audiences may be encouraged, or discouraged, from participating in democratic processes of self-constitution *during* performance, and therefore in the active formation of democratic communities. The overall argument I shall offer suggests that in the latter half of the twentieth century Western theatres, more often than not, discouraged democracy, and that this is a key reason why in the same period there was so much experimentation in performance beyond theatre.[13] Though I shall be focusing on Western, and particularly on British, theatres, the phenomenal growth in extra-theatrical performance in performative societies throughout the world indicates, I think, what we could call a global democratic deficit. Democracy seems to spread, but its systems for popular

[13] See: Kershaw, *Cambridge History of British Theatre*, esp. chapters 15 and 20–3.

political participation tend to fail the electorate at large even as the imperative to participate through performance pervades every realm of social life. Hence this view of a decline in democracy is in flat contradiction of the received wisdom that sees post-1989 as a period in which democracy flourished. Accordingly, I offer it as a starting point for debate.

Before I create an outline history of post-World War Two audiences in Britain, though, it will be useful to take a brief look at examples of unruliness in the theatre from an earlier period. When naughty spectators take the protocols of theatre into their own hands, so to speak, through riots and other incidents of 'illegitimate' self-empowerment, theatre ecology is often treated to a shock of renewal.

UNRULY AUDIENCES

Masterpieces are born and grow into maturity partly at the cost of audience acquiescence to the disciplines of theatre, particularly the discipline of applause. The louder and the longer we applaud the more we participate in the making of masterpieces. Hence in theatre ecologies that are an embedded part of hierarchical societies, standing ovations produce and reinforce systems of cultural dominance to which audiences are then subjected. Such reinforcement is best understood as fundamentally systemic, so that even a radical masterpiece cannot avoid effects that conserve structural oppression. An audience that riots, or otherwise denies the applause that makes masterpieces, exposes the functions of the protocols of theatre in the wider systems of domination, and in so doing challenges its environment to adapt to its needs. To put this in theatre ecology terms: a riot introduces entropy into the ecotone of stage and auditorium, actor and audience, so that its edge effects become unpredictable; a riot might make or break the reputation of a play, a production, or a theatre, but the impact of its excess of entropy can hardly be ignored. Such disordered energy always poses both a threat and an opportunity to an ecosystem, as it is the source both of decay and potential destruction and of rejuvenation and potential renewal. In this sense all ecosystems have an ambivalent potential, but ecotones are especially dynamically ambivalent, and those of theatre ecologies are no exception. Even so, it may take much more than the edge effects of a single riot to produce significant systemic change.

A strong example of this kind is provided by John Drinkwater's now mostly forgotten play *The Tinker's Wedding*. On the second night of its short London run in the early 1920s the theatre manager Bache Matthews

received a telephone tip-off that there was going to be trouble, and a booked-out balcony seemed to bear this out. Sure enough, when the play began, in Giles Brandreth's words:

all hell broke loose. From the gods, lumps of plaster – torn from the theatre walls – were hurled at the stage. Cigarette cases, clasp knives (one of which was thoughtfully followed by a roll of crepe bandage) and a large latch-key all landed at the cast's feet.[14]

The curtain was brought down and Drinkwater appealed for an explanation. The people in the balcony elected a spokesman, who told him that the portrayal of the priest in his play was offensive to their church and if the show continued not a line would be heard. All lovers of free speech will be glad to know that the play did indeed continue, though nothing could be heard above the din. Probably twenty-first-century liberal sensibilities would class this incident as a case of the censorship that it no doubt was. But equally a different attitude might emerge if the balcony crowd had been black and protesting against racism. My main point here is that the communities that the theatre customarily constructs through its rituals of silence and applause, through its disciplinary procedures, may not be as enlightened nor as benevolent as theatre makers, scholars and enthusiasts might like to think. Yet also the entropy which unruly audiences inject into unresponsive theatre ecologies can have positive transmutational edge effects.

The rioting church-goers at *The Tinker's Wedding* were a paradoxical part of a wider phenomenon. In an analysis of the 'Gallery First Nighters' in the London theatre of the 1920s and 1930s Maggie B. Gale indicates the evolution of an audience segment that did not restrict itself to conventional responses, so that the theatre critics 'regularly complained that they were noisy and disrespectful'. She argues that these mostly upper-working-class ticket-holders to the 'Gods', or upper gallery, of West End theatres 'produced a new breed of critical ... audiences who wanted to seek "knowledge – not sentiment"'.[15] The language of 'breeding' is, of course, appropriate to an ecology of performance. The regular intercourse between this new audience 'breed' and the older ones in the stalls and circle, and between all of them and the stage, arguably led to a new kind of West End dramatist – Noel Coward, Miles Malleson, John Van Druten, for example – and a healthier interaction of theatre and society.

[14] Gyles Brandreth (ed.), *Great Theatrical Disasters* (London: Grafton Books, 1986), p. 132.
[15] Maggie B. Gale, 'The London Stage 1918–1945', in Kershaw, *Cambridge History of British Theatre*, pp. 152–3.

The new breed's refusal to stick only to the rules of applause and other existing protocols appears to have been crucial to this beneficent evolution in British between-wars theatre ecology.

Here is another fairly well-known story about applause to underline my counter-argument about its tendency towards tyranny, in Gyles Brandreth's version:

> On 21 April 1894, the curtain came down on the opening night of Bernard Shaw's *Arms and the Man* and the audience broke into tumultuous applause, with one exception. 'Rubbish' shouted a lone man at the top of his voice. 'I quite agree with you, my friend,' Shaw called back from the stage, 'but who are we two against the hundreds here that think otherwise.'[16]

The power of the playwright can be reinforced through ironic dissimulation – a mocking lie – because in the moment of its performance applause unthinkingly aims to dismiss dissent, to suppress difference, to forge a particular kind of community. In an already healthy theatre ecology, where the ecotones are awash with a thriving diversity, say, the applauding community may produce the positive edge effect of negative feedback: applause may equal more diversity. But the ecological dynamic can never settle into an entirely stable state. This is a point that is crucial to Jill Dolan's discussion of the feminist spectator who:

> might find that her gender ... as well as her ideology and politics make the representation[s of the stage] alien and even offensive ... Determined to draw larger conclusions from this experience, she leaves the theatre while the audience applauds at the curtain call and goes off to develop a theory of feminist performance criticism.[17]

So Dolan, and probably many other dissident critics, might concur with my suggestion that in the ecology of Western theatres applause, like laughter, is the unthinking component of a system that can create highly oppressive communities. I have been very selective in my examples to illustrate this point, but there is a rich history in twentieth-century British theatre, albeit mostly in anecdotal form, of audience interruptions, riots and other disturbances, as well as the various practices of applause, that can be called up for further exploration of these particular edge effects.[18] A fuller survey of that history would, I think, confirm that

[16] Brandreth, *Great Theatrical Disasters*, p. 137; see also Peter Hay (ed.), *Theatrical Anecdotes* (Oxford University Press, 1987), p. 267.
[17] Dolan, *Feminist Spectator as Critic*, pp. 3–4.
[18] Brandreth and Hay are rich in this respect; see also: Ned Sherrin, *Ned Sherrin's Theatrical Anecdotes: A Connoisseur's Collection of Legends, Stories and Gossip* (London: Virgin, 1992).

the communities which were constituted through applause and the other protocols of theatre, however liberal or revolutionary they may have been, increasingly relied more on an elimination of difference than a recognition of diversity – even, ironically, when the onstage representations celebrated debate and multiplicity.

I shall argue that this abiding tension in the community-forming process of British theatres, and possibly those in other Western countries, in the twenty-first century is still sustained by an ecology which increasingly privileged the institution of theatre over the politics of performance, so that the communities of the audience became defined *primarily in terms of theatre and its self-interests* in a competitive cultural marketplace. In ecological terms, the ecotone of theatre survived under increased pressure from an inhospitable wider environment, but mostly at the expense of a robust diversity of its species inhabitants and activities. This evolution can be traced in the second half of the twentieth century, when the disciplines of audience membership became positive feedback in an ecology of performance contaminated by dangerous self-regard, an unthinking self-reflective narcissism. Hence, the potential of the performance/theatre ecotone, where audience and actors, stage and auditoria, theatres and society may interact to produce new energies and forms, was being drained of its power to create diversity by a decline in its general environment – as when acid rain falls repeatedly on a forest, suppressing some flora and driving away most of the fauna.

The taming of the audience through the historical suppression of unruly responses in the theatre, the narrowing of the repertoire of overt reactions in reception, the consequent elevation of applause to make it *the* major expression of audience as community in the late twentieth century: these processes indicate, I think, Western mainstream theatre's increasing capitulation to near-fascistic vectors in its socio-political environment. As theatre audiences were transformed from *patrons* to *clients* between the 1950s and 1970s they succumbed to the dubious power of the professional. Then as they were further transmuted from *clients* to *customers* in the final twenty years of the second millennium they submitted, maybe even happily, to the dehumanising dominance of the market. In the British theatre ecology these terms of identity are similar to 'applause' in indicating a quasi-biological influence on audience constitution and behaviour. In the interests of brevity and clarity I shall concentrate in the following account on English audiences, with the implication that the story may have a broader relevance to theatres in other overdeveloped countries. It is a story of the growing dispossession of the audience, a

shutting-down of options in this particular performance ecology. So whomever the future of the theatre ecology belonged to, by the turn of the millennium it certainly was not the public of a healthy democratic polity.

THE CHANGING 'NATURE' OF THE AUDIENCE: 1945–2000

The examples of riot and resistance I have quoted took place before World War Two. Since the turn of the nineteenth century English audiences usually had been defined by theatres in publicity materials and programmes, and therefore probably thought of themselves, as patrons. Here was another word that probably worked like a protein, colouring the audience's sense of itself. Generally, two main traditions of patronage continued between the wars. Firstly, there was a popular tradition that stretched back to the melodramas and music halls of Victorian England, in which audiences were actively demonstrative in their engagement. Secondly, there was a more genteel tradition, which had been initiated by the Bancrofts at London's Prince of Wales theatre in the late-nineteenth century, and which had grown in importance as theatre managers such as Annie Horniman and Barry Jackson followed their lead in aiming to attract the burgeoning middle classes. John Pick provides a neat sketch of the dominant between-wars style of audience patronage in London: 'The stalls dressed formally for the West End theatre and for the opera, and both were after dinner diversions for the regulars.' Outside London the significance of regional repertory companies partly lay in 'the notions of service which informed their management ... There was a good deal more involvement by local people in their work – through playgoers' societies, discussion groups ... theatre club meetings and the like.'[19] So in all types of theatre audience patronage implied audience power – the patron assumes a right will be met – and this no doubt contributed to the tendency in pre-World War Two audiences, and especially the gallery first-nighters, sometimes to take matters into their own hands. In this general theatre ecology the diversity of social class was less important to lively edge effects in performance than the leeway afforded by patronage to the autonomy of all the different groups in the audience.

Dan Rebellato has shown that this situation began to change in the period immediately following World War Two. The popularity of theatre

[19] John Pick, *The West End: Mismanagement and Snobbery* (London: John Offord, 1983), pp. 117, 119.

during wartime meant that at first it continued to attract a fair cross-section of the population, and audiences at most theatres still had a moderately wide repertoire of activities to indulge in, including drinking tea and eating biscuits in the auditorium. Consequently, these audiences seemed to have felt pretty free in vocally expressing their views of the show: booing and yells of approval were still common practice, and a wide range of laughter was in play, including forms that were later rarely, if ever, heard, such as cackles of derision. In the 1950s the propriety of this freedom of response was increasingly debated, with writers such as Noel Coward, J. B. Priestley and Terence Rattigan defending the right of the audience to express judgement however they wished. In contrast, some journalists and, not surprisingly, many actors argued for more decorum: in 1952, for example, Sybil Thorndyke stormed 'Sometimes I feel like spitting at the audience because of the noise made by unwrapping chocolates.'[20] Either way, the patrons of theatre were exercising an assumed right because that role made them the arbiters of taste; which, to preview my argument a little, is rather a different matter from being the judges of value for money. The messy edge between stage and auditorium in this theatre was a sign of vitality and potential growth. As Rebellato puts it, 'this self-consciousness in the audience is a recognition of collective identity and collective power'.[21] It is the productive antithesis to the tyranny of applause.

Rebellato argues convincingly that the audience's role as patron began to be gradually transformed with the creation by George Devine of the English Stage Company at the Royal Court Theatre in 1955. Symptomatic of this shift was the appointment of an 'audience organiser' to arrange group visits, a function with a subtly disciplinary agenda. Devine set about making a theatre that would be superior to the audience, in which poor box-office would demonstrate not something wrong with the theatre, but with the public. In aesthetic terms, this meant stripping the audience of any assumed authority, but particularly the right of the patron to arbitrate taste: Lindsay Anderson, Associate Director (on and off) from 1959 to well into the 1970s, had proposed that the phrase '*Judge not* should be inscribed on [every Royal Court] programme.'[22] In ethical

[20] Dan Rebellato, *1956 And All That: The Making of Modern British Drama* (London: Routledge, 1999), p. 108.

[21] Ibid., p. 105.

[22] Ibid., p. 110, also in: Charles Marowitz, Tom Milne and Owen Hale (eds.), *The Encore Reader: A Chronicle of the New Drama* (London: Methuen, 1965), p. 46. Anderson was subsequently to say of

terms, it meant denying the audience a dignified identity as a basis of judgement. John Osborne recalls Devine peering through the curtain at the punters on the first night of *The Entertainer*, and urging: 'There you are, dear boy, take a look out there ... What do you think, eh? Same old pack of cunts, fashionable arseholes. Just more of them than usual, that's all.'[23]

The other side of the coin to this disgraceful disdain is the elevation of the professional artist as an aesthetic expert who knows what is good for the public. Rebellato points out that this casts the audience in the role of *client*, a role defined by an assumption of automatic deference to the expert. However, the term 'client' did not perform a protein function similar to 'applause' for 'theatre' or 'patron' for 'audience', because it was not much used by theatres or theatre critics in the period. Rather, the influence of this change of status was more subtly introduced into the theatre ecology through a redefinition of theatre artists as modern 'professionals', together with an assumption of the attitudes of superiority that implies. The effect on the audience was more viral than peptic, undermining their ability to demand a rich theatrical diet. And this new role for theatre artists was reinforced significantly by the growth of Arts Council bureaucracies, which had a vested interest in the valorisation of the professional.[24] The reinvention of the traditional 'profession' swiftly spread through British theatres – the new repertory theatres and, later, the national theatres, but also parts of the West End – in the late 1950s and into the 1960s and 1970s. The messiness of audience edge effects in the performance ecology of these theatres was reduced through a newly astringent 'professionalism' on the part of artists, managers and funding mandarins.

Hence, the authority of the patron was gradually hollowed out, in its place was installed the subservience of the supplicant–client, and audiences became 'better behaved'. A narrowing range of response from the audience was produced through redefining and relocating its functions as part of a meritocratic and hierarchical cultural system. Not surprisingly, this chimes strongly with changes in the wider sphere of the social in the 1960s and 1970s in, for example and paradoxically, the expansion of the

Devine that 'He was unique in his time', in Philip Roberts, *The Royal Court Theatre and the Modern Stage* (Cambridge University Press, 1999), p. III.

[23] John Osborne, *A Better Class of Person: An Autobiography, vol. II 1929–1956* (London: Faber, 1983). Quoted in: Rebellato, *1956 and All That*, p. 112.

[24] Robert Hutchison, *The Politics of the Arts Council* (London: Sinclair Browne, 1982), pp. 54–6.

universities. When, in 1964, Harold Wilson famously celebrated 'the white heat of the technological revolution', he was making the hallmark of the expert – including such technicians of the cultural as George Devine – into a guarantee of the highest and most desirable standards in every social domain.[25] Viewed from this perspective Devine's famous claim that 'You should choose your theatre like you choose a religion' has a sinisterly despotic ring about it.[26] The implied reduction in the authority and power of the theatre audience is a suppression of vitality in the ecology of performance, and an undermining of the theatre's democratic potential.

The treatment of the audience for theatre during the 1980s and 1990s is similarly revealing of wider historical change.[27] Having put the audience in a subservient role through professionalisation, theatres were encouraged to treat them like quasi-royalty. As described in the previous chapter, most theatres were transformed by a wholesale redesign of their 'interface' with the audience. This would appear to produce what the theatres often claimed: an increase of accessibility, a democratisation of cultural resources. By implication, the audience-as-client was under attack in the interests of democratic empowerment, but this redefinition was driven more by the cultural marketplace than any enthusiasm for theatrical hustings. Theatres were integrated into the burgeoning service, tourist, heritage and 'hospitality' industries and in the process its audiences were refashioned as *customers*. Theatre and performance were subsumed into lifestyle in the performative society, and the pleasures of the theatre-going 'experience' gained as much – or more – emphasis as any enjoyment of the production and performance itself.

In this new system of consumption the audience appears to become the fulcrum of 'success', to regain the power it once had as a patron. After all, in a *service* relationship it is the customer who, at least in theory, always calls the tune. But the audiences' power is the result of what Illich calls a 'radical monopoly' in which superficial differences distract from the fact that, basically, only one kind of thing is available, such as motorcars powered by internal combustion engines.[28] Such power is an illusion

[25] The first ever Government Ministers for Technology and the Arts were appointed in 1964: Kenneth O. Morgan, *The People's Peace: British History 1945–1990* (Oxford University Press, 1992), pp. 239–40.

[26] Irving Wardle, *The Theatres of George Devine* (London: Eyre Methuen, 1978), p. 279.

[27] See also: Baz Kershaw, 'Framing the Audience for Theatre', in *The Authority of the Consumer*, ed. Russell Keat, Nigel Whiteley and Nicholas Abercrombie (London: Routledge, 1994).

[28] Ivan Illich, *Tools for Conviviality* (London: Marion Boyars, 1985), p. 52.

fostered by false diversity, and the process creating that in this theatre ecology is a draining of diverse vital energies from the experience consumed.

Something of this vampire drive can be detected in official cultural policy. Hence, in 1988 the Arts Council Secretary-General, Luke Rittner, had no problem in calling the arts a 'unique and precious commodity'.[29] But, paradoxically, the fantasy of consumer power – of audiences becoming the sovereigns of consumption – is achieved by turning the audience into an object of consumerism. The modified conventions of the theatre experience transform the audience itself into a commodity, as their bodies embody the ideology of theatre as a commodity form. This becomes the case even if, as is often argued for postmodernist cultural practice, the audience entertain the theatre ironically, with a self-reflexive awareness of themselves as the consuming commodity. The irony embraces the paradox of pleasurable self-abjection, as it cannot abstract the audience from the vectors of the theatre ecology. From this ecological perspective, the ecotone qualities of theatrical performance become unsustainable because of a fatal reduction in self-critique, a critical loss of negative feedback. The commodification of theatre and performance as ecosystems becomes a series of self-destructive vicious circles.

In such a consumerist theatre the quality of applause is an index of a widening chasm between performance and its social, political and eco-logical environment, because such appreciation becomes fatally tinged with a narcissistic self-regard. Desultory clapping becomes an increasingly rare event as it is an admission of income wasted. Standing ovations become an orgasm of self-congratulation for money spent so brilliantly. The self-administered economic virus becomes all-consuming. What Lyn Gardner claimed of West End first-nighters at the start of the twenty-first century may be true of other audiences: 'The applause . . . usually bears no more relation to the merits of the show than the response of proud parents to the infant school nativity play.'[30] Ironically, as the theatre experience appears to grow richer, so the true measure of its quality – the flexibility of audience engagement through many means – is impover-ished. So, to put the case especially bluntly, towards the end of the

[29] Luke Rittner, 'Secretary-General's Report', in Arts Council of Great Britain, *43rd Annual Report and Accounts* (London: Arts Council of Great Britain, 1988), p. 5.

[30] Gardner, 'Just Sit Down and Shut Up', p. 4. The turn-of-millennium emergence of unison clapping at the end of a show – sometimes encouraged by the playing of loud and rhythmic music – is another aspect of the syndrome that I am describing. I am grateful to an anonymous reviewer for the journal *Modern Drama* for drawing my attention to this phenomenon.

twentieth century the ecology of theatrical performance was chronically polluted by audience egotism, and political significance, democratic exchange, the power of community all but evaporated from English theatres in the heat of an orgy of compulsive narcissism.

A CASE STUDY: PULLING PUNCHES FOR A QUIETER LIFE

The notion that theatre protocols crucially shape audience self-definition and reception may appear to be stretched too far by these last remarks. And, of course, there are a number of lines of defence that can be advanced in an effort to protect the autonomy of the audience. Hence, reader-response theory delivers up the audience as a primary maker of meaning; semiotics and poststructuralism encourage a reading against the grain; Derridean deconstruction ensures that the slipperiness of the performative will always trouble the institutional reifications of the theatre. These are, of course, serious objections to a theory of performance in theatre that sees it as environmentally and historically embedded in the ways my argument implies, and they usefully push back against any tendency to think of theatre as overdetermined. Indeed, in an ecology of theatre reader-response theory, deconstruction and so on can enable us better to understand the rich complexities of the edge effects of actor and audience interactions. But by the same token I would suggest that the systemic forces that may produce, for example, the commodification of an ecotone and its edge effects require to be recognised as potentially extremely powerful. Ecologically speaking, microscopic amounts of particular elements can transform some environments beyond recognition, and in some periods audience protocols may have such an effect on the transactions of theatre. As Brecht once claimed, 'the theatre can stage anything: it theatres it all down'.[31]

Even given such reservations, my line of argument suggests that something radical will always need to be done to break out of the syndrome of audience acquiescence. For example, one source of an antidote might well be found in Boal's theatre of the oppressed. If we turned all the theatres into forums for facilitating 'rehearsals for revolution' we might be on our way to making democratic performances that will matter to the legislature. Such a policy could well have appealed to the social-inclusionist thrust of Britain's New Labour government, as indicated by the fact that Boal himself was

[31] Bertolt Brecht, *Brecht on Theatre*, ed. and trans. John Willett (London: Eyre Methuen, 1974), p. 43.

invited in 1998 to invent a ceremony to reopen London's County Hall, closed by Prime Minister Thatcher in 1986, for political business.[32] Five years later, though, the building was taken over by advertising magnate Charles Saatchi as a gallery for his personal collection of contemporary high art. Boal was not asked back for that opening. An ecologist would warn against the application of macro-solutions to environmental problems that are rooted in the micro-relations of an ecological system. Likewise I would hesitate to advocate such a radical Boalian scrub-down, on the grounds that a more eco-sensitive approach is required to enervate the elements that continued to pacify the edge effects of theatre in the twenty-first century.

The final part of my argument, therefore, shifts from the long perspective of audience history to focus on a case study that may take us closer to at least one key vector of such ailments of late-twentieth-century theatre ecology. Mark Ravenhill's play *Shopping and Fucking* was first staged in 1996 by director Max Stafford-Clark. By 1998 it had become an international hit, with productions in New York, Johannesburg and other major cities. The show is now conventionally grouped with others written by young 'in-yer-face' playwrights such as Sarah Kane and Jez Butterworth.[33] These are often said to have brought a new directness, aggression and relevance into British theatre in the 1990s, much as John Osborne and the 'first wave' of new dramatists did in the 1950s under the tutelage of George Devine. That Max Stafford-Clark had been director of the Royal Court Theatre during the 1980s provides a suggestive genealogy for Ravenhill's play, but in my case study the 'genetics' of theatre are of less concern than performance ecology. To explore the ecology of *Shopping and Fucking* in performance I will first briefly analyse the production from the perspective of the audience history explored above. I will then concentrate on a particular moment in performance that I think might illuminate a way through the impasse of theatre as commodity and enable us to see how theatre ecology could be newly connected to environment, community and democratic process.

The play graphically and wittily anatomises how the metropolitan sex industry sucks especially vulnerable young people into its degrading rituals of exploitative ecstasy. During its London run it succeeded in attracting youthful audiences to witness its bizarre combination of

[32] Boal was invited via the London-based arts company Artangel.
[33] Aleks Sierz, 'Cool Britannia? "In-yer-face" Writing in the British Theatre Today', *New Theatre Quarterly* 14: 4 (November 1998); Aleks Sierz, *In-yer-face Theatre: British Drama Today* (London: Faber, 2001).

neo-Brechtian design – an upstage free-standing wall flashes out one-word themes for each scene in designer neon – with farcical action that extravagantly out-Ortons Joe Orton at his brutal best. The show dramatises the commodification of desire through a knowing postmodern take on the constructedness of sexual identity. The plot ensures that the characters are tested continually to reconstruct themselves as each other's sexual objects, with money circulating at the cold heart of every desperately lustful exchange. The bleakness of this scenario would seem to offer sufficient resistance to the seductions of West End privilege, by implication staging a critique of the theatre as marketplace for the human. But the contrast between, on the one hand, the story of degrading sexual commercialism onstage, and on the other hand, the commercialisation of degradation by the theatre in staging the show, produces an irony which may, paradoxically, evaporate in the pleasures of performance. Through their enjoyment of the display that turns the sexual subject into a commodity, the audience participates, through the ecology of theatre as a disciplinary system, in a process of consumption that does exactly the same to them.[34] So despite the radicalism of its attack, *Shopping and Fucking*, in this context, may reinforce the self-defeating narcissism of consumerism.[35] We may say that the performance ecology of this play in the theatre ecologies of the late-twentieth century always risked production of a positive feedback against itself.

In this interpretation, the deliberately 'shocking' nature of the play's material operates like a virus that destroys its intended effects. Viewed from this perspective, it should not seem paradoxical that a way out of the vicious circle of reception is suggested by a moment in performance when the performers of the play deliberately pulled its punches. This took place at the West Yorkshire Playhouse, Leeds, in September 1997, and is described by Dominic Shellard as follows:

In scene thirteen, Lulu asks Mark to describe 'the most famous person you've ever fucked' and Mark begins to relate a bizarre event that allegedly occurred in a London nightclub … It was 1984 or 1985, possibly in Annabel's or 'Tramp', and

[34] Michael Kustow reports Ravenhill as noting that 'Some young people in the audience … laughed at the horror. I want to bring them from the cynicism to something more.' Is laughter at suffering part of the dehumanising process of commodification? Michael Kustow, *Theatre@Risk* (London: Methuen, 2000), p. 212.

[35] Compare, for example, the reception of Caryl Churchill's *Serious Money* (1987). See: Linda Kintz, 'Performing Capital in Caryl Churchill's *Serious Money*', *Theatre Journal: Theatre and Capital* 51: 3 (October 1999), 251–66; Vera Gottlieb, '1979 and After', in Kershaw, *Cambridge History of British Theatre*, pp. 414–15.

Figure 7 Mark Ravenhill, *Shopping and Fucking* – Out of Joint Theatre, London, 1996. Robbie (Andrew Glover) looks on as Mark (James Kennedy) recounts his fantasy sexual desecration of the Queen of Hearts.

Mark was tripping. Desperately needing the toilet, he finds himself followed into the gents by a woman dressed up as a WPC[36] who appears eager for action. Mark ... describes the encounter: 'So I'm in there. I'm in and kneel. I pay worship. My tongue is worshipping that pussy like it's God. And that's when she speaks. Speaks and I know who she is.' The woman is identified as Princess Diana ...

On 31 August 1997 Princess Diana was killed in a car crash. I witnessed the performance of *Shopping and F**king* two days later. As this scene approached, the audience ... became nervous. ... most clearly feared that the as yet unidentified woman in the toilets might turn out to be the woman for whom many in the country were in united and grief-stricken mourning. I was unsure as to whether the script would be changed. It would have been in keeping with the work's desire to disconcert to leave it unamended. It would also undoubtedly have provoked a mass walkout or even ... a verbal or literal invasion of the stage ... As the audience began to speculate as to the woman's name, the tension rose. Mark uttered the speech printed above and added 'I recognise the voice. Get a look at the face. Yes. It's her.' ... the moment of catharsis was reached. The woman possessed a 'ginger minge', had lost weight and had formerly been a

[36] Woman police constable.

member of the Royal Family. She could safely be confirmed as the Duchess of York. The sense of relief was overwhelming, although it might have been dissipated by Mark's announcement that a second policewoman 'squeezes her way in. With blonde hair', were it not for the timely intervention of Robbie who screamed, 'SHUT UP. SHUT THE FUCK UP' . . . It was a revelatory moment.[37]

Shellard does not offer much of an explanation for this apparent preference, by both actors and audience, of quiescence – but the 'revelatory moment' bears closer investigation to determine as precisely as possible what was happening in those seconds of avoidance. It is not simply, I think, that the close conjunction of fantasy sex on a Yorkshire stage and a horribly real death in a Parisian underpass is ethically repugnant. It *is* that, but then so is much of the rest of the play's action. It is also that something was happening in the relations between fiction and the 'real world' with which the actors and the audience, according to Shellard, were not equipped to deal. This manipulation of the performance ecotone was a suppression of powerful vitality in the edge effects of its particular theatre ecology, for the fiction of the sex in the cubicle was slipping towards truly phantasmal territory in the world beyond the theatre. As Shellard reminds the reader, millions of people were manifestly in the grip of phenomenal collective mourning in the wake of the Princess of Wales's death, but of course convincing explanations for such a phenomenon are very hard to come by.[38] But one does not need to draw on complex psychoanalytic or cultural theories in order to identify in the grief, real or feigned, a response to a *deficit* somewhere in the social life of the United Kingdom.

It may be that late-capitalist hyperrealist individualism had sucked dry the lifeblood of family and community to produce a yearning for utopian collectivity. It may be that the deficit was sourced in the paucity of public ceremony, particularly ceremonies dealing with death, as the typical British funeral had become a pretty paltry affair staged by production-line professionals. It may simply have been that in every sphere of the social, including theatre, opportunities for meaningful participation in public life were especially decimated by eighteen years of Tory rule. However we speculate about causes, though, we are speculating about a deficit displaced rather than acknowledged. So had the first woman to enter the cubicle been

[37] Dominic Shellard, *British Theatre Since the War* (New Haven and London: Yale University Press, 1999), pp. 197–8.
[38] Adrian Kear and Deborah Lynn Steinberg (eds.), *Mourning Diana: Nation, Culture and the Performance of Grief* (London: Routledge, 1999).

Diana then not only would the extremely offensive image of cunnilingus on a well-loved, now-mutilated corpse have come into play, but through that the public deficit would have had to be recognised, however obliquely, as a hollowness at the heart of the mourning and thus as a particularly acute attack on whatever remained of 'England' as an imagined community. But how could that be dealt with in a theatre which itself had been hollowed out by forty years of subtle denigration of its audience, producing a per-formance ecology that was generally self-defeating? That 'revelatory moment' in the West Yorkshire Playhouse signalled a profound and widespread crisis of confidence in the public life of people living in Britain.

But still, we might yet detect in that moment of avoidance a route through the impasse of a theatre ecology dying of narcissistic applause and self-regard. In aesthetic terms, what was being avoided was extreme excess, a moment in which an already excessive play would have risked going well 'over the top' into truly dangerous territory. In Derridean terms, this was a moment of especially suggestive supplementarity, for it plays strongly on the two main ways in which Derrida developed that key concept of deconstruction.

The supplement adds itself, it is a surplus, a plenitude enriching another plenitude, the *fullest measure* of presence. It cumulates and accumulates pres-ence . . . But the supplement supplements. It adds only to replace. It intervenes or insinuates itself *in-the-place-of*; if it fills, it is as one fills a void.[39]

Thus the supplement may both add to an entity that is already complete and make good something that is insufficient. I shall argue that the moment of avoidance at the West Yorkshire Playhouse was simultan-eously a supplement in both these senses, depending on the perspective one takes on it. I suggest that this fundamental ambivalence may be characteristic of performance ecotones, and thus supplementarity would become a vital quality of their slippery edge effects in theatre ecology. That Shellard intuits such complex slippage might be under way is suggested by the phrases he uses in attempting to reconstruct his own frame of mind: 'I was unsure as to whether the script would be changed.' The unnecessary and 'repulsive phrase' (Fowler's judgement) 'as to whether' seems to underline a paradoxical certainty about ambivalence and uncertainty that is especially Derridean.[40]

[39] Jaques Derrida, *Of Grammatology*, trans. Gayatri Chakravorty Spivak (Baltimore: Johns Hopkins University Press, 1976 [1967]), p. 144.
[40] H. W. Fowler, *A Dictionary of Modern English Usage*, 2nd edn, revised by Sir Ernest Gowers (Oxford: Clarendon Press, 1965), p. 37.

As with most matters due to Derrida, the application of the idea of the supplement to Shellard's account of the performance of *Shopping and Fucking* renders the moment of avoidance especially complex. But it is worth working through its implications for the light it may shed on twenty-first-century audiences and their applause. From the perspective of the audience history described above, the 'revelatory moment' – in the first sense of the supplement, 'a plenitude enriching another plenitude' – may add to a narcissistic process. Primarily, the protocols of contemporary audience membership, aiming to be complete in themselves, producing the self-satisfied customer of a self-satisfied institution. But rather than 'plenitude enriching ... plenitude', the avoidance confirms the narrowing range of response available to audiences – Mammon forbid that a global success of capitalist culture could produce a walkout or a riot! This particular ecological system only *appears* to be thriving on an applause that actually signals a growing paucity, the loss of plenitude in how the audience might choose to engage with performance. Consider this particular performance as an ecotone potentially utterly rife with edge effects – spinning off a resurrected, mutilated angel–Princess debauched – that might have redeemed the deficits implied by its ecology, if only the audience had been allowed to embrace the full force of its riotous plenitude.

In the second sense of the supplement Derrida refers to a process that adds to something in order to make it more complete, indicating a lack in the constitution of that something. In this sense, and from a cultural point of view, the revelatory moment of avoidance paradoxically also *adds* to the sense of general loss in the broader culture, to the deficit that the grief for Diana seemed aimed to clear. The moment achieves this by trying to protect, through substitution, a major national icon in its continuing ascendance. In a famous BBC interview in November 1995, the Princess of Wales had, with astonishingly poised audacity, redesignated herself the Queen of Hearts. But the moment in the toilet cannot entirely succeed in protecting the fantasy Queen from 'violation' because it simply raises the spectre of deferral: it does this literally by making Diana the second woman to enter the cubicle. Her turn is next. So the supplementarity of the moment, in both of Derrida's senses, operates to doubly magnify a deficit in the community of the audience and in the imagined community of the nation. This, I think, is condensed in the image of oral sex with a phantasm, an act that is inevitably sterile, a virile conception that cannot conceive. The ecology of this particular performance is virulent in its ironic acknowledgement that it cannot acknowledge what it is 'really' about. But in making that denial the supplement of the

performance itself, it – the performance – paradoxically adds to what it denies. Not only is this ecotone already utterly rife with edge effects, but it also engages an entropic energy – in its 'positive' denial – that would revitalise its ecology potentially beyond all measure.

So had there *not* been an avoidance by the performers, had the audience been offered the opportunity to risk unruliness in response to such extreme and ambivalent vitality, then it is entirely possible that the whole apparently 'negative' process could have been reversed. For a direct encounter with the deficit in the public life of the nation, in a public institution – the theatre – which was then constantly reinforcing the deficit, could have been the first step towards successfully dealing with it. If Diana had been allowed by the actors to be the first woman into the cubicle, then the audience reaction envisaged by Shellard might have helped to bring the actual lack in public life, for which the dead Princess was substituted as supplement, out of the nation's collective closet.

DENOUEMENT

Is there a case, then, for arguing that twenty-first-century theatre should be much less concerned about creating offence and that its audiences should be encouraged to embrace every possible opportunity to become unruly? There is a danger this might be read as a recommendation for the invention of new theatrical recipes for riots, but performance can stir up theatre in much more interesting ways than that. Theatre and performance ecologies need simply to become a little more true to their own creative promiscuity in order that the audience may begin to reclaim their power. Nor am I implying that all Western theatre is necessarily suffering from the syndrome that I have been trying to describe. Performance ecology usually thrives on excess – even the excess of subtraction, as in Beckett's aesthetic – and so it almost always has the potential to produce a more positive supplementarity. Nonetheless, the history of audiences in late-twentieth-century Britain should give us cause for concern about the future of theatre. I am not alone in thinking this. The sociologists Nicholas Abercombie and Brian Longhurst have explored the troubling links between spectacle, narcissism, commodity and the audience as consumer, and Howard Barker has attacked the state of contemporary theatre and its audiences from a similar perspective.[41] Barker offers the

[41] Nicholas Abercombie and Brian Longhurst, *Audiences* (London: Sage, 1998); Howard Barker, *Arguments for a Theatre* (Manchester University Press, 1993).

'Theatre of Catastrophe' as an antidote to the malaise, but there are other tactics, somewhat less grand in conception, that one might suggest to help combat the contamination. Remember I am still dealing in theatre and performance as ecological systems, so the marginality of the following suggestions might be more apparent than real. The same may be true of their seeming frivolity.

While we should always be wary of defining audiences too grossly, and particularly in terms of binary contrasts, it should be healthy to encourage an impish attitude to what the Arts Council of England has coyly called 'audience development'. Thus, theatres should avoid the production of what Richard Schechner calls 'accidental audiences': a collection of individuals who have gathered only because they want to consume a particular cultural product. But equally they should be wary of appealing to 'an integral audience', an audience which is 'in the know' about why the theatre is important to them collectively, as a 'community' audience.[42] Both types of audience, in different ways, are now particularly pervious to the effects of positively entropic theatre ecologies, which drain away vitality. The accidental audience is faced with too much uncertainty in the risk society to publicly admit it has paid for a failure; while the integral audience, knowing it is part of a dying breed, is prone to take everything dished up for it with acquiescent gratitude. To despoil this dilapidation, theatres could use the existing and emergent digital technologies of the box office to construct riven audiences, audiences consisting of groups with vastly contrasting or conflicting interests in their shows. In other words, more deliberate diversity in the audience would be a positive force for revitalising theatre ecology.

Theatres could also promote more selective inattention, the waywardness of focus that audiences always bring to onstage performances, but aim to locate it more in the auditorium. For example, they could profitably reintroduce that early manifestation of Boal's invisible theatre: audience 'plants'. Organised audience plants were common in nineteenth-century French theatre, when they were known as *claques*. Their leaders, who were on the payroll of the theatre, were charged with massaging audience responses to create 'successful' shows. The highly effective leader of the *claque* at the Comédie Française, appropriately named Vacher, was one such. In the 1850s a new director of the theatre was considering banning the *claque*. Vacher responded by saying, 'I beg of

[42] Richard Schechner, *Performance Theory*, rev. edn (London: Routledge, 1998), pp. 193–6.

the director to study my art of acting as he would study that of any Comedian.'[43] He knew as well as any twentieth-century director that there is great artistry in manipulating audience reactions. But the art of the audience plant does not have to be predicated solely on commercial success, as that of the *claque* was. It could be reintroduced to encourage the views of particular constituencies with interests in the themes of particular playwrights or shows: what about a queer *claque* for Noel Coward, a working-class *claque* for Alan Ayckbourn, a *claque* of real dogs for Tom Stoppard's *The Real Inspector Hound*?

The alert reader will have spotted that these are all proposals for making the audience itself into a supplementary ecotone, a place of edge effects which will itself combat the dangers of its own docility. These desperate measures are proposed with tongue only half in cheek. The late-twentieth-century history of English audiences may indicate, I think, something especially disturbing in the state of much Western theatre. Dispossession, commodification and the narcissism of consumerism were rampant, but the case can be put more bluntly. Theatrical performance is the most public of all the arts because it cannot be constituted without the direct participation of a public. Reduce that participation in any way and you reduce the environmental, the political and, especially, the democratic potential of theatre. That there can be a public, or publics, that *could* use the theatre for environmentally democratic ends should be clear enough, as theatre continued to attract audiences – just – despite the widening array of competition in the digital age. But the price of securing such support for survival was very high. In adapting to dominant socio-political forces in its environment through the reshaping of audiences as clients and customers the theatre tended to shut down a key resource of resistant vitality. The crucial freedoms that an audience needs to sustain a successful performance ecology, which could reinvigorate any theatre ecology – the freedoms of unpredictable congress, of untoward social exchange, of radical mutation – were whittled away. Any sense that the theatre was theirs as a place of public rejuvenation, especially in the revitalisation of democratic processes, slipped inexorably towards illusion and hyperreality. The more the audience applauded the less the theatre ecology belonged to them. That is why the theatre in the twenty-first century, perhaps more than anything else, needs unruly audiences.

[43] Hay, *Theatrical Anecdotes*, p. 254.

Spectacles of performance: excesses of power

This vast drama of nonhuman nature is in every respect stunningly wondrous. (Murray Bookchin[1])

INTRODUCTION

Spectacle of course was not always what it became by the twenty-first century. Economics, politics, science, technology and more have changed its nature, probably irrevocably. The threat of unchecked pollution facing Earth's biosphere, a possible calamity for humanity, is adding a further twist to its future. For this potential crisis of global ecology promises to be extraordinarily spectacular. Its effects add a new urgency to gaining fresh understandings of spectacle as an element of performance ecology, and of its possibilities as a singular instrument of ecological activism. That singularity in an age of such complexity suggests a profound genealogy, and one that needs to be viewed in a longer historical perspective than those explored in the last two chapters. So I begin this analysis with three snapshots of spectacles spanning the second half of the last millennium. These will serve as preliminary pointers to some of the constant constituents of spectacle as a factor of performance ecology. They will also provide a glimpse of the late-twentieth-century paradigm shift towards performance that confirmed the spectacular as an especially potent phenomenon in the realms of excessive power.

[1] Murray Bookchin, 'What is Social Ecology?', in *Environmental Philosophy: From Animal Rights to Radical Ecology*, ed. M. E. Zimmerman (Englewood Cliffs, N.J.: Prentice Hall, 1993); also at, Website – Anarchist Archives: http://dwardmac.pitzer.edu/Anarchist_Archives/bookchin/socecol. html (01.10.2006).

In 1559 Richard Mulcaster described the entry into London of the future Queen Elizabeth I:

If a man should say well, he could not better tearme the citie of London at that time, than a stage wherein was shewed the wonderfull spectacle, of a noble hearted princess towards her most louing people.[2]

Almost two hundred years later, in 1757, a reporter from the *Gazette d'Amsterdam* described the death of 'Damiens the regicide', suffering what Foucault was later to call 'the horrifying spectacle of punishment':

Finally, he was quartered ... the excessive pain made him utter horrible cries, and he often repeated: 'My God, have pity on me!' The spectators were all edified by the solicitude of the parish priest of St Pauls who despite his great age did not spare himself in offering consolation to the patient.[3]

The contrast between the future Queen's entry and the regicide's death indicates the extremities of power available to spectacle as a form of cultural performance. It also suggests how totally opposing life and death transformations through spectacle can be utterly interdependent – there is no regicide without a king or queen – but also irreconcilable, as between, say, the ecstasy of adulation and the horror of abjection.

Another two hundred years on and Jean Baudrillard, in 1981, responded to an altogether different type of spectacle, Francis Ford Coppola's *Apocalypse Now*:

[He] makes his film like the Americans made war ... it is a dream, a baroque dream of napalm and of the tropics, a psychotropic dream ... [of] the sacrificial, excessive deployment of a power already filming itself as it unfolded, perhaps waiting for nothing but consecration by a superfilm, which completes the mass-spectacle effect of this war.[4]

Baudrillard's vision of late-twentieth-century 'mass-spectacle effect' indicates, in the paradigm of performance, a radical transformative dimension for spectacle. It collapses the differences between creativity and destruction, dream and reality, culture and nature in an extravagant scenario that reflexively celebrates its own paradoxical impact. In the

[2] Quoted by George Kipling, 'Wonderfull Spectacles: Theater and Civic Culture', in *A New History of Early English Drama*, ed. John D. Cox and David Scott Kastan (New York: Columbia University Press, 1997), p. 153.

[3] Michel Foucault, *Discipline and Punish: The Birth of the Prison*, trans. Alan Sheridan (London: Penguin, 1991), p. 3.

[4] Jean Baudrillard, *Simulacra and Simulation*, trans. Sheila Faria Glazer (Ann Arbor: University of Michigan Press, 1981), p. 59.

process, I will argue, spectacle gains an entirely new kind of political and environmental potency.

There are some unchanging qualities, though. Spectacle is always aimed to produce excessive reactions – the WOW! vector – and at its most effective it touches highly sensitive spots of the human psyche by dealing directly with extremities of power: gods, monarchy, regicide, terrorism, war, disasters, catastrophe, apocalypse now. This is why when activism engaged spectacle in the past – Guy Fawkes and the Gunpowder Plot, the Boston Tea Party and so on – it generated such strong responses and produced lasting icons of history, even when there were few witnesses of the event itself or it happened only in the imagination. It is also why the legitimate theatre in the West, despite some wonderfully brave attempts, has rarely incorporated a significant degree of spectacle in its shows. As a result the history of spectacle is splattered with riven responses: it is loved or hated, assiduously embraced or utterly shunned.

Conventional definitions and traditional treatments of spectacle in dramatic and theatrical theory reflect this bifurcating force. Uncertainty about the true value of spectacle can be traced back to Aristotle's *Poetics*: 'The Spectacle [*opsis*] . . . of all the parts [of drama] is the least artistic, and connected least with the art of poetry.'[5] And, perhaps surprisingly, most standard modern reference works on theatre, such as *The Oxford Companion to the Theatre* (1967) and *The Cambridge Guide to Theatre* (1992), participate in the syndrome that separates serious art from spectacle. From these you can find out about theatre in Spain or the obscure seventeenth-century actor Gabriel Spencer, about Speech or even the Spectacle Theatres of Renaissance Italy, but on spectacle itself the authorities are tellingly silent.[6] A few reference texts around the turn of the last millennium include the concept but are cautious about its significance. Patrice Pavis discusses it in his *Dictionary of the Theatre* (1996), but warns (echoing Baudrillard): 'A general theory of spectacle would seem to be premature at present . . . because the borders between reality and spectacle are not easy to define.'[7] *The Oxford Encyclopedia of Theatre and Performance* (2003) is a little less sceptical, but still cautions that despite ' . . . sporadic attempts to revive the Greek *opsis* as a theoretical

[5] Aristotle, *Poetics*, trans. S. H. Butcher (New York: Hill and Wang, 1961), p. 64.
[6] Phyllis Hartnoll (ed.), *The Oxford Companion to the Theatre*, 3rd edn (Oxford University Press, 1967); Martin Banham (ed.), *The Cambridge Guide to Theatre*, rev. edn (Cambridge University Press, 1992).
[7] Partice Pavis, *Dictionary of the Theatre: Terms, Concepts and Analysis*, trans. Christine Schantz (University of Toronto Press, 1998), p. 347.

concept ... the English word "spectacle" seems destined to remain less precise in its application'.[8]

I shall return to the pathology of this critical history shortly. My main purpose in this chapter is to develop a more balanced view of the power of spectacle through a take on the topic informed by ecology. Because in the twenty-first century, as predicted by Debord, Baudrillard, Guattari and other major theorists, spectacle has become fundamentally constitutive of the performative societies, and in ways which are wholly integral to the encroaching environmental crisis.[9] So the traditional prejudices and uncertainties surrounding spectacle have to be challenged. The deep human fascination with spectacle, including the 'vast drama of non-human nature', requires some unravelling. Hence, in its earlier incarnations this chapter was named for the ambivalent impact of its topic. The title of the conference paper and subsequent article on which it is based signalled the ancient conflict in human attitudes to spectacle: 'Curiosity or Contempt'.

That was borrowed from *The Shorter Oxford English Dictionary*'s first definition of spectacle, which talks of 'A person or thing exhibited as an object either of curiosity or contempt ... '.[10] There is a strong dynamic in this view of spectacle because it suggests – despite the binary assumption of that 'or' – that the same display of excess can be the subject of human rapture and disgust. More significantly still, it implies that the commonly human, the person, the subject – as much as any object or thing – can be, as it were, at the heart of spectacle. This is especially interesting because the magnitudes of power at play in spectacle tend to expel the merely human, to objectify it, to replace it with emblems, ciphers, symbols and other types of abstraction: the sacrificial effigy, the idealised Olympic torso, the stylised masks of gender, the nymphs at play in nature's wonderland and so on. Hence, the great Royal Entries of sixteenth-century England 'served as manifestations of the king's divinity';[11] the extravagant display of torture reduced the all-too-human Damiens to bits of meat and bone; and in Baudrillard's projection of Vietnam as the first postmodern, hyperreal, and environmentally

[8] Dennis Kennedy (ed.), *The Oxford Encyclopedia of Theatre and Performance*, vol. II (Oxford University Press, 2003), p. 1273.
[9] Baudrillard, *Simulacra and Simulation* (1994); Guy Debord, *The Society of the Spectacle* (Detroit: Black and Red, 1977); Félix Guattari, *Chaosmosis: An Ethico-aesthetic Paradigm*, trans. Paul Bains and Julian Pefanis (Sydney: Power Publications, 1995 [1992]).
[10] *Shorter Oxford English Dictionary*, 3rd. edn (Oxford University Press, 1970), p. 1962.
[11] Kipling, 'Wonderfull Spectacles', p. 161.

devastating war there are, almost by definition, no humans at all because they are transmuted into special effects. Mary McCarthy highlighted this potential with fabulous irony in a 1967 comment about the in-flight 'tourists ... bound for Tokyo or Manila ... able to watch a South Vietnamese hillside burning while consuming a "cool drink" served by the hostess'.[12] Apocalypse now! Indeed.

It is the paradigmatic historical shift indicated by Baudrillard's fevered vision that renders the notion of spectacle newly relevant to the border-lands between radical activism and theatre and performance ecologies. He marks the pervasiveness of spectacle in late twentieth-century neo-liberal societies as a major cause of the collapse of hierarchies that previously ordered culture and nature. The suspicions of excess in performance, visual or otherwise, expressed by the dramatic and theatrical theorists were a symptom of those hierarchies. But if spectacle is everywhere in the performative society, so much so that humans are constituted through it, then in theatre and elsewhere it gains new kinds of significance. This chapter explores that process by trying to rethink the place of spectacle in theatre and performance ecology historically, and this is part of an attempt to understand how spectacle in the twenty-first century became a flexible force for positive ecological change. Paradoxically, this new potential results from the abiding fact that spectacle seems always to transform the human into something more, or less, than itself. In spec-tacle the human may embrace the non-human to sublimely transmute humanity.

This, then, is one of the key paradoxes of spectacle that may make it ecologically sublime: it deals with the human in non-human ways. And there are others: it multiplies power through excessive waste; it plays on the visceral mainly through the visual; it can attract and repel in the same instant. But besides picking out some of the tricky constants of spectacle it is important, of course, to understand how it may have changed in history, particularly in its mediation of the powers that shape the human as subject of environmental factors. Because if the social itself has become a spectacle how might humans best realise what it is to be commonly *more and less than just human* in a world that constitutes humanity through such powerful paradoxes? If humans are thus constituted does that mean, for example, that we will be looking to deal with the 'other' in *inhuman* ways, that we will be addicted to excess, that we will always be

[12] Mary McCarthy, *Vietnam* (Harmondsworth: Penguin, 1968), p. 12.

ambivalent in the world – loving and hating it, divided in ourselves and against each other? And how might that then open up new scope for the positive use of spectacle by eco-activists?

In the light of such speculations I must confess that, as I researched the history of spectacle and developed this line of thought, there were moments when I nostalgically hankered after a more comfortable dwelling place. At one point I was even tempted to draw on the very first recorded use of the word in English for my original title. This can be found in Richard Rolle of Hampole's *The Psalter*, published in 1340. Rolle was clearly a man who enjoyed an uncomplicated response to what he calls the 'spectakils' of 'the Hoppynge & daunceynge of tumblers and harlotis ... '[13] But while 'Tumblers and Harlots' was catchier than 'Curiosity or Contempt', I thought it might mislead readers about my actual interests in the topic.

ARGUMENT

I shall be addressing three main questions about spectacle, and a further overriding one about their implications for ecological activism through theatre and performance. First, what is it about theatre that has made most theorists of drama so suspicious of spectacle? Second, might it be possible to describe how spectacles changed generally in their articulations to power between the sixteenth and twenty-first centuries? Third, if homo sapiens is constituted through spectacle what might that imply for the 'human' in the twenty-first century? Finally, when 'humanity' is subject as a matter of course to extremes of pressure from the greatest of powers (physical, political, cultural, natural, environmental) what might survive? These questions have particular relevance to the pursuit of theatricalised and performative activism, and especially eco-activism, because together they may direct us to attend to matters beyond representation, beyond issues of what any particular theatre or performance event might be made to mean discursively, and towards trying to figure what it might be *doing* to the participants' sense of the human.

I characterise the importance of spectacle to activism in this manner in order to imply that perceptions of ethical, social, political and environmental value – a 'sense of the human' – in the twenty-first century have been intensified in two main ways. Firstly, through the means via which

[13] Martin Harrison, *The Language of Theatre*, rev. edn (Manchester: Carcanet, 1998), p. 252.

audiences and spectators of theatre, performance and spectacle were positioned as *participants* in the performative society. Secondly, by how spectacle in spectacularised societies tends *automatically* to engage with the circulation of especially significant magnitudes of power in culture and nature. I am aware that the formulation at the theoretical fulcrum of these claims – that 'sense of the human' – risks looking like an appeal to notions of an essentialised self, a transcendent subject that could form the basis for universalised conceptions of humanity. I also acknowledge that the postmodern death of the subject, which renders such appeals invalid, provides a theoretical entrance for strong claims about the primacy of performativity to the persona. So I am interested to work through how a more challenging version of *the subject as a disappearing act* opens up new ways of figuring a *sense* of the human beyond, as it were, liberal humanist visions of political or ethical global commonalities founded on logocentric laws.

A few brief comments on performativity, ecofeminism and identity will have to serve as my pennyworth of slingshot against this phallocentric Goliath. Some sense of the full impact that 'performativity' might have on notions of ecology can best be gained from the concept's uses in feminist theories of sexuality and gender. The modern 'father' of performativity, J. L. Austin, uses these aspects of identity more to confirm than challenge them, with the marriage vow, 'I do', figuring prominently in his analysis.[14] But given his determined shift of attention from the factors of language (which, for example, produce patriarchal law) to the intentions of its users (for example, as a source of radical freedom) it is hardly surprising that performativity became a key concept in post-World War Two feminism. If the powers of male domination are maintained by common uses of the protein of language – so that 'man' becomes the measure of all things, including nature – then 'performativity' is a flexible platform from which to challenge them radically. The grounds for this were cleared by the pioneers of poststructuralist feminism, especially the French theorists Luce Irigaray, Hélène Cixous and Julia Kristeva, who brightly highlighted how the culture/nature divide was central in a web of binary thought and action that always subjected women to men and nature to culture. Hence Irigaray insists '– just as nature has to be subjected to man in order to become a commodity, so ... does the

[14] J. L. Austin, *How to Do Things with Words*, ed. J. O. Urmson (Oxford University Press, 1962), pp. 5–11.

"development of the normal woman" '.[15] But it was Judith Butler who carried the importance of 'performativity' in the evolution of both feminist and, later, queer theorists to its most powerfully challenging extreme. She argued that there is nothing essential to sexual or gender differences because they are just a 'reality effect' caused by a 'stylised repetition of acts'.[16] Humans *create* their gender and sexuality in every moment through everyday performances.

Around the same time that Butler was making the feminist case for performativity, Val Plumwood issued a call for an 'integrative feminism' based on ecological principles, which she argued would involve a movement 'towards an active, deliberate and reflective positioning of [women] *with* nature against a destructive and dualising form of culture'.[17] Of course, the intent of that 'with' becomes all-important to the performative processes that might create radical ecofeminists. How might the non-human, with which those processes must engage, be best conceived – the pun is deliberate – as both *within* and *without* the human? This question poses an opposing, but paradoxically inversely identical, movement to performativity as theorised by Butler, who focuses primarily on identity formation of the human. For perception of the non-human within the human requires that the subject – human identity – becomes a disappearing act. From this perspective, just as Butler's 'performativity' deconstructs human identity so that it can be remade afresh, so it constructs non-human identity as an integral part of the human.

It is this sense of a reflexively doubling creativity, a production of the 'non-human in the human', that must be evoked in order to suggest how the factors and vectors of spectacle may make the human both more and less than itself. It is on this basis that I ironically insist on the possibility of human transmutation of the human beyond itself through spectacle.[18] This is crucial to creating the potential and always provisional ecological significance of the paradox of the non-human within the human, of the human-animal, of the paradoxical primate. As noted already, that does not imply some kind of transcendental signifier, a human 'soul'. How

[15] Luce Irigaray, *This Sex which Is not One*, trans. Catherine Porter and Carolyn Burke (Ithaca: Cornell University Press, 1985 [1977]), p. 187; see also: Hélène Cixous and Catherine Clément, *The Newly Born Woman*, trans. Betsy Wing (Manchester University Press, 1986 [1975]), pp. 63–5.

[16] Judith Butler, *Gender Trouble: Feminism and the Subversion of Identity* (London: Routledge, 1990), pp. 139–41.

[17] Val Plumwood, *Feminism and the Mastery of Nature* (London: Routledge, 1993), p. 39.

[18] Donna Haraway essayed a similar move to destabilise the 'human' through her trope of the cyborg, see: 'A Cyborg Manifesto: Science, Technology, and Socialist-Feminism in the Late Twentieth Century', in *Simians, Cyborgs and Women: The Reinvention of Nature* (London: Routledge, 1991).

could it, when the subject is also constituted as a wholesale disappearing act? But the non-human within the human is what connects homo sapiens to all other organisms and to the world, unavoidably. It is paradoxically also the basis of a common humanity. Given that, the key concern of this chapter becomes: how, in the twenty-first century, might the human gain a stronger sense of the non-human world, and of humanity's integral part within it, through the spectacles of theatre and performance ecology?

As the performative society is characterised so crucially by spectacle then the paradoxes of spectacle could provide clues about the nature of a common humanity. Consideration of the non-human within the human of the paradoxical primate might challenge restrictive and divisive notions of class, race, gender, sexuality and so on that commonly hamper agreements about global cultural and natural justice. And a related tendency to imagine the poorest nations and peoples of the world as somehow happily ignorant of the sophisticated perplexities of its over-developed societies could also be called into question. Altogether these are complicated factors, of course, so I shall not be offering a fully 'joined-up argument' in this chapter. Rather, I will make a series of linked observations. In doing so I will concentrate on examples of Western spectacle, partly because it is the best documented, but mainly because historically it has dealt with powers great enough to shape global histories.

There are a couple of hypotheses within my approach that I should briefly explain at this stage. The first is that the ways in which spectacle has dealt with power may allow us to group it into broad types. There are certainly more, but here I am positing just four, namely:

- Spectacles of domination: spectacles of church, monarchy, state; religious rites, coronations, military parades – rituals of the powerful.
- Spectacles of resistance: spectacles of the people, the masses, the revolutionary avant-garde; charivaris, political protests, re-enacted uprisings – carnivals of the weak.
- Spectacles of contradiction: spectacles that negotiate new types of power-broking; saturnalia, hunger strikes, non-violent resistance, terrorist attacks – festivals of division.
- Spectacles of deconstruction: spectacles that question and displace the nature of the 'real'; shamanic tricks, *trompe l'œils*, masquerades – celebrations of the equivocal.

This fourfold schema is not, of course, closed to mutation as these categories overlap and in the flux of history sometimes, as it were, bleed

into each other. It is a temporary instrument that I hope will help to keep our bearings in complicated territory. I also hope to use it against itself, to question the assumptions that theatrical theorists have tended to make about spectacle so as to introduce a degree of reflexivity into my argument. For one thing is sure in this twenty-first-century age of deep uncertainties: if subjects are constituted through spectacle then humans will need to develop an especially reflexive take on how they appear as non-humans between and among themselves in order to get anywhere near to a sense of the commonly human.

My second hypothesis is about changing relationships between scale and time. It has been customary in Western traditions to link spectacle and size, so that it has become habitual to think of spectacle as usually large-scale.[19] Olympics scholar and influential theorist of spectacle John MacAloon reaffirms this: 'Not all sights ... are spectacles, only those of a certain size and grandeur ...'[20] But there has been a massive trans-formation of the human sense of scale in the past five hundred years, so that the traditional association of spectacle with gigantism has been dis-placed. This transformation of scale derives from a shrinking of the world. For example, between the 1500s and the 1960s the globe shrank seventy-fold or more, as the 10 mph average travel speed of horse-drawn coaches and sailing ships gave way to the 700 mph of jet passenger air-craft.[21] In the late-twentieth century this trend accelerated exponentially. Global digitisation through the World Wide Web and Internet has scaled down the world even more. One result of this is that – at least in postindustrial Western societies, but increasingly elsewhere – spectacle can now be minute. I refer to this phenomenon later as the 'miniatur-isation of spectacle'.

To get to that point I shall briefly sketch out a few stages in the history of Western spectacle using my schema of the four types. I will also briefly review the anti-spectacular bias of drama and theatre in theory and practice, as this has shaped the critical tradition that in the twenty-first century still struggles for dominance in the study of theatre and per-formance. I shall argue that a critique of this bias can illuminate the importance of spectacle to the circulation of power in the social, political

[19] *Shorter Oxford English Dictionary*, 3rd edn, (definition 1) has 'A specially prepared display of a more or less public nature (esp. one on a large scale)', p. 1962.

[20] John J. MacAloon, *Rite, Drama, Festival, Spectacle: Rehearsals Toward a Theory of Cultural Performance* (Philadelphia: Institute for the Study of Human Issues, 1984), p. 243.

[21] See diagram at David Harvey, *The Condition of Postmodernity* (Oxford: Blackwell, 1990), p. 241.

and environmental spheres – and indicate some of its newly relevant importance for activism. I will approach my first question, about the historical distrust of spectacle by drama and theatre theorists, through a tight focus on the question of collapsing scenery, first using it to outline some of the paradoxical qualities of spectacles of deconstruction. Because it is, I think, such qualities of spectacle that may best carry the charge of eco-activism in the twenty-first century.

COLLAPSING SCENERY 1 – WATCH IT ALL COME DOWN

There is a wonderful moment in Buster Keaton's short film *Steamboat Bill Jnr* that resonates with the ambivalent pleasure characteristic of spectacles of deconstruction and paradox. I take a close look at it partly because film and cinema – in acute contrast to 'serious' theatre – embraced spectacle with untroubled warmth from the outset, but also because the reproductive technologies of film, television, video, audio and so on, obviously have been crucial to creating the society of the spectacle and the performative society. It also provides a link to my analysis of dramatic theory's habitual horror of spectacle, as well as ironically con-nects with the chapter's concern with the human response to environ-mental threats in the twenty-first century. My coda for this slightly cheeky analytical sleight of hand (a reflexive displacement, perhaps?) is Oscar Wilde's typically seductive comment on the opening night of *Lady Windermere's Fan*: The play was a great success, but the audience was a total failure.[22]

Possibly there has always been a close connection between spectacle and disaster, because disaster unexpectedly unleashes extreme powers that rupture a world that human beings dream of keeping wholly intact, suddenly splitting open normality to expose its utter instability. It achieves this by threatening always to eliminate the human, to reduce it to total insignificance in the grand scheme – or chaos – of things. Hence, the classic incident of spectacle in *Steamboat Bill Jnr* plays on the human fear of disaster by heightening Keaton's trademark vulnerability, exposing his human fragility to the ultimate threat of instant extinction. Significantly, the moment can be appreciated without knowing the plot of the film, but it is important to my ecological themes that it is preceded by four minutes of Keaton wrestling with a cyclone, which eventually blows him,

[22] Quoted in Peter Hay (ed.), *Theatrical Anecdotes* (Oxford University Press, 1987), p. 81.

Figure 8 Buster Keaton, *Steamboat Bill Jnr* – 1928. A publicity shot of Keaton in the window of the fallen wall, after the dust and the cyclone of the scene have cleared.

in a hospital bed with wheels, into a street where it stops in front of a two-storey house. The sequence cross-cuts between Keaton falling out of the bed, then crawling under it for shelter, and a man on the second floor of the house realising that the front wall is about to collapse forward. The man jumps out of the upstairs window and lands on the bed, which is blown away by the cyclone, taking him with it. Keaton stands, facing the audience and scratching his head – such a human gesture of puzzlement – while behind him the whole front wall falls intact towards the street. Miraculously, he is standing exactly where the top window is positioned, so he survives the disaster as the wall crashes around him. After a split second of brilliant comic timing, he leaps in the air as if bounced up by the impact of the fallen wall and runs off to the next scene.

I will interpret this moment in terms of the curiosity and contempt of my original title. As the wall falls the spectator obviously is encouraged to fear the worst, to entertain contempt for a world that can be so fickle. As the dust clears these worst fears are relieved by the curious – in the sense

of the oddly inevitable – coincidence of the window's position in the falling wall being exactly where Keaton is standing. So in an instant the world is made both contemptuous and curious, disgusting and alluring. The dramatic, and comic, success of the spectacle rests on this instant production of affective ambivalence. But this is not just a matter simply of reversed expectation. More fundamentally, the spectacle's ambivalence also arises from two sets of contradictory viewpoints, between, firstly, what the spectators can see, but Keaton cannot, and secondly, what Keaton knows, but the spectators do not.

In other words, the ambivalent spectacle is not so much produced in the contrast between the huge falling wall and Keaton's vulnerability, but by a sudden gap opening up between different ontologies or versions of the real, a kind of fissure in the way that knowledge of the world is usually assembled. Moreover, that gap or fissure is highly paradoxical in its relation to the real world of late-1920s silent movie-making. By this point in his career Keaton was an international star and it was well known that he chose to do his own stunts. The danger in the spectacle is manifest: the wall weighed over a ton and there is a story that 'one of the cameramen found the suspense so intolerable that he looked away at the last moment'.[23] Herein lies the paradox: the utter vulnerability on display is heightened because the distance between Keaton and his character collapses with the wall. As in Baudrillard's vision of apocalypse now, fiction and reality are, as it were, forced to collide, and in the process a star rises out of the ontological rubble. In more general terms, human mortality immortalises itself in the moment of spectacle, and the spectator sees this paradoxical process as it is happening. In this sense the spectacle is a human transmutation through which Keaton is rendered, sublimely, both human and non-human – a paradoxical primate! We glimpsed something of this quality of extraordinary acting in chapter 3, achieved by George Formby through a vulnerability that was less directly environmentally located. In Keaton's case, that the spectacle is produced by a cyclone becomes key to the scene's sublime effects.

Perhaps what survives here is an ecological ethic that is overtly biocentric in its integration of mind and body, spirit and bone, culture and nature through creation of the paradoxical primate. I think the scene may achieve these effects so powerfully because the technology of film, especially through close-ups, allows the vulnerability of the commonly

[23] Tom Dardis, *Keaton: The Man Who Wouldn't Lie Down* (London: Deutsch, 1979), p. 155.

human, as a root in the non-human, to be placed firmly – actually and metaphorically – at the centre of the spectacle, and this is a result that live spectacle finds extremely difficult to create. Through such processes, though, spectacle may produce a sudden deconstruction of the world and the nature of the human as humans thought they knew it. Unlike the ritual spectacles of state and authority as represented by Renaissance Civic Entries or Damiens's dreadful death, which aim to sew every detail of the real into a seamless scheme of power, deconstructive spectacles work paradoxically to open up new domains for radical revisions of the way things are. They are therefore an especially powerful potential force for progressive eco-activism.

COLLAPSING SCENERY 2 – OR THE EDIFICE COMPLEX

So, particularly given this kind of potential, what is it that has made dramatic critics and theorists so suspicious of spectacle? The pathology can be traced back a long way through the usual sources. We would start with Aristotle's *Poetics*, maybe give a nod to the spectacular shadows in Plato's cave, then go on to Horace warning that 'Medea must not butcher her boys before the people' (c. 20 BC), to Ben Jonson's attack (1641) on effects that leap 'from stage to the tumbril', to Schlegel warning that 'it is possible for theatre to degenerate into a noisy arena of merely bodily events' (1808) and Hegel cautioning that tragedy particularly should shun 'a lavish display of the sensuous side of things' (1820).[24] The tradition continues through Shaw, Eliot and others in the twentieth century, then meets major challenges from Artaud and his admirers in the post-World War Two period. In Artaud's wake recent theorists – from Kowsan to de Marinis, and from Schechner to Pavis – have, more or less, embraced spectacle within the generous rubric of performance, and we could trace this pro-spectacular bent back through Wagner to Voltaire in the eighteenth century and Castelvetro in the sixteenth century. Yet until the late-twentieth century this latter strand in Western critical history was always very tenuous. But why did such pathological contempt for spectacle get the upper hand of curiosity about its purposes? Is it just that the theorists, by definition, were logocentric; or had they sensed some serious lack in the theatre itself?

Perhaps examples of collapsing scenery in twentieth-century theatre might throw some light on this issue, because the ways in which

[24] Oscar Lee Brownstein and Darlene M. Daubert, *Analytical Sourcebook of Concepts in Dramatic Theory* (Westport, Conn.: Greenwood Press, 1981), p. 365.

unwanted spectacle has sometimes inserted itself into the serious business of drama offers instances of accidental deconstruction. Falling scenery constitutes a kind of theatrical lapsus, perhaps a lacuna in theatre ecology, which can open vistas on the underlying causes of the pathological distaste of the theorists. The American critic George Nathan, in a review of a production by Norman Bel Geddes of a play called *Siege*, coined a telling phrase about such underlying causes. According to Peter Hay, Geddes had 'spent a fortune for a massive set that showed four stories of an old Spanish fortress ... ', but the critics massacred the show. Nathan, though, penned the wittiest line of attack, when he diagnosed Geddes as suffering from an 'edifice complex'.[25]

There are many examples of the edifice complex, some of which show that it may even be built into the architectural ecology of certain types of theatre. One of my favourites of this kind is Bulwer-Lytton's play *The Lady of Lyons* of 1838, which did not open on its premiere evening because the safety curtain got irretrievably stuck – producing the spectacle of an audience that wasn't.[26] But brevity dictates that I be highly (and probably naughtily) selective in my choice of more pertinent exemplars. So here are a couple of possibly apocryphal stories about those archetypal principals of power: obelisks and phalluses. I quote from Giles Brandreth:

When Sir John Gielgud appeared as Oedipus at the National Theatre in London in 1968, the set in Peter Brook's production was dominated by a gigantic golden phallus, thirty feet high. Coral Browne saw it and remarked, 'Well it's no one I know.'

And, more to the point, so to speak, Brandreth quotes a second case:

Another giant phallus – beige this time – was used in a modern version of Aristophanes *Lysistrata* staged in Cambridge, Massachusetts, in 1979. Mid-way through the opening performance, the wires supporting the phallus gave way and, as if in symbolic gesture, it fell right across the stage knocking the leading lady to the ground.[27]

A more sombre comeuppance befell Donald Wolfit in his 1953 London production of *King Lear*. Here is Peter Hay's version of the environmental disaster:

Wolfit ... played the storm scene standing against an eighteen-foot obelisk, which required holding in position by a man standing behind it, and thus

[25] Hay, *Theatrical Anecdotes*, p. 223.
[26] Giles Brandreth, *Great Theatrical Disasters* (London: Grafton Press, 1982), p. 3.
[27] Ibid., p. 8.

hidden from the audience. Just before the coronation [of Elizabeth II] ... the task was carried out by a patriotic stage-hand who had begun to celebrate the forthcoming event somewhat in advance of others. On the line 'Strike flat the thick rotundity o' the world!' the stage-hand hiccoughed and lurched forward, causing the obelisk to strike hard the back of Wolfit's head. The actor, being enormously strong, finished the scene supporting both the obelisk and the patriot, by then paralytic. When Wolfit came into the wings, he was limping – the bump on his head was concealed by his wig and he did like his injuries to be seen.[28]

Though these examples are flippant, I quote them to underline a crucial point of my argument. The distaste of the critics and theorists for spectacle is possibly founded in the limitations of theatre as a cultural form. At first glance these may seem to be caused by shortcomings in the theatre's mechanical means of production, creating anxiety about technical disaster. But of course there was always something more fundamental than a fear of falling principals at stake.

What is it about spectacle itself, though, which the theorists and the legitimate theatre were avoiding? Was it simply that this theatre ecology was too refined to fully embrace the carnival indulgence of the body, or could it be that it was unable to handle the full extremities of power that spectacle can unleash? The poor actor sent bowling by the toppled phallus may stand – or rather, fall – as an emblem of this weakness in theatre: theatre hardly has a chance of survival when the fickleness of absolute force is let loose. From this sceptical perspective, Coral Browne's witty dismissal of the giant golden phallus hailed the edifice complex to deny the full majesty of the Oedipus complex. Similarly, Wolfit's pretend limp looks like much more than a front for damaged pride: it speaks eloquently of failure to integrate the unpredictable might of extra-theatrical power – whether of spirits, monarchy, or the natural environment (yet another storm) – into the make-believe of the stage.[29] Here is an ecology that paradoxically seems frequently to prefer to seal off the energies on which it depends.

To put these observations conversely: the dominant traditions of Western theatre have aimed to tame spectacle, to incorporate spectacle in a reduced form into its disciplinary regimes. They could achieve this because those regimes are fundamentally shaped by the socio-metrics of

[28] Hay, *Theatrical Anecdotes*, p. 342.
[29] The traditional fear of actors of working with animals and children may be part of this syndrome, see: Nicholas Ridout, 'Animal Labour in the Theatrical Economy', *Theatre Research International* 29: 1 (2004), 57–65; *Stage Fright, Animals, and other Theatrical Problems* (Cambridge University Press, 2006).

theatre architecture, the structural norms of society reified in wood, stone, concrete.[30] Socio-metrics ensure that, from an activist point of view, theatre ecologies almost always play safe with especially dangerous stuff. Hence, the spectacular in theatre has been mostly in fact anti-spectacle, because the disciplinary mechanisms of the theatre automatically undermine the extreme force of the powers, but especially the ambivalent powers, that spectacle is designed to foster. This is why desire for spectacle – whether in state ritual or street carnival, say – has constructed specially designed buildings or designated areas for its production: from the amphitheatres of Roman antiquity, through the Natural Science museums and Winter Gardens of nineteenth-century England, and to the theme parks, Millennium Domes and Olympic stadiums of the twenty-first century. Compared to these, the modern theatre is a very modest, near-hermetic environment. From this perspective, the theatre was always condemned to fall short in its dealings with new types and magnitudes of power as they circulated around the monumental monarch, or in the body politic of the industrial revolution, or through the decentred networks of the neo-liberal globalised economy, or in the turbulence of the biosphere as global warming passes the point of no return. Staging the tempest just dampens it down. Little wonder, then, that historically, really radical activists have tended to shun the theatre, unless they went to prevent it by a riot, or to shoot a President.

SPECTACLES IN HISTORY

My second question, about how spectacle has been variously articulated to power in history, obviously raises many complications. But it is perhaps worth risking some historical sketchiness in order to see how spectacle may function differently in the twenty-first century from earlier times. Although I shall be comparing spectacle across five centuries, there is no teleology in my tale. Rather, I present this patchy panorama to show how the changing uses of spectacle demand that we adopt appropriate conceptual systems for their analysis. I return, then, to my scheme of the four types of spectacle for this historiographic task. The underlying method to my argument might be best described (adapting Donna Haraway's idea of 'situated knowledge')[31] as situated theory, because it

[30] Richard Schechner, *Performance Theory*, rev. edn (London: Routledge, 1988), pp. 160–4.
[31] Haraway, 'Situated Knowledges: the Science Question in Feminism and the Privilege of Partial Perspective', in *Simians, Cyborgs and Women*, pp. 183–202; see also Donna J. Haraway

attempts to use ways of thinking that may be fit for purpose according to the period of each.

The spectacles of the English Renaissance were shaped in large part by the stark polarities of court/church and commons. On the one hand, there were the grand rituals of fealty – from the public Royal Entries to the private Court Masques, say – and, on the other hand, there were the carnivalesque fetes and fairs of streets, squares and greens, the archetype being London's Bartholomew Fair. The binary structure of this classification need not blind us to greater complexities, for example, that the civic triumphs were ideologically nuanced by the emergent humanism of the Renaissance. As George Kipling has shown: 'If the king came to judge his people in the civic triumph, the queen came to mediate, bringing mercy beyond justice.'[32] But whatever gender the monarch, these streetwise scenographies left little doubt as to who was absolute top dog in the human links of the Great Chain of Being.[33] Similarly, the indoor spectacles of Court Masques and Festivities shifted the monarch from centre stage, but the designer's new command of optical perspective (also applied in the public playhouses) ensured sight lines that culminated in the best seat in the house, a throne whose occupant was flattered to know she was missing absolutely nothing. In any theatrical event, the rituals of fealty conformed to a principle of holy state power that was centrifugal, concentrating totally in the divine right of the monarch.

The fair, however, was the people's performance domain, an anarchic mess of multiple spectacles that refused to conform to any obvious pattern of power:

Here a Knave in a Fools Coat with a trumpet sounding . . . would fain persuade you to see his puppets; there a rogue . . . in an antic shape like an incubus; on the other side Hocus Pocus . . . showing his art of Legerdemain to the astonishment . . . of a company of cockoloaches . . . And all together make such distracted noise, that you would think Babel were not comparable to it.[34]

This, of course, is the immersive spectacle of carnival celebrated by Bakhtin for its revolutionary potential. But the claim that it could

Modest_Witness@Second_Millennium.FemaleMan©_Meets_Oncomouse™: Feminism and Technoscience (London: Routledge, 1997).

[32] Kipling, 'Wonderfull Spectacles', p. 164.

[33] An exception to prove the rule was Queen Mary's 1561 entry into Edinburgh; see ibid., pp. 169–72; for the Great Chain of Being, see: E. M. W. Tillyard, *The Elizabethan World Picture* (Harmondsworth: Penguin, 1963 [1943]).

[34] Anon., seventeenth-century pamphlet, quoted in Samuel McKechnie, *Popular Entertainment Through the Ages* (London: Samson Low, Marston, n.d.), p. 33.

out-Babel Babel also points to its chief weakness from an activist point of view. Just as the source of its energy is a multiplicity of creative voices, the people's pleasures unleashed, so it has no obvious political direction, as it operates centripetally, dispersing itself in excess. This polarisation of spectacular types in Renaissance England did not simply reflect an extreme asymmetry of powers in the period. Rather, that imbalance was produced through the astonishing magnitude of their difference. In comparison the Elizabethan theatre was timid, generally alluding to the full force of spectacle through synecdoche and other reductive tropes. As the Chorus in *Henry V* apologetically has it: 'Oh Pardon! That a crooked figure / May attest in little part a million...'[35]

We must be wary of imposing too simple a schema of analysis across time. In nineteenth-century Great Britain, for example, the growth of spectacle on the London stage would seem to disprove my argument about the anti-spectacular bent of theatre. The first aquatic dramas were floated early in the century at Sadler's Wells Theatre, on a stage that was in fact a very large water tank. During the next eighty years the machinery of theatres grew increasingly elaborate and stage effects became more complex and lavish.[36] Surely this shows that the Victorian theatre took on board the exponential rise in the production of power by the industrial revolution? Yet the new technologies of the stage – especially gas lighting – mostly forced the action back behind the proscenium arch, physically and visually containing it even as it grew more frenetically extravagant. This reductionism was further reinforced by the psychology of the darkened auditorium, the first step towards the twentieth-century theatre's docile audiences.

Two linguistic shifts emerging in the Victorian era seem to confirm this analysis. Gradually, 'audience' replaces 'spectator' as the most common appellation of the crowd. Through this, theatre attendees were encouraged to think of themselves as a collective paying attention to sound, particularly to words, rather than as individuals primed to enjoy the delights of scopophilic excess. A parallel shift in the term for the audience's space, from 'spectatory' to 'auditorium', underlines the point. Then in the late-nineteenth century 'spectacular' was coined as a noun to refer to a showy event of large-scale proportions beyond the scope of theatre. In 1890 the *Pall Mall Gazette* enthused about: 'An amphitheatre ... in

[35] William Shakespeare, *Henry V*, ed. A. R. Humphries (Harmondsworth: Penguin, 1968), p. 59: Pro. 15.
[36] Richard Leacroft, *The Development of the English Playhouse*, rev. edn (London: Methuen, 1988), pp. 140–65.

which spectaculars on a grand scale might be produced before a half-million spectators.'[37]

No amphitheatres were built to this size, but Victorian science and engineering ingenuity ensured delivery of much more pervasive spectacles for the nineteenth-century imaginary to feed on. The building of the first Natural History museums, with displays of artefacts culled from almost every corner of the world, was out-matched by the great steel and glass Winter Gardens, such as Caxton's Crystal Palace in London, which housed massively popular displays of exotic plants alongside the latest inventions of the age of steam. In these key institutions of industrial society, as Carla Yanni and Una Chaudhuri have shown, the spectacular theatricalisation of nature staged both a voracious taxonomic discipline and fostered the dream of an achievable green utopia.[38] Such displays paradoxically produced spectacular distraction from the contradictions they created, say, vastly popular pleasures resting on the mass misery of the factory system, man lording over nature by destroying it. A more distributed spectacle was staged on a national and increasingly global scale through the new steam-driven transport systems.[39] The extraordinary increase of power – literally, metaphorically – in Victorian England and its expanding Empire flourished through what Chaudhuri calls a 'hypocritical fantasy',[40] masking deep anxieties that divided people in themselves and set the stage for Freudian psychology. Queen Victoria claimed to enjoy these new cultural performances as much as her subjects, so we might safely surmise that the spectacles of state and street were becoming deeply but ambiguously meshed with each other. These spectacles of latent contradiction covertly advertised the uneasy coexistence of monarchy and the first major phase of modern democracy, fertile ground for the international activism that eventually produced revolution elsewhere in the world.

These examples indicate a division between serious theatre and the pleasures of the masses, between legitimate stage and popular spectacle

[37] Harrison, *Language of Theatre*, p. 253.

[38] Carla Yanni, *Nature's Museums: Victorian Science and the Architecture of Display* (London: Athlone Press, 1999), pp. 149–52; Una Chaudhuri, *Staging Place: The Geography of Modern Drama* (Ann Arbor: University of Michigan Press, 1997), p. 77.

[39] In 2000 I directed a site-specific spectacle in Bristol docks on one of the great icons of this expansion, Isambard Kingdom Brunel's steamship the ss *Great Britain*. This convinced me that latent contradiction was probably *the* Victorian pathology. See: Baz Kershaw, 'Performance, Memory, Heritage, History, Spectacle – *The Iron Ship*', *Studies in Theatre and Performance* 21: 3 (2002).

[40] Chaudhuri, *Staging Place*, p. 77.

that widened throughout the twentieth century. The growth of mass pleasures beyond theatre, first in the dream-worlds of cinema and television, and later in the theme parks, heritage centres, shopping malls and so on, promoted the society of the spectacle. These ubiquitous pleasure-zones of consumption theatricalised experience by turning the everyday into an immersive spectacle of increasing overproduction, in which people became spectators of themselves as participants in an emergent cultural (dis)order. This process was vastly hastened in the last quarter of the twentieth century by mediatisation and globalisation combined, and as the millennium turned it was hurtled into hyperdrive under the full force of the digital revolution.

Such were the conditions that extended spectacle beyond the large-scale, into a miniaturisation that personalised, and paradoxically fabulously magnified, its appeal. Making it highly accessible, for example, at the click of a mouse. Such were the sources for the emergence of a new kind of human sensorium, described most forcefully by Debord and Baudrillard, as the energies and powers of spectacle became pervasive in everyday life, no longer primarily a matter of occasion but also perfused in perception. Technology was of course a major factor in the production of this extraordinary environment, but hands-on access to high-tech gizmos was not necessary to its spread beyond the rich nations of the world. This was because reproduction through a myriad of methods and on a vast range of scales became a principle force in its creation. The humble Coca-Cola can trigger a sense of the global reach of this new cultural paradigm just as well as intimate knowledge of the World Wide Web. So the spread of technology begs interpretation in this wider sense, to indicate how billions of people came to participate in the paradigm, discovering the paradoxical ways in which it both empowers and disempowers.

For the performative society fostered the new sensorium through the coupling of liberal democracy and capitalist marketplace, so that the powers of political enfranchisement – no matter how strong or attenuated – were always inflected by the economic dominance of consumerism and its subjugations. And, integral to the paradoxes produced by uniting such incompatibles, in the second half of the twentieth century there was a growing public awareness of the fragility of planet Earth and the threat of ecological catastrophe promised by unbridled exploitation of its natural resources. Such tensions have encouraged new kinds of activism in, for example, the anti-globalisation movement, the World Social Forum, the burgeoning of green organisations and campaigns on every continent, and

their complexities have generated a new importance for spectacles of contradiction and deconstruction.[41] Also, at root, this is why I think activists of all kinds, but especially eco-activists aligned with ecofeminism, could benefit from knowing of how such spectacles may be most effectively produced.

SPECTACLES OF DECONSTRUCTION IN THE PERFORMATIVE SOCIETY

My third main question, about how humans may be constituted by spectacle in the twenty-first century, is best approached through example rather than historical survey because it is such a relatively recent phenomenon. My interest in this paradigmatic development of spectacle is twofold. First, I want to identify in more detail how the human subject may be differently constructed through spectacle than in the past. Second, I want to clarify how the society of the spectacle was being transformed into the performative society. So as this chapter draws to a close I shall briefly anatomise the work of three performance artists who have certainly provoked a good deal of curiosity and contempt: namely, Australia's semi-cyborg Stelarc, and the Latino self-styled 'border artists' Guillermo Gómez-Peña and Coco Fusco. These artists are especially pertinent to my argument because they represent a new, international wave of radical performance that emerged in the final two decades or so of the twentieth century. They exemplify a highly reflexive response to the new sensorium through the paradoxes in their use of performance situated in extra-theatrical public contexts. I discuss them as exemplars of a style of performance that engaged with small-scale spectacle.

To clarify this choice, two points are worth making about key effects of global mediatisation on the human relationship to spectacle. These draw directly on the critical traditions of the Frankfurt School, of Guy Debord and the Situationists, and of Baudrillard and the postmodernists, which emphasised mediatisation as a crucial process in dispersing performance throughout culture.[42] The eye of the camera, the ear of the microphone,

[41] See, for example: Robin Cohen and Shirin M. Rai (eds.), *Global Social Movements* (London: Athlone Press, 2000); Paul Kingsworth, *One No, Many Yeses: A Journey to the Heart of the Global Resistance Movement* (London: Free Press, 2003); George McKay, *Senseless Acts of Beauty: Cultures of Resistance since the Sixties* (London: Verso, 1996); George McKay (ed.), *DiY Culture: Party and Protest in Nineties Britain* (London: Verso, 1998).

[42] Rolf Wiggershaus, *The Frankfurt School: Its History, Theories and Political Significance* (Cambridge, Mass.: MIT Press, 1995); Sadie Plant, *The Most Radical Gesture: The Situationist International in a*

the dimpled skin of the keyboard, the extra finger of the mouse – these all have repositioned everything as performance for someone else and, crucially, for ourselves as well. The ghost in the global machine is a performer and we are that ghost.

First, spectacle is constitutive of the performative society, but not simply through the historical types of dominant, resistant and contradictory spectacle. Those types depended on producing a scale that would somehow match the magnitude of the powers with which they were dealing. This continues, of course: the New Labour farce of Britain's Millennium Dome and the terrorist tragedy of the collapsing twin towers are stupendous examples. But in the twentieth century there was also a wholesale scaling-down of spectacle, a miniaturisation fashioned by the shrinking of the world and the advent of new media technologies. It was implicit in the first movie cameras and projectors, became explicit with the cathode-tube, pixel and plasma screens, then rocketed towards ubiquity in the hypermobility of multimedia mobile phones, iPods and similar devices. As noted in chapter 2, the fabulous flexibility of reproduction in digital technologies fast-forwarded the vectors of deconstructive spectacle, creating new human sensoria for the twenty-first century. Of course there had been precursors, but they lacked the electronic media's technical suppleness. What was once 'unique and authentic' became ubiquitous and counterfeit[43] – a construction embracing deconstruction. The digital revolution made this process increasingly pervasive: every vision of disaster, every fantasy of civilisation, the carnival of deconstructive knowledge itself, could be captured in the magic of the microchip.

Second, this whole process is deeply paradoxical, as it shrinks the human to nothing – mere digital information – while dispersing the human everywhere. The contrast between tiny avatar figures on computer monitor screens and the limitlessness of the World Wide Web is a paradigm for this. That both are delivered through the same technology is profoundly destabilising of the human: where am I, the human subject, in this paradigm? Such searching then produces the further paradox of a culture founded on narcissism as millions are always looking for their selves in the spectacle. But because the performative society is primarily a spectacle of deconstruction, where the eye always sees itself looking, the

Postmodern Age (London: Routledge, 1992); Steven Connor, *Postmodernist Culture: An Introduction to Theories of the Contemporary* (Oxford: Basil Blackwell, 1989).

[43] Susan Stewart, *On Longing: Narratives of the Miniature, the Gigantic, the Souvenir, the Collection* (Durham, N.C. and London: Duke University Press, 1999), p. 68.

search for secure identity is a lost cause. This is another outcome of deconstructive spectacle. Instead of a figure of survival, as pictured by Buster Keaton, the human becomes *only* a disappearing act, a fabulous figment, a ghost in the hard-drives of the hyper-real. But also these non-human elements of the subject can open up profound ecological reson-ance for the human. Then the most radical ambivalence of the para-doxical primate shimmers with uncanny energy. For the non-human within the human may remind these primates that they are just as much atoms and liquids and animals, say, as they are uniquely intelligent creatures in a world that is not, after all, just of their own making.

The twenty-first century thus may be characterised by mighty cultural and natural processes that are radically changing the ways in which power circulates through the human. Liberal democracy, late-capital-ism, digital technologies and global mediatisation together create per-formative societies that give the human access to agency – the performative, as Derrida argued, is always carried forward by a 'yes'[44] – but an agency that is always in danger of being totally cancelled out. The idea of the 'posthuman' is one response to this paradox.[45] But also turn-of-the-millennium artists such as Stelarc, Fusco and Gómez-Peña – like Buster Keaton – produced performances that aimed to negotiate this death of the human in ways that placed its survival at a premium. My trope for this potential is the 'non-human in the human' because that implies a necessary connection with the myriad other biotic agents upon which human futures depend. I shall briefly analyse my two examples to explore these points, focusing on questions of spectatorial participation and agency as key to the potential of deconstructive spectacle as efficacious ecological activism.

STELARC: A TWENTIETH-CENTURY CYBORG

In the final decades of the twentieth century the Australian performance artist Stelarc undertook a number of spectacular body suspension events and Internet experiments that raise crucial questions about the survival of the human in an age of ambivalent borders.[46] The suspensions involved

[44] Jacques Derrida, 'From *Psyche* – Invention of the Other', in *Acts of Literature*, ed. Derek Attridge (London: Routledge, 1992), p. 298.
[45] Katherine N. Hayles, *How We Became Posthuman: Virtual Bodies in Cybernetics, Literature, and Informatics* (University of Chicago Press, 1999).
[46] Website – Stelarc: www.stelarc.va.com.au/index2.html (01.10.2006); Website – Suspensions: www.stelarc.va.com.au/suspens/suspens (01.10.2006); Website – Ping Body: www.stelarc.va.com.

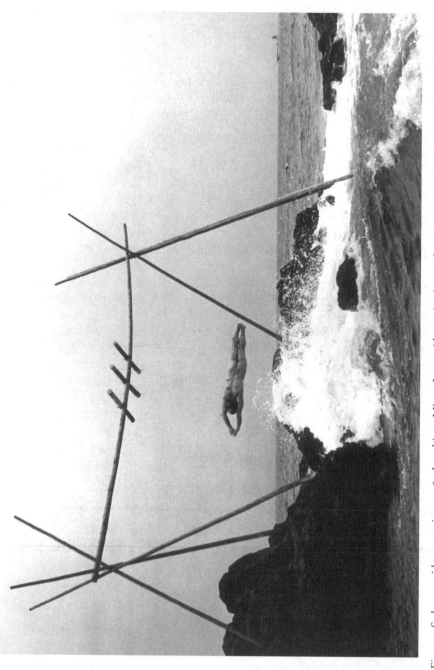

Figure 9 Stelarc, seaside suspension – 1981. Jogashima, Miura, Japan: tide coming in, weather overcast, waves crash against the rocks spraying and splashing the pierced body as it sways in blustery winds. Duration 20 minutes. Photograph: Ichiro Yamana.

hanging himself from various structures and machines by meat-hooks pierced through his skin, in a wide range of environments. In *Ping Body* (1995/6) the meat-hooks were replaced by electrical stimulators linked to the World Wide Web, so that people at computer terminals in remote locations could activate his body. The conceptual and (relative) technical simplicity of these events created, I think, quintessential deconstructive spectacles in the run-up to the millennium.

Stelarc's suspensions force a deconstruction of the human through their juxtaposition of the body in pain and the image of flying. The hooks through the skin allude to torture and butchery, processes through which the sentient being becomes mere meat and something of the non-human within the human is exposed. The regicide 'Damiens effect' perhaps. The pain of the technique gestures towards what Elaine Scarry calls 'the unmaking of the world'; because pain has no referent it is un-shareable, not just resisting language but destroying it.[47] Paradoxically, though, in Stelarc's suspensions the pain is a means to achieving an image of human transmutation, as they allude to flying free and, in the West at least, people transformed into angels and/or, ironically, 'super(wo)men'.[48] Hence these events speak simultaneously of human obsolescence and survival. They achieve this paradox so successfully because Stelarc, like Buster Keaton as Steamboat Bill, places the vulnerability of his humanity on the line 'at the heart' of the spectacle. Precisely because pain has no referent – how can we imagine what his pain must be like? – the spectator participates in what the spectacle deconstructs to reconstruct, the ineffability of 'human' survival at the moment that it is most challenged by its environment. Thus I propose this as an example of the non-human within the human that confirms an ecological connection to the biosphere as a potential source of radical activism. The performance ecology of the spectacular suspensions, particularly those set in natural environments, was well designed to manifest such a positive activist charge.

The *Ping Body* events perform similar paradoxes, but sometimes with a more immediately political charge. The muscle stimulators connected to

au/pingbody/index.html (01.10.2006); see also: Stelarc and James D. Paffrath (eds.), *Obsolete Body/Suspensions/Stelarc* (Davis, Calif.: JP Publications, 1984); Marquard Smith (ed.), *Stelarc: The Monograph* (Cambridge, Mass.: MIT Press, 2005).

[47] Elaine Scarry, *The Body in Pain: The Making and Unmaking of the World* (Oxford University Press, 1985).
[48] Compare Orlan and Abramovic: Bernard Blistene, Caroline Cros, Régis Durand, Christin Buci-Glucksmann and Elinor Hartney, *Orlan: Carnal Art* (Paris: Flammarion, 2004); Marina Abramovic, *Abramovic: The Biography of Biographies*, photographs Alessia Bulgari (Milan: Charta, 2005); Website – Orlan: www.orlan.net (03.10.2006).

the Internet imply that, theoretically, anyone anywhere can shift Stelarc's body about, provided they have access to the technology. Thus the individual autonomy of the artist is displaced and disempowered through mediation. But it also expresses potential empowerment of the many, as Stelarc's body becomes the repository of a partial body politic, the people sending the digital signals. 'Skin [says Stelarc] was once the boundary of the self. As interface it was once the site of the collapse of the personal and the political. Skin no longer signifies closure.'[49] Stelarc's spectacular evacuation of the self becomes an opening for a new kind of political engagement as his 'users' establish their agency through his body. In a sense, then, the event alludes to an ideal of direct democracy, in which co-present bodies collectively decide on the future. But, paradoxically, in this event bodies are replaced by dis-embodied representations, digital messages activated by spatially atomised participants. The signals they send have to be interpreted by Stelarc's computer to produce coherent commands for the muscle stimulators, otherwise his body could be damaged beyond repair. In the event, 'Stelarc' becomes a function of the system he has created.

So the 'translation' of the users' inputs ironically turns Stelarc's body into a metaphor that suggests the remoteness and relative inaccessibility of significant political power for the vast majority of people. The system of *Ping Body* reflects how effective democracy is discouraged in the wider culture of the performative society. Spectators can participate in the creation of the miniaturised spectacle, only to have it demonstrate that such participation does not amount to very much. The spectacle of deconstruction that places the commonly human at its heart may teach a key lesson about power in twentieth-century society, but it is not an especially hopeful one. Perhaps this is because the technical set-up leaves little or no room, so to speak, for the non-human in the human, as any sense of Stelarc's 'humanity' is massively overdetermined by the digital system of which it is an integral part.

Hence, Stelarc's spectacles of deconstruction generate far-reaching questions about the place of the political, and the environmental place of the human, in the performative society. They show that miniaturised spectacles in such a society may be just as ambivalent as their gigantic forerunners. Such spectacles may divide humans both from each other and themselves, and the more that this process is reinforced by new

[49] Stelarc, quoted in Tracey Warr, 'Sleeper', *Performance Research* 1: 2 (Summer 1996), 11.

technologies the more the human will need to find a radical response to transcend their enormous attenuating force. The availability of sources for such a response was demonstrated by Stelarc's suspension events, which were transmutations that made the subject a disappearing act at the moment in which they enabled the non-human in the human to appear. In this respect his suspensions were more successful than *Ping Body*, I think, because the endurance of the disappearing subject was more overtly on display. The blurring of the 'boundary of the self' in *Ping Body* suppressed that kind of potential, in the process perhaps partly confusing the issues of power at stake in the spectacle. But together these examples show that the nightmare splitting of humanity against itself that began to take hold of global society in the twentieth century has to be challenged head on if the human is to successfully head it off in the future. They may also make clear that such splitting potentially reinforces enormous powers of conflict between nature and culture, between the non-human and the human, which are leading to ecological catastrophe.

GÓMEZ-PEÑA AND COCO FUSCO – HUMAN-ANIMALS FOR THE TWENTY-FIRST CENTURY

In 1992 the Latin American performance artists Guillermo Gómez-Peña and Coco Fusco staged *Two Undiscovered Amerindians Visit* It was presented in Sydney, London, Washington and elsewhere, usually for free in museums or city squares. Gómez-Peña describes the show as follows:

Coco and I lived for three-day periods in a gilded cage, on exhibition as 'undiscovered Amerindians' from the (fictional) island of Guatinau. I was dressed as a kind of Aztec wrestler from Las Vegas, and Coco as a Taina straight out of *Gilligan's Island*. We were hand-fed by fake museum docents, and taken to the bathroom on leases. Taxonomic plates describing our costumes and physical characteristics were displayed next to the cage. Besides performing 'authentic rituals' we would write on a laptop computer, watch home videos of our native land, and listen to Latin American rock music on a boom box.[50]

Now this small-scale spectacle was a border performance in a number of wholly uncompromising ways. Because it achieved a thoroughgoing ambivalence through overlapping the boundaries between fiction and fact, performance and museum display, history and contemporary culture,

[50] Guillermo Gómez-Peña, *The New World Border: Prophecies, Poems, Loqueras for the End of the Century* (San Francisco: City Lights, 1996), p. 97. Here Gómez-Peña names *Two Undiscovered Amerindians Visit* as *The Guatinaui World Tour*.

'their' culture and 'ours', desire and shame, real and fake identities. In pretending to be an exhibition of 'authentic' natives, while withholding any indication that it was indeed a pretence, it implicated spectators in its reduced spectacle of human degradation in challenging and highly contradictory ways. But also it troubled the distinctions between 'culture' and 'nature', 'human' and 'animal' through its inescapable allusions to prisons and zoos. In the process, I will argue, it hugely opened up the potential of ecological activism. Its ontological ambivalence, its refusal to settle on what was 'real', was key to the production of this effect, in the following ways.

First, the cage reanimates the histories of colonialism as spectacle. Coco Fusco: 'In order to justify genocide, enslavement, and the seizure of lands, a "naturalized" splitting of humanity along racial lines had to be established.'[51] The golden cage ironically reactivates this 'splitting', and then the incommensurable mixing of signs – watching 'home videos of our native land' – potentially places that colonialist history in the kind of creative light that could produce a reflexive critique of its vicious ideologies. And second, the spectacle was playing directly with extremities of power by touching a raw nerve of the 'colonial unconscious' that still haunts the Western psyche. Coco Fusco again: 'Consistently from city to city, more than half of our visitors believed our fiction and thought we were "real" . . .'[52] Through the simple stratagem of refusing to signal clearly the ontological status of its codes, this spectacle risked reinforcing the very forces it aimed to subvert. This is because, obviously enough, the global history it animated was constructed through and through by structural distinctions as between white skin and black skin, humans and animals, masters and monstrosities, civilisation and barbarism, culture and nature. The small-scale spectacle of the cage had the audacity to play with those contradictions as if they were invisible.

But how might this attempted wholesale destabilisation of signification have reinforced a common sense of the human in the performative society? The answer hinges on how it transmuted contradictions into paradoxes, and this in turn rests in the forms of contradictory spectator participation it encouraged. Spectators could simply stand and stare, but

[51] Coco Fusco, 'The Other History of Intercultural Performance', in *The Routledge Reader in Politics and Performance*, ed. Lizbeth Goodman and Jane de Gay (London: Routledge, 2000), p. 132; Coco Fusco, *English is Broken Here: Notes on Cultural Fusion in the Americas* (New York: New Press, 1997).

[52] Fusco, 'Other History ', p. 134.

also they could literally 'buy into' the spectacle. For fifty cents they could purchase photographs of themselves standing in front of Fusco and Gómez-Peña in the cage, stories told by the natives (in gibberish), a sexual display of the male's genitals (wittily withheld, hidden between his legs), a chance to feed the caged unfortunates and so on. These choices raised the stakes on the spectators' interpretation of the event, potentially triggering a sense of ethical responsibility towards the 'natives'. But clearly there was always also the potential that spectators would go away entirely happy with their new 'possession', even though it was a sign of profound racism. This is the key contradiction of the event – it promotes and attacks racism – and the rest follow on: it presents humans as animals; it normalises the monstrous; it is a barbaric display of civilisation.

But the structure of the spectacle aims to work against these contradictions by creating edge-effect transactions across at least two kinds of border, two types of ecotone where contrasting performance ecologies overlap. The first is literally between the bars, on the liminal line of the cage perimeter, especially as spectators purchase participation. The second is between those who pay money to participate in the spectacle and the rest of the free-viewing spectators, a scene that potentially transforms the latter into self-conscious onlookers, reflexive viewers aware of their participation *as* spectators, and therefore still implicated in the spectacle. In these ecotones a multiple exchange is constantly constructed and deconstructed between the performers, the paying participants, and the non-paying spectator–participants. This offers the potential for a continuous re-visioning of identity as between each of the three groups (and others positioned between them). The non-payers may see spectators like themselves transformed into active consumers; the paying consumers may see the performers transformed from willing colluders in their own confinement to exploited objects of degrading entertainment; the performers may see the non-paying spectators amused, appalled or otherwise engaged by their willingness to be commodified, and see the paying spectators proud, ashamed or otherwise disaffected by their cooperative acceptance of such cultural 'sharing'. Or vice versa, for all of these possibilities and more, as the event triggers a miasma for mixed identities.

The continuous process of identity challenge and potential transmutations for all concerned is a very high-risk aesthetic and ethical strategy, reinforcing the spectacle's ambivalence. It animates the fundamental instability of identities as a product of performativity, as figured by ecofeminism, in the very process of aiming to call into question the nature of the realities on which these identities depend. Little wonder,

perhaps, that so many of the spectators ran for the bolt-hole of past prejudices. But also, surely, amazing that roughly the same number apparently became willingly involved in such a demanding task of reflexive reconstruction. Given what was historically, politically, ethically, environmentally at stake in this deconstructive spectacle, that result is, I think, very telling of a potential for radicalism in the performative society.

So the performance ecology of *Two Undiscovered Amerindians Visit ...* provided radical means for both performers and spectators to encounter the non-human in the human, as it bravely dealt in the contradictions that have generated global injustice for so many, and which are now driving humanity towards ecological calamity. The magnitude of the powers it engaged ensured that how these contradictions played out for individual spectators would be unpredictable, hence the more or less riven response. But its spectacular structure also enabled the performers, in the moment of direct performative exchange, at the liminal lines of identity and through its edge effects as an ecotone, to challenge the ethical assumptions of the spectators' action, encouraging all to see the situation from at least two sides at once. This was a trigger for humans to acutely perceive the political, ethical and environmental contradictions bequeathed by their history and animated by the event, and possibly to transmute them into challenging paradoxical truths. A racist is a person enchained by freely chosen denials. Colonialist history is a nightmare dreamed up by an Empire's murdered. Genocide favours the dead with an unbeatable wholesale deal. The paradoxical primate is an animal that knows it is all-too-human. And perhaps, given the irony that the Guatinaui islanders are presented as an endangered species: ecological suicide is man's last step to a cleaner planet. Thus spectacles of deconstruction have the potential to generate powerful reflexivities concerning the nature of the non-human within the human in the twenty-first century.

Lest these last reflections seem too painfully fanciful let me recount an anecdote that Coco Fusco relates in her luminous discussion of the production. It concerns the sighting of a real 'remnant' of the history of appalling exploitation that the golden cage aimed to bring home for all its spectators. 'And at the Minnesota Fair last summer, we saw "Tiny Teesha, the Island Princess", who was in actuality a black woman midget from Haiti making her living going from one state to another.'[53] Fusco's reflection on this encounter in the light of her experiences in the cage is

[53] Ibid., p. 133.

absolutely salutary. She writes: 'When we came upon Tiny Teesha in Minnesota, I was dumbstruck at first. Not even my own performance had prepared me for the sadness I saw in her eyes, or my own ensuing sense of shame.'[54]

I propose such 'sadness in the eyes' as a metonym that indicates something of the common humanity I have been trying to evoke. Such 'sadness' bespeaks an absence that one can comprehend only by recognising something similar in oneself. A mutual vulnerability? The potential of sharing a common fate? This is a 'sense of the human' that has to be continually recreated because it emanates in a condition that all humans share in the globalised world produced by performative societies. In the twenty-first century, perhaps the most crucial predicament is that in being divided against ourselves, and between each other, we humans will continue to be divided against nature. The spectacles of deconstruction that characterise the performative society can encourage a reflexivity that enables us to see this very clearly. But then as society is constituted of such spectacles, we risk always getting caught in an endlessly recessive mirror-reflection that simply reinforces the powers of violent division, reproducing the destructiveness that usually ensues from spectacles of domination, resistance and contradiction.

CODA

Perhaps these, then, are some of the lessons that ecological activists might learn from reflecting on the powers of spectacle in the twenty-first century. They are tough lessons because, as I hope I have made clear, the 'common humanity' in question is by no means of the traditional type imagined by liberal humanism, in which everyone can be similarly hurt or feel joy, say. Rather, this is a much more bleak and challenging version of the place of the human in the process of becoming, but one in which the disappearing act of the human may ultimately be cause for hope. This was the puzzle posed by the reiterated acts of performativity seen as both the source of identity and its continual loss. This is the challenge offered by an ecofeminism that fully recognises the identity shared by humans and non-human organisms while refusing ultimately to collapse the difference between human and non-human identity. These are the opportunities proposed by the ambivalence of deconstructive spectacle in the

[54] Ibid., p. 135.

performative society as it threatens ecological disaster. The key to the positive powers of the contradictions in such spectacles lies in paradox, most crucially the paradox of what I have called the non-human in the human. Reflexive participation in spectacular performance ecologies informed by that paradox, I have argued, may connect humanity to its ecological environment in a manner that is deeply responsive and responsible. In the next part of *Theatre Ecology* I will explore means to imagine this through a series of thought experiments designed to test the bounds of intelligibility in theatre and performance ecology. These will be speculations for the future that grow from such reflections on spectacles from the past. Their aim will be to extend the scope of how we might think of human participation in ecologies yet to come. But whatever particular form those take, the participation must be of kinds that are continually renewed through humans courting, as it were, the non-human 'other' in themselves and each other.

Terry Eagleton, drawing on 'one of our leading technicians of otherness', Slavoj Žižek, suggests some of the benefits of this predicament, as follows:

It is at the point where the other is dislocated in itself, not wholly bound by its context, that we can encounter it most deeply, since this self-opaqueness is also true of ourselves. I understand the Other when I become aware that what troubles me about it, its enigmatic nature, is a problem for it too. As Žižek puts it: 'The dimension of the Universal thus emerges when the two lacks – mine and that of the Other – overlap ... What we and the inaccessible Other share is the empty signifier that stands for the X which eludes both positions.'[55]

To install humanity as such an empty signifier 'at the heart' of global spectacle in order to give it a new lease of ecologically radical life means continually recognising and reproducing this mutual vulnerability. It means the human recognising in the 'other' of the non-human within itself something akin to the qualities of spectacle that provoke then deconstruct contempt and curiosity. Buster Keaton managed to achieve this over and over for his audiences, even as he became a star. It is an achievement that radical eco-activists might find well worth pondering as the wall of a future that is likely to be nothing if not spectacular starts to fall.

[55] Terry Eagleton, *The Idea of Culture* (Oxford: Blackwell, 2000), pp. 96–7.

For the future: ecologies of theatre and performance

Preamble

It looked like the top part of the back of some enormous buried beast, maybe a gargantuan rhino. A largely flat expanse of gently bulging rock fissured with networks of rain runnels reaching to its uneven edges, the whole thing around 40 metres long and 20 wide. Hard to tell, as it was punctuated by scrubby shrubs and its perimeter sloped gently away to small trees where the bush began. Narrow wooden slatted walkways saddled it in a horizontal framework, meandering across its surface, branching and rejoining randomly, sometimes ending in dead-ends, like a maze-way planned by an absent-minded ghost. But soon it was clear that these were desire paths to another time, a dreamtime, for everywhere there were shallow carvings in the undulated rock. A high-up open place with a powerful sense of ancient use, etched into seductive shape by the low slanted rays of the late afternoon Australian winter sun.

I had been invited here by colleagues from the Arts and Aboriginal Departments at the Ourimbah campus of Newcastle University, New South Wales, where I was visiting researcher during the British summer of 2001. We were the only people at the site on this midweek working day. Nerrida was descendant of an Aboriginal nation that had lived here not so long ago and I was surprised when she suggested we step off the clean boards to take a closer look at the markings in the rock. Decades before I'd spent time charting petroglyphs on the lava flows of Hawaii, abstract geometries stuck in memory like blackened bits of burned-up blueprints. I mentioned the sorely scratched knees on which those images hung to Nerrida. She smiled, pointing to a group of score-marks in the rock that soon resolved into the outline of a fish. We followed her as she stepped with the care of a wading heron across the great slab that was alive with markings. A lizard with a leg missing, a bird in flight, a stick figure with a drum or maybe a pregnant mum, there an arrow and here a

circle with half a quadrant line. She explained no one now knew for sure what all these had been for, especially the more abstract marks. There were theories, of course. Could be they were pointers to song-lines or trading routes for an unknown number of nations that had been native to this high peninsula. Does the past always entail an undecipherable future?

Nerrida spoke with the supple precision of an advanced expert for whom knowledge really mattered. Then gradually a chilling passion slipped into her voice as she began to read a newer story from the ancient marks. Until recently interpretation of this and similar sites nearby assigned just one nation for the whole territory, indicating a sedentary lot who fed well from the harvest of the sea and fruits and game from the bush. That was the old story told in ignorant good faith by generations of white settlers who had sliced through the bloodlines of Aboriginal oral history. Her group's research said otherwise. These carvings were net-worked with other peninsula and inland sites and suggested several tribal nations living in productive harmony, with specialised hunter–gatherer skills according to location and possibly an extended trading system that stretched deep into the coastal-region bush and, who knows, beyond that through to the heart of Australia. Nerrida tactfully stopped there. Here had been a sophisticated civilisation that made an exceptionally light ecological footprint, long-lived generations leaving super-feint traces which tragically had been used to justify genocide. The lowering sun filled the shallow etch-lines with a blackening depth so they seemed to lift above the surface of the rock. Insubstantial. Tenuous. Temporary visitors to a planet named Woe. Remember: coming events cast their shadow before.

It dawned on me that I had just spent four weeks tracing the phantasmal partners of this rock art in the psychic landscape of settler generations following the first British colonisation in 1788. Sixty-four years after that fateful date the earliest steam-powered ocean liner, the ss *Great Britain*, had arrived in Port Phillip Bay with 630 passengers bound for Melbourne. This was the first of thirty-two voyages from England between 1852 and 1875 which together had carried over 14,000 people to Australia, mostly economic migrants seeking a new life on the golden shores. I was there to research the family memories of descendants of those passengers and had visited the Genealogical Society in Melbourne to add to the names I'd culled from the ship's current contact list in Bristol. In theory it was an easy task as the genealogists estimated between 20 and 30 per cent of Australia's population of 19 million had ss *Great Britain* ancestors. In practice the job was a wonky bagatelle with lots of

near misses and bounced e-mails. But still I had found a set of keen correspondents covering a good geographic, demographic and generational spread, though there were fewer than twenty of them! That suited my project, as I wanted a qualitative depth of living memory to inform the show I planned to stage on the ship. Eventually I enjoyed long conversations, mostly face-to-face, with just eighteen descendants, all of them with rich family histories. Some were supported by thorough archival and ethnographic research. Two of my informants were brothers from Adelaide who remembered as boys regularly visiting their great-grandmother, Mary Crompton. She had kept a journal of her honeymoon voyage on the ss *Great Britain* that was available as a booklet in the ship's gift shop back in Bristol. This became one of the chief sources for the show. But also the tenor of my meetings with all those generous Australians riddled every moment of its six-hour performances with a deep unease about the future.

The descendants' tough Australian warmth spoke volumes about the hardships and successes of forebears in an alien land. But also I was deeply struck by the reach of living memory in their stories. Always they witnessed direct oral lifelines to the voices of the dead stretching back to well over a century through grandparents who had told stories of *their* parents' struggle to gain a foothold on the continent. In the brothers Crompton's case the oral transmission of Australian memories reached to 1850, the year in which their great-great-grandparents emigrated from England with their eight remaining children. Mary Crompton was the youngest and then age five. Here were histories still living on the breath, some of which came within just sixty years of the start of British colonisation. In all these memory-streams there were two major mnemonic watersheds that placed their carriers firmly on the time-map of Australian social ecology. The receding collective memory of that first settlement and its early aftermath, heavily scored by penal-colony ethics, then family memories of ancestral immigrant landings, particularly between 1840 and 1868 when transportation of convicts was phased out and the great gold rush flourished. The family consequences of the immigration were of course legion, so it was hardly surprising that the 'Aboriginal problem' only very rarely crept into view without bidding. The tact that the 'problem' attracted was always sophisticated and intense, truly phenomenal in its yearning for an inevitably paradoxical and sometimes hard-won compassion. None can be wholly responsible for a past before their time, but in such moments the breath in the voices of my all-too-human collaborators seemed to rise out of a vast sea of sighs. Here was the

rock art's phantasmal double, like a drawing on water that can never be stilled. Memory traces of abused ghostly strangers. Ones that might always refuse to die, so long as there's flowing blood in descendants' veins.

I wanted to somehow call up this failed Australian forgetting in our show on the ss *Great Britain,* in part to privately honour what Nerrida had shown me at the sacred site, in part publicly to explore how such disturbing memorials can be cause for celebration and hope. We called it *Mnemosyne Dreams* for the Greek goddess of memory. So just nine months after I saw the rock pictures that possibly outdated Western civilisation, the performer–artist Sue Palmer played a legendary figment performing the historical Mary Crompton who restages what others have told her they remember. One scene was based on a story Mary heard about a Maori woman who smoked a pipe through a Victorian veil. The veil suggested modesty and mourning, and the smoke blown gently through its pipe-hole led to words about the Aboriginal dreamtime. All this was presented in the Promenade Deck of the ship, where Mary once strolled and was told the story. Collapsing the time and space of past and present into each other to open up connections between memories and waking dreams, we tried to imply that every moment when the future fails to escape memory of a tragically conflicted history may be grounds for pathologies of hope. Another advantage, perhaps, of suffering from nostalgia for the future.

ON THOUGHT EXPERIMENTS

FM2030's body stands in cryonic suspension at the Alcor Life Extension Foundation in Scottsdale, Arizona, just 80 miles north-east of Biosphere II. As a leading futurologist of his time he proved prescient in predicting social trends, such as scientists being able to correct genetic flaws, and professed a 'deep nostalgia for the future'.[1] He changed his birth name from F. M. Esfandiary to the date of his centenary in the belief that 'the years around 2030 will be a magical time . . . In 2030 we will be ageless and everyone will have an excellent chance to live forever.'[2] He died in July 2000, by which time it had been clear for years that the Biosphere II experiment in artificially reproducing Earth's environment as a self-sustaining independent

[1] The Iranian–American futurist FM2030 (F. M. Esfandiary) is credited with coining this phrase. Website – Wikipedia, Esfandiary: en.wikipedia.org/wiki/F.M._Esfandiary (03.10.2006).
[2] Website – FM2030: www.fm2030.com/bio-page.cfm (18.11.2006).

system had failed. As an idea that somehow might save humans from ecological devastation it was a non-starter. But how might we square such contradictory perspectives on the future to find a cure for hope as a pathology? How can human animals think about the future in ways that might lead to antidotes for performance addiction? Not wanting to give up on nostalgia for the future, this final part of *Theatre Ecology* explores the potential of theatre and performance ecology as a source of convincing answers to such ridiculous questions. Sceptical readers might wish to skip to the Epilogue to see how it *really* all turns out.

This trilogy of chapters does not quite slide into the realms of science fantasy, I hope, though it does draw on physics quite a bit and finally brings us back to Biosphere II as an analogue for theatre ecology in the twenty-first century. It directly addresses difficult problems of method in the ecologies of performance and theatre, severely testing the degrees of applicability of analogical, homological and paralogical modes of analysis to performance practices situated in highly contrasting locations. The chapters connect to earlier examples and case studies by focusing on spectacle, participation, spectatorship, theatrical staging and performance beyond theatre. They are crucially aiming to generate further understandings of the circulation of power in performance and theatre ecology, especially as it articulates to fundamental political, social and cultural vectors. To achieve this they explore key factors of ecology such as negative feedback, energy exchange, interdependency, sustainability and so on, considered as potentially characteristic of all dynamic systems in and beyond the environmental and performance commons of Earth. Strange conjunctions, surprising coordinates and slippery concatenations emerge from simple eco-imaginative *thought experiments*. These foster three main conjectural exercises regarding the strange possibilities of congress between theatre and performance ecologies and stellar, tropospheric, molecular and biotechnological phenomena. This weird conglomerate of force fields is meant to open up hopeful glimpses of an evolution of performative ecologies yet to come.

Such an approach to the future prospects of ecology in the performance paradigm for sure is probably like whistling against a howling gale, but it hinges on a long-standing habit of staging productions at what I used to call 'ideological hot spots'. Places where there is an intensity of energy, or at least a deep potential for the generation of such intensity, because they have been or are or might become the focus of excessive feelings or acute contestation or extreme tensions of a creative kind. The London Drury Lane Arts Laboratory in the late 1960s was such a place, a

'mecca for the underground society and a centre for cultural – and chemical – experiment' as a contemporary observer put it.[3] In the early 1980s I hooked up with Welfare State International when they moved to Ulverston in Cumbria, a town on the Lake District's margins but central to a higher concentration of nuclear installations per capita of population than anywhere else in the world.[4] The chronically rusting ss *Great Britain* was a struggling heritage site in 2000 but perfect setting for a full-on spectacle about how Empire, engineering and emigration were root contributors to global eco-spoilage.[5] The hunches pursued in the following chapters produce little more than pale argumentative analogues of the extravagant creativity that made the Arts Lab, Welfare State and ship-designer Isambard Kingdom Brunel justly celebrated internationally. They push against conventional academic envelopes with the weak excuse of being *extended* thought experiments, try-outs for quirky treatments of futurity that probably are best not trusted.

Also these chapters root in the gaps between culture and nature that perhaps only more seasoned thought experimentalists should try to gauge, and of course there is a grotesquely impressive genealogy of grand masters in that trade to tremble before. William Gilbert in 1660 compared the behaviour of small spherical magnets to the properties of the Earth to conclude it not only acts like a magnet but it *is* a magnet. Benjamin Franklin in 1752 flew a kite with a key attached to its string in a thunderstorm on a calculated bet that a spark might jump from it to his hand thus proving lightning is electricity. Salvador Luria in 1943 watched a colleague playing a slot machine and linked its uneven payouts to the patterns of bacteria becoming resistant to viral attack through genetic mutation.[6] Such lateral thinking is a dicey business and I would advise scepticism for readers of this last part of the book. Because there is good reason *not* to believe there's a method in the madness of it despite its past success in illuminating global magnetism, electrical storms and genetic homeopathy. For every successful thought experiment there are certain to be countless failed ones. If this were not the case, why have so many

[3] Sandy Craig (ed.), *Dreams and Deconstructions: Alternative Theatre in Britain* (Ambergate: Amber Lane Press, 1980), p. 16.

[4] Mike White, 'Resources for a Journey of Hope: the Work of Welfare State International', *New Theatre Quarterly* 4: 15 (August 1988).

[5] Baz Kershaw, 'Performance, Memory, Heritage, History, Spectacle – *The Iron Ship*', *Studies in Theatre and Performance* 21: 3 (2002).

[6] Keith J. Holyoak and Paul Thagard, *Mental Leaps: Analogy in Creative Thought* (Cambridge, Mass.: MIT Press, 1995), pp. 186–8.

serious tomes been devoted to studying them?[7] And what validity is there in perpetuating my creative hot-spot addiction through an inadvisable gravitation towards extreme analogical, homological and paradological cogitation? Not content with ranging across ridiculous scales from the cosmic to the microcosmic, these chapters try to turn black holes transparent, pin down universal energy exchange, and picture theatre as a pathologically closed biome. They all hang on no more than coincidences of pattern and form in unreasonable couplings of totally contingent cases. Insanity or what?

COMPANIONABLE INCOMPATIBLES

At about the same time that I was planning to get my knees scratched up by petroglyphs on lava flows and rejecting a show in a banyan tree in Honolulu, the great Gregory Bateson was giving a paper on insanity to the Second Conference on Mental Health in Asia and the Pacific at the East–West Centre, University of Hawaii. 'Pathologies of Epistemology' is perhaps the most succinct exposition of his ecological theory of mind, a thought experiment that extravagantly blows established distinctions between mental and bodily phenomena, and therefore culture and nature, beyond kingdom come. Because he implies that time may already have run out for humans to achieve ecological sanity.

You decide that you want to get rid of the by products of human life and that Lake Erie will be a good place to put them. You forget that the eco-mental system called Lake Erie is part of *your* wider eco-mental system – and that if Lake Erie is driven insane, its insanity is incorporated in the larger system of *your* thought and experience.[8]

The basis for this argument is that what homo sapiens calls thinking is not just located in the human mind, or in culture, but also in many of the processes of the 'natural world'. This notion in turn is founded on the idea that an idea is a 'difference' operating as part of a structure of circuits that is common in the interrelationships between and among living organisms and the non-organic parts of Earth's environments. The difference – let's say between 'hot' and 'cold' – enables these circuits to

[7] A selection: Roy Sorensen, *Thought Experiments* (Oxford University Press, 1992); Tamar Szabó Gendler, *Thought Experiment: On the Powers and Limits of Imaginary Cases* (New York: Garland, 2000); Martin Cohen, *Wittgenstein's Beetle and Other Classic Thought Experiments* (Oxford: Blackwell, 2005).

[8] Gregory Bateson, *Steps to an Ecology of Mind* (University of Chicago Press, 2000 [1972]), p. 492.

work as a system in which 'self-correctiveness', or trial and error, becomes possible. The flowers grow in the spring because as part of such a system they can detect the difference between hot and cold, along with quite a few other differences that enable them to grow sooner or later or even not at all. The feedback gained through trial and error in these systems at any particular time will tend to push them either towards 'homeostasis', a state of equilibrium, or to 'runaway', a state of self-harm. Utterly key to this account of systemic 'thinking' is that it does not make sense to separate 'organisms' from 'environments' as they are aspects of the *same* system. So: 'What thinks is the total system which engages in trial and error... The unit of survival is *organism* plus *environment*.'[9] Hence the meta-system sustaining life on Earth is an 'ecology of mind'.

We saw in chapter 1 that other radical ecologists, such as Arne Naess, consider the organism-plus-environment formulation to be too bio-centric, though Bateson's arguments do incorporate, and significantly extend, the foundational components of ecological analysis.[10] But I invoke his most adventurous thinking here to play for a wild kind of credence for the thought experiments in the following chapters. Because if Bateson is correct in thinking that thinking is much more widespread between nature and culture than that distinction has allowed for in the history of modernism, then perhaps the practice of such experiments may be worth the risks after all. It is true, though, that the methods I pursue are not 'scientific', in the sense that they will not be amenable to testing against mathematical or 'natural' laws of the kind that D'Arcy Thompson explores, say in his comparisons of structural stresses and strains as between modern bridges and dinosaur skeletons and all points in between.[11] There is an affinity though, I'm sure, between Thompson's desire to demonstrate fundamental consonances between engineering and biology, and my playful habit of drawing parallels between environmental phenomena and the performance systems of the paradoxical primate. That playfulness may be foolish, based as it is on the extraordinary idea of an ecology of mind. But there might still be a smidgeon of sense in the wonky wonderings of this final trilogy of *Theatre Ecology*.

What follows, then, is a hobbled and partial application of 'ecosophy' as first coined by Arne Naess, then qualified by Félix Guattari. Naess defines ecosophy as '*a philosophical world-view or system inspired by the*

[9] Ibid., Bateson's emphasis. [10] Chapter 1, pp. 16–17.
[11] D'Arcy Wentworth Thompson, *On Growth and Form*, ed. John Tyler Bonner (Cambridge University Press, 1966), pp. 238–58.

conditions of life in the ecosphere'; so, given I grandly eschewed grand theory world-views in chapter 1, that leaves me with a bit-part philosophy in search of inspiration.[12] Enter Guattari, who in 1989 argued that 'Now more than ever, nature cannot be separated from culture; in order to comprehend the interactions between ecosystems, the mechanosphere and the social and individual Universes of reference, we must learn to think "transversally".'[13] This part's exercises in 'transversal' thinking between apparent ecological incommensurates also build on a crucial critique that Guattari brought to Bateson's ecological theory of mind. This was directed at the latter's conceptualisation of 'context' as somehow *encompassing* action, as in the key formulation 'organism *plus* environment' (action plus context).[14] Guattari phrases his critique in a rather abstract manner when he argues that the 'existential taking on of context is always brought about by a praxis which is established in the rupture of the systemic "pretext"'.[15] The sense of such an active 'rupture', which *transforms* the contextual system as it 'takes it on', seems meant to merge the vectors of rational thought and imaginative intervention in a typical move that collapses philosophy and art together in the moment it celebrates their differences. So journeys of transversal thinking tend to the paradoxical, and this leads Guattari to a suitably extravagant claim: 'In short, no one is exempt from playing the game of the ecology of the imaginary!'[16]

I am happy to offer the thought experiments of the final part of *Theatre Ecology* as an 'ecology of the imaginary' as they stretch the bounds of ecological analysis as pursued so far in this book. The experiments make unlikely comparisons to create interconnections via parallels, analogies and homologies between apparently unrelated human performances and natural phenomena on vastly contrasting scales, across incommensurable ontologies and disciplines, through contradictory logics. Their overall purpose is to extend the paradological methods of my paradoxology of performance, as they aim to bring incompatible and contradictory examples into paradoxical couplings to reveal an overriding truth or two

[12] Arne Naess, *Ecology, Community and Lifestyle*, trans. and ed. David Rothenberg (Cambridge University Press, 1989), p. 38. His emphasis. Ecosophy, from the Greek *oikos* and *sophia*, 'household' and 'wisdom', hence 'ecological wisdom'.
[13] Félix Guattari, *The Three Ecologies*, trans. Ian Pindar and Paul Sutton (London: Athlone Press, 2000), p. 43.
[14] Bateson, *Steps to an Ecology*, p. 492.
[15] Guattari, *Three Ecologies*, p. 54. There are similarities here with McKenzie and the pearl oyster example of chapter 4. See pp. 121–3.
[16] Ibid., p. 57.

about performance and theatre ecology. They draw directly on the techniques of creativity that I was privileged to be part of evolving through many stimulating collaborations during over four decades of making performances. I mean the kind of imaginations that raise a skeleton *Titanic* from the muddy bottom of an East End dock or set the last mermaid alive singing about pollution under the dry-docked propeller of the first steam-driven ocean liner. From that angle on action it seems quite 'natural' to compare protest dramaturgy and the black holes of space in figuring how modernist progress aims to incorporate an irresistible gravity. Or to intertwine the actions of theatrical performance and molecular free radicals in a dance that might reveal how energy exchange could thrive on imaginative ambivalence. Or to conflate performances in theatres and the environments of man-made biomes to demonstrate how replications of nature by culture might constitute unsustainable ecologies. Inevitably then these three exercises are in the subjunctive and transitive mood through and through as they search for new environments in which incompatibles can become entirely companionable.

TOWARDS AN ECO-SANITY?

All three chapters in this part started out as texts for performance at conferences, being conceived as an associative provocation, as an anatomical dissection and as a prismatic meditation. Hence none of them were written in conventional academic modes of argumentation; all worked through juxtaposing incongruous materials, snatches of contrasting analyses, odd couplings of examples. Chapter 10 was presented in 1999 and 2000 in Wales and England; chapter 9 in 2002, once in Croatia and twice in the USA; chapter 8 in 2001, once in Germany and three times in Australia. Chapter 10 was reworked for publication twice, in 2000 and 2005; chapter 9 was first published in conference-paper form in 2003 and then significantly developed but not restructured for publication now; chapter 8 was published with slight alterations in 2002 and has been slightly amended again for *Theatre Ecology*. The point of those details is to show these chapters have had quite a busy history, growing out of a relatively short period of intensive scholarly and creative experiment.

The first of the trilogy as presented here was part of my nautical 'noughties', the early 2000s when I spent a good deal of time researching material for shows on the SS *Great Britain*. It was one of three papers on protest events given to a packed seminar room at the Johannes Guttenburg

Universität in Mainz as part of the Seventh Annual Conference of Performance Studies international, which over the previous years had become a test site for weird and wacky subjects as well as for some of the most advanced and cogently argued extensions of performance studies itself. If asked, I'd probably place the Mainz paper firmly in the former category, given the reactions it subsequently garnered at seminars in Brisbane and Sydney. Debate at the latter focused on whether my original rather critical treatment of Greenpeace was too sweeping, given the risks taken by protesters in incidents such as the 1985 sinking of the *Rainbow Warrior* by French agents in New Zealand, in which a Greenpeace photographer lost his life. Much more than a very fair point, I thought.

The sub-title of the original paper was 'the environment as partner in protest?'. I wanted to explore the tensions between political purpose and aesthetic effect in eco-activist performance. What might those tensions reveal about attitudes to the environments in which protest was set? My choice of two highly contrasting events from the final decades of the twentieth century exemplifies the range of such attitudes in the ecological movement. The amazing 1995 Greenpeace protest on the Shell-owned Brent Spar oil-rig was a spectacle caught in the contradictions of dancing with the dominant. The media transformed the 'nature' that the protest set out to protect into a 'backdrop', so that aesthetics turned culture into nature's arbiter. The protest, like the force fields of the black holes of space, created an 'event horizon' that risked reproducing the environmental pathology it was attacking. In contrast, a protest staged by the activist network Earth First! in 1985 may have had an opposite effect. At a children's party organised by the Forest Service in Oregon, USA, a protester in a Smokey the Bear costume was attacked – with a subtle kind of violence – by a Park Ranger. This was a moment of paradoxical aesthetics that perhaps opened a performative 'black hole' to a realm beyond the nature/culture binary. These analogical analyses suggest the ethical potential of performance ecologies that confront the paradoxes of environmental responsibility. Their contrasts indicate how the vicious circle in which violence towards 'nature' entails violence among humans, and vice versa, might be short-circuited by protest performance. They suggest how performance could become a factor equivalent to the 'worm holes' linking black holes to give glimpses of a future that might somehow avoid ecological catastrophe. The style of argument aims to match the paradoxes of environmental protest, by analysing very specific local events that have global implications through a 'cosmic' frame of reference.

The horrors of intra-species violence were very much part of the environment for which chapter 9, on performance energy, was first evolved. It was written on invitation from a group of artists, academics and activists to present at a symposium linked to a performance festival in Zagreb, Croatia. The energies of the whole event were extraordinary as undercurrents from the recent Bosnian conflict flowed through the packed programme of shows we sometimes literally had to run between to see. The version of the paper given in Zagreb was shorter and less ruminative than the one presented here. It sparked off a keen discussion about how negative and positive energies in performance could be as clearly distinguished as my use of homological examples from physics implied. The challenge of this attempt to evolve a thought experiment beyond analogical analysis was wonderfully challenged by colleagues who knew all too well the mess of ethical paradoxes produced by the violence of civil-war zones.

Key to this first version of the experiment were the homological links it aimed to forge between, first, negative feedback and sustainability in theatrical performance ecologies and, second, the behaviour of the molecules known as 'free radicals', which are generally thought to cause cancer and other fatal diseases. The analysis focuses on a common factor in the comparison – energy exchange – in search of a perspective on particular performances through which free radicals might be conceived as other than having a negative vector. It aimed to weave a web of cross-reference that turned the predominant view of the role of free radicals in physics on its head. But the debate in Zagreb made clear that I was underplaying the homology and that the crucial free radical vector in the structure of my analysis was that they could not be pinned down in this way, as on a wider view they were actually ambivalent in their effects! Hence the thought experiment has been further evolved for publication here. Now it presents its examples of iconoclastic actors, pioneering directors, and the Earth's environmentally alert performance groups as potentially operating, under certain conditions, just as free radicals do in physics. Their particular effects as vectors can only be judged in relation to their specific environmental location. Thus performances can be homologous to molecular free radicals. They achieve this homology by creating 'energy out of place' that is adaptive to their varied environments. Through such adaptations it is likely, but by no means certain, that the 'negative feedback' of free radical performances may increase the sustainability of the ecosystems of which they are an integral part.

The adaptations of the Zagreb paper are typical of the stop-start-try-again nature of performance and theatre ecologies, whether they are

considered as actual ecosystems responding this way and that in order to survive or as an approach to analysis of performance and theatre that is still very much emergent. So there is a certain aptness in the fact that the final chapter of *Theatre Ecology* is both the earliest written and the last to be presented here. As noted in chapter 1, chapter 10 has been through more adaptations than the rest, but it stayed fundamentally the same because it rests entirely on a simple intuition. Namely, that there is a fundamental homology between traditional Western theatre buildings, starting with the indoor playhouses of early-modern Europe, and the latest high-tech examples of botanical greenhouse gardens that reach back to the same period. That idea became the key kick-start for this book. So the last chapter refracts back to its beginnings and the creative links between transparent man-made biomes – the advanced botanical gardens of the late-twentieth century – and twenty-first-century theatre buildings. It discusses Baudrillard's view that Biosphere II in the Arizona desert is a 'human zoo' and draws parallels between its relation to 'nature' and theatre's place in contemporary culture. It explores more general relationships between performance, theatre and ecology by drawing on ecological anthropology to question and extend notions of spectatorship in twentieth-century theatre theory. Searching for a clear view of what might constitute biocentric performance in the twenty-first century, it analyses the uses of landscape, pastoral and wilderness as tropes for nature in theatrical performance.

Thus this final chapter highlights the interrelations between methods for creating ecologies of performance and theatre and the concerns and themes that run through the earlier parts of the book about the 'nature' of theatre and performance ecology. It indicates how the vectors of the performative societies – the ways in which they spectacularise, theatricalise and dramatise humans and the Earth's environment – give rise to an urgent need for homeopathic performance and theatre ecologies. At the absolute core of this concern is a desire to find ways to better address and understand the dilemmas connecting endemic intra-species human violence and extreme ecological risk in the third Christian millennium. In chapter 1 I expressed this in terms of a seemingly ubiquitous double bind that has produced a near universal addiction to performance for humans. Inevitably, the generality of that hypothetical claim will tend to blur over the myriad specific ways in which it operates invidiously in practice. In the light of that conundrum, I offer in this final part of *Theatre Ecology* three all-too-tenuous experiments towards an eco-sanity that could, just, provide slim hints of how performance might usher the

paradoxical primate past hope as a pathology to create ecological prospects which make nostalgia for the future worth embracing. These are just a few of the many lessons driven home by riding on the back of a buried wise beast high up on a peninsula during a sunny winter's afternoon in eastern Australia in August 2001.

Performance and black holes: on eco-activism

ART AND ACTIVISM

In the final decades of the twentieth century overt performative tactics increasingly shaped eco-activist protest. Part of protest's purpose in turning to performance was, of course, to gain high-profile media space: resistant representations to raise general ecological awareness. But also there was for some eco-activists a more radical agenda, and one which was well aware of the contradictions involved in such dangerous dancing with the prime agents of cultural commodification – the press, TV, film and so on.[1] John Jordan, for example, a leading figure in the UK self-nominated DiY (do-it-yourself) protest movement, draws on Guy Debord when he argues that:

Art has clearly failed historically as a means to bring imagination and creativity to movements of social change . . . What makes DiY protest so powerful is that it 'clearly embodies a rejection of the specialised sphere of old politics, as well as of art and everyday life' (Debord). Its insistence on creativity and yet the invisibility of art and artists in its midst singles it out as an historical turning point in the current of creative resistance. By making the art completely invisible, DiY protest gives art back its original socially transformative power . . .[2]

Such a claim may seem contradictory in the context of performances designed to hit the headlines, so Jordan also quotes Dubuffet to clarify his point: 'Art . . . loves to be incognito; its best moments are when it forgets what it is called.'[3] This shifts contradiction into the much more interesting area of paradox, for the flip side of this forgetfulness, so to speak, is

[1] Richard Schechner, *The Future of Ritual* (London: Routledge, 1993), pp. 45–93; Baz Kershaw, *The Radical in Performance: Between Brecht and Baudrillard* (London: Routledge, 1999), pp. 89–125.
[2] John Jordan, 'The Art of Necessity: the Subversive Imagination of Anti-road protest and Reclaim the Streets', in *DiY Culture: Party and Protest in Nineties Britain*, ed. George McKay (London: Verso, 1998), p. 131; Guy Debord, *The Society of the Spectacle* (Detroit: Black and Red, 1977), Thesis 155.
[3] Jordan, 'The Art of Necessity', p. 131.

about an art that does not declare its name, about the way that art lies in concealing art. In other words, Jordan is suggesting that the power of the art of performance is greatest when you do not overtly know you are seeing it.

This kind of invisibility is somewhat different from the types explored in Peggy Phelan's influential book *Unmarked*.[4] She discusses the complex interplay of visible reproduction – in theatres and the media, for example – as a social economy of signs that is always already structured for domination of the subordinate and the powerless. So to protest visibly is automatically to offer oneself up to the power of dominant ideologies, such as patriarchy or capitalism. This process in turn, though, may be considered as determining the powerful invisibility of *what is not seen by some* in performance itself, whether in everyday situations or in overtly cultural locations such as theatres, cinemas, art galleries. That is to say, what the spectator does not see, or perceive in some other way, the spectator does not 'get'. This then becomes a basis for the formation of elite, specialist, or otherwise 'in the know' audiences and, for example, of the potential of 'passing' as something one is not, and vice versa. We might call this an exclusionary invisibility in performance.

But the invisibility of art that John Jordan is discussing in other types of event or construct, such as protest rallies or slogans, rests on a *mistaking* of the highly visible for something that it is not. In this version of invisibility, the art of performance goes in total masquerade, as it were, and is seen as something else – such as a political demonstration – so that the 'art' of the performance does its work in unsuspected ways. That 'work' may reinforce or undermine dominant ideologies or supra-systems in ecology, but in any event it will be all the more powerful for 'taking' the spectator unawares: the spectator is seduced into participating in its effects for change. A conventional view of the ethics of such aesthetic invisibility would probably link it to deceit, seeing the spectator as in some way duped or even brainwashed by the process. But a deep ecological perspective would view this as part of a 'gestalt' effect, in which the spectator is aware that something other than the obvious is in process. However, she chooses not to focus on it because the event itself calls attention to yet other, for the moment, more important vectors, say protest instead of art, dangers in the forest instead of its beauties. This is why the ecologist–philosopher Arne Naess calls for ' ... environmentalism to *move from ontology to ethics*

[4] Peggy Phelan, *Unmarked: The Politics of Performance* (London: Routledge, 1993).

and back,[5] to evolve flexibility in judgement of particular realities. So an ethical response to an eco-activist protest event – say, agreement that it is stupid to increase greenhouse gas emissions globally – is not altogether ignoring the ontology of its aesthetics. Paradoxically, in Jordan's terms, this enables the aesthetics of the protest to do their work of pleasure-making all the more effectively. We may say that this is an inclusionary invisibility in performance.

This chapter uses the attempt to produce such 'invisible art' in two eco-activist protests to explore the tricky territory in which art and environment, performance and ecology might successfully meet in resistance to a global 'progress' that is killing us all. I shall work more by association than by argument in an effort to sneak up to perspectives on performance and theatre ecology that threaten to cloud over as soon as one tries to describe them. For, as we have seen in earlier chapters, the effort to talk intelligibly about the ecologies of performance and theatre is, to adapt a phrase from Alan Watts, a bit like trying to bite your own teeth. The moment you think you've done it you probably haven't.[6]

A PARADOXICAL LANDSCAPE

I continue to write, therefore, in a paradoxical landscape where a paradoxology of performance provides important tools for shaping ecological understandings. It is paradoxical, firstly, because any attempt to comprehend 'nature' from within 'culture' is similar to thinking that a door will always be ajar, both open and transparent. But simply by using the word 'landscape' I am casting a shadow over 'nature'. Thus the historian Keith Thomas nicely captures the symbiosis of practice and perception in the denigration of nature when he argues of eighteenth-century England that: 'Just as the landscape-gardeners sought to collect together all natural beauties and to shut out everything unpleasant or unharmonious, so the picturesque travellers looked to nature only for conformity to a preconceived model . . .'[7] Secondly, this territory is paradoxical because even as eco-activist protest became more performative it tried to make the aesthetics of performance transparent, so that only 'the issue', the 'point' of

[5] Arne Naess, *Ecology, Community and Lifestyle*, trans. and ed. David Rothenberg (Cambridge University Press, 1989 [1976]), p. 67.
[6] See: Patrick Hughes and George Brecht, *Vicious Circles and Infinity: An Anthology of Paradoxes* (Harmondsworth: Penguin, 1978), p. 64. All paradoxes from this source unless otherwise indicated.
[7] Keith Thomas, *Man and the Natural World: Changing Attitudes in England 1500–1800* (Harmondsworth: Penguin, 1984), p. 266.

the protest draws attention to itself. Thirdly, it is paradoxical because ecological activism itself is almost inevitably riddled with paradox.

- To stop a logging company destroying the old-growth forest on Mare's Island, British Columbia, the local Indian nation drove 400,000 steel spikes into the trees they wanted to save – you have to damage nature in order to save it.
- To stop the road-builders at Fairmile in East Devon, England, protesters burrowed into the ground, dug holes in the floor of their tunnels, secured iron loops in concrete in the holes and chained themselves to the loops – you have to use the technologies of progress to attack its effects.
- To stop toxic waste from a chemical plant from poisoning the coastline for miles around Lafayette, New Jersey, Greenpeace plugged its underwater outlet pipe, causing a higher concentration of pollution on the site which will take hundreds, perhaps thousands, of years to clear – you have to make things worse to make them better.

These contradictions and/or paradoxes are generated because to take *cultural action* for an *ecological cause* always risks recreating the pathology – endemic human denigration of the 'natural world' – that it is trying to eliminate. This will be the case so long as culture and nature are conceived in opposition to each other, as they are in modernism and other dominant ideologies of the overdeveloped world.

I am dwelling on paradox because, as I argued in chapter 1, any effort to 'create discourse about performance ecology will be enmeshed in paradox'. Putting this crudely: how can we write about the natural world (whatever *that* is?) – and the relationships of performance to it – when 'the natural world', being a cultural construct, probably makes nature more inaccessible? Moreover, this type of problem is massively compounded by David Harvey's already quoted claim that, if 'socio-political projects are ecological projects, then some conception of "nature" and "environment" are omnipresent in everything we do. [Hence] ... ecological arguments are never socially neutral any more than socio-political arguments are ecologically neutral.'[8] If we accept this argument, it obviously follows that all theatres and all performances, one way or another, are articulated to ecological concerns, whether we acknowledge that or not.

This makes the performances of eco-activists especially interesting, because when they attempt to make the aesthetics of their performances

[8] David Harvey, *Justice, Nature and the Geography of Difference* (Oxford: Blackwell, 1996), pp. 174, 182.

invisible they expose the paradoxes involved in using the tools – in this case the dramaturgical and performative tools – to dismantle what the tools have made. In the process they may be seen to animate attitudes to 'nature' through performance that they may deplore in their other actions, such as public statements to the press. In this respect their protests are especially marked by a key general characteristic of performance, in that they perform far more than they mean to.[9] I am especially interested in the contradictions that result from this plenitude in performance, not as a route into a critique of eco-activist protest, but as a way of thinking further through to a theatre and performance ecology that will make its inevitable contradictions and paradoxes *productive* in the struggle for environmental sanity. So while I am full of admiration for the achievements of eco-activists, I think also that many of the actions they have mounted – despite huge successes – have been in some crucial respects counterproductive. This can be seen most clearly by focusing on what, according to John Jordan, they often prefer to make invisible; that is to say, the art of performance in the events of their protests, and especially perhaps their dramaturgical aesthetics. That is the main purpose of this chapter: to explore the dynamic play of visibility and invisibility in the dramas of eco-activist protests.

But as we have seen in earlier chapters, there are huge methodological problems in such an undertaking because the usual approaches to performance analysis, from the perspective of the ecologies of performance, also almost inevitably reproduce the environmental pathologies an ecologist would argue they should be trying to avoid. Put at its simplest, the act of seeing performance as a cultural product tends to transform nature into a resource to be exploited in its making. Scholars and theorists of performance interested in exploring theatre and performance ecology therefore need to be wary of the usual strategies of performance analysis. New modes of thinking need to be invented. I suggested in chapter 1 that Biosphere II, the huge glass hangar that aims to replicate the Earth's ecosystems in the Southern Arizona desert, may be a useful trope for analysing Western theatre from an ecological point of view. In chapter 10 I will more fully argue that twenty-first-century theatre is a very close cousin of Biosphere II, because while it may seem to be culturally transparent – holding a mirror up to 'nature', say – yet it has become hermetically sealed off from the 'natural world'. In this chapter I will undertake a similar methodological move through a thought experiment

[9] I am grateful to Carol Burbank, formerly of the University of Maryland, for this formulation.

that looks at eco-activist performance through the perspective of the black holes of space.

BLACK HOLES

Possibly everyone has heard of black holes. They are one of the twentieth century's greatest inventions because they capture the imagination for a way of thinking that literally, figuratively and radically changed the world: Einstein's general theory of relativity. The theory installed paradox at the heart of science and the material – and immaterial – universe. Things can be in two places at once. We can meet ourselves coming in the opposite direction. Light is both a wave and a particle. So black holes represent a spectacular example of the paradoxes of relativity. In theory they produce singularities: a dimensionless object of infinite density. As you approach the event horizon of a black hole, the point of no return when its power will inevitably suck you in, the effects of gravitation severely modify time and space. Time slows down relative to that of distant observers and completely stops on the horizon itself.

Astronomers believe they have discovered black holes in a binary star system called Cygnus X-1, in the Large Magellanic Cloud of a galaxy neighbouring our own, and in the constellation Monoceros. Astrophysicists have conjectured that many substantial-sized galaxies may contain black holes at their centre. Cosmologists – Stephen Hawking among them – have suggested that black holes may be connected to each other by 'wormholes', passages through space–time that, theoretically, would allow time travel. Go into a wormhole and you might instantly find yourself in another time and place – another universe even – where it emerges in another black hole. Black holes and their potential wormholes are my trope for addressing the complexities of a performative analysis of eco-activist protest.[10]

ON ASSEMBLAGES AND HOMOLOGIES

In what ways might future performances be like a black hole, or even a wormhole, in culture? What parallels might be drawn between eco-activist protest and black holes/wormholes in order to envision the relevance such performance may have for the coming ecological crisis? These are the critical questions for the main thought experiment of the

[10] Website – Wikipedia 'Black Holes': http://we.wikipedia.org/wiki/Black_holes (07.10.2006).

chapter. This aims to explicate the possibility of what might properly be called 'super-homologies' between (a) the universe as described by the likes of cosmologist Stephen Hawking, (b) the world as a series of assemblages as imagined by philosophers Gilles Deleuze and Félix Guattari, and (c) the performance paradigm as posited by performance theorists, but especially Jon McKenzie. As outlined in chapter 1, homologies might be generally described as two or more sets of relational components that when compared manifest common patterns between the sets. Comparative anatomy thus spots a homology between an elephant's trunk and the human nose and lips in respect of the eyes of both.

Through their concept of the 'machinic assemblage' Deleuze and Guattari vastly extend this fabulous game of correspondences: 'a *machinic assemblage* of bodies, of actions and passions, an intermingling of bodies reacting to each other... the ship-machine, the hotel-machine, the circus-machine...'.[11] Guattari indicates the amorphous range of the machinic assemblage when he links it to 'various levels of ontological intensity... [in order to] ...envisage machinism in its totality, in its technological, social, semiotic and axiological avatars'.[12] So the avatar, for example, as a point of comparison between assemblages, connects into their many contrasting ontological domains, their existence in many different realities. Jon McKenzie picks up on this quality when he indicates 'interface design and the study of socio-technical systems' as key exemplars that 'define machinic performances as arising whenever different processes "recur" or communicate across diverse systems'.[13] The avatars of search engines on computer screens, for instance, give access for the user to many varied though recognisably corresponding machinic performances in the distributed archives through, say, knowledge domains that otherwise may appear to have little or nothing in common.

Precisely because this theorising reaches towards the limits of intelligibility, I want to deploy it in my experiment for the creation of homologies between black holes and protest performances for the future. As indicated in the preamble to this part, Guattari linked the integration of culture and nature to what he calls 'transversal' thinking: 'Now more than

[11] Gilles Deleuze and Félix Guatarri, *A Thousand Plateaus: Capitalism and Schizophrenia*, trans. Brian Massumi (London: Athlone Press, 1988 [1980]), p. 88.
[12] Félix Guattari, *Chaosmosis: An Ethico-aesthetic Paradigm*, trans. Paul Bains and Julian Pefanis (Sydney: Power Publications, 1995 [1992]), p. 34.
[13] Jon McKenzie, 'Hacktivism and Machinic Performance', in *The End of the 1960s: Performance, Media and Contemporary Culture*, ed. Edward Scheer and Peter Eckersall (Sydney: Faculty of Arts and Social Sciences, University of New South Wales/Performance Paradigm, 2006), p. 89.

ever, nature cannot be separated from culture; in order to comprehend [their] interactions ... we must learn to think "transversally"'.[14] This 'transversal' cogitation becomes possible because: 'Machinic propositions elude the ordinary games of discursivity and the structural co-ordinates of energy, time and space.'[15] In other words, the idea of assemblages, 'machinic' or otherwise, legitimises comparison between domains conventionally conceived as incomparable. So these are the deliberately insubstantial grounds on which I hope to create a few super-homologies for a potential performance ecology that incorporates the cosmic and micro-cosmic, visible and invisible dimensions of eco-activist protest. This next *thought experiment*, structured ironically through a good old dramaturgical analogy, opens with a scene on the wild high seas.

ON THE WILD HIGH SEAS

On 30 April 1995 a dozen Greenpeace activists occupied a defunct oil-rig, the Brent Spar, 120 miles off the coast of the Shetland Isles in the North Sea. They were there to protest Shell Oil's plans to tow it out into the Atlantic in order to dump it in deep water. Once onboard, they unfurled a banner displaying the slogan 'Save our Seas'. The piquant contrast between the physical skill and ideological audacity of the boarding of the rig, and the tired old technique of waving or displaying a banner, marked the first act of a spectacular drama that was to last for almost two months. There were many plot-lines running through the protest – including the struggle between multinational capital and environmentalist passion, and the battle between experts for scientific and economic truth – but the 'action scenes' on the rig itself are the best place to look for the dramaturgical principles informing the events as a whole.

These scenes can be neatly divided into two 'acts' corresponding to the two periods of Greenpeace's occupation of the rig. The first took place between 30 April and 23 May and was marked mostly by a pioneering spirit of brave endurance: this was the first environmental protest of its kind, demanding high levels of technical skills and complicated logistics in the creation of tolerable living conditions by the protesters. Daily Internet communiqués were issued from the rig and the Greenpeace

[14] Félix Guattari, *The Three Ecologies*, trans. Ian Pindar and Paul Sutton (London: Athlone Press, 2000 [1989]), p. 43; compare Deleuze and Guattari, *Thousand Plateaus*, 'What we call the mechanosphere is the set of all abstract machines and machinic assemblages', p. 71.
[15] Guattari, *Chaosmosis*, p. 38.

support ship, *Moby Dick*, describing conditions aboard. From the 9 May 1995 diary entry:

The idea of living on a floating polluted island is not a pleasant prospect but we have now firmly set this before us. Since the construction of our wind generator above on the heli deck and the increasing media interest surrounding our stay, the morale of crew members has reached a satisfactory level... (9 May 2001)[16]

This act ended when the Scottish Courts finally gave Shell permission to evict the protesters.

The second act lasted from 7 to 20 June, when a smaller group of activists reoccupied the rig following Shell's decision, with the support of the UK Conservative government, to continue with their plans to dump it at sea. The tone of the communiqués gives a good idea of the rising tensions, and dangers, of the action.

In the early hours of this morning, five activists ... hung a banner reading 'Save Our Seas' from the walkway. They attempted to paint the side of the Spar, but were knocked back by water cannons from the nearby Shell supply vessel the *Rembas*. Around 10.30 am the climbers got back onto the *Moby Dick*, after spending hours at the mercy of the hoses. As the last three climbers came off, the water cannons were turned on them again and one woman was sprayed with the water cannon for a constant 20 minutes while she was dangling on a rope. Shell has denied this, saying they were 'testing equipment'. (7 June 1995)[17]

Despite the dangers, the activists stayed aboard the platform even as it was towed over 330 miles out into the Atlantic. Their bravery and tenacity paid off though. With rising condemnation in the media and from several European governments Shell backed down and a major victory for the environment was won; on 20 June the towing tugs turned back towards Norway. One of the activists described the scene:

We were sitting inside the Spar's compartment, when suddenly the water cannons just stopped. We walked out onto the platform to see if anything was happening. On the *Altair* [Greenpeace support ship] we could see little silhouetted figures dancing around. We couldn't figure out what was going on, until the *Altair* radioed us and told us the great news. After that moment an

[16] Diary quotations from Greenpeace website, 'Greenpeace Brent Spar – Internet Diary 1995', accessed online 22.11.2001 (no longer available on the Greenpeace website). An edited account is currently at Greenpeace: www.greenpeace.org/international/about/history/the-brent-spar (07.10.2006)

[17] Greenpeace Brent Spar – Internet Diary (no longer available on the Greenpeace website).

incredible rainbow appeared in the sky. Somebody later described the vision to look like a 'film set', which it did, the light was amazing. (20 June 1995)[18]

Not only had David apparently vanquished Goliath, but nature itself seemed to cooperate in the production of a spectacular finale, reproducing the Greenpeace logo in the sky.

THE DANGERS OF THEATRICAL METAPHOR

Theatrical metaphors can be applied so easily to this action because of the obvious drama in the situation. The theatricality that caused its climactic scene to look like a 'film set' made the 'art' in this protest especially visible – a spectacle for the times. The sometimes extreme dangers in the 'art' of such Greenpeace protests have often dominated the angle of media attention, the dering-do of these 'stunts' framed as outlandish circus: an image constantly countered by claims that its activists are highly trained and very well equipped.[19] Such attention to the performative excesses of events is the price usually paid in any struggle for media dominance, and it is one that also comes with unfortunate side effects for the ecological message of the protest. While the protesters may prefer the 'art' of their actions to be invisible, so that the message predominates, the media highlights the 'art' because it makes good copy and great images.

This effect has its roots in the very first Greenpeace protest in the early 1970s, when an ad hoc group of Vancouver environmental activists sailed an old boat into the fallout zone of America's nuclear-bomb tests on Amchitka Island in the Aleutians. The resulting media coverage generated a growing international wave of support. So from the outset Greenpeace dramaturgies of protest were fashioned with regard to the broadcast networks. We may say, then, that the positive feedback pressure from the 'machinic assemblage' of the global media for the Brent Spar event created a 'spectacularisation' of environmental protest that tended to turn nature into a 'backdrop' for the all-too-human action. Its aesthetics had few of the ambiguities or indeterminacies of deconstructive spectacle, its slogans were straightforward ('Save our Seas'), its action simply a high-tech sit-in, so it could be easily recouped through the spectacular processes of mediatisation in the performative society. The protest's action, as we have seen, could so easily be turned into a dramatic narrative

[18] Ibid.
[19] Stephen Durland, 'Witness: the Guerrilla Theatre of Greenpeace', in *Radical Street Performance*, ed. Jan Cohen-Cruz (London: Routledge, 1998), pp. 67–73.

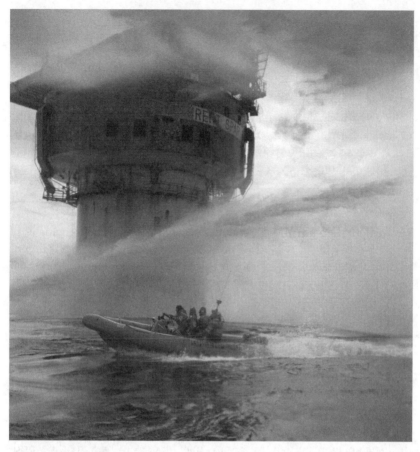

Figure 10 Greenpeace, Brent Spar protest – 1995. The dangers of North Sea activism become manifest as the Greenpeace inflatable outmanoeuvres the water cannons on an approach to the polluted rig.

because its techniques as spectacular theatrical art were so conventional, presenting nature as background setting for the human, even as its quality as protest was very exceptional and extraordinary.

The dramaturgy of the Shell protest could hardly escape these effects of mediatisation because it drew upon well-established theatrical genres. On one level, the protest was straightforward agitprop – a rallying cry for environmentalists. On another level, it was an epic struggle between antagonists with a dominant thematic focus and a through-line that ensures rising tension leading to a climax – fortunately Shell's submission – and a denouement: a Greenpeace sunset. In this performance the

dramaturgy tended to ensure that human culture was still the primary focus of attention, apparently even for the protesters, despite its environmental themes and intent. So the event's aesthetics reproduce the very pathology – culture versus nature, nature subservient to humans – that it is ostensibly attacking. There is then a contradiction between the excellent outcome of the protest – a partial victory for 'nature' – and the dramatic means by which it was achieved, which in effect made culture the arbiter of nature. In this performance event, despite all appearances, the environment is a very minor player in a theatre ecology that seemingly cannot avoid being radically severed from the nature it so dearly wants to protect.

ON PROTEST AND PARADOX

How might the thought-experimental trope of the black hole enable us to see a way beyond this kind of creative impasse and the analytical conundrums it generates? The most obvious 'black hole' in the Brent Spar saga is the vision of environmental devastation that inspired the action. This vision posits the impact of human culture on nature as spiralling out of control towards a global catastrophe for humanity. The singularity at the heart of the 'black hole' that produces this effect is the 'progress' for mankind promised by late-modernist international capital and its globalising powers. In this scenario Shell Oil is one of many major machinic assemblages that manufacture the materials essential to a 'progress' dependent on the carbon emissions that create global warming. The forces of this machinic assemblage have to be resisted and disrupted in order to 'save' the natural world. But such resistance sets up a polarity, a dualistic antagonism that, as we saw, may be used to *reinforce* the world-view that created the problem in the first place: culture versus nature. So this is a major spectacle of contradiction. The paradox this produces is key to the circulation of global capitalist power within which the spectacle of the Greenpeace event sets itself: The more mediatised you get the less power you have to use. Shell gives way but wins the bigger game.

Hence even the 'anti-progress' achieved by the protest strengthens the gravitational power of progress as a 'black hole', for the more spectacular the 'matter' that falls towards it – as more extreme forms of dramatic protest acknowledge it as an extremely effective force, say – the stronger its pull becomes. In trying to avoid making a contribution to this intensifying 'gravitation' towards global disaster, mainstream environmental organisations like Greenpeace, paradoxically, tend to take on some of the characteristics of the very bodies they are opposing: corporate structures, high-tech

dependencies, media manipulation and so on. Hence both in terms of the types of high-profile dramas their protests create, and of their infrastructural mechanisms for production of those dramas, they 'mirror' – they are a part of – the pathological processes that they oppose. Have such organisations, then, reached the cultural equivalent of the black hole's 'point of no return'; are they on or over the 'event horizon' beyond which there is no escape from the prospect of disaster; or are they on an 'apparent horizon' which will still allow their resistant efforts to escape the pathologies that are generating the ecological nightmare?

TOWARDS A POSITIVE PERFORMANCE ECOLOGY

Given the paradoxical nature of this territory, we will probably benefit from taking Hamlet's advice and approaching these questions crab-wise. The global scale of Greenpeace, at least in part, causes it to reproduce and reinforce the ecological pathologies it opposes ('in part' because it is a complex organisation, with many layers and dimensions through which actions can emerge that may avoid such reproduction). Still, in the next step of our search for viable ecological responses to the larger conundrum of incorporative power, such as that exercised by the mainstream global media, it makes sense to stay at the level of global resistance movements, but ones that may more ambiguously infiltrate the machinic assemblages of the globalised systems of recuperation with radical performance ecologies. The objective of this search is clear enough: examples of deconstructive spectacle that may operate 'transversally', i.e. across a range of highly contrasting contexts, in attempts to elude the 'gravitational' pull of the black hole of global ecological disaster. Such spectacles may constitute performance ecologies that utilise paradox to reach beyond the spectacle of contradictory theatrical ecologies, such as those produced by Greenpeace on Brent Spar.

The most prominent movement that experimented with the possibilities of such performance ecologies was an *anti-organisation* created especially to evade some of the traps I have discussed. One of the most active protesters of Earth First! in the UK, Alex Plows, offers this pen-sketch:

In a sense, EF! does not exist at all – certainly not as a campaign group such as Friends of the Earth, with paid membership and policy-making bodies. Instead, EF! is an egalitarian, non-hierarchical 'disorganisation', relying on grass-roots networking and local/individual autonomy rather than centralised policy control.[20]

[20] George McKay, *Senseless Acts of Beauty: Cultures of Resistance Since the Sixties* (London: Verso, 1996), p. 152.

This closely echoes the 1990 account by a leading analyst of the movement, Rik Scarce:

Earth First! was to be... just a force of devoted, unpaid, grass-roots activists occupying a niche they had created for themselves in the environmental movement – in short, an anarchy... The closest thing to membership cards are T-shirts with [the] clenched-fist logo and the motto 'No Compromise in Defense of Mother Earth'.[21]

Initiated in reaction to Greenpeace by American activist Mike Roselle and colleagues in 1979, Earth First! has been one of the more militant wings of environmentalism, prepared to damage property, and sometimes more, in the crusade for ecological justice. This 'disorganisation' aims to extend the reach of protest through the networks of the local with a grass-roots activism that balances resistant actions with proactive environmental projects, such as reforestation schemes. Its protests tend to be decentred, and they include tree occupations, tunnelling at road-building sites, street transformations and so on. These forms tend to place the protesters as acting in the environment, rather than on it. Their actions are more akin to 1960s guerrilla theatre than 1930s agit prop, often replacing the po-faced seriousness of the mainstream organisations with the humour of pranks and spirit of party. The dramaturgies of Earth First! protests, therefore, might throw some useful light into the paradoxical black hole encountered by Greenpeace on Brent Spar.

My favourite Earth First! protest is a 1985 action – let's call it 'Smokey the Bear' – which focused on the fact that the great majority of forest fires are caused by logging companies. Here is a full description by Mike Roselle:

In Corvallis, Oregon, 1985, the Forest Service had reserved the high school auditorium for a huge Smokey the Bear birthday party for elementary school children. There were going to be 300 kids present, plus parents... We had heard that the Forest Service didn't have a Smokey the Bear Costume – someone had washed it and the bottom had shrunk way down. Earth First! did, so I put on the bear costume and walked into the party and the kids immediately surrounded me because it was Smokey's birthday – I was moving through this *sea of kids* passing out flyers. The Forest Service guys came over and said, 'Look, can't you just leave? We don't mind you demonstrating *outside*, but we don't want you inside here.' I said, 'This is *my* birthday party; I'm not going anywhere...'

There was a law enforcement ranger there – one of the 'tree pigs' as they're called... He walked over and put his arm around me, smiling at me one of those 'You asshole' kind of grins as he said, 'Look. Come on. Take this outside!'

[21] Ibid., p. 153.

He had his arm around me and I had my arm around him and he's pushing and I'm resisting – we're about the same size. Meanwhile the kids think it's really cool – the ranger and Smokey! Finally he said, 'Well, I'm going to have to put you under arrest.' I said, 'That's going to be really great – arresting Smokey the Bear at his own party!'

When he realised that I *wanted* him to arrest me, he hesitated. Then he tried to tear my head off! But he tried to do it in such a way that the kids didn't get too freaked out. We had this struggle that was going on that was subtly violent – I said through gritted teeth, 'Look you're going to tear this costume' and he hissed 'Well, that's okay.' Finally he pulled it off and said, 'Look kids, he's not a *real* Smokey,' and I said, 'Hey kids, he's not a *real* ranger' and grabbed his flat-brimmed hat and threw it across the room like a frisbee. I said, 'Your glasses are next,' and he just kind of stared at me. At this point a bunch of people from our group came over to me, and a bunch of Rangers came over to him, and they pulled us apart.[22]

Compared to the Brent Spar action, this example clearly takes us from the sublime to the ridiculous in eco-protest. Yet what is at stake eco-logically is just as crucial: forest fires contribute significantly to global deforestation and climate change. The fact that Earth First! was broad-casting – that logging companies are ten times more likely to be the source of fires than anything else, including children and lightning – is highly significant, particularly when the Forest Service was spending large sums on events that effectively covered up the facts. In this example, the black hole of 'progress' is deliberately clouded by ignorance or duplicity on the part of the very people who are supposed to be caring for this particular bit of nature.

But what might this little drama indicate about a more hopeful per-formance ecology than the one used on Brent Spar? What in its theatre ecology would produce a comparable analysis to the one undertaken for the Greenpeace action? A key can be found, perhaps, in the classic dramatic category of farce, for as Eric Bentley argues, 'the principal motor of farce is . . . the impulse to attack (or Hostility)'.[23] To best understand the multiple vectors of hostility that simultaneously are producing the drama in this event it needs to be viewed from the perspective of the visibility–invisibility equation established by John Jordan's theorising. It is clear that the Earth First! protester is the primary source of hostility in this scenario, but for the gathered throng of children and their parents it is likely that he was, literally and metaphorically, an entirely invisible

[22] V. Vale and Andrea Juno (eds.), *Pranks!* (San Francisco: V/Search Publications, 1987), p. 126.
[23] Eric Bentley, *The Life of the Drama* (New York: Atheneum, 1964), p. 225.

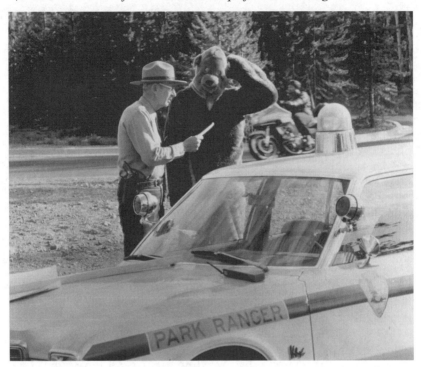

Figure 11 Earth First!, Yellowstone Park action – 1985. Cousin to Smokey, a Grizzly Bear is read his rights by a Park Ranger as traffic passes in Yellowstone National Park, USA.

antagonist: he is just Smokey the Bear attending his own birthday party! But in the lead-up to the violent encounter the protester's hostility is magically transferred to the Forest Ranger, who becomes a potentially highly visible aggressor prepared to eject Smokey from his 'own' celebration. The many ironies at play in this scene make it an especially ambivalent event: who might be held responsible for destroying the enjoyment of the children? Ironically, the root of its ambivalence is the anthropomorphism of the bear costume. In wearing the costume the human protester is, as it were, 'taking over' nature in ways that align him with the logging companies responsible for delivering the good management of forests, culture doubling-up against nature through assuming a 'natural' disguise. But also he is 'taking the side' of nature in using anthropomorphism to attack the Forest Service for the ecological damage it condones by not exposing the role of the logging companies in destroying the forests the Service is charged with conserving. Theatrically speaking,

this action draws both on traditional ritual animism through the 'magical' identification of animal disguise, and on postmodern performance art in its playing with the pastiche sham of dressing up as a bear.

But of course the scene, through all this, is deadly serious once the forest authorities decide they have no option but to intervene in it. Because then the law enforcement Ranger becomes the hostile antagonist in the farcical drama, the enemy of Smokey the Bear and therefore of 'nature', even though he is dressed as the very image of the responsible ecological authority. The protest then transforms into deconstructive spectacle in the moment of repressed violence. For when the Ranger rips the head off Smokey, yet another 'black hole' between 'culture' and 'nature', and one that is much more immediate and sinister than the idea of 'progress', opens up. This little act of environmental guerrilla theatre implies that the power of force available to all authority may be wholly inimical to 'nature'. The dramaturgy of the event ironically hands over the power of exposure to the environmentalist, only to reveal that violence between humans could well be a *function* of human violence to the environment, hostility to nature. Here is an especially fearsome black hole of the ecological crisis, for its gravity is generated by a vicious circle in which violence to nature entails violence among humans and vice versa. And vicious circles produce particularly virulent paradoxes: If you want something to end, never say never.

But perhaps there is one small glimmer of hope on the event horizon of this particular black hole, which is hinted at by the grim humour in the drama. When the Earth First! protester shouts out 'Hey kids, he's not a real ranger,' then skims the brimmed hat across the room like a frisbee, he is gesturing towards a different, more positive kind of paradox. The ranger is not a real ranger because he has, as it were, contradicted his public role; his actions deny what his uniform says he is; he is a ranger but not a ranger; an official custodian of nature who attacks it. As discussed in chapter 4, such self-reference suggests another pole of paradox, which is *infinity*, the quality informing Foucault's famous formulation that 'All modern thought is permeated by the idea of thinking the unthinkable.' Such formulations create the conceptual equivalent of a black hole, an infinite regress, which in turn can produce a tenuous type of hopefulness. Might we venture to say, then, that the paradoxes produced by the dramaturgy of the Earth First! action evoke the slim possibility of a 'wormhole' – a way through to another universe – as part of the black hole that this protest engages? That is to say, the black hole of a violence on nature that produces violence between humans, and so on *ad*

infinitum. Maybe I'm grasping at straws, but also maybe that's the best one can do as a next step to envisioning performance ecologies that will generate a more hopeful prognosis for nature. In threatening that the Ranger's spectacles might well follow his hat, the Earth Firster apparently *stalls the violence.* If he can really so economically ruin the Ranger's vision, in its metaphorical as well as its literal sense, then the forests might well have a better chance of survival – and so might humanity.

<div align="center">PERFORMANCE ASSEMBLAGES</div>

I have argued that the success of the Earth First! protest rested on how it transformed the contradictions of its practice into paradoxes to produce deconstructive spectacle. Its formal means for achieving this was a combination of the ritual trope of animal disguise with the ironic game-playing of performance art. But this aesthetic structure, in turn, relied on its simultaneous engagement with two major machinic assemblages that create the 'black hole' of late-modernist global culture through the idea of 'progress'. The first assemblage was the system of forestry use evolved by logging companies in the USA (and exported to the rainforests of many 'third world' countries), which, according to Earth First!, wreaks extensive environmental damage on the forests they are supposed to 'manage'. The second assemblage was the law-enforcement agencies charged with ensuring that such 'management' is environmentally sound and sustainable. The malfeasance of the latter in disguising the failure of the former in this respect was the point of exposure by Earth First! of their *joint* production as machinic assemblages, alongside many others, of the 'black hole' of a 'progress' and an 'intra-species violence' which mutually reinforce each other. In Deleuze and Guattari's terms the protest 'spoke transversally' because it indicated that the conflict between culture and nature that produces intra-species conflict, and vice versa in a continuing vicious circle, is based on entirely false premises, i.e. that nature can be separated from culture. Moreover, the protest can be regarded as a machinic performance in Jon McKenzie's sense because it arose in the conjunction of two machinic assemblages – the forestry and law-enforcement systems – involved in self-contradictory actions ultimately designed to reinforce the same outcome: a strengthening of the 'black hole' of 'progress'.

In achieving this exposure the Earth First! protest, I think, managed to sidestep some of the contradictions of the Brent Spar action because it worked to disguise, to make invisible, its own qualities of performance. It was a protest event masquerading as a party turn, a violent struggle pretending

to be a friendly hug, an eviction transformed into a transformative game. Such ambivalent genres link the event to the traditions of the trickster, and to some types of postmodern performance, and create the semiotic slipperiness that in turn produces the paradox of infinite regress through which the 'black hole' may turn out to be not quite so black after all. It achieves this, in contrast to the Brent Spar action, by more overtly engaging in paradox in its performative structure by, at least metaphorically, subsuming the human in nature and vice versa. The bear costume does this: it is a cultural artefact that pretends it isn't. And through that it aims to confirm Picasso's dictum: Art is a lie that makes us realise the truth. However tenuous the truth it produced, this is why it was hopeful, giving us clues about what performance needs in order to successfully revision the nature–culture divide.

For example, consider the relationships between organisational ethos and aesthetic outcomes in the two events and it becomes clear that the question of 'community' is highly relevant to the types of protest dramaturgy that environmental movements are most likely to produce. Both Greenpeace and Earth First! helped to establish international communities of interest during the final three decades of the twentieth century, significantly contributing to the creation of global social movements.[24] But in order to tackle multinational corporations and governments Greenpeace had itself to evolve a corporate identity founded on a particular type of institutionalised community. I am suggesting that this, in turn, in large part determines the types of dramaturgy that will structure its protests. Earth First! was created partly to counteract what its adherents saw as the limitations of this approach, by avoiding institutionalisation in order to produce a more fluid sense of shifting communities that form as and when protest seems necessary and appropriate. The dramaturgies of its events are less predictable than those of Greenpeace as the decentred dis-organisation provides scope for more improvisation and spontaneity in temporary communities of protesters. Similar considerations inform my argument that effective performance ecologies are much more likely to be found in performance beyond theatre than within the bastions of theatre buildings, however ecologically sound the thinking of their boards of directors.

Finally, I hope I have managed to suggest something of the qualities of the 'super-homologies' that might emerge through such thought experiments, in drawing analogies between the black holes of space, the progress

[24] Robin Cohen and Shirin M. Raj (eds.), *Global Social Movements* (London: Athlone Press, 2000).

of humanity towards ecological catastrophe, and various structures in the dramaturgies of protest, all considered as potential exemplars of performance ecology in the performance paradigm. Deleuze and Guattari envisage the functions of 'black holes' in a variety of ways, but the following perhaps best suggests the kind of homologies my thought experiment has been searching for: 'It may be necessary for the release of innovative processes that they first fall into a catastrophic black hole: stases of inhibition are associated with the release of cross-roads behaviour.'[25]

Greenpeace and Earth First! challenged major agents of the catastrophic black hole of progress in the arena where it is produced, on the high seas and in the forests. In this sense at least the protesters 'fall into' it by engaging it directly. The 'stases of inhibition' is what then appears on the event horizon of the black hole, an entrapment in the excessive gravitational pull of carbon addiction and deforestation on the other side of sustainability. This has to be taken on, so to speak, the protesters immersed in its forces in order to create a 'release of crossroads behaviour', a vision of other options beyond the pathologies of the black hole, perhaps through the wormhole. The situation of these protests was *that* extreme. Greenpeace became caught on its contradictions; Earth First! transformed them into paradox. Together these examples indicate some of the principles of successful eco-activist protest in the performance paradigm imagined by Jon McKenzie, to create complex but clear directions to hope in a less threatening future.

So I suggest that environmental radicalism through performance ecology requires especially iconoclastic and highly reflexive dramaturgies in order to find wormholes in the black holes of the ecological crisis that will counter performance addiction. Its performative paradoxes have to be finely tuned for it to see through the nature of the 'nature' of its own limitations. It cannot act out what that old cynic Sam Goldwyn meant when he said 'Include me out!' Therefore it will need to imagine ways to dramatise into performance some of the wisest words that Nietzsche wrote: 'What then in the last resort are the truths of mankind? – They are the *irrefutable* errors of mankind.'

[25] Deleuze and Guatarri, *Thousand Plateaus*, p. 334.

CHAPTER 9

Performance and energy: on free radicals

VITALITY

The nineteenth-century American actor, Joseph Jefferson III, once said –
according to Sarah Bernhardt, 'very meekly' – 'As for me, I find that I act
best when my heart is warm and my head is cool.'[1] In the same century,
but almost as if in another universe, Samuel Taylor Coleridge famously
wrote of Edmund Kean: 'Kean is an original; but he copies from himself.
To see him act is like reading Shakespeare by flashes of lightning.'[2] A
'warm heart', a 'cool head' and 'flashes of lightning' in the context of
comments on acting have this in common: they signify the vitality that is
crucial to all performance. While the exact nature of such vitality remains
a mystery, we know from science something of the key process that
sustains it: energy transfer. There are many ways to describe this, but the
definition sometimes found in modern physics has a special resonance for
the evolution of performance ecology. Physics talks of 'the capacity of a
physical system to perform work' or 'the ability to perform certain tasks'.[3]
Hence the physical systems that were Jefferson and Kean in performance,
as with all other organic actors, possessed that capacity because their
materials were infused with energy. The transformation of energy in and
between materials is the process that expresses vitality, and without
appropriate vitality performance is not likely to bring about change.
Hence a convincing general account of the powers of performance to
induce change will rest on cogent figuring of how energy circulates in
theatre and performance ecologies. But we will need a particular case of

[1] Sarah Bernhardt, *The Art of the Theatre*, trans. H. J. Stenning (New York: Dial Press, 1925); quoted
in Peter Hay, *Theatrical Anecdotes* (Oxford University Press, 1987), p. 13.
[2] Samuel Taylor Coleridge, *Table Talk and Omniana*, 1888; quoted in Hay, *Theatrical Anecdotes*,
p. 14.
[3] Microsoft Encarta, 'Energy'; Website – Wikipedia, 'Energy': http://en.wikipedia.ord/wiki/Energies
(10.11.2006).

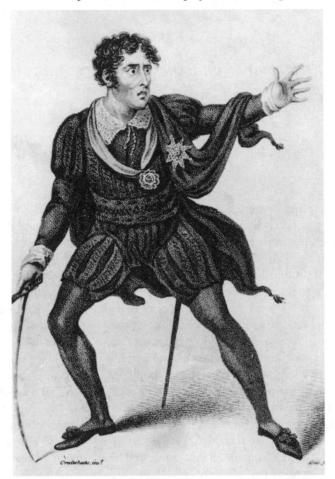

Figure 12 Edmund Kean as Hamlet, Drury Lane Theatre, London – 1814. The sword
sprung against the ground and tassels swirling in reverse counterpoint depict a striking
moment of energised performance as Hamlet starts at his father's Ghost.

energy exchange to focus our analysis, one as distinctive and yet as
common as, say, lightning. A challenging contender for this task would
be the molecular or atomic species that chemistry calls 'free radicals'.

FREE RADICALS

A free radical is a molecule (or atom) that contains at least one unpaired
electron and so follows an atomic orbit on its own. First identified in

organic form in 1900, free radicals play significant roles in creating energy transfer in life processes, being highly reactive and involved in numerous kinds of chemical exchange. Not surprisingly, perhaps, overall they produce ambivalent effects. Some free radicals are Promethean, as they are essential to combustion, their concentration determining the varied flammability of materials. Biological free radicals are necessary for life, as they kill harmful bacteria, but also scientists may have identified in them a tragic potential. For example, DNA appears sometimes to be attacked by oxidation created by free radicals, so they might nurture the mutations that produce cancer. They may also cause some transition metals to turn carcinogenic, hence they have been implicated in lung disease, diabetes, emphysema, liver damage, schizophrenia and other major degenerative human processes, including aging itself. Atmospheric free radicals are produced in Earth's upper atmosphere by ultra-violet solar radiation acting on other agents, such as chlorofluorocarbons, which then attack the ozone layer. However, it is not always easy to tell if the energy of particular free radicals is the cause, or an outcome of some other cause, of these biological, atmospheric and other processes. So, as with more easily detected performances, there is ambiguity in the dance of free radicals. And while some free radicals, such as melanin, may last for millions of years, most of the rest react very quickly with other molecular elements and only exist for very short periods of time. Like performance, they are usually very difficult to study.[4]

So the high reactivity, pervasiveness, ambivalence and ephemerality (against a 'background' of durability) of free radicals make them promising candidates for thought experiments about performance and ecology. Hence the key question for the following analysis is: if 'free radical' becomes a focusing trope for energy exchange in theatre and performance ecology, how might that illuminate the ecological value of energy in particular performance practices and theories? Two brief thought-experimental forays into highly contrasting present-day and historical examples will provide an initial test of this angle of approach to performance as indicating free-radical activity in the emergent crises of the ecological era. Firstly, cross-national processes in twenty-first-century global economies; secondly, actor processes in nineteenth-century legitimate theatre.

[4] Microsoft Encarta, 'Free Radicals'; Website – Wikipedia: 'Radical (chemistry)': http://en.wikipedia.org/wiki/Radical_%28chemistry%29 (28.08.2006).

GLOBAL ECONOMIES, ORGANISATIONAL PERFORMANCE

Many of the agents contributing significantly to twenty-first-century global poverty and pollution may be thought of as free radicals. Félix Guattari points in this direction when he writes of 'the suffering of the Third World' as a 'demographic *cancer*'.[5] Seen from this perspective, factors generated by the multinational conglomerates of globalised capital – such as Exxon Mobil, GlaxoSmithKline, Time Warner and many others[6] – may be propagating a particular free radical of economic investment to produce 'oxidation' in the 'political DNA' of developing nations. That is to say, these free radicals attack the capacity for self-determination of those nations' fiscal infrastructures. The free radical in question commonly comes in the form of 'export credit', as virtually all the world's overdeveloped countries operate export credit agencies (ECAs) that channel state subsidies and other funds to mostly multinational companies in order to bolster commercial projects in the 'third world'. In 2000, for example, the World Bank 'provided about $8 billion to projects with adverse environmental impacts . . . such projects also received over eight times that amount from the ECAs'.[7] This economic profit-making process has political consequences because 'governments of impoverished countries are often required to provide "sovereign counter guarantees" ensuring they will assume the debt if the local industry fails to pay'.[8]

This system of exchange encourages the 'performance' of the export-credit free radicals to cause reduction of risk controls in the form of effective, political, negative-feedback loops, i.e. the 'sovereign counter guarantees' undermine nation-state autonomy. This increases the impact of these free radicals on self-sustainability in the host nation, so there is little or nothing to prevent them damaging local systems, political, economic and environmental. We might call such effects of exported credit 'energy out of place', as their negative impact on the host countries' political negative-feedback systems, the powers to control their own economic affairs, produces a positive-feedback loop that tends to increase their national debt and thus keeps them impoverished in the ecology of the twenty-first-century global economy.

[5] Félix Guattari, *Chaosmosis: An Ethico-aesthetic Paradigm*, trans. Paul Bains and Julian Pefanis (Sydney: Power Publications, 1995), p. 119, my emphasis.
[6] Website – Forbes: 'Lists': www.forbes.com/lists/ (03.10.2006).
[7] Patrick Hossay, *Unsustainable: A Primer for Global Environmental and Social Justice* (London: Zed Books, 2006), p. 98.
[8] Ibid.

This analogical example suggests one clear method for assessing the qualities of free radicals in such global systems, so that we might distinguish 'good' (or at least 'better') free radicals from 'bad' (or 'worse') ones in economic and organisational performance ecologies by their likely systemic effects. In the case of export credit there is a straightforward parallel with the investment by 'angels' in mega-musicals as discussed in chapter 5, money chasing money to produce profit that generally turns out to be viral, especially for the poor, in neo-liberal globalised capitalism. This raises the interesting prospect of whether there are any theatre or performance ecologies in which free radicals will be more likely to produce benign effects, and if so under what conditions might that be most likely? How do we need to figure these components of such systems in order convincingly to produce this analytical open sesame, in which a clear negative effect paradoxically produces a positive outcome? Perhaps a famous Parisian saying may give us a clue: You get the best view of Paris from the Eiffel Tower because you can't see it from there. In other words, search for paradoxes in the high dramas of structural or systemic events because that is where free radical effects might most blindingly occur. An eyesore gives a brilliant view of the city it overlooks.

ACTOR PROCESSES, THEATRICAL PERFORMANCE

That last conundrum suggests why the question of how we think of energy in performance may be such a crucial one, and why a paradoxology of performance might provide significant theoretical perspectives for such thinking. For, in a sense, strong paradoxes potentially carry such powerfully transformative energies, as their contradictions – the clash of negative and positive charges – produce an overriding truth, a flash of insight, if you like. To tease this prospect out a little I pull back from the global perspective evoked by Guatarri's Third World 'cancer' to focus on a more local analogy, in the sense of being certainly close to home for all organisms, even if they never see or sense its source; namely, the lightning of storm clouds. This will lead us into another brief thought experiment, bringing us back to 'energy' as having the potential to provide a singular explanatory node in the creation of general ecologies of performance. For energy is paradoxical in that it has no substance, except when it approaches the speed of light and transforms into mass, as happens in the creation of petrified lightning or Fulgurites.[9] Does such an

[9] Chapter 1, see pp. 7–9.

expression of massive yet momentarily controlled combustion indicate the proximity of positive free radicals?

The key questions for this thought experiment focus on my opening examples. Did Edmund Kean produce something of this effect for Coleridge and others, and might Joseph Jefferson III even have achieved the same result at lower speeds? Let us presume that Jefferson's comment on his best acting as combining a 'warm heart' and 'cool head' have a parallel in the structure of clouds in thunderstorms, which are electrically negatively charged around their base and positively charged closer to their top. The negative charge at the base of the cloud induces a positive charge in the earth below, which acts as the second plate of a huge capacitor and a lightning flash results. Many meteorologists believe that lightning, which comes in a number of types, is the way that the biosphere maintains the total negative charge of the Earth's surface, which is crucial to its life-sustaining processes.[10] Geochemists consider that lightning may also have important functions in the overall chemical constitution of the atmosphere.[11] So lightning is a vector of the Earth's weather systems that plays vital part in maintaining the biosphere, as it produces a major global negative-feedback system, paradoxically constituting a local destructive force that is globally benign, a hit that heals.

Did Coleridge intuit something of this connection by implying that Edmund Kean's acting was somehow like lightning, powerful enough for George Lewes, over forty years after Kean's death, to recall his performances as 'irradiated with . . . flashes'?[12] Following this line of analogical thinking perhaps we might begin to see in what ways Kean acted like a free radical in performance, striking enough, according to anecdotal record, to cause some members of his audience (including Lord Byron) to experience convulsions and to swoon or faint.[13] After Kean's death the actress Fanny Kemble observed he was:

[10] Microsoft Encarta, 'Lightning'; Website – Wikipedia, 'Lightning': http://en.wikipedia.org/wiki/Lightning (03.10.2006); J. Alan Chalmers, *Atmospheric Electricity*, 2nd edn (Oxford: Pergamon Press, 1967).

[11] William L. Chameides, 'The Role of Lightning in the Chemistry of the Atmosphere', in *The Earth's Electrical Environment, Commission on Physical Sciences, Mathematics, and Applications* (Washington, D.C.: National Academy Press, 1986).

[12] Lewes may have known of Coleridge's comment, but his recall of Kean's performances was still clearly very strong. George Lewes, *On Actors and the Art of Acting* (London: Smith Elder, 1875), p. 5; quoted in Simon Shepherd and Peter Womack, *English Drama: A Cultural History* (Oxford: Blackwell, 1996), pp. 114–15.

[13] Simon Trussler, *Cambridge Illustrated History of British Theatre* (Cambridge University Press, 1994), p. 210.

a man of most original and striking powers, careless of art, perhaps because he did not need it, but possessing those rare gifts of nature without which art is as a dead body ... if he was irregular and un-artistic like in his performance, so is Niagara compared with the waterworks of Versailles.[14]

Of course such similes may simply be a product of rhetorical convention in a Romantic age, where 'nature' was habitually called on to stand in as a sign of excess in culture. Yet both Joseph Roach and Jane Goodall note that there was ongoing debate in this period about the 'beast actor' and the interaction of 'natural' impulse and aesthetic control, which was clearly linked to the early development of evolutionary theory.[15] From the perspective of theatre ecology, I would hesitate to claim much more than that such cultural perturbation may indicate correspondence between the processes of staged performance and emergent knowledge of the 'natural world'. But at the very least the convulsions and fainting of audience members at Kean's performances, apocryphal or not, suggest he produced a powerful energy out of place in the theatre of his times. Lightning striking the same place more than once and often in unpredictable ways, certainly events notable enough to go down as a very clear mark in theatre history.[16]

In concert with other extraordinary actors, Kean may be one of the exceptions that proves a general rule of performance ecology. Namely, that energy exchange on vastly different scales – from the atmospheric of lightning to the microcosmic of free radicals – are intimately interlinked, raising the commonplace paradox that the extraordinary often appears in very ordinary guise (and gals). For lightning is a pretty frequent affair in the world. Scientists calculate it strikes the Earth on average 100 times in every second.[17] And just as it charges up the Earth, so in the upper atmosphere it plays a role in making and maintaining the ozone layer. Not surprising, then, that twentieth-century scientists provide us with a telling, if somewhat whimsical, link to Coleridge and Kean in this thought experiment, in the form of 'sprite lightning'. This phenomenon was first photographed in 1989. It 'appear[s] as reddish-orange neon-like flashes' above thunder clouds in a lightning storm and possibly *every*

[14] Hay, *Theatrical Anecdotes*, p. 46.
[15] Joseph R. Roach, *The Player's Passion: Studies in the Science of Acting* (Ann Arbor: University of Michigan Press, 1993), pp. 168–9; Jane R. Goodall, *Performance and Evolution in the Age of Darwin: Out of the Natural Order* (London: Routledge, 2002), pp. 170–2.
[16] Joseph Donohoe, *The Cambridge History of British Theatre*, vol. II, *1660–1895* (Cambridge University Press, 2004), p. 227.
[17] Chameides, 'Role of Lightning', p. 74.

lightning bolt attempts to produce sprites, which usually appear in small clusters, just as they do in Shakespeare's plays.[18]

So lightning, free radicals, extraordinary natural actors: here is a nexus of ambivalent performance shared across global, microscopic and human scales in which negatives and positives may become as intimate as the two terms of a paradox. They are splendid examples of high-powered energy exchange produced by meetings of opposites whose effects are unpredictable, even though they are commonplace, maybe even ubiquitous. Thus they transfer a paradoxical energy that predictably is unpredictably out of place, capable of rendering the negative positive. Could this be characterised as a risk-laden general benignity in performance ecology? A thunderbolt revealing what the dark looks like? If this seems a mite unhealthily mystical, think of the immediate after-effect of a lightning flash on vision, that instant of refocus when its seems one can see through the dark as the after-image fades. Still these conclusions to my thought experiment may seem simply fanciful, even though twentieth-century science provides some close equivalents, for example through the concepts of atomic physics. Was it just fancy that led the great English astrophysicist Sir Arthur Stanley Eddington to conclude: Substance is one of the greatest of our illusions?

PERFORMANCE ENERGY

Energy is a vital concept in ecology, because it is the global circulation of energy that will dictate the future health, or even survival, of the Earth's biosphere. Thus energy economics attempts to determine the limits to growth in human societies globally. Too much growth – of population, production, consumption – may produce environmental pollution and a global warming that increases exponentially to create a catastrophic resource decline for many living organisms. Limits theory in ecological thinking aims to figure where and how growth overshoot might occur in order to protect the negative feedback systems that help to stabilise the global ecosystem. Such sub-systems are essential to conserve the balance of energies that makes a total system viable.

Remember: move predators from grassland and the prey will overbreed, then overgrazing will cause soil erosion and an end to the grassland.[19] The escalating positive feedback of unchecked population growth

[18] Website – Wikipedia, 'Lightning': 'Sprites, elves, jets and other upper atmospheric lightning': http//en.wikipedia.org/wiki/Lightning#Upper-atmospheric.

[19] David Pepper, *Modern Environmentalism: An Introduction* (London: Routledge, 1996), p. 69.

may create uncontrollable damage, producing an over-abundance of disordered energy, or entropy, in the total ecosystem.[20] In classical mechanics this equation also applies to the Earth because the principle of energy conservation states that energy can be transformed but not created or destroyed, hence wasteful or low-efficiency transformations of energy – say burning fossil fuels to create electricity – introduce disordered energy, which cannot be easily reused, into the environment. The same is true in bioenergetics, so that all living organisms on earth ultimately depend on the sun for energy replenishment. According to the second law of thermodynamics, the process of increasing entropy will evolve inevitably over time on a global scale as the sun's production of energy declines. The balance between usable and unusable energy on Earth at any particular moment is therefore crucial to the survival of all species of life, which is why the question of sustainability – the sustainable uses of energy – is one of ecology's greatest stimulants.

But how might such ecological analysis be more specifically useful to the study of theatre and performance? Do some theatres and performances exchange energy more efficiently than others, no matter what their scale or style? What kinds of performance might be best for identifying threats to negative feedback in ecosystems? Do some theatre and performance ecologies contribute more to global sustainability than others, and if so under what conditions? Are some energies of performance more radical in this sense than others? These are questions that obviously raise complicated factors in the interaction and mediation of 'culture' and 'nature', and again pose the challenge of how analysis can avoid reproducing the ecological pathologies it aims to address. Headache questions from which thought experiments might provide only a little light relief.

The analytical moves of my thought experiments in this chapter serve two main purposes. Firstly, they provide a test of scale for my methods of constructing homologies between contrasting areas of experience as a means to identify some general principles of performance ecology. If this approach can be made productive across vast ranges of physical scale then perhaps it will be easier to recognise the ecological value of its general application. So I draw on the microscopic world of free radicals in acute contrast to the macrocosmic universe of black holes explored in the previous chapter. Such contrasts, I hope, will open up the space and time

[20] The arguments are of course complex; see, for historical example: John McNeill, 'More People, Bigger Cities', in *Something New Under the Sun: An Environmental History of the Twentieth Century* (London: Penguin, 2001), pp. 269–95.

of performance to reflexive comparisons through what follows in the main thought experiment of this chapter. I search for signs of free radicals first in theatre and performance theory and then in metaphors of creative practice, as they provide a telling historical panorama of how energy has been pictured by influential thespian folk. I conclude with two brief comparative close-ups on projects that directly engaged ecological energies in highly contrasting urban and desert settings at opposite ends of the Earth.

These further contrasts will extend the methods of earlier chapters and their arguments about the socio-political impact of theatre and performance ecology. They will also indirectly address some ancient problems in dramatic and theatre theory, such as why tragic plays might be good for humans. If black holes paradoxically can throw analytical light on the forms of performance spectacle as used by eco-activists, perhaps free radicals might tell us about the positive potential of performance energy for ecological good causes. This will still be a hard trick to turn, however, because as we have seen free radicals often have had a very bad press. So this chapter also aims to build further on the paradoxology of performance by exploring how bad can be good when the worst may be yet to come.

ENERGY IN THEATRE AND PERFORMANCE THEORY

In over four decades of making performances I have rarely come across colleagues involved in staging theatre who never talk about energy. To produce a play, or to devise a show, is to work on the shaping of energy. Yet although energy is crucial to performance, you will not find entries for it in the main English-language encyclopaedias and dictionaries of theatre.[21] It is not a key concept in the history of dramatic theory, although there are a number of terms – such as action, emotion, magnitude – that obviously point to it.[22] Much the same is almost as true in theories about the theatrical performer, which attracted significant attention in the final decades of the second millennium. Hence 'energy' gains a pretty low profile in two high-quality (and representative) books of

[21] For example, see: Martin Banham (ed.), *The Cambridge Guide to Theatre* (Cambridge University Press, 1992); Patrice Pavis, *Dictionary of the Theatre: Terms, Concepts, and Analysis*, trans. Christine Shantz (Toronto University Press, 1998).

[22] Oscar Lee Brownstein and Darlene M. Daubert, *Analytical Sourcebook of Concepts in Dramatic Theory* (London: Greenwood Press, 1981), pp. v–vi.

analysis of acting and performing which focus on training and aesthetics.[23] The term is listed in the index of one of the best collections of writings on acting, but with only two entries.[24] As we shall see, the fact that energy was crucial to the thinking of leading avant-garde practitioners, such as Jerzy Grotowski, Peter Brook and Eugenio Barba, serves to make this turn of the millennium silence especially eloquent.[25]

As the emergent performance paradigm profoundly challenged the limits of theatrical representation in the late-twentieth century it elicited a historical drift that Marvin Carlson illuminatingly calls an 'attempted balance between a theatre of signs and a theatre of energies'.[26] How theatre and performance scholars positioned themselves regarding 'signs' and 'energies' is very telling of their attitudes to the 'human', and by implication to the potential ecological impact of their subject. Bernard Beckerman reflects a modernist view with its faith in high-energy mastery of the environment: 'the performer projects an uncommon vitality – what Michael Goldman calls "terrific" energy'.[27] Stephen Greenblatt identifies the driver of his cultural–materialist project to rescue Shakespeare from aesthetic idolatry as 'social energy', with its qualities of 'power, charisma, sexual excitement … free floating intensities of experience' always placing the human centre stage.[28] Patrice Pavis pleads a moderation of theatre semiotics' totalising tendency to turn everything onstage into a sign, risking obfuscation as he productively squints at the human through a ' "semiotization of desire" or "vectorization" [which] reconciles a semiology of the perceptible with an energetics of displacement that are not visible'.[29] Josette Féral edges towards an evaporation of the human

[23] Alison Hodge (ed.), *Twentieth-Century Actor Training* (London: Routledge, 2000); Philip Auslander, *From Acting to Performance: Essays in Modernism and Postmodernism* (London: Routledge, 1997).

[24] Phillip B. Zarrilli (ed.), *Acting (Re)Considered* (London: Routledge, 1995).

[25] Eugenio Barba and Nicola Savarese, *A Dictionary of Theatre Anthropology: The Secret Arts of the Performer*, trans. Richard Fowler (London: Routledge, 1991); Jerzy Grotowski, *Towards a Poor Theatre* (New York: Simon and Shuster, 1968).

[26] Carlson also describes this in terms of an accommodation of semiotic–structuralist and psychoanalytic–poststructuralist theoretical influences. Marvin Carlson, *Theories of the Theatre: A Historical and Critical Survey, from the Greeks to the Present*, expanded edn (Ithaca and London: Cornell University Press, 1993), p. 514.

[27] Bernard Beckerman, *Theatrical Presentation: Performer, Audience and Act* (London: Routledge, 1980), p. 6; quotation from Michael Goldman, *The Actor's Freedom: Toward a Theory of Drama* (New York: Viking Press, 1975), p. 7ff.

[28] Stephen Greenblatt, *Shakespearian Negotiations: The Circulation of Social Energy in Renaissance England* (Oxford: Clarendon Press, 1988), p. 19.

[29] Patrice Pavis, *Analysing Performance: Theater, Dance, and Film*, trans. David Williams (Ann Arbor: University of Michigan Press, 2003 [1996]), p. 313.

through performance, positing the performer as dangerous antidote to the symbolic order of theatre in becoming 'the point of passage for energy flows ... that traverse him without ever standing still in a fixed meaning or representation ... putting those flows to work and seizing networks'.[30] We have slipped closer to the realms of the postmodern here, engaging a system of networked energy that tends towards an ecologically inflected view, but still the human male is focus of the flow. Theatrical radicals potentially become freer in this decline of modernity. But even as the balance tips towards a fuller appreciation of energy in performance these influential theorists deliver mostly a negative charge to ecological hope.

So the theatre scholar Freddie Rokem, in an important essay reviewing this tradition from the vantage point of 1999, correctly argued that energy had received 'no attempt ... to examine [it] systematically, as a key concept for the theory of theatre and performance'.[31] He considers this very odd, given the widespread view that the actor is a figure 'inspired or "charged" with divine or metaphysical powers'. To better conceptualise energy in performance he proposes a general theory of theatre as constituting

a mingling of ontological spheres, which as a rule do not co-exist to the same extent in other contexts ... as between the aesthetic and the social, the fictional and the historical, the natural and the supernatural, the static and the dynamic, the naive and the metatheatrical.[32]

This is a lively list that allows Rokem to range from Shakespeare to the Bible, through semiotic analyses of theatre to the practices of particular directors, and to take in the 'metaphysical energies' of stage effects and their importance in the transmission of history by performance. The discussion is illuminating in many ways, not least for its insistence that the energies of performance can be politically transformative, especially in highly charged historical circumstances, such as those created by the second world war of the twentieth century. Rokem's chief prescription for such a radical energetics of theatre is surprising. Detach the free radicals of theatre, political or otherwise, from the chains of signification by turning audiences into participants as spectator–witnesses implicated in the drama's action. As with Brecht's street-scene example, in this system doing – reacting to the car crash of climate change, say – comes before

[30] Josette Féral, 'Performance and Theatricality: the Subject Demystified', trans. Terese Lyons, *Modern Drama* 25: 1 (March 1982), 174.
[31] Freddie Rokem, 'Theatrical and Transgressive Energies', in *Performance: Critical Concepts in Literary and Cultural Studies*, vol. 1, ed. Philip Auslander (London: Routledge, 2003), p. 292.
[32] Ibid., p. 294.

thinking as a first condition for drawing up the potential of positive ecological energy through performance.[33]

So, very promising stuff. Unfortunately, though, from a theatre ecology perspective the full force of Rokem's argument is crucially hampered by his claim that the 'friction' produced when different 'ontological spheres' meet 'is the source of the *unique* energies created by the theatre'.[34] Even allowing that the theatre is a unique place of ontological experiment – a prospect that the paradigm of performance flatly contradicts – the notion of 'unique energies' runs counter to standard usage, which posits 'energy' as a *general* potential for change, i.e. in the capacity to perform work. If this standard is applied to theatre and other cultural institutions it is easier to justify the potential transformative power of theatre or performance *per se*, as they become specific vectors for some of the multitudinous conversions of energy that are essential to life. Rokem is actually very well attuned to the potential of such conversions in theatre. He approvingly quotes the iconoclastic theatre artist-theorist Herbert Blau: 'When we grow weary of the disorder of the world . . . we retreat to or look for energy in the apparent order of art, its ingrown autonomy.'[35] He recognises the paradox that for some vectors an increase of entropy in a system can be restorative, as Jon McKenzie's central paradox of the performance paradigm indicates.[36] The paradox lies in the ways that a unique exchange of energy, like lightning striking an ancient oak, can be common enough for a system, such as the biosphere, to be sustained by a negative charge ultimately producing a positive outcome. But in this essay Rokem has some difficulty forging a language adequate to his excellent perceptions of energy in performance. Finally he returns to the traditional notion of a spectator–witness 'catharsis' that can somehow, magically, unite all the theatre's energetic forces to positive effect in 'the "total experience" of a theatrical performance'.[37]

[33] Ibid., pp. 306–7; Bertolt Brecht, *Brecht on Theatre*, ed. and trans. John Willett (London: Eyre Methuen, 1974), pp. 121–9.

[34] Ibid., my emphasis.

[35] Herbert Blau, *The Eye of Prey: Subversions of the Postmodern* (Bloomington: Indiana University Press, 1987), p. 165.

[36] 'The paradox: fragmentation can become an identity, disintegration can serve an integrating function.' Jon McKenzie, *Perform or Else: From Discipline to Performance* (London: Routledge, 2001), p. 254.

[37] Rokem, 'Theatrical and Transgressive', p. 307. This take on catharsis is importantly qualified in *Performing History*, where Rokem argues it also can be 'more like a "ritual" of resurrection . . . where the victim is given the power to speak about the past again'. Freddie Rokem, *Performing History: Theatrical Representations of the Past in Contemporary Theatre*, University of Iowa Press, 2000, p. 205.

We seem to be a long way from actual free radicals in this almost cosmically mystical notion of the power of the performative. Or are we? 'Total theatre' became a crucial motif in Western avant-garde performance in the second half of the twentieth century. Its key practitioners were certainly considered radical, but in what ways might they have dealt in the 'energy out of place' characteristic of microcosmic free radicals?

THE HISTORICAL AVANT-GARDE

The historical avant-garde of the twentieth century 'propagated a radical break with preceding formulae of artistic production and promoted creativity as part of a wider cultural–political revolution'.[38] Such standard definitions imply that experimental artists may be the 'free radicals' of the total system of Western cultural ecologies. So we might do worse than turn to the main theorising practitioners of avant-garde theatre in late modernism in order to find a critical mass that focuses on positive energy in performance ecology. I hope my ecofeminist friends will look kindly on the following retreat into a well-worn lion's den for the next test of my thought-experimental method. A weak rationalisation, perhaps, but there's no denying that the male pride of theatre directors Peter Brook, Jerzy Grotowski and Eugenio Barba has been especially influential. Tellingly, the weight of their analysis of energy falls mainly on the performer, then the spectator–participant.

Eugenio Barba devotes a section of his *Dictionary of Theatre Anthropology* to energy. There he provides an illuminating East–West survey of the languages and techniques of performing in an effort to identify the universal principles of the actor's art in shaping 'nervous and muscular power'.[39] He identifies the outcome of that art, in the Occidental traditions, as the performer's 'presence' and draws attention to equivalent terms in Oriental actor-training systems. The ideology informing this analysis places a hierarchical distance between 'daily' and 'extra-daily' actions, with the implication that through her mastery of the latter the 'great performer' is potentially dealing in universal forces. In the balance between 'sign' and 'energy' Barba seems to tip primarily to the latter in an 'activist understanding of the actor's energies'[40] when he claims: 'There

[38] Günter Berghaus, *Avant-garde Performance: Live Events and Electronic Technologies* (Basingstoke: Palgrave Macmillan, 2005), p. 14.
[39] Barba and Sevarese, *Dictionary of Theatre Anthropology*, p. 74.
[40] Rokem, 'Theatrical and Transgressive', p. 301.

are certain performers who attract the spectator with an elementary energy which "seduces" without mediation.'[41] His tag for this state is the 'dilated body', which is 'a glowing body, in the scientific sense of the term: the particles which make up daily behaviour have been excited and produce more energy ... they move further apart, attract and oppose each other with more force'.[42] He does not name them, but the free radicals of science are obviously circulating nearby, and Barba's thoroughgoing focus on the biology of the performer gestures towards an ecology of performance. Unfortunately, though, the move is never completed, because he conceives of theatrical energy pragmatically as a 'how' rather than a 'what'. He is preoccupied with how it can be used rather than what it might constitute, tending to see the audience as a receptor ready for impact.[43] This is reasonable for a director primarily interested in technique, but its effect is paradoxically to prevent Barba's theatrical project from achieving a biocentric ethic. Instead he fixates it on the human actor operating in what he elsewhere calls a 'land-less country',[44] a country that is everywhere and nowhere. At a stroke, ecology evaporates as avant-garde performance is excused responsibility for what it may constitute through the dangerous privilege of free radicalism.

As Freddie Rokem perceptively points out, Peter Brook is fond of 'quasi-scientific metaphors' – volcanoes, explosions, carbon-arc lamps– when he talks about energy and the theatrical event.[45] The volcano appears in *The Empty Space* (1968), the explosion and arc lamp in an interview of 1992.[46] Between these dates Brook directed some twenty-two productions, developing an increasingly sophisticated focus on the actor–audience relationship.[47] The arc-lamp metaphor reflects this and, as a machine that makes a form of miniature lightning, it is promising from a theatre-ecology perspective. Brook has a fair understanding of its technology, which was in use in theatres from the 1840s until (as spotlights) the late-twentieth century: 'In a carbon-arc lamp two poles touch, there's a change in temperature, then combustion, and a thoroughly useful and wonderful result – light.'[48] What he omits is that the poles have to be

[41] Barba and Sevarese, *Dictionary of Theatre Anthropology*, p. 54. [42] Ibid.

[43] Eugenio Barba, *The Paper Canoe: A Guide to Theatre Anthropology* (London: Routledge, 1995), p. 50.

[44] Ibid., p. ix. [45] Rokem, 'Theatrical and Transgressive', p. 302.

[46] Peter Brook, *The Empty Space* (New York: Avon Books, 1968), p. 47; Peter Brook, 'Any Event Stems from Combustion: Actors, Audiences, and Theatrical Energy', *New Theatre Quarterly* 8: 30 (May 1992).

[47] Albert Hunt and Geoffrey Reeves, *Peter Brook* (Cambridge University Press, 1995), pp. xiv–xvi.

[48] Brook, 'Any Event', p. 108.

drawn apart to produce the arc of the electrical spark. But his account of the audience and actors as 'two basic elements' equivalent to the poles seems to work in this direction: 'At the outset, these two elements are separated. The audience represents multiple sources of energy ... An event will only occur if each of these individual instruments becomes attuned ... The same thing occurs with the actors.'[49] Sparks in and between auditorium and stage! An account of highly focused energy widely dispersed, like equatorial lightning storms seen from an intercontinental flight? But the theoretical flying is not so high, as the interview transcript reveals a more down-to-earth slippage between metaphors as Brook goes on to explain that a 'vibration' is needed in the 'auditorium' for these 'harps' to be 'tuned in the same way'.[50] From a theatre-ecology perspective two points are of interest here. First, the metaphor shifts from science–technology to art–orchestration. Second, the interviewer is a lighting designer who had worked with Brook on several projects. The shifting metaphors seem to be an implicit appeal to the designer to cede to the master conductor of high art. Despite the small-scale lightning and the free radicals needed for combustion, this is theatre as a humanist theology – a classical symphony – delivered by an apparently benign super-power. Brook's quasi-scientific vision transports us well away from a biocentric view of theatre.

Both Brook and Barba were, in very different ways, disciples of the Polish director Jerzy Grotowski. Barba worked with him closely in the early 1960s; Brook, in his preface to Grotowski's magnum opus *Towards a Poor Theatre*, says he is 'unique' and elsewhere calls him a 'visionary'.[51] There are strong traces of Grotowski's early visions in the later creative orientations of his two admirers. Consider the quasi-Darwinian pronouncement about energy in the master's 'Statement of Principles':

Why do we sacrifice so much energy to our art? ... to fill the emptiness in us: to fulfil ourselves. Art is neither a state of the soul (in the sense of some extraordinary, unpredictable moment of inspiration) nor a state of man (in the sense of a profession or a social function). Art is a ripening, an evolution, an uplifting which enables us to emerge from darkness into a blaze of light.[52]

The modernist 'enlightenment' that informs this line of thinking about energy in performance illuminates the great humanist projects of Brook's CICT (Centre International de Créations Théâtrales) in its search for 'one truth' and Barba's ISTA (International School of Theatre Anthropology) in

[49] Ibid. [50] Ibid. [51] Grotowski, *Poor Theatre*, p. 13; Brook, *Empty Space*, p. 53.
[52] Grotowski, *Poor Theatre*, p. 256.

its dedication to discovering the performer's absolute 'presence'.[53] But the critical mass for a convincing ecological account of energy in performance has not materialised from these and similar sources, partly because their principles ran into widespread questioning by poststructuralist, postcolonialist and postmodernist theoreticians, not to mention the artists whom they celebrate. 'Truth' has been deeply troubled and 'presence' profoundly problematised as components of an essentialist subjectivity implicated in oppression by analysts of culture and performance such as Judith Butler, Herbert Blau, Philip Auslander, Josette Féral and many more.[54] In this theoretical turn (as outlined in the discussion of spectacle in chapter 7) performing becomes a deconstructive play between presence and absence and multiple truths, and energy – that most fugitive of performative tropes – shimmers into an especially elusive but powerful indeterminacy. Free radicalism with a vengeance, perhaps?

Grotowski's 'Poor Theatre' period has been similarly interrogated, but his subsequent explorations of 'paratheatre' – performance with no spectators, only participants, often in 'natural' environments, never in theatres – is hotly contested still. Philip Auslander, for example, argues it 'was based on disputable psychological and semiological assumptions' while Theresa May, who took part in Grotowski's later projects, insists that they reconstructed 'participants much in the same way as deep ecology begs for reconstituting human beings as members of ecological communities'.[55] This radical reduction of 'distance' between performer and spectator appears crucial to a late-twentieth century 'postdramatic theatre' where, according to Hans-Thies Lehmann, a '*centripetal* dynamic develops, in which theatre becomes a moment of *shared energies* instead of transmitted signs'.[56] How closely this 'theatre beyond drama' may align with postmodernist preoccupations perhaps can be best judged in the light of Jean-François Lyotard's idea of 'energetic theatre', whose 'business . . . is neither to suggest such and such means such and such, nor to say it, as Brecht wanted. [But] to produce the greatest intensity (by excess

[53] Hunt and Reeves, *Peter Brook*, p. 4; Barba and Savarese, *Dictionary of Theatre Anthropology*, p. 5.
[54] Michael Kirby, 'On Acting and Not-Acting,' in Zarrilli, *Acting (Re)Considered*, pp. 43–58; Judith Butler, *Bodies that Matter: On the Discursive Limits of 'Sex'* (London: Routledge, 1996); Philip Auslander, *Liveness: Performance in a Mediatised Culture* (London: Routledge, 1999).
[55] Auslander, *From Acting to Performance*, p. 27; Theresa J. May, 'Re-Membering the Mountain', in *Performing Nature: Explorations in Ecology and the Arts*, ed. Gabriella Giannachi and Nigel Stewart (Bern: Peter Lang, 2005), p. 357.
[56] Hans-Thies Lehmann, *Postdramatic Theatre*, trans. Karen Jürs-Munby (London: Routledge, 2006), p. 150, his emphasis.

or by lack of energy) of what is there, without intention'.[57] So energy, not signs. And not Brecht, but Artaud. Hence both postmodern and post-dramatic theatre celebrates the great, paradoxical magician of the delib-erately unintelligible, who probably had himself in mind among the artists he famously pictured as 'like victims burnt at the stake, signalling through the flames'.[58] Not so free radicals, then. Yet certainly there is 'energy out of place' in Artaud's frighteningly memorable image. But is it ecologically responsible or irresponsible energy? And am I the first to wonder, somewhat ridiculously, if this figure draws attention to itself at the price of the conflagration's environmental effects, the impact on the place of its enactment?

FROM THEATRE INSTITUTION TO PERFORMANCE ENVIRONMENT

So to bring my experiment to a close let us pull focus on the burning performer and take in the broader perspective of their placing in the world. In this respect there was a universe of difference, but also some profound continuities, between Edmund Kean in the early-nineteenth century and the performers in postdramatic theatre at the end of the twentieth. I will mark the differences first. Kean no doubt produced the extraordinary intensities of energy out of place that identifies the free radical, the controlled spectacle of his style igniting much more beyond his spectators' palpitating hearts.[59] In an age when theatres quite often literally lit up the skies of London as they blazed away, Joseph Donohue's comment on the acting of the period as 'ultimately touching on the forces that unite the theatre with surrounding life' has much more than a ring of truth about it.[60] When theatres are embedded in the social like free radicals in combustible materials, the energy of actors, even if just by excessive repute, may infuse the environment of many more than those who attended their place of work.

Towards the mid-twentieth century Laurence Olivier possibly achieved a similar result, albeit aided and abetted by film stardom. But as the theatre in most overdeveloping countries inexorably slipped down the league table

[57] Jean-François Lyotard, 'The Tooth, the Palm', trans. Anne Knap and Michel Benamou *SubStance* 5: 15 (1976), 110; also in Auslander, *Performance: Critical Concepts*, vol. II (London: Routledge, 2003).
[58] Antonin Artaud, *The Theatre and Its Double*, trans. Mary Caroline Richards (New York: Grove Press, 1958), p. 13.
[59] Roach, *Player's Passion*, p. 168.
[60] Joseph Donohue, *Theatre in the Age of Kean* (Oxford: Basil Blackwell, 1975), p. 83.

of popular pastimes – or, what is much the same thing, rose to become mainly a coterie concern, then a segmented cultural marketplace as described in chapter 5 – the forces connecting its live events to surrounding life were drastically attenuated, dampened down.[61] The most common antidote to this pathology for major theatres as the third millennium neared – embrace the progress of mediatised spectacle to secure a place in the new world disorder – proved to be as much a curse as a cure. The institutions survived, even sometimes thrived, but often like coral with the life gradually draining out of them, or like a capped volcano with a super-heated self-consuming core. Thus mainstream theatre 'culture' almost everywhere tended to reproduce the modernist pathology of progress that promised an end to 'nature', even as it protested that encroaching demise or celebrated a fantasy survival beyond it.[62] The commodification of performance in late-twentieth century theatre was bound to produce an ecology that was especially hard to sustain.[63] That environment automatically cast free radicals as a negative type, ironically caught in the theatrical equivalent to Emerson's law of reflexivity denied: the field cannot well be seen from within the field.

However, the spirit of Kean was not entirely dead. Even as free radicalism was subject to subversion in most theatre buildings, other aesthetics closer to the principles of Lyotard's energetic theatre were evolving in experimental performance. But this newly radical approach to performing – clearly informing some live art, site-specific theatre, and digital and community-based performance, say – has yet to generate a theoretical response founded fully on ecological principles, though in the early-twenty-first century there are thankfully growing signs of its emergence, as we saw in chapter 1 and will see more fully in the last one that comes next.[64] This yet again raises the question of how best to approach analysis of the companies and groups developing the aesthetics of energetics. So in the final section of this chapter I shall extend my thought experiment by briefly considering two projects, staged at opposite ends of the Earth, which quite deliberately worked to create 'energy out of place' through

[61] Baz Kershaw, 'Framing the Audience for Theatre', in *The Authority of the Consumer*, ed. Russell Keat, Nigel Whiteley and Nicholas Abercrombie (London: Routledge, 1994).

[62] For stimulating analyses of this syndrome, see: Una Chaudhuri, 'Animal Geographies', in Giannachi and Stewart, *Performing Nature*, (2005); Maurya Wickstrom, 'Commodities, Mimesis, and *The Lion King*: Retail Theatre for the 1990s', *Theatre Journal* 51: 3 (October 1999) and *Performing Consumers: Global Capital and its Theatrical Seductions* (London: Routledge, 2006).

[63] Baz Kershaw, *The Radical in Performance: Between Brecht and Baudrillard* (London: Routledge, 1999), chapter 1.

[64] For interesting discussions, see: *Frakcija: Performing Arts Magazine – Energy* 19 (March 2001).

performance ecologies evolved well beyond the bounds of the historical theatre estate.

The choreographer and dancer Tess de Quincey's bodyweather project, called the Triple Alice Labs, was conducted in the central Australian desert as the third millennium turned. At a much cooler spot (climatically speaking) in the Earth's northern hemisphere the various projects of the UK multidisciplinary eco-activist company PLATFORM mostly took place in their base-city, London. Other starkly obvious contrasts between them should spark with the two short thought experiments that opened this chapter. Triple Alice fundamentally drew on the performer's excessive energies in an environment that was light years away from the black holes of the twenty-first century commodified theatre estate, while PLATFORM regularly aimed to plug into the negative energies of multinational capitalist organisations at the very heart of their operations. Yet both, I think, deployed the energetics of out-of-place performance to turn the negative impact of free radicalism to profoundly positive ecological effects.

PLATFORM was founded in 1984 as an interdisciplinary group dedicated to the transformative power of art in radical campaigns 'to promote an alternative future'. Since then it has regularly brought together 'environmentalists, artists, human rights campaigners, educationalists and community activists ... driven by the need for social and ecological justice'.[65] The ambition of this agenda has produced unpredictable but extraordinary creative projects that characteristically are hard to classify. I will very briefly focus on just two examples to tease out the paradoxical impact of the group's behaviour as a free radical.

The 1992 *Still Waters* proposed 'the recovery of the buried rivers of London'[66] and included an action in which two strange figures followed the course of the Walbrook tributary that runs into the River Thames from the north:

One wears a shroud made from the pages of the London Business telephone directory. The other carries two flasks of water, one of distilled and one of undistilled drain water. At buildings blocking the course of the river its width is

[65] PLATFORM, 'Celebrating 21 Years of Innovation, Inspiration and Impact'. Anniversary pamphlet. Website – www.platformlondon.org (12.10.2006).
[66] PLATFORM information leaflet.

marked on the pavement with chocolate money and distilled water is spat at the obstructing wall. This is repeated at nine different sites, including the Bank of England. At the River Thames the shroud is removed and, after sounding the storm drain lid (a large metal hinged structure) the shroud is buried under stones at the mouth of the storm drain sluice.[67]

The performance-arty sheen of this poignantly whimsical event was coupled into a network of other creative initiatives, including 'the Delta project which led to the installation of a micro-hydro turbine in London's River Wandle, and ... the creation of the largest urban renewable energy scheme in the UK – RENUE – which ... received a £1 million grant from the Millennium Commission'.[68] In this performance ecology a multiplicity of activist forms aims to evolve a new 'ethico-aesthetic paradigm'. This wants nothing less than a revitalisation of corporeal 'life on the planet [through] incorporeal species such as ... the arts' to produce both metaphorical and actual transformative energy out of place.[69]

The 1999 *Killing us Softly* also became part of a network of projects that focused on 'the culture and impact of Transnational Corporations and their dependency on oil'. It was a lecture–performance, an extraordinary one-person confessional event that explored parallels ' ... between historical examples of genocidal psychology and contemporary corporate behaviour'.[70] The participant–audience members were isolated from each other, sitting in small cubicles that faced performer James Marriott's desk, from where he tells searing, incriminating tales about human dependency on oil, including his own family history transformed 'into a true saga of the reckless western guzzling of fossil fuels [and] his [rich] ancestors' descent into carbon addiction'.[71] The links between personal history and everyday 'normal' corporate activities that turn executives into neo-Nazi desk-murderers implicate the audience both as 'priests' in their confessional boxes and as 'office workers' at their carrels, trapped through a nightmare complicity in a 'business religion' overseen by Gog and Magog. The horrific vacuity of the deskwork genocide under confession implies that the audience ironically might be empowered through such participant–witnessing, to become positive free radicals that reflexively challenge the anti-ecologism of capitalist belief modelled by the show's scenography. In their individual cubicles they sit in for people disastrously compartmentalised, just like the minds of the 'desk killers' of Shell Oil that arguably

[67] PLATFORM, 'Neither Time Nor Material', leaflet.
[68] Ibid. [69] Guatarri, *Chaosmosis*, p. 120. [70] PLATFORM information leaflet.
[71] James Meek, 'How One Family Became Addicted to Carbon', *Guardian* (15 Nov. 2000), p. 18.

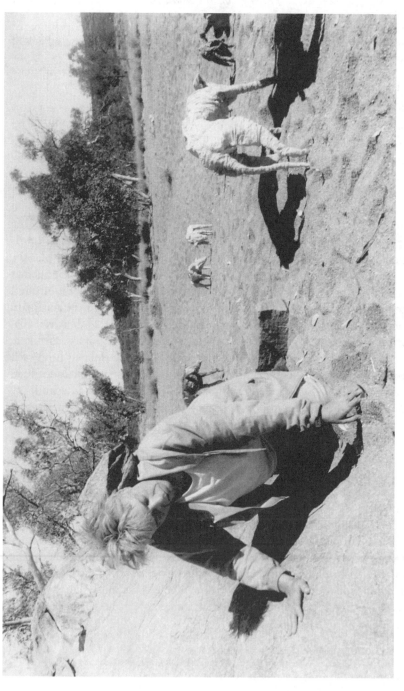

Figure 13 Triple Alice Laboratory 1 – 1999. Bodyweather exploration in the high heat of the dry creekbed Iwupataka (Jay Creek) in Kupula Urbala, near Hamilton Downs, Alice Springs. Dancer Tess de Quincey, dogs from 'Pack' by Pamela Lofts. Photograph: Juno Gemes.

instigated the execution of Ken Sara-Wiwa and many thousands more.[72] This performance ecology profoundly engages the vectors of global capital – such as, to take a small example, the export-credit system – in a struggle to produce environmentally sound strikes at the heart of economic darkness.

The sun glared pitilessly on the Triple Alice Labs in the desert near Alice Springs between 1999 and 2001. Associated theoretical work has continued through to 2006 in the cooler climate of the University of Sydney. The practice of the project involved a large group of varying participants, mostly dancers and physical-theatre practitioners, who lived and worked in the desert for two to three weeks in each year. They followed a bodyweather movement training[73] and application regime of Grotowskian rigour that, in the words of an observer, aimed to discover 'a poetics which responds to locale in Australia ... a category of the ontologically unspoken ... a living "topo-analysis"'.[74] The 'performers' laboratory' was complemented by a 'writers' laboratory' that documented the project, and by groups of local artists – painters, poets and so on – working alongside the performers. Unlike PLATFORM's work, the Labs did not have a highly explicit eco-logical imperative, focusing more on body–land and environmentally related questions, such as 'Can we perform atmospherics?'[75]

Such curious questions may open the Labs to accusations of being just another example of self-indulgent performance art, no more relevant to the political condition of Australian society than, say, unwitnessed lightning in the wilderness. But just as the interaction of Kean's theatre and its wider environment might be seen as charged with extraordinarily significance for evolutionary thinking, so perhaps can the Lab be articulated to its context through the vectors of thought-experimental performance ecology. As with the arc lamp and lightning, there were two main poles in play at the Labs, vastly charged with negative and positive energy through two hundred years of tragic history following the first European settlement in 1788, the year before Kean's birth. Even in the earliest preparatory experiments that led to the later Labs, local indigenous Aboriginal people were involved, automatically bringing into play the fabulously eco-sensitive qualities of

[72] An environmental affect probably impossible to achieve in the conventional theatre auditorium assumed by Freddie Rokem's argument.

[73] Website – de Quincey (Bodyweather): www.bodyweather.net (06.10.2006).

[74] Martin Harrison quoted in: Tess de Quincey, 'Sites of Multiplicity and Permeation', in *Théâtre: Espace sonore, espace visuel*, ed. Christine Hamon and Anne Surger (Presses Universitaires de Lyon, 2003), p. 240; also at www.bodyweather.net/mainframe1.html (22.06.2007).

[75] Ibid., p. 243.

their forebears' 'prehistoric' culture in those desert lands. In this place water was always an extremely scarce and precious resource, so naturally in the Aboriginal dreamtime there were spirit ancestors responsible for rain and for lightning, the latter named Mamaragan or Namarrkun. By the late-twentieth century these were in revival as Aboriginals everywhere, including the central desert nations, sought restitution of their rights.[76]

None of this seems to have been *explicitly* evoked by de Quincey's Labs.[77] But it did not need to be, as its relevance to twenty-first century Australian performance ecologies was bound to resonate through the project, perhaps more so because it remained implicit. According to Gay McAuley, who was a chief participant, the Labs' location ensured they tapped

into powerful forces that raise questions about Australian attitudes to their national identity: if the centre of the continent symbolises the nation's innermost self ... then what can be said when this innermost self has been seen by most of its inhabitants as a void, an absence, an emptiness? Even more troubling is the relationship between the original inhabitants and the incoming waves of col-onisers, settlers, and immigrants, still unresolved after two hundred years of cohabitation. [So for] European Australians the sense of place must always raise questions about legitimacy and dispossession, and will doubtless do so until effective reconciliation is achieved with the Aboriginal people of Australia.[78]

Of course, successful reconciliation could not avoid respect for Aboriginal prehistory, a process that the twenty-first-century indigenous peoples call 'waking up to the dreamtime'. This is a finding of 'roots' that had a profound significance for survival and sustainability in the central desert of the continent, as rare and as precious in the age of ecology as lightning and rain over Uluru. So did the Triple Alice Labs manage anything resembling Edmund Kean's effects on early Victorian culture in their deeply arid environment? In the very earliest preparatory visit, in 1991–2, the performers camped alongside an Aboriginal community who were claiming heritage to the dried-out Lake Mungo, a site of great ritual sig-nificance. A comment from this group suggests that they were participant–witnesses to something extraordinary in de Quincey's bodyweather

[76] Richard G. Kimber, 'Australian Aboriginals' Perceptions of Their Desert Homelands (Parts 1 and 2)', *Aridlands Newsletter* 50 (November/December 2001); Website – http//:cals.arizona.edu/OALS/ALN/aln50/kimberpart1.html (06.10.2006); Charles P. Mountford, 'The Lightning Man in Australian Mythology', *Man* 55 (Sept. 1955).

[77] Gay McAuley (ed.), *About Performance: 5 – Bodyweather in Central Australia* (University of Sydney: Department of Performance Studies, 2003); Website – www.arts.usyd.edu.au/departs/perform/docs/AP5intro_1.pdf.

[78] Gay McAuley 'Bodyweather in the Central Desert of Australia: towards an Ecology of Performance', available at: www.bodyweather.net/gm_firt_2000.pdf (02.07.2007).

dancing: 'you's waking up the land'.[79] So maybe, just maybe, the energetics of the Lab released at least a few positive free radicals, some lightning in the wilderness that illuminated pathologies of hope for a profound reconciliation?

I close this chapter with these two examples because their creative ambitions aimed for an ecologically sound emphasis on the environment *as much as* on the human performer. This simple move promises to evade performance ecologies that mistakenly take the human as a primary pole of ecological health, but it still risks displacement of biocentric sensibilities at the outset. Yet humans cannot help but work through the human, as it were, even when the quest is to locate the non-human in the human through the environment, as discussed in chapter 7. But how might this conundrum be conceived as usefully crucial to the energetics of performance ecology generally? The performer–theorist Phillip Zarrilli provides a clue to an answer when he perceptively writes: 'For the actor, whatever the actions to be performed, these actions are the "material" conditions of his or her work.'[80] To create a general principle of performance ecology this can be rephrased in accord with the definition of energy in physics with which this chapter began, the capacity of a physical system to perform work. Hence, *what the flow of energy affords to these actions of performance-in-environment produces the material conditions of performing.* This expresses an attempt to grasp the ungraspable, to sense out the profound nature of vitality in performance.

The manifold interactions of energy exchange through performing are always a process of becoming in the biosphere, like the lightning that turns free radicals positive to energise the Earth, without which there would be no paradoxical primate. So in trying to fix on the chief qualities of energy in performance in the twenty-first century, in order to figure its transformative values in performance ecology, we could do worse than ponder Jonathan Swift's elegant paradox as if it referenced the lightning and free radicals of theatre: There is nothing in the world constant but inconstancy.

[79] De Quincey, 'Sites of Multiplicity', p. 240; see also Gay McAuley, 'Site-Specific Performance: Place, Memory and the Creative Agency of the Spectator', *Arts: The Journal of the Sydney University Arts Association* 27 (2005).

[80] Zarrilli, *Acting (Re)Considered*, p. 21.

Performance and biospheres: on hermetic theatre

INTRODUCTION

I take it as axiomatic that any effort to write about theatre and per-
formance ecology will be enmeshed, hopefully with delight, in paradox.
To quote David Harvey's insight about ecological reflexivity again, this is
because 'if all socio-political projects are ecological projects, then some
conception of "nature" and "environment" is omnipresent in everything
we do'.[1] So writing about 'performance and nature', say, will be like
trying to trace the outline of the writing hand with the pen used in the
writing. We might draw an important lesson about performance and
theatre ecology from this. Namely, whatever may *escape* specific attempts
to 'capture' the complexities of an ecological account of theatre and
performance is precisely what needs to be attended to. Hence it becomes
crucial to be alert to the fact that the *performativity* of writing about
theatre and performance ecology *could* be reproducing the very pathology
it wants to question: the exploitation and degradation of the Earth's
environment by humankind.[2] Each page I write potentially contributes to
the advancing calamity for humanity. In this chapter's thought experi-
ment, my trope to keep this problem of method in a reflexive focus is
Biosphere II.

BIOSPHERE II

Biosphere II is a gigantic glass 'ark' the size of a huge aircraft hangar
situated in the Southern Arizona desert. Inside at one end is a rainforest,

[1] David Harvey, *Justice, Nature and the Geography of Difference* (Oxford: Blackwell, 1996), p. 174.
[2] Because of the unavoidable 'paradox about "performativity" ... its necessary "aberrant" relation to
its own reference'. Andrew Parker and Eve Kosofsky Sedgwick (eds.), *Performativity and
Performance* (London: Routledge, 1995), pp. 2–3.

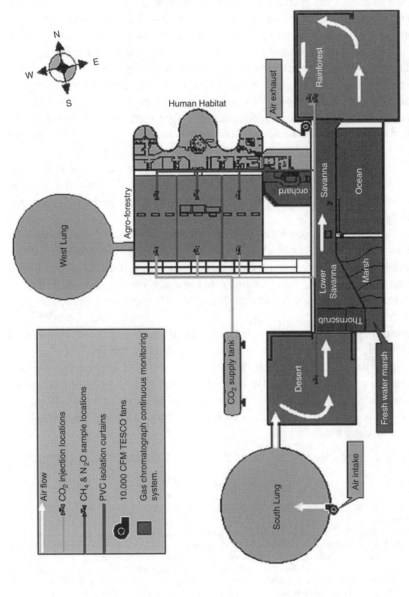

Figure 14 Biosphere II, Arizona, USA – c. 1991. Plan view of the giant ark with ecosystems designed to a human scale, plus 'lungs' to absorb expanding air as the desert sun heats up the artificial atmosphere. Compare aerial view on p. 8.

at the other end is a desert, and in between there is a coral reef and marshland. These areas aim to replicate some of the main types of terrain that make up the global ecosystem. Biosphere II was designed to be self-sustaining, so it can be sealed off from Biosphere I, the Earth itself.[3] The airtight structure was completed in 1991, and two survival 'missions' with human subjects were conducted in 1991–2 and (for six months) in 1994. However, its environment proved unstable and, though it continued as a research and educational establishment into the twenty-first century, in 2006 plans were in place to redevelop it as centrepiece of a 'planned community'. But back in September 1991 eight men and women volunteers had walked through its airlocks to begin a two-year ecological experiment in biome survival that potentially had profound ramifications for the future of life on the planet. Some accounts claim that these eight were formerly a theatre group. Maybe only actors would have the courage to risk such total immersion in the unreal – or, perhaps better, the hyper-real.

Reviews of Biosphere II constitute a decidedly mixed press. Its greatest fans claim, for example, that: 'living in an artificial biosphere is a noble experiment ... Great things will be learned inside Bio2 about our Earth, ourselves, and the uncountable other species we depend on.'[4] But its detractors are equally confident: 'Biosphere II is a monument to scientific hubris ... a confused tangle of duplicities.'[5] Such riven reactions are entirely predictable, given that no less an authority than Baudrillard claimed it as 'the first zoo to include the human species'.[6] So how else might we best picture Biosphere II: a true promise of global ecological sanity; a monument to the hopelessness of the contemporary human condition; a fabulous sideshow for the twenty-first century? Were the Biospherians saviours, sophists or ciphers of a world that may be already lost to the human?

[3] Websites – Biosphere II: www.biospherics.org/ (25.01.2007); www.bio2.com (25.01.2007).

[4] Kevin Kelly, 'Biosphere II: an autonomous world', *Whole Earth* 77 (1990), 105.

[5] Timothy W. Luke, 'Reproducing Planet Earth: the Hubris of Biosphere 2', *Ecologist* 25: 4 (1995), 157, 162.

[6] Baudrillard wrote of Biosphere II: 'Hallucination très américaine que cette océan, cette savane, cette forêt vierge reconstitués en miniature, vitrifiés et congelés sous leur bulle expérimentale. A l'image exacte des attractions de Disneyland, Biosphère II n'est pas une expérience, c'est une attraction expérimentale' [A truly American hallucination, with an ocean, savannah and virgin forest reconsituted in miniature, glazed and congealed in an experimental bubble. A mirror image of Disneyland, Biosphere II is not an experience but an experimental sideshow], my translation. Jean Baudrillard, 'La Biosphère II', in *Des mondes inventés: les parcs à thème*, ed. Anne-Marie Eyssartel and Benard Rochette (Paris: Les Editions de la Villete, 1992), p. 127.

Baudrillard was wrong to claim that Biosphere II was the *first* human zoo, though it may be the largest ever built. The history of ethnographic exhibition of human beings goes back at least five hundred years. And if we include that other kind of zoo for the display of humanity – the theatre – then the practice is a good deal older. Theatre and human ethnographic displays are alike in that they have always been ambivalent cultural institutions: as the tired old binary arguments have it, are they primarily about entertainment or education, forgetfulness or knowledge? But Baudrillard was also right in putting his sharp analytical finger on something yet more significant than this type of ambivalence in zoos and theatres, for they rely on a crucial separation between observed and observer, they conjure up an act of 'looking-on' which tends to turn 'nature' – plant, animal, human – into spectacle and then, too often, commodity. Paradoxically, the 'zoo' of Biosphere II transforms ecology itself into theatre. Or conversely, it theatricalises Biosphere I through its production of the performance of ecology.

It is worth briefly unravelling these powers of Biosphere II for their relevance to my arguments about the relationships between theatre and performance ecologies. Its power to transform ecology into theatre derives from how the glass building and its stated purposes – to reproduce natural biomes in a man-made environment, to experiment with the chances of human survival and so on – produce *ontological* ambivalences. For example, the plants and animals that lived in Biosphere II were 'real' in some of the ways that examples of the same species in oceans, savannahs and rainforest outside it are real. They have the same biological structures, can survive only in particular environmental niches and so on. But the different *collections* of animals and plants that make up its six biomes are not ecologically 'real' in these senses, they are a simulacrum created by humans. Their spatial relationships, for instance, may be modelled on examples outside Biosphere II, but those 'original models' had been created by complex environmental processes that were sub-tracted in (or substituted by) the process of making the version inside the glass ark.

Hence the animals and plants in Biosphere II are both 'real and not-real' in ways homologous to the objects and people on the stages of theatres during performance. It is this real/not-real ambivalence that makes the ecology created inside the glass building different from the ecology outside on which it is modelled. It is that clear ambivalence which creates a significantly sharp distinction between these two types of ecology. Of course related types of distinction are everywhere in the

performative society with its dramatising and theatricalising tendencies, from domestic aquariums to safari parks, window boxes to botanical gardens, show houses to heritage sites, street fashions to aviation displays . . . take your pick. But this astonishing spectacle is discernible in all its fabulous variety largely because of the pretty clear-cut cases provided by theatres and other sites of deliberate ontological doubling. Theatre and performance may be like the two sides of a spinning coin, but paradoxically they are also distinct enough to be worlds apart. This difference is the basis of my treatment of theatre ecology as a specially marked sub-category of performance ecology, which, as this chapter's opening reiterated, has a much more diverse and pervasive presence in the ecosystems of Earth.

Hence in this final chapter I return focus to the ecological ramifications of theatre, mainly because it is a relatively stable entity in such complicated territory, particularly when it refers to theatre buildings (specially built or converted) and the institutional structures that enable performances to be staged in them. I will come back to the nature of performance ecology later, because my initial purpose is to test in what ways, if any, the idea of the theatricalised biosphere – 'nature' as reproduced by or turned into theatre – might have ecological value. I shall more fully develop an argument put forward in earlier chapters: namely, that, especially since the nineteenth century, theatre has been like Biosphere II because it was increasingly sealed off from the environments it aimed to 'model'. Thus an 'ecology of theatre' may be limited in what it can tell us about the Earth's environment and, perhaps especially, about the ecological crises *of* that environment. It could be, even, that the theatre's main usefulness is to indicate the kinds of cultural construct to avoid in a search for ecological sanity. To investigate this proposition I next draw a few further distinctions between theatre ecology and performance ecology. These distinctions are informed by debates in ecological anthropology about the role of culture in shaping perception in the relationships between humans and their environment.

THEATRE AND NATURE

Tim Ingold has a witty take on 'culture' that is especially relevant, I think, to all the notions of theatre ecology that I have explored in earlier chapters. He argues that, as reflexive animals, humans 'can describe their environment and report on their actions within it, as though they had themselves stepped outside it, posing as mere spectators. But in so doing the

environment reverts to nature.'[7] In his view 'nature' is a cultural construct that separates humans from their environment, because 'Systems of cultural classification are not … a precondition for practical action in the world, but are invoked to recover the meaning that is lost when that action turns reflexively inwards on the self.'[8] From this perspective, Western theatre *qua* theatre may be seen to serve a *double* function in the 'recovery of meaning' about a 'nature' that separates humans from their environment.

Firstly, as a place for the production of self-reflexive culture through performance in the staging of plays, say, the theatre assumes or proposes various versions of 'nature' through its mimetic codes. Hence, for example, 'nature' may be transmuted into 'landscape' or 'pastoral' or 'wasteland'. In this process the theatre experience becomes at least twice removed, as it were, from action in the wider environment: (a) by the institution of theatre itself, and (b) by making metaphors of its objects of attention. The usual arguments mounted in defence of this abstraction in the dominant forms of Western theatre hinge on the idea that such theatrical 'distancing' will place audiences in a better position to under-stand or to 'grasp' the world.[9] However, these traditional arguments almost invariably assume that the role of spectatorship (or audience membership) is relatively unproblematic *in itself*; the enhanced inter-pretive power of the spectator in reflecting on the world is usually taken as justification enough for the characteristics of the role. Where there have been influential objections to this view, say in Bertolt Brecht's Epic Theatre (especially the *Lehrstücke*) or in Augusto Boal's theatre of the oppressed, they have been framed primarily in terms of the spectators' scope for action *within the theatrical event*. That scope is usually defined with reference to various kinds of 'audience participation' – in Brecht's case through clarified powers of interpretation (*Verfremdungseffekt*), in Boal's case through invi-tations to intervene in the onstage action (spect-actor) – so that any questioning of the position or role of audience/spectator *qua* audience/spectator tends to stop, as it were, at the exit of stage or foyer door. As a result, theatrical efficacy tends to be seen as subsequent to the experience of theatre, a causal effect of theatre-as-a-whole. In these systems, in Tim Ingold's terms, theatre is construed as a 'precondition for practical action'.[10]

[7] Tim Ingold, 'Culture and the Perception of the Environment', in *Bush Base, Forest Farm: Culture, Environment and Development*, ed. E. Croll and D. Parkin (London: Routledge, 1992), p. 52.

[8] Ibid., p. 53.

[9] Daphna Ben Chaim, *Distance in the Theatre: The Aesthetics of Audience Response* (Ann Arbor: MIT Press, 1984).

[10] Ingold, 'Culture', p. 53.

But, secondly, this approach elides the point at which the function of theatre in creating 'nature' comes most forcefully into play. For the primary productive purpose of theatre may be seen *not* as the staging of performances that represent 'landscape' or 'wilderness' or other constructs of 'nature', say, but to be the *creation of spectatorship*. In other words, the dominant traditions of theatre (especially in the West) have been a pretext for the making of spectators (or audiences). The important point here is that, as Ingold argues, this may be *the* cultural process most necessary to the production of a 'nature' (or other cultural classifications) that separates 'us' from 'our' environment. From this perspective, perhaps theatre – and its performances – may be seen as the social institution that has most quintessentially modelled the abstraction of humans in the 'natural world'. Hence, to be sceptical about theatre's purposes, even to be 'anti-theatre', may be seen as a strong vote for collapsing the modernist culture–nature binary that has been the principle misconception causing humans to destroy the Earth's environment.

Related debates can be found in ritual studies, which serve to indicate a much wider ecological basis for any anti-theatrical 'prejudice' in the twenty-first century. As Ronald Grimes notes, in 'the conventional account, ritual is cultural rather than natural'.[11] Unlike eating, sleeping and similar behaviours, even copulating, it is not a genetically or biologically driven activity, something the human animal cannot help doing. Like theatre, ritual is optional, which is to say that it is a cultural form that produces spectatorship. However, Grimes aligns with many ecologists in arguing that the culture–nature distinction is not 'an impassable divide'. He moves into radical theoretical territory, though, when he suggests that:

> ritualisation is hard-wired into the structure of the brain and nervous system, a function of primate biological hardware rather than of merely human, cultural software. Even if one tries to escape explicit rites, tacit ritualisation nevertheless emerges unbidden.[12]

With this, we are back in the land of the paradoxical primate. Because the recognition in the performative act of writing such a distinction, as between 'hardware' and 'software', calls up the reflexivity of 'self-consciousness' and/or, in the terms of my analysis, 'spectatorship'. But it

[11] Ronald J. Grimes, 'Ritual Theory and the Environment', in *Nature Performed: Environment, Culture and Performance*, ed. Bronislaw Szerszynski, Wallace Heim and Claire Waterton (Oxford: Blackwell, 2003), p. 35.
[12] Ibid., p. 36.

is crucial to recognise that does not, as it were, collapse the distinction between theatre and ritual that Grimes's argument may seem to imply. Theatre may be thought of as a ritual, as might spectator sports, say, but these are rituals in which spectatorship is *not* optional. However absorbing the performance for the spectator, systemically she/he is still a spectator. Whereas the kind of 'genetic ritual' that Grimes is rooting for in his discussion of 'ritualisation' creates participants for whom spectatorship may *become* an option. Paradoxically, absorption does not prevent that option. This raises complex issues about the 'nature' of human perception, reception and reflexivity. These centre on the human-animal's powers to 'decide' *whether or not* to be reflexive in response to what any particular environment affords. Enter the paradoxical primate, for whom, as Samuel Butler said, there is nothing so unthinkable as thought, unless it be the entire absence of thought.

The analysis of my thought experiment with Biosphere II is my main method in this chapter for keeping these considerations in perspective, as we explore whether or how theatre and performance might constitute the spectator, not so much socially or culturally, but environmentally and ecologically. Was twentieth-century Western theatre, for example, fundamentally like Biosphere II, promising useful knowledge about 'nature' by positioning the human – whether as Biospherian inhabitant or visiting spectator – as acting *on* the environment? Or might theatre, after all, have had the potential to be more in accord with Tim Ingold's version of a world in which the human animal can become somehow beyond 'nature', by acting *in* the environment of Biosphere I?

I shall approach these questions first through an analysis of writings on contemporary theatre by Bonnie Marranca, Elinor Fuchs and Una Chaudhuri – three American scholars whose research I greatly admire. All three have made major contributions to theatre analysis in ways which give due acknowledgement to the complexities of practice, so I offer my comments in a spirit of especially positive applause for their groundbreaking works. I shall look at the tropes they employ in their characterisations of the 'ecology of theatre', especially focusing on how they inflect the theatre's production of spectators. Following that I shall briefly comment on the development of Western theatre in the nineteenth and twentieth centuries to demonstrate how the object of their attentions may need to be reinvented in the twenty-first century in order to become ecologically effective. Finally, I shall return to the possibilities of performance ecology in hope of striking an optimistic note.

ECOLOGIES OF THEATRE

In *Ecologies of Theater* Bonnie Marranca argues for:

a linkage of ecology and aesthetics that in the search for newer and deeper kinds of knowledge [will] outline the biocentric world view ... a nonhierarchical embrace of the multiplicity of species and languages in a work, that can address the issue of rights in non-sentient being.[13]

She names Peter Brook, the Living Theatre, Grotowski's Polish Laboratory Theatre, Théâtre du Soleil and others as especially relevant to this theme, because they concentrate so fully on space in their work, and because 'surely any elucidation of a theatre ecology begins in the understanding of performance space'.[14] This follows because what Marranca is drawn to most in the analysis of theatre are 'concepts of field, space, landscape'. She seems most attached, though, to the last of these, particularly in her discussions of Gertrude Stein: 'Elements in a landscape – people, objects, or nature – only become meaningful to one when they are looked on.'[15]

The historian Keith Thomas has shown how, particularly in eighteenth-century England, the growth in appreciation of wild natural scenes was possibly an anxious reaction to the massive increase in land brought under cultivation: the idealisation of 'landscape' as compensation for ecological damage.[16] In this move 'man' detaches himself from the environment to produce 'landscape' in ways similar to those outlined by Ingold in his discussion of the processes of observation and spectatorship. Ingold uses the example of a squirrel in its habitat to make a useful distinction between the objectification of an environment through observation and the use of an environment by an agent:

the environment of the squirrel might be described as including the tree in which it lives. But so long as the tree is regarded in 'squirrel neutral' terms as a ready-made object, built to independent specifications, it can only exist in an environment for an external observer. So also, it is only in the observer's environment that the squirrel exists as an object which, by virtue of its essential attributes, is 'fitted' to the tree. In short, the tree is not part of the environment *for* the squirrel, it is part of the environment *of* the squirrel *for* the detached observer.[17]

[13] Bonnie Marranca, *Ecologies of Theater: Essays at the Century Turning* (Baltimore: Johns Hopkins University Press, 1996), p. xvi.
[14] Ibid., p. xvii. [15] Ibid., p. 51.
[16] Keith Thomas, *Man and the Natural World: Changing Attitudes in England 1500–1800* (Harmondsworth: Penguin, 1984), pp. 263–9.
[17] Ingold, 'Culture', p. 41.

Spectatorship of a squirrel – or a character, or a subject – in a landscape in the theatre is inevitably caught up in this process of detaching the agent from its environment, and thus reduces the chances of insight into the environment *of* the agent and therefore of the agent itself in biocentric terms. Hence, for centuries 'landscape' has been a major trope contributing to the elevation of the human over the environment. Whether landscape is seen as a source of rejuvenating contemplation (a feast for the eyes of the Enlightenment) or of spiritual renewal (a succour for the soul of Romanticism) it is most usually at the service of 'man'. This is not to say that a study of the various uses to which 'landscape' has been put by theatre is a redundant exercise, as a collection of essays edited by Elinor Fuchs and Una Chaudhuri admirably shows.[18] But still – recalling that Biosphere II constructs its biomes as settings for visitors to gaze on – we should be wary of a theatre ecology and its performances that centres on landscape, even in Marranca's wonderfully subtle ecological ambition to shape a 'non-hierarchical embrace of the multiplicity of species'.

Elinor Fuchs's writing on ecological theatre proposes a more embedded take, so to speak, on the relationships between ecology and aesthetics. 'Pastoral' is her key term in this revision, because there has been:

in some of the more innovative contemporary theatre an extension of pastoral, or perhaps better said, a pastoral for the age of ecology ... [However] there is not yet an ecological movement in theater ... Rather I would say that the new pastoral in theater draws on a perceptual faculty not unlike that developed by ecology, a systems awareness that moves sharply away from the ethos of competitive individualism towards a vision of the whole, however defined in any given setting.[19]

'Systems awareness' and 'a vision of the whole' promisingly suggest some of the complexity of interpretation needed to create ecologies of theatre and performance, and the idea of 'pastoral' may indicate an improvement on 'landscape' as a useful analytical trope. What would then be at stake in that 'vision of the whole' is the 'nature' of the pastoral that is referenced, and the ways in which twenty-first-century theatre might engage with its interpretive traditions.

These traditions are by no means uncontested, of course, as can be discerned in the part that 'pastoral' has had in the evolution of ecological

[18] Elinor Fuchs and Una Chaudhuri (eds.), *Land/Scape/Theater* (Ann Arbor: University of Michigan Press, 2002).

[19] Elinor Fuchs, *The Death of Character: Perspectives on Theater After Modernism* (Bloomington and Indianapolis: University of Indiana Press, 1996), p. 107.

thinking and movements. David Pepper, for example, notes the 'arcadian' and 'imperialist' strands of eco-centrism stretching back at least to the eighteenth century, and shows how 'pastoral' was variously deployed in both. Briefly, the arcadian emphasis found in nineteenth-century English Romanticism had a strong elitist aspect, while the imperialist inflection can be found in appeals to the rural idyll in recruiting campaigns for both World Wars of the twentieth century.[20] In America pastoralism gathered different but cognate emphases, as Fuchs demonstrates when, in a later essay, she discusses the dangerous nostalgia for pastoral visions produced by the 'urban jungle' in Arthur Miller's *Death of a Salesman*.[21] This echoes much earlier European reactions against city life, which, as Keith Thomas explains, found counterpoint in the idealising nostalgic desire for the pastoral in the seventeenth and eighteen centuries.[22] Hence, pastoralism in twenty-first-century theatre may also be a part of a human pathology preventing the much-needed development of an ecological 'systems awareness'.

Despite this, 'pastoralism' may still be interpreted as an advance on 'landscape' in the ecology of theatre, for while 'landscape' tends to position the subject as looking *on* 'nature', 'pastoral' suggests a more direct engagement with notions of dwelling and place that have been important to ecological thought. This is because 'pastoralism' conventionally imagines the subject as being *in* 'nature', even as it is idealised, evoking a sense of *place* that is incorporative. In theatrical terms, it implies a step away from the darkened auditoria of the dominant traditions of Western theatre towards spaces that may transform the spectator into a participant. It also suggests an important critical inflection of Fuchs's claim that 'we are becoming ecologists of theater. No longer fascinated by single organisms in their habitat ... we pull back to scan ... the thing-held-full-in-view-the-whole-time.'[23] The shadow of the trope of 'landscape' hovers over her adoption of Thornton Wilder's phrase, the 'thing-held-full-in-view', but 'pastoral' provides, as it were, a zoom-in lens for its inspection. Perhaps the glass of Biosphere II produces something akin to this effect, allowing visitors a depth of focus into its seductive charms, especially as they glimpse the bionauts at work or play in its green shade.

[20] David Pepper, *Modern Environmentalism: An Introduction* (London: Routledge, 1996), pp. 217–26.
[21] Fuchs and Chaudhuri, *Land/Scape/Theater*, pp. 32–4.
[22] Thomas, *Man and the Natural World*, pp. 250–1. [23] Fuchs, *Death of Character*, p. 107.

THEATRE AND ECOLOGY

Among American scholars, Una Chaudhuri has made the most sustained address of the conundrums of ecology and theatre. Chaudhuri develops a sophisticated analysis of the place of 'nature' in Western theatre from the late-nineteenth century to the 1990s. She sees in theatrical naturalism a 'stubborn obstacle' to the development of an ecologically sound theatre. The obstacle is that naturalism portrays the environment as always 'in the service of a social drama' and this is achieved through the turning of nature into a metaphor, which itself represents 'a new relation of the human and the natural worlds, making the latter a privileged sign of the superiority of the former'.[24] She also argues that this problem has continued in the works of the twentieth-century avant-garde that Marranca and Fuchs celebrate, because the avant-garde tends to use ecology itself as a metaphor. In an earlier essay Chaudhuri had been adamant that: 'By making a space on its stage for ongoing acknowledgements of the rupture it participates in – the rupture between nature and culture, forests and books . . . – the theater can become the site of a much-needed ecological consciousness.'[25] For theatre to produce this consciousness it needs to make a 'turn towards the literal, a programmatic resistance to the use of nature as metaphor'.[26] But to claim this as a means to create an ecological theatre sounds rather odd, at least with regards to buildings designated as theatres, because such places are defined by their power to produce metaphors through the creation of spectators. Even as theatre refined its representations to the minimalism of a Beckett or the 'primitivism' of the body artists of live art, such as Franco B. or Ron Athey or Stelarc, the alchemy of metaphor may be seen as crucial to its promiscuous spawning of spectators.

Chaudhuri's appeal to the literal is not, however, the result of any lack of ecological insight, as she develops a highly reflexive critique of theatre's protocols. Rather, the problem is in the object of her attentions, the theatre itself and its production of spectators. It is through the latter that theatre contains the 'culture' (which includes 'nature') created by performance like a glass-walled zoo, hermetically sealing it off from ecological engagement of the most significant kinds. The 'zoo' is all the more

[24] Una Chaudhuri, *Staging Place: The Geography of Modern Drama* (Ann Arbor: University of Michigan Press, 1997), p. 77.
[25] Una Chaudhuri, '"There Must Be a Lot of Fish in That Lake": Toward an Ecological Theatre', *Theatre* 25: 1 (Spring, 1994), 28.
[26] Ibid., p. 29.

effective because its main component – the making of spectatorship – has been achieved, as it were, invisibly, as the attention of audiences, critics and historians has primarily focused upon the onstage action: only relatively recently have scholars begun seriously to address the 'nature' of audiences during the last two hundred years.[27] This disengagement on the part of both audiences and scholars was exacerbated in the latter part of the twentieth century by a pathology through which theatre became increasingly commodified as part of the so-called 'cultural industries' of the globalised economy.[28] And this commodification is just the latest stage in a long historical process that has tended to sever theatre from a responsive and responsible relation to the environment. Of course, Biosphere II may be seen as participating spectacularly in this pathology as a theatrical metaphor for human domination on the planet.

In *Staging Place* Chaudhuri provides a resonant historical perspective on my argument about Biosphere II, when she briefly explores the relevance of greenhouses in nineteenth-century Britain to the evolving interaction of the 'human' and 'natural' worlds:

[the] glass-houses that were built at great expense and to enormous public delight, constituted a kind of 'theatre of nature', where 'the scientific control of natural processes – the basis of the new industry – was realized with the use of glass, iron and steam in the cultivation of plants.' Partly expressions of the collective European anxiety about the colonial exploitation of the world, partly recognitions of industrialization's transformation of nature into a commodity, these 'museums' displayed the 'masterpieces of nature' to a delighted and increasingly class-diverse audience . . . Ancestors of the great World Fairs to come . . . as well as of the huge organised amusements of later mass entertainment . . . [29]

The colonising glasshouses of Crystal Palace, Kew Gardens and so on were part of the tradition of Victorian 'Great Exhibitions' in Britain. These included, for example, the Empire of India Exhibition of 1895, which in turn incorporated the performance of military spectacles and

[27] Nicholas Abercrombie and Brian Longhust, *Audiences* (Sage: London, 1998); Susan Bennett, *Theatre Audiences: A Theory of Production and Reception*, 2nd edn (London: Routledge, 1997); Herbert Blau, *The Audience* (Baltimore: Johns Hopkins University Press, 1990); Jim Davis and Victor Emanjelov, *Reflecting the Audience: London Theatre going 1840–1880* (University of Iowa Press, 2001); Baz Kershaw, 'Oh for Unruly Audiences! Or, Patterns of Participation in Twentieth-Century Theatre', *Modern Drama* 44: 2 (Summer, 2001).

[28] Baz Kershaw, *The Radical in Performance: Between Brecht and Baudrillard* (London: Routledge, 1999), pp. 49–52.

[29] Chaudhuri, *Staging Place*, p. 77; quotations from George Kohlmaier and Barna von Sartory, *Houses of Glass: A Nineteenth-Century Building Type* (Cambridge, Mass.: MIT Press, 1986).

'oriental' fantasies staged at the 6,000-seat Empress Theatre in Earl's Court.[30] Clearly there was a link between glasshouses, great exhibitions and the spread of spectacle within the picture frame of the proscenium arch in the many new theatres built in Victorian England, vastly stimulated by the technologies of gas lighting and railways.[31] Theatre historians have tended to stress the social and political significance of these shows (particularly focusing on issues of class, gender, colonialism and race), so that the growth in human domination of nature through the industrial revolution is rarely even a sub-theme in their histories.

Yet we might sense something of this repressed theme returning – in the long wake of Garrick and de Loutherbourg – in the taste for pastoral spectacle enacted, for instance, by Thomas Greave's dioramic backdrop for Charles Kean's 1856 *Midsummer Night's Dream* and the other bucolic idealisations hovering in the 'distance' of many Victorian productions[32] (see Fig. 15, p. 314). Such backdrops, coupled with the gradual shift to an almost totally darkened auditorium as gas and then electric lighting were introduced, formed an essential aspect of a theatrical rhetoric that, paradoxically, created a growing separation between 'foregrounded' actors and increasingly docile spectators. The ecology of this theatre would appear to put 'nature' at *three* removes from actual human action in the environment. Yet, ironically, on some winter nights, especially in London, the thick industrial fog would seep into the crowded theatres, blurring the view of the stage, a deeply telling instance of environmental feedback, which conceivably helped to fuel the first stirrings of the modern environmental movement.[33] Just as tellingly, an ecological history of theatre that would confirm or challenge such speculation is still waiting to be written.

PERFORMANCE ECOLOGY

The botanical experts at London's Kew Gardens were among the chief advisers to the designers of Biosphere II, suggesting a surprisingly close

[30] Breandan Gregory, 'Staging British India', in J. S. Bratton, Richard Allen Cave, Breandan Gregory, Heidi J. Holder and Michael Pickering, *Acts of Supremacy: The British Empire and the Stage, 1790–1930* (Manchester University Press, 1991), pp. 151–3.

[31] Iain Mackintosh, *Architecture, Actor and Audience* (London: Routledge, 1993), pp. 35–40.

[32] Simon Trussler, *British Theatre: An Illustrated History* (Cambridge University Press, 1994), pp. 242–3.

[33] Pepper, *Modern Environmentalism*, pp. 207–17. I am grateful to my colleague Jim Davis, at the University of Warwick, for bringing my attention to the presence of fog in nineteenth-century British theatre.

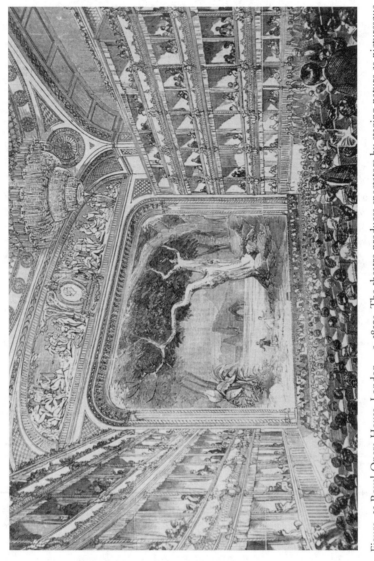

Figure 15 Royal Opera House, London – c. 1850s. The theatre produces spectators by staging nature as picturesque background. In the distance sea and cliffs with a naturally perfect gothic arch.

historical connection between the hubris of the Victorian industrial–colonial nexus and the vaunting ambitions of the Biospherians. The Biospherians, though, as we might expect, were very alert to the eco-politics of their project and its implications for the anthropocentrism of the great modernist traditions of Western 'civilisation':

Designing a biome is an opportunity to think like God … You go two ways with this. Mimic an analog of a particular environment you find in nature, or invent a synthetic based on many of them. Bio2 is definitely a synthetic eco-system. But so is California by now … Humans are 'keystone predators' acting as checks of last resort. Populations of plants or animals that outrun their niches can be kept in reasonable range by human 'arbitration.' If the ocotillo shrub takes over, the bionauts will hack it away. You can build synthetic systems as small as you want. But the smaller you make it, the greater role human operators play because they must act out the larger forces of nature beyond the ecological community. The subsidy we get from nature is incredible.[34]

The irony that such 'acting out' – as god, keystone predator, master of the bio-world – can only occur because it is 'subsidised' by the self-same natural forces it has to exploit is not, of course, lost on the Biospherians. Like the directors and actors of postmodern theatre, they are self-reflexively aware that the 'stage' of Biosphere II may be positioned in a deeply ambiguous relation to the world it aims to mimic. Theirs is a biocentric performance awash with ecological ambivalence. It is an extremely serious scientific experiment – some have claimed the future of humankind may depend on its success; and it is a massive tourist attraction – with the usual range of gift shops, cafes and car parks that draws many thousands of visitors to gaze into its green interior every year, perhaps as if in yearning for an always already lost world. But if they are yearning, what kind of place – or places – is it that they are after?

There is a moment in Una Chaudhuri's argument when, I think, she has a key principle of an ecological aesthetics of biocentric performance most fully in her grasp, and that is when she touches on the question of civilisation and its 'roots', metonymically signalled through the juxta-position of books and forests. In the Western imaginary – crucial to the production of ecological crisis – 'civilisation' and the 'wilderness', 'culture' and 'nature' customarily have been locked in a disastrous opposition, with the former feeding uncontrollably off the latter to offset

[34] Kelly, 'Biosphere II', p. 12.

its fears of the abyss, the totally unknown 'other'. Chaudhuri quotes Robert Harrison on Vico to underline the point:

To burn out a clearing in the forest and to claim it as the sacred ground of the family – that, according to Vico, was the original deed of appropriation that first opened the space of civil society. It was the first decisive act, which would lead to the founding of cities, nations, and empire.[35]

In the light of this, we might view Biosphere II as an inverted replaying of that 'original deed', an attempt at restitution, an act of healing aimed to make amends with 'nature'. Is this what the crowds are attracted by, a secular prelapsarian spectacle? If so, the hermeticism of the glass ark is fabulously ironic; as in theatre, the more one yearns for contact – with 'nature' or its substitutes – the more out of reach it will become. Hence, paradoxically, the ecology of twentieth-century theatre in the West, like Biosphere II, has reproduced the environmental pathologies that an ecologically aware theatre might most wish to avoid.

Perhaps it follows from this that *performance ecology* should somehow productively engage with 'the original deed of appropriation', to propose revisions of the separation of humans from their environment via 'nature' while acknowledging the extent of the separation? Marranca, Fuchs and Chaudhuri are possibly all correct in identifying postmodern performance as a strong arena for such revisions, because its reflexivity may most crucially challenge the dualisms of modernism which have fuelled the ecological crisis, particularly those between body and mind, analysis and creativity, thought and action, spectator and participant, culture and nature. But clearly, to the extent that postmodern performance in *theatre* depends on a sustained separation between performer and spectator, however ironically framed, then it risks replaying the tropes – of landscape, of pastoral, of wilderness, for example – that may reinforce the source of the environmental nightmare in the human.

This is why I think that biocentric performance events that use an ethically principled immersive participation, transforming spectators into participants – rituals for the ecological era – are most likely to lead to new performance ecologies. But such events can be voraciously oppressive of participants, forcing on them versions of 'community' that are fascistic in their virulence.[36] Surely when this is coupled with a potential regression to a point of origin for civilisation – the moment of the forest clearing

[35] Chaudhuri, ' "There Must be a Lot of Fish" ', p. 28.
[36] Kershaw, *Radical in Performance*, pp. 195–9.

beginning – the dangers of absolutism will come flooding in: we and only we have the knowledge to save the world, because only we have been 'there'? To guard against this, the kinds of 'place' that such performance aims to create will need particularly careful attention. The cultural geographer Nigel Thrift hints at the complexities that such a project would involve:

the ecology of place is a rich and varied *spectral gathering*, an articulation of presence as 'the tangled exchange of noisy silences and seething absences' . . . which both value and multiply anomaly, receptivity and imaginary capacity: ghosts, apparitions and monsters; magic, haunting and dreams; rites, rituals and raves. And it is this new way of describing becoming . . . which is allowing a . . . more open sense of place to make its way into the open.[37]

At first sight this proposed fresh sense of place would seem to throw us right back into the stock-in-trade – tragedies, melodramas, spectacular scenographies and so on – of the theatre ecology that I have been arguing it may be necessary to avoid. But Thrift is talking about a much more complex place of exchange, as the doubling in his use of the senses of 'open' implies. In such doubly-open places a new kind of biocentric performance might dissolve the boundaries between performer and spectator to produce participants in ecologically responsive action which recognises and embraces the agency of environments.

In a search for possible 'models' for such performance ecologies one would need, I suggest, to be on the lookout for the reflexivities of paradox. Hence, the quality of platial openness that Thrift is recommending might be found in the tight passageways of the performative mazes staged by the Colombian director Enrique Vargas, which provide, I think, highly suggestive indicators for future ecologically responsible performance.[38] We might look as well to some of the early happenings staged by the likes of Allan Kaprow and Bruce Lacey; or to the aesthetic antics of protest groups growing out of new global social movements at the turn of the millennium and beyond; or for signs of environmentally engaged performance in the many companies that in the twenty-first century profess ecological principles.[39] The immersive experience offered

[37] Nigel Thrift, 'Steps to an Ecology of Place', in *Human Geography Today*, ed. Doreen Massey, John Allen and Philip Sarre (Cambridge: Polity Press, 1999), pp. 316–17.

[38] Kershaw, *Radical in Performance*, pp. 187–216.

[39] Robin Cohen and Shirin M. Rai (eds.), *Global Social Movements* (London: Athlone Press, 2000); Baz Kershaw, 'Ecoactivist Performance: the Environment as Partner in Protest?', *Drama Review* 46: 1 (Spring, 2002); George McKay, *DiY Culture: Protest and Party in Nineties Britain* (London: Verso, 1998); Website – Ashden Directory: www.ashdendirectory.org.uk/ (26.08.2006).

by such events is potentially different in kind to the one promised by the experiment of Biosphere II.

The giant glass ark has been seen as a metaphor for human survival against all the odds produced by the human animal. It is a metaphor that is heightened by the transparent 'act of appropriation' of the hermetic envelope, the disjunction produced by a man-made 'nature' cut off in most crucial respects from nature's 'nature'. Immersive performance events which are articulated directly to what's left of the 'natural world', unlike theatre, may have the capacity to collapse that disjuncture, to suture more fully human 'nature' with nature's 'nature'. They might achieve this in ways that will not reverse the 'first decisive act' that led to civilisation, but which could lead humans to a fuller appreciation of how they are a wholly integral part of the Earth's environment, acting *in* it rather than *on* it. In such small ways might performance and theatre ecology contribute to a new ecological sanity in Biosphere I.

Epilogue

Listen up for the cracks

The radio reporter is in Nairobi, Kenya, attending the United Nations annual conference on climate change. He tells us he has divided his time in Africa between the conference and visits to a Masai tribe 40 miles to the south of the capital. The Masai are cattle people legendary for their warrior history, dignified beauty and survival skills in regions where the weather can be especially harsh. He has been to a village named Nado Enterit where he called in at the primary school. When he asks the children how many of them recently had seen any of their family cattle die he is met by a 'forest of hands'. He has also spoken with a man and his wife who once had twenty-four cattle, but now after five years of drought there are just four left and the price per head has fallen from 20,000 shillings to just a few hundred. Hunger is a constant companion to their family and they have decided to try farming, supported by a small grant from the Kenya Anglican Church. The decision is a matter of some shame. As this is a written report we only hear the Masai man's voice through the reporter's slightly desperate delivery. When he relates the story of the turn to small agriculture his tone grows hollow, as if he might be thinking of decimated forests across many lands.

The reporter returns to the UN conference in Nairobi a chastened man. He describes the white marquee in the grounds of the air-conditioned conference centre, where the world's press receives regular briefings.[1] He tells of exiting the marquee, his arms full of leaflets and position papers, into gardens where he is greeted by the smell of piles of deliciously cooked meat and an African drummer and dancers for entertainment. Not the 'real Africa', he says, and suddenly I recall the cheap plastic Australian Aboriginal figurine that my parents for years kept on top of the television. Where is it now? Why on Earth did I keep it? The reporter is saying again how the

[1] Website – BBC Radio 4: www.bbc.co.uk/radio4/atoz/index.shtml#f (*From Our Own Correspondent*, Wednesday 2 August 2006, 13:30–14:00, Radio 4 FM).

conference speeches have been littered with 'urgent calls to action' and 'demands for achievable plans' and the need for 'talks about talks' in the future. Secretary-General Kofi Annan, at his last UN climate-change gathering, in his closing speech complains of a lack of global leadership against the coming devastation, before he and the 6,000 smart and well-suited delegates made their way to Nairobi airport for the flights home. I can never quite make up my mind if I'm glad I can still listen to such stuff on this old computer. I look out of my study window at the late-autumn trees, their blackened boughs barely stirring in the lightest of breezes. A good day today, the low pale sun slowly stroking house walls with long oval shadows cast by the rickety satellite dishes. No birdsong, but a couple of cracks from the direction of the park set the remnant pigeons scattering across the milky blue sky, a couple crossing the transatlantic flight paths. No jet streams either now, thank goodness.

I'm hungry so it's into the old routine before top-up time. I will shut down the computer and disconnect the battery. I'll close the steely study shutters and climb down the creaky steps, stripped of their softening carpets long ago – never mind the cracks – as if stupidly prepared for a spring redecoration, thinking for the umpteenth time how lucky to have the stairwell skylight, today letting in ashen sunbeam shafts. It's all the way down to the iron-battened basement, past the old laying-out room and the kitchen, past my daughter's bolted door to the stuffed playroom with its jigsaws missing crucial pieces, dust-ridden family photo albums, recycled bikes and patched-up dynamos. Maybe that awkward Aboriginal doll is in here somewhere. She'd been visiting Kenya earlier in the year of that UN climate conference and was sometimes scared witless by the vigilante gangs with their AK4s and funerals on trucks, but it turned out good training for the stiffened years to come. Oh where are you now, my darling young one? Do the routine business, eat the last of the bartered black bread, kit up and drag your old bones back to the skylight maybe hoping it'll be the last time ever. Peek over the parapet and down the Brow. Not much change, the heaps of rusting scavenged cars and trucks that used to grunge up this steep road much as they were a week or so ago, though someone's set a small white-smoked fire by the collapsed railway bridge at the mucky water's edge. Scan the broken rooftops to the city. On the rare days like this one Bristol Lagoon looks almost bearable, its sluggish scum black against the crumbling concrete island towers where the bastard rulers live. Weakly prepare to abseil down the back. Listen up for the cracks.

Appendix: a chronology of chapter sources

This chronology lists the main research events (seminars, conferences/ symposia), public occasions (lectures, formal presentations), practice-as-research projects (field investigations, productions, performances), and places of publication (journals, books) that led to this book. I include it partly to indicate some of the formal ways in which it has been a deeply collaborative venture, partly to show for non-academic readers something of the varied journeys which some writings make before they settle into the book environment, and partly to expose something of the messiness in the generation of ideas and arguments in 'emergent fields' of scholarly and creative research. The list also suggests how the genealogies of the chapters interweave and intersect, though in focusing on the public events leading to publication it misses out the continuous and crucial influence of teaching and creative performance projects in my explorations of theatre and performance ecologies. Needless to say, perhaps, this chronology is also completely misleading regarding the dimensions of sheer muddledom that the 'progress' of environmentally responsive research is likely always to be heir to. Bold chapter numbers indicate previous chief places of publication.

1999

Conference: 'The Theatrical Biosphere and the Ecologies of Performance', at
Chapter 10 *Here Be Dragons*, 5th Annual Performance Studies international
 Conference, University of Wales, Aberystwyth, April 1999.

Chapter 5: 'Discouraging Democracy: British Theatres and Economics,
 1979–1999', Special Issue on Theatre and Capital, *Theatre
 Journal*, 51: 3 (October 1999).
Conference: 'Whose Performance is it Anyway? Or, Oh for Unruly
Chapter 6 Audiences!', at *Whose Theatre is it Anyway? Performance, Politics
 and Community*, University of Wolverhampton, October 1999.

2000

Seminar: 'Oh for Unruly Audiences! The Decline of Participation in Post-
Chapter 6 war Western Theatre', Goldsmiths College, University of
 London, February 2000.
Performance: *The Iron Ship*, large-scale spectacle for promenading audience,
 ss *Great Britain*, Bristol Docks, May 2000.

Chapter 10: 'The Theatrical Biosphere and Ecologies of Performance', *New
 Theatre Quarterly*, vol. 16 part 2 (*NTQ* 62), May 2000.
Conference: 'The Theatrical Biosphere: Ecologies of Performance II', at
Chapter 10 *Between Nature: Explorations in Ecology and Performance*, Centre
 for the Study of Environmental Change, Lancaster University,
 July 2000.
Conference: 'Curiosity or Comtempt: on Spectacle and the Human', at
Chapter 7 *Performance and Spectacle*, Australasian Drama Studies Associ-
 ation, University of Newcastle, Australia, July 2000.

2001

Lecture: 'Dramas in the Performative Society: Theatre at the End of its
Chapter 2 Tether', Inaugural Professorial Lecture, University of Bristol,
 February 2001.
Conference: 'Ecoactivist Performance: the Environment as Partner in
Chapter 8 Protest?', at *Translation/Transition/Transformation*, 7th Annual
 Performance Studies international Conference, Johannes
 Gutenberg-Universität, Mainz, Germany, March 2001.

Chapter 6: 'Oh for Unruly Audiences! Or, Patterns of Participation in
 Twentieth-Century Theatre', *Modern Drama*, 44: 2 (Summer
 2001).
Lecture: 'Ecoactivist Performance: the Environment as Partner in
Chapter 8 Protest?', at Department of Theatre Studies, University of
 New South Wales, Sydney, August 2001.
Seminar: 'Ecoactivist Performance: the Environment as Partner in
Chapter 8 Protest?', at Department of Comparative Literature, University
 of Queensland, Brisbane, August 2001.
Lecture: 'Dramas in the Performative Society: Theatre at the End of
Chapter 2 its Tether', at Department of Theatre, Monash University,
 Melbourne, August 2001.

Chapter 2: 'Dramas of the Performative Society: Theatre at the End of its
 Tether', *New Theatre Quarterly*, vol. 17 part 3 (*NTQ* 67), August
 2001.

2002

Seminar: Chapter 7 Performance:	'Curiosity or Contempt: On Spectacle and the Human', at Department of Drama, Loughborough University, March 2002. *Mnemosyne Dreams*, small-scale one-woman durational performance, ss *Great Britain*, Bristol Docks, May 2002.
Chapter 8:	'Eco-Activist Protest: the Environment as Partner in Protest?', *Drama Review*, 46: 1 (Spring 2002).
Symposium: Chapter 9	'Radical Energy in the Ecologies of Performance', at *Vague, Volatile, Incomprehensible*, Academy of Dramatic Art, Zagreb, Croatia, November 2002.
Conference: Chapter 9	'Radical Energy in the Ecologies of Performance', at *Theatre and Material Culture*, Annual Conference, American Society for Theatre Research, University of Philadelphia, USA, November 2002.
Seminar: Chapter 9	'Radical Energy in the Ecologies of Performance', at Department of Theatre, University of Maryland, USA, November 2002.
Seminar: Chapter 9	'Radical Energy in the Ecologies of Performance', at Department of Theatre Studies, Northwestern University, USA, November 2002.

2003

Seminar: Chapter 10	' "These fragments might I shore against our ruins?" – Performance in an Age of Global Terror', at School of Music and Drama, University of Exeter, February 2003.
Seminar: Chapter 3	'George Formby and the Northern Sublime', at Department of Drama: Theatre, Film, Television, University of Bristol, February 2003.
Seminar: Chapter 9	'Radical Energy in the Ecologies of Performance, at Research seminar Series, Samuel Beckett Centre, Trinity College, Dublin, March 2003.
Chapter 9	'Radical Energies in the Ecologies of Performance', in *Frakcija: Performing Arts Magazine*, Issue 28–9 (Zagreb, Croatia), Summer 2003.
Seminar: Chapter 3	'George Formby and the Northern Sublime', at Department of Film and Drama, University of Reading, November 2003.

Chapter 3: 'George Formby and the Northern Sublime', in *Extraordinary Actors*, ed. Martin Banham and Jane Milling, Exeter University Press, 2003.

Chapter 7: 'Curiosity or Contempt: on Spectacle, the Human, and Activism', Special Issue on Activism, *Theatre Journal* 55: 4 (December 2003).

2004

Performance: *Green Shade*, ecological installation–performance, Wickham Theatre, University of Bristol, May 2004.

Seminar:
Chapter 10 'The Theatrical Biosphere and Ecologies of Performance II', at Research Seminar Series, University of Calgary, Canada, November 2004.

Conference:
Chapter 10 'Radical Theatre in The Twenty-First Century – an Ecological View', at *Teaterdagarna*, Rikstheatern, Stockholm, Sweden, November 2004.

2005

Conference:
Preambles 'Citizen Artists in the Twenty-first Century? An Ecological Perspective', at *Citizen Artist: Theatre, Culture and Community*, International Federation of Theatre Research, University of Maryland, USA, July 2005.

Performance: *Being in Between*, durational movement-based performance, Bristol Zoological Gardens, October 2005.

Chapter 10: 'Ecologies of Performance: on Theatres and Biospheres', *Performing Nature: Explorations in Ecology and the Arts*, ed. Gabriella Giannachi and Nigel Stewart, Bern: Peter Lang, 2005.

2006

Chapter 4: 'Performance Studies and Po-chang's Ox? Steps to a Paradox-ology of Performance', *New Theatre Quarterly* 22: 1 (*NTQ* 85), February 2006.

Conference:
Chapter. 1 'Performance Ecologies and Biotic Rights,' at *Performing Human Rights*, Performance Studies international Conference, Queen Mary, University of London, June 2006.

Bibliography, multimedia, websites

BIBLIOGRAPHY

Abercrombie, Nicholas and Brian Longhurst, *Audiences*, London: Sage, 1998.

Abramovic, Marina, *Abramovic: The Biography of Biographies*, Milan: Charta, 2005.

Amis, Martin, *Einstein's Monsters*, Harmondsworth: Penguin, 1988.

Ansorge, Peter, *From Liverpool to Los Angeles: On Writing for Theatre, Film and Television*, London: Faber and Faber, 1997.

Aristotle, *Poetics*, trans. S. H. Butcher, New York: Hill and Wang, 1961.

Artaud, Antonin, *The Theatre and Its Double*, trans. Mary Caroline Richards, New York: Grove Press, 1958.

Arts Council of England, *Boyden Report*, London: Arts Council of England, 1999.

'£100 Million more for the Arts', *Arts Council News* (August 2000).

Arts Council of Great Britain, *The Glory of the Garden: The Development of the Arts in England: A Strategy for a Decade*, London: Arts Council of Great Britain, 1984.

A Great British Success Story, London: Arts Council of Great Britain, 1986.

43rd Annual Report and Accounts, London: Arts Council of Great Britain, 1988.

Aunger, Robert (ed.), *Darwinising Culture: The Status of Memetics as a Science*, Oxford University Press, 2000.

Auslander, Philip, ' "Just be Yourself": Logocentrism and Difference in Performance Theory', in *Acting (Re)Considered*, ed. Phillip B. Zarrilli, London: Routledge, 1995.

From Acting to Performance: Essays in Modernism and Postmodernism, London: Routledge, 1997.

Liveness: Performance in a Mediatised Culture, London: Routledge, 1999.

Auslander, Phillip (ed.), *Performance: Critical Concepts in Literary and Cultural Studies*, 4 vol., London: Routledge, 2003.

Austin, J. L., *How to Do Things with Words*, ed. J. O. Urmson, Oxford University Press, 1962.

Banham, Martin (ed.), *The Cambridge Guide to Theatre*, Cambridge University Press, 1992.

Banham, Martin and Jane Milling (eds.), *Extraordinary Actors*, Exeter University Press, 2003.

Barba, Eugenio, *The Paper Canoe: A Guide to Theatre Anthropology*, London: Routledge, 1995.

Barba, Eugenio and Nicola Savarese, *A Dictionary of Theatre Anthropology: The Secret Arts of the Performer*, trans. Richard Fowler, London: Routledge, 1991.

Barker, Howard, *Arguments for a Theatre*, Manchester University Press, 1993.

Barnard, Paul, *Drama*, London: National Arts and Media Strategy Unit, 1991.

Barthes, Roland, *Mythologies*, selected and trans. Annette Lavers, London: Granada, 1973.

Image–Music–Text, trans. Stephen Heath, London: Fontana, 1977.

Basting, Anne Davis, *The Stages of Age: Performing Age in Contemporary American Culture*, Ann Arbor: University of Michigan Press, 1998.

Bateson, Gregory, *Steps to an Ecology of Mind*, University of Chicago Press, 2000.

Baudrillard, Jean, *Simulacra and Simulation*, trans. Sheila Faria Glazer, Ann Arbor: University of Michigan Press, 1981.

Simulations, trans. Paul Foss, Paul Patton and Philip Beitchman, New York: Semiotext(e), 1983.

'La Biosphère II', in *Des mondes inventés: les parcs à thème*, ed. Anne-Marie Eyssartel and Benard Rochette, Paris: Les éditions de la villete, 1992.

The Gulf War Did Not Take Place, trans. Paul Patton, Sydney: Power Publications, 1995.

Beckerman, Bernard, *Theatrical Presentation: Performer, Audience and Act*, London: Routledge, 1980.

Beckett, Samuel, *Waiting for Godot*, London: Faber and Faber, 1959.

Bender, Mike, Paulette Bauckham and Andrew Norris, *The Therapeutic Purposes of Reminiscence*, London: Sage, 1999.

Benjamin, Walter, *Illuminations*, trans. Harry Zohn, London: Fontana, 1992.

Bennett, Susan, *Theatre Audiences: A Theory of Production and Reception*, 2nd edn, London: Routledge, 1997.

'Theater/Tourism', *Theatre Journal* 57: 3 (October 2005).

Bentley, Eric, *The Life of the Drama*, New York: Atheneum, 1964.

Berghaus, Günter, *Avant-garde Performance: Live Events and Electronic Technologies*, Basingstoke: Palgrave Macmillan, 2005.

Bernhardt, Sarah, *The Art of the Theatre*, trans. H. J. Stenning, New York: Dial Press, 1925.

Birringer, Johannes, *Media and Performance: Along the Border*, Baltimore and London: Johns Hopkins University Press, 1998.

Blacking, John, 'Music, Culture and Experience', in *Music, Culture and Experience: Selected Papers of John Blacking*, ed., Reginald Byron, Chicago University Press, 1999.

Blackmore, Susan J., *The Meme Machine*, Oxford University Press, 1999.

Blau, Herbert, *The Eye of Prey: Subversions of the Postmodern*, Bloomington: Indiana University Press, 1987.

The Audience, Baltimore: Johns Hopkins University Press, 1990.

Blistene, Bernard, Caroline Cros, Régis Durand, Christin Buci-Glucksmann and Elinor Hartney, *Orlan: Carnal Art*, Paris: Flammarion, 2004.

Bolter, Jay David and Richard Grusin, *Remediation: Understanding New Media*, Cambridge, Mass.: MIT Press, 1999.

Bond, Edward, *Lear*, London: Eyre Methuen, 1972.

Bookchin, Murray, 'What is Social Ecology?', in *Environmental Philosophy: From Animal Rights to Radical Ecology*, ed. M. E. Zimmerman, Englewood Cliffs, N. J.: Prentice Hall, 1993.

Bornat, Joanna, 'Reminiscence and Oral History', in *The Oral History Reader*, 2nd edn, ed. Robert Perks and Alistair Thomson, London: Routledge, 1998.

Bourdieu, Pierre, *Distinction: A Social Critique of the Judgement of Taste*, trans. Richard Nice, London: Routledge, 1986.

Brandreth, Giles, *Great Theatrical Disasters*, London: Grafton Books, 1986.

Bratton, Jacky, *New Readings in Theatre History*, Cambridge University Press, 2003.

Brecht, Bertolt, *Brecht on Theatre*, ed. and trans. John Willett, London: Eyre Methuen, 1974.

Bret, David, *George Formby: A Troubled Genius*, London: Robson Books, 2001.

Brook, Peter, *The Empty Space*, New York: Avon Books, 1968.

'Any Event Stems from Combustion: Actors, Audiences, and Theatrical Energy', *New Theatre Quarterly* 8: 30 (May 1992).

Brownstein, Oscar Lee and Darlene M. Daubert, *Analytical Sourcebook of Concepts in Dramatic Theory*, Westport, Conn.: Greenwood Press, 1981.

Buell, Lawrence, *The Environmental Imagination: Thoreau, Nature Writing, and the Formation of American Culture*, Harvard University Press, 1995.

Bull, John, *Stage Right: Crisis and Recovery in British Contemporary Mainstream Theatre*, London: Macmillan, 1994.

'The Establishment of Mainstream Theatre, 1946–1979', in *The Cambridge History of British Theatre*, vol. III, *Since 1895*, ed. Baz Kershaw, Cambridge University Press, 2004.

Butler, Judith, *Gender Trouble: Feminism and the Subversion of Identity*, London: Routledge, 1990.

Bodies that Matter: On the Discursive Limits of 'Sex', London: Routledge, 1993.

Cage, John, *Silence: Lectures and Writings*, Cambridge, Mass.: MIT, 1966.

Calder-Marshall, Arthur, *Wish You Were Here: The Art of Donald McGill*, London: Hutchinson, 1966.

Carlson, Marvin, *Theories of the Theatre: A Historical and Critical Survey, from the Greeks to the Present*, expanded edn, Ithaca and London: Cornell University Press, 1993.

Performance: A Critical Introduction, 2nd edn, London: Routledge, 2003.

Carroll, Lewis, *Alice in Wonderland*, ed. Donald J. Gray, New York: Norton and Norton, 1971.

Cassell Companion to Theatre, London: Market House Books, 1999.

Chaim, Daphna Ben, *Distance in the Theatre: The Aesthetics of Audience Response*, Ann Arbor: MIT Press, 1984.

Chalmers, J. Alan, *Atmospheric Electricity*, 2nd edn, Oxford: Pergamon Press, 1967.
Chambers, Iain, *Popular Culture: The Metropolitan Experience*, London: Methuen, 1986.
Chameides, William L., 'The Role of Lightning in the Chemistry of the Atmosphere', in *The Earth's Electrical Environment*, Commission on Physical Science, Mathematics and Applications, Washington, D.C.: National Academy Press, 1986.
Chaudhuri, Una, '"There Must Be a Lot of Fish in That Lake": Toward an Ecological Theatre', *Theater* 25: 1 (Spring/Summer 1994).
 Staging Place: The Geography of Modern Drama, Ann Arbor: University of Michigan Press, 1997.
 'Animal Geographies', in *Performing Nature: Explorations in Ecology and the Arts*, ed. Gabriella, Giannachi and Nigel Stewart, Bern: Peter Lang, 2005.
Chomsky, Noam, *Deterring Democracy*, London: Vintage, 1992.
Cixous, Hélène and Catherine Clément, *The Newly Born Woman*, trans. Betsy Wing, London: I. B. Taurus, 1996.
Clark, Michael, *Paradoxes from A to Z*, London: Routledge, 2002.
Cless, Downing, 'Eco-Theatre, USA: the Grassroots Is Greener', *Drama Review* 40: 2 (Summer 1996).
Cohen, Gillian and Stephanie Taylor, 'Reminiscence and Ageing', *Ageing and Society* 18 (1998).
Cohen, Martin, *Wittgenstein's Beetle and Other Classic Thought Experiments*, Oxford: Blackwell, 2005.
Cohen, Robin and Shirin M. Raj (eds.), *Global Social Movements*, London: Athlone Press, 2000.
Coleridge, Samuel Taylor, *The Collected Works of Samuel Taylor Coleridge, vol.* XIV, *Table Talk*, ed. Carl Woodring, London: Routledge, c.1990.
Connor, Steven, *Postmodernist Culture: An Introduction to Theories of the Contemporary*, Oxford: Basil Blackwell, 1989.
Conway, Martin A., *Autobiographical Memory: An Introduction*, Milton Keynes: Open University Press, 1990.
Cork, Sir Kenneth, *Theatre is for All (The Cork Report)*, London: Arts Council of Great Britain, 1985.
Coult, Tony and Baz Kershaw (eds.), *Engineers of the Imagination: The Welfare State Handbook*, rev. edn, London: Methuen, 1990.
Counsell, Colin and Laurie Wolf (eds.), *Performance Analysis: An Introductory Coursebook*, London: Routledge, 2001.
Cozzi, Enzo, 'Chilean Sacred Dancers and Western Secular Magicians: Two Paratheatrical Ecologies of Mind', in *Performing Nature: Explorations in Ecology and the Arts*, ed. Gabriella Giannachi and Nigel Stewart, Bern: Peter Lang, 2005.
Craig, Sandy (ed.), *Dreams and Deconstructions: Alternative Theatre in Britain*, Ambergate: Amber Lane Press, 1980.
Daintith, John (ed.), *Biographical Quotations*, London: Bloomsbury, 1997.

Dardis, Tom, *Keaton: The Man Who Wouldn't Lie Down*, London: Deutsch, 1979.

Davies, Andrew, *Other Theatres: The Development of Alternative and Experimental Theatre in Britain*, London: Methuen, 1987.

Davis, Jim and Victor Emeljanow, *London Theatregoing: Reflecting the Audience, 1840–1880*, University of Iowa Press, 2001.

Davis, Tracy C., *The Economics of the British Stage, 1800–1914*, Cambridge University Press, 2000.

Dawkins, Richard, *The Selfish Gene*, 2nd edn, Oxford University Press, 1989.

The Selfish Gene, 30th anniversary edn, Oxford University Press, 2006.

The Extended Phenotype: The Long Reach of the Gene, rev. edn, Oxford University Press, 1999.

de Certeau, Michel, *The Practice of Everyday Life*, trans. Stephen Rendall, Berkeley: University of California Press, 1988.

de Quincey, Tess, 'Sites of Multiplicity and Permeation', in *Théâtre: Espace sonore, espace visuel*, ed. Christine Hamon and Anne Surger, Presses Universitaires de Lyon, 2003

de Toqueville, Alexis, 'Some Observations on the Drama Amongst Democratic Nations', trans. Henry Reeve, in *The Theory of the Modern Stage*, ed. Eric Bentley, Harmondsworth: Penguin, 1968.

Democracy in America Nations, vol. II, ed. Phillips Bradley, New York: Alfred A. Knopf, 1945[1840].

Debord, Guy, *The Society of the Spectacle*, Detroit: Black and Red, 1977.

Deleuze, Gilles and Félix Guattari, *A Thousand Plateaus: Capitalism and Schizophrenia*, trans. Brian Massumi, London: Athlone Press, 1988.

Derrida, Jacques, *On Grammatology*, trans. Gayatri Chakravorty Spivak, Baltimore: Johns Hopkins University Press, 1976.

Margins of Philosophy, trans. Alan Bass, Brighton: Harvester Press, 1982.

Limited Inc, ed. Gerald Graff, trans. Samuel Webber, Evanston, Ill.: Northwestern University Press, 1988.

'Signature Event Context', in *A Derrida Reader: Between the Blinds*, ed. Peggy Kamuf, Hemel Hempstead: Harvester Wheatsheaf, 1991.

'From Psyche – Invention of the Other', in *Acts of Literature*, ed. Derek Attridge, London: Routledge, 1992.

Archive Fever: A Freudian Impression, trans. Eric Prenowitz, University of Chicago Press, 1996.

Dolan, Jill, *The Feminist Spectator as Critic*, Ann Arbor: UMI Research Press, 1988.

Geographies of Learning: Theory and Practice, Activism and Performance, Middletown, Conn.: Wesleyan University Press, 2001.

Donohue, Joseph, *Theatre in the Age of Kean*, Oxford: Basil Blackwell, 1975.

Donohue, Joseph (ed.), *The Cambridge History of British Theatre*, vol. II, *1660–1895*, Cambridge University Press, 2004.

Dunlop, Rachael and Jeremy Eckstein, 'The Performed Arts in London and Regional Theatres', *Cultural Trends* 22 (1994).

Durland, Stephen, 'Witness: the Guerrilla Theatre of Greenpeace', in *Radical Street Performance*, ed. Jan Cohen-Cruz, London: Routledge, 1998.

Dyer, Richard, *Only Entertainment*, London: Routledge, 2002.

Eagleton, Terry, *The Idea of Culture*, Oxford: Blackwell, 2000.

Ecological Economics: The Journal of the International Society for Ecological Economics, Amsterdam and New York: Elsevier, 1989–.

Elkins, Paul, *Wealth Beyond Measure: Atlas of New Economics*, London: Gaia Books, 1992.

Eyre, Richard and Nicholas Wright, *Changing Stages: A View of British Theatre in the Twentieth Century*, London: Bloomsbury, 2000.

Feist, Andrew and Robert Hutchison, *Cultural Trends in the Eighties*, London: Policy Studies Institute, 1990.

Feist, Andy, 'Consumption in the Arts and Cultural Industries: Recent Trends in the UK', in *From Maestro to Manager: Critical Issues in the Arts and Cultural Management*, ed. Marian Fitzgibbon and Anne Kelly, Dublin: Oak Tree Press, 1997.

Felshin, Nina (ed.), *But Is it Art?: The Spirit of Art as Activism*, Seattle: Bay Press, 1995.

Féral, Josette, 'Performance and Theatricality: the Subject Demystified', trans. Terese Lyons, *Modern Drama* 25: 1 (March 1982).

Fisher, John, *George Formby*, London: Woburn–Futura, 1975.

Fiske, John, *Understanding Popular Culture*, Boston: Unwin Hyman, 1989.

Fitzgibbon, Marian and Anne Kelly (eds.), *From Maestro to Manager: Critical Issues in Arts and Cultural Management*, Dublin: Oak Tree Press, 1997.

FitzHerbert, Luke, Cecelia Giussani and Howard Hurd (eds.), *The National Lottery Yearbook*, London: Directory of Social Change, 1996.

Foucault, Michel, *Discipline and Punish: The Birth of the Prison*, trans. Alan Sheridan, London: Penguin, 1991.

Fowler, H. W., *A Dictionary of Modern English Usage*, 2nd edn, revised by Sir Ernest Gowers, Oxford: Clarendon Press, 1965.

Fox, John, *Eyes on Stalks*, London: Methuen, 2002.

Frakcija – Magazin za Izvedbene um Jetnosti: Performing Arts Magazine – Energy 19 (March 2001).

Friedman, Milton and Rose Friedman, *Free to Choose*, Harmondsworth: Penguin, 1980.

Fuchs, Elinor, 'Another Version of Pastoral', *Theater* 25: 1 (Spring/Summer 1994).

 The Death of Character: Perspectives on Theater after Modernism, Bloomington and Indianapolis: Indiana University Press, 1996.

Fuchs, Elinor and Una Chaudhuri (eds.), *Land/Scape/Theater*, Ann Arbor: University of Michigan Press, 2002.

Fuller, Matthew, *Media Ecologies: Materialist Energies in Art and Technoculture*, Cambridge, Mass.: MIT Press, 2005.

Fusco, Coco, *English is Broken Here: Notes on Cultural Fusion in the Americas*, New York: New Press, 1997.

'The Other History of Intercultural Performance', in *The Routledge Reader in Politics and Performance*, ed. Lizbeth Goodman and Jane de Gay, London: Routledge, 2000.

Gablik, Suzi, *Reenchancement of the Art*, London: Thames & Hudson, 1991.

Galbraith, John Kenneth, *Economics and the Arts*, London: Arts Council of Great Britain, 1983.

Gale, Maggie B., 'The London Stage 1918–1945', in *The Cambridge History of British Theatre*, vol. III, *Since 1895*, ed. Baz Kershaw, Cambridge University Press, 2004.

Gardner, Lyn, 'Just Sit Down and Shut Up', *Guardian Saturday Review* (14 October 2000).

Geertz, Clifford, 'Deep Play: Notes on the Balinese Cockfight', in *The Interpretation of Cultures*, London: Fontana, 1993.

Gendler, Tamar Szabó, *Thought Experiment: On the Powers and Limits of Imaginary Cases*, New York: Garland, 2000.

Giannachi, Gabriella, *Virtual Theatres: An Introduction*, London: Routledge, 2004.

Giannachi, Gabriella and Nigel Stewart (eds.), *Performing Nature: Explorations in Ecology and the Arts*, Bern: Peter Lang, 2005.

Giddens, Anthony, *Beyond Left and Right: The Future of Radical Politics*, Cambridge: Polity Press, 1994.

Glaister, Dan, 'ACE Rhetoric, Pity about the Grants', *Guardian* (16 February 1999).

Glaser, Barney G., *Emergence vs Forcing: Basics of Grounded Theory*, Mill Valley, Calif.: Sociology Press, 1992.

Glaser, Barney G. and Anselm L. Strauss, *The Discovery of Grounded Theory*, New York: Aldine, 1967.

Glotfelty, Cheryll and Harold Fromm (eds.), *The Ecocriticism Reader: Landmarks in Literary Ecology*, Athens and London: University of Georgia, 1996.

Goldman, Michael, *The Actor's Freedom: Toward a Theory of Drama*, New York: Viking Press, 1975.

Gómez-Peña, Guillermo, *The New World Border: Prophecies, Poems, Loqueras for the End of the Century*, San Francisco: City Lights, 1996.

 Ethno-Techno: Writings on Performance, Activism and Pedagogy, London: Routledge, 2005.

Goodall, Jane R., *Performance and Evolution in the Age of Darwin: Out of the Natural Order*, London: Routledge, 2002.

Gottlieb, Vera, '1979 and After', in *The Cambridge History of British Theatre*, vol. III, *Since 1895*, ed. Baz Kershaw, Cambridge University Press, 2004.

Gottlieb, Vera and Colin Chambers (eds.), *Theatre in a Cool Climate*, Oxford: Amber Lane Press, 1999.

Greenblatt, Stephen, *Shakespearian Negotiations: The Circulation of Social Energy in Renaissance England*, Oxford: Clarendon Press, 1988.

Gregory, Breandan, 'Staging British India', in J. S. Bratton, Richard Allen Cave, Breandan Gregory, Heidi J. Holder and Michael Pickering, *Acts of*

Supremacy: The British Empire and the Stage, 1790–1930, Manchester University Press, 1991.

Grim, Patrick, *The Incomplete Universe: Totality, Knowledge and Truth*, London: MIT Press, 1991.

Grimes, Ronald J., 'Ritual Theory and the Environment', in *Nature Performed: Environment, Culture and Performance*, ed. Bronislaw Szerszynski, Wallace Heim and Claire Waterton, Oxford: Blackwell, 2003.

Grotowski, Jerzy, *Towards a Poor Theatre*, New York: Simon and Shuster, 1968.

Guattari, Félix, *Chaosmosis: An Ethico-aesthetic Paradigm*, trans. Paul Bains and Julian Pefanis, Sydney: Power Publications, 1995.

The Three Ecologies, trans. Ian Pindar and Paul Sutton, London: Athlone Press, 2000.

Haines, John, 'Living Troubadours and Other Recent Uses for Medieval Music', *Popular Music* 23: 2 (May 2004).

Haraway, Donna, *Primate Visions: Gender, Race, and Nature in the World of Modern Science*, London: Routledge, 1989.

Simians, Cyborgs and Women: The Reinvention of Nature, London: Free Association Books, 1991.

Modest_Witness@Second_Millennium.FemaleMan©_Meets_Oncomouse:™ *Feminism and Technoscience*, London: Routledge, 1997.

Harris, Geraldine, *Performing Femininities: Performance and Performativity*, Manchester University Press, 1999.

Harrison, Jane, *Ancient Art and Ritual*, London: Williams and Norgate, 1913.

Harrison, Martin, *The Language of Theatre*, rev. edn, London: Carcanet, 1998.

Harrison, Robert Pogue, *Forests: The Shadow of Civilisation*, University of Chicago Press, 1992.

Hartnoll, Phyllis (ed.), *The Oxford Companion to the Theatre*, 3rd edn, Oxford University Press, 1967.

Harvey, David, *The Condition of Postmodernity*, Oxford: Blackwell, 1990.

Justice, Nature and the Geography of Difference, Oxford: Blackwell, 1996.

Hay, Peter (ed.), *Theatrical Anecdotes*, Oxford University Press, 1987.

Hayles, Katherine N., *How We Became Posthuman: Virtual Bodies in Cybernetics, Literature, and Informatics*, University of Chicago Press, 1999.

Hebdige, Dick, *Subculture: The Meaning of Style*, London: Methuen, 1979.

Heim, Wallace, 'Performance and Ecology: a Reader's Guide', in *Performing Nature: Explorations in Ecology and the Arts*, ed. Gabriella Giannachi and Nigel Stewart, Bern: Peter Lang, 2005.

Hetherington, Kevin, *The Badlands of Modernity: Heterotopia and Social Ordering*, London: Routledge, 1997.

Hewison, Robert, *The Heritage Industry: Britain in a Climate of Decline*, London: Methuen, 1987.

Culture and Consensus: England, Art and Politics since 1940, London: Methuen, 1995.

Hobsbawm, Eric, *The New Century*, trans. Allan Cameron, London: Abacus, 2000.

Hodge, Alison (ed.), *Twentieth-Century Actor Training*, London: Routledge, 2000.

Hollege, Julie and Joanne Tomkins, *Women's Intercultural Performance*, London: Routledge, 2000.

Holyoak, Keith J. and Paul Thagard, *Mental Leaps: Analogy in Creative Thought*, Cambridge, Mass.: MIT Press, 1995.

Hossay, Patrick, *Unsustainable: A Primer for Global Environmental and Social Justice*, London: Zed Books, 2006.

Hughes, Patrick and George Brecht, *Vicious Circles and Infinity: An Anthology of Paradoxes*, Harmondsworth: Penguin, 1978.

Hunt, Albert and Geoffrey Reeves, *Peter Brook*, Cambridge University Press, 1995.

Hutchison, Robert, *The Politics of the Arts Council*, London: Sinclair Browne, 1982.

Illich, Ivan, *Tools for Conviviality*, London: Marion Boyars, 1985.

Ingold, Tim, 'Culture and the Perception of the Environment', in *Bush Base, Forest Farm: Culture, Environment and Development*, E. Croll and D. Parkin ed., London: Routledge, 1992.

Ingram, David, *Green Screen: Environmentalism and Hollywood Cinema*, 2nd edn, Conn.: David Brown Book Company, 2004.

Irigaray, Luce, *This Sex which Is not One*, trans. Catherine Porter and Carolyn Burke, Ithaca: Cornell University Press, 1985.

Jackson, Shannon, *Professing Performance: Theatre in the Academy from Philology to Performativity*, Cambridge University Press, 2004.

Jameson, Frederic, 'Postmodernism and Consumer Society', in *Postmodern Culture*, ed. Hal Foster, London: Pluto Press, 1985.

Jones, Steve, *In the Blood: God, Genes and Destiny*, London: Flamingo, 1997.

Jordan, John, 'The Art of Necessity: the Subversive Imagination of Anti-road Protest and Reclaim the Streets', in *DiY Culture: Party and Protest in Nineties Britain*, ed. George McKay, London: Verso, 1998.

Kear, Adrian and Deborah Lynn Steinberg (eds.), *Mourning Diana: Nation, Culture and the Performance of Grief*, London: Routledge, 1999.

Kelly, Kevin, 'Biosphere II: an autonomous world', *Whole Earth* 77 (1990).

Kennedy, Dennis (ed.), *The Oxford Encyclopedia of Theatre and Performance*, 2 vols., Oxford University Press, 2003.

Kershaw, Baz, 'Reminiscence Theatre: New Techniques for Old People', *Theatre Ireland* 2 (February 1983).

 The Politics of Performance: Radical Theatre as Cultural Intervention, London: Routledge, 1992.

 'Framing the Audience for Theatre', in *The Authority of the Consumer*, ed. Russell Keat, Nigel Whiteley and Nicholas Abercrombie, London: Routledge, 1994.

 'Cross-cultural Performance in a Globalised World', *Theatre Forum* 8 (Winter/Spring 1996).

'The Politics of Performance in a Postmodern Age', in *Analysing Performance: A Critical Reader*, ed. Patrick Campbell, Manchester University Press, 1996.

'Pathologies of Hope in Drama and Theatre', *Research in Drama Education* 3: 1 (February 1998).

'Discouraging Democracy: British Theatres and Economics, 1979–1999', Special Issue on Theatre and Capital, *Theatre Journal*, 51: 3 (October 1999).

The Radical in Performance: Between Brecht and Baudrillard, London: Routledge, 1999.

'The Theatrical Biosphere and Ecologies of Performance', *New Theatre Quarterly* 16: 2 (May 2000).

'Oh for Unruly Audiences! Or, Patterns of Participation in Twentieth-Century Theatre', *Modern Drama* 44: 2 (Summer 2001).

'Dramas of the Performative Society: Theatre at the End of its Tether', *New Theatre Quarterly* 17: 3 (August 2001).

'Ecoactivist Performance: the Environment as Partner in Protest', *Drama Review* 46: 1 (Spring 2002).

'Performance, Memory, Heritage, History, Spectacle: *The Iron Ship*', *Studies in Theatre and Performance* 22: 3 (2002).

'Radical Energy in the Ecologies of Performance', *Frakcija – Magazin za Izvedbene um Jetnosti: Performing Arts Magazine* 28–9 (Summer/Autumn 2003).

'Curiosity or Contempt: on Spectacle, the Human, and Activism', *Theatre Journal*, 55: 4 (December 2003).

'George Formby and the Northern Sublime', in *Extraordinary Actors*, ed. Martin Banham and Jane Milling, Exeter University Press, 2003.

'The Ecologies of Performance: On Theatres and Biospheres', in *Performing Nature: Explorations in Ecology and the Arts*, ed. Gabriella Giannachi and Nigel Stewart, Bern: Peter Lang, 2005.

'Performance Studies and Po-chang's Ox: Steps to a Paradoxology of Performance', *New Theatre Quarterly* 22: 1 (February 2006).

Kershaw, Baz (ed.), *The Cambridge History of British Theatre*, vol. III, *Since 1895*, Cambridge University Press, 2004.

Kershaw, Baz and Gordon Langley (eds.), *Reminiscence Theatre: Dartington Theatre Papers* 4: 6 (1982).

Kimber, Richard G., 'Australian Aboriginals' Perceptions of Their Desert Homelands (Part 1 and 2)', *Aridlands Newsletter* 50 (November/December 2001).

King, Anthony D., *Culture, Globalisation and the World System*, London: Macmillan, 1991.

King, David, 'Climate Change: Adapt, Mitigate or Ignore', *Science* 303: 5655 (October 2004).

Kingsworth, Paul, *One No, Many Yeses: A Journey to the Heart of the Global Resistance Movement*, London: Free Press, 2003.

Kintz, Linda, 'Performing Capital in Caryl Churchill's *Serious Money*', *Theatre Journal: Theatre and Capital* 51: 3 (October 1999).

Kipling, George, 'Wonderfull Spectacles: Theater and Civic Culture', in *A New History of Early English Drama*, ed. John D. Cox and David Scott Kastan, New York: Columbia University Press, 1997.

Kirby, Michael, 'On Acting and Not-Acting', in *Acting (Re)Considered*, ed. Phillip B. Zarrilli, London: Routledge, 1995.

Kohlmaier, George and Barna von Sartory, *Houses of Glass: A Nineteenth-Century Building Type*, Cambridge, Mass.: MIT Press, 1986.

Kruger, Loren (ed.), *Theatre Journal: Theatre and Capital* 51: 3 (October 1999).

Kustow, Michael, *Theatre@Risk*, London: Methuen, 2000.

Langley, Dorothy, with Gordon Langley, *Dramatherapy and Psychiatry*, London: Croom Helm, 1983.

Lash, Scott, *Sociology of Postmodernism*, London: Routledge, 1990.

Lash, Scott and John Urry, *Economies of Signs and Space*, London: Sage, 1994.

Lavender, Andy, 'Theatre in Crisis: Conference Report, December 1988', *New Theatre Quarterly* 5: 19 (August 1989).

Leacroft, Richard, *The Development of the English Playhouse*, rev. edn, London: Methuen, 1988.

Lefebvre, Henri, *Everyday Life in the Modern World*, trans. Sacha Rabinovich, London: Harper and Row, 1971.

Lehmann, Hans-Thies, *Postdramatic Theatre*, trans. Karen Jürs-Munby, London: Routledge, 2006.

Lewes, George Henry, *On Actors and the Art of Acting*, New York: Greenwood Press, 1968.

Lewis, Richard S., *Challenger: The Final Voyage*, New York: Columbia University Press, 1988.

Litz, A. Walton, Louis Menand and Lawrence Rainey (eds.), *The Cambridge History of Literary Criticism*, vol. VII, *Modernism and the New Criticism*, Cambridge University Press, 2000.

Lovelock, James, *Gaia: A New Look at Life on Earth*, reissue, Oxford University Press, 2000.

Luke, Timothy W., 'Reproducing Planet Earth: the Hubris of Biosphere 2', *Ecologist* 25: 4 (1995).

Lyotard, Jean-François, 'The Tooth, the Palm', trans. Anne Knap and Michel Benamou, *SubStance* 5: 15 (1976).

The Postmodern Condition: A Report on Knowledge, trans. Geoff Bennington and Brian Massumi, Manchester University Press, 1985.

MacAloon, John J. (ed.), *Rite, Drama, Festival, Spectacle: Rehearsals Toward a Theory of Cultural Performance*, Philadelphia: Institute for the Study of Human Issues, 1984.

Mackintosh, Iain, *Architecture, Actor and Audience*, London: Routledge, 1993.

Mangan, Michael, *Staging Masculinities: History, Gender, Performance*, Basingstoke: Palgrave Macmillan, 2003.

Marowitz, Charles, Tom Milne and Owen Hale, (eds.) *The Encore Reader: A Chronicle of the New Drama*, London: Methuen, 1965.

Marranca, Bonnie, 'Performance World, Performance Culture', *Performing Arts Journal* 10: 3 (1987).
　Ecologies of Theater: Essays at the Century Turning, Baltimore: Johns Hopkins University Press, 1996.
May, Theresa J., 'Re-Membering the Mountain', in *Performing Nature: Explorations in Ecology and the Arts*, ed. Gabriella Giannachi and Nigel Stewart, Bern: Peter Lang, 2005.
McAuley, Gay, 'Body Weather in the Central Desert of Australia: towards an Ecology of Performence', in *Théâtre: Espace sonore, espace visuel*, ed. Christine Hamon and Anne Sugers, Presses Universitaires de Lyon, 2003.
　'Site-Specific Performance: Place, Memory and the Creative Agency of the Spectator', *Arts: The Jounal of The Sydney University Arts Association* 27 (2005).
　(ed.), *About Performance*, University of Sydney: Department of Performance Studies, 2003.
McCann, Paul, 'The Trouble Starts with a Million-pound Windfall', *Independent on Sunday: Focus* (24 August 1997).
McCarthy, Mary, *Vietnam*, Harmondsworth: Penguin, 1968.
McCluhan, Marshall and Quentin Fiore, *The Medium is the Massage: An Inventory of Effects*, New York: Bantam, 1967.
McGuigan, Jim, *Culture and the Public Sphere*, London: Routledge, 1996.
McKay, George, *Senseless Acts of Beauty: Cultures of Resistance since the Sixties*, London: Verso, 1996.
McKay, George (ed.), *DiY Culture: Party and Protest in Nineties Britain*, London: Verso, 1998.
McKechnie, Samuel, *Popular Entertainment Through the Ages*, London: Samson Low, Marston, n.d.
McKenzie, Jon, *Perform or Else: From Discipline to Performance*, London: Routledge, 2001.
　'Hacktivism and Machinic Performance', in *The End of the 1960s: Performance, Media and Contemporary Culture*, ed. Edward Scheer and Peter Eckersall, Sydney: Faculty of Arts and Social Sciences, University of New South Wales/Performance Paradigm, 2006.
McKibben, Bill, *The End of Nature: Humanity, Climate Change and the Natural World*, rev. edn, London: Bloomsbury, 2003.
McNeill, John, *Something New Under the Sun: An Environmental History of the Twentieth Century*, London: Penguin, 2001.
Meek, James, 'How One Family Became Addicted to Carbon', *Guardian* (15 November 2000).
Mellor, Geoff J., *They Made Us Laugh: A Compendium of Comedians Whose Memories Remain Alive*, Littleborough: George Kelsall, 1982.
Merlin, Bella, 'Practice as Research in Performance: a Personal Response', *New Theatre Quarterly* 20: 1 (February 2004).
Mithen, Steven, *The Singing Neanderthals: The Origins of Music, Language, Mind and Body*, London: Phoenix/Orion Books, 2006.

Morgan, Kenneth O., *The People's Peace: British History 1945–1990*, Oxford University Press, 1992.

Morley, Sheridan, *Theatre's Strangest Acts: Extraordinary but True Tales from Theatre's Colourful History*, London: Robson Books, 2006.

Mountford, Charles P., 'The Lightning Man in Australian Mythology', *Man* 55 (September 1955).

Murray, Janet H., *Hamlet on the Holodeck: The Future of Narrative in Cyberspace*, Cambridge, Mass.: MIT Press, 1997.

Myerscough, John, *The Economic Importance of the Arts in Britain*, London: Policy Studies Institute, 1987.

Naess, Arne, *Ecology, Community and Lifestyle*, trans. and ed. David Rothenberg, Cambridge University Press, 1989.

New Penguin Dictionary of Theatre, London: Penguin, 1988.

Orlin, Doris, *Paradox*, Chesham: Acumen, 2003.

Orwell, George, *The Road to Wigan Pier*, Harmondsworth: Penguin, 1962.

Osborne, John, *A Better Class of Person: An Autobiography*, vol. II, *1929–1956*, London: Faber and Faber, 1983.

Parker, Andrew and Eve Kosofsky Sedgwick (eds.), *Performativity and Performance*, London: Routledge, 1995.

Pavis, Patrice, *Dictionary of the Theatre: Terms, Concepts, and Analysis*, trans. Christine Shantz, Toronto University Press, 1998.

Analysing Performance: Theater, Dance, and Film, trans. David Williams, Ann Arbor: University of Michigan Press, 2003.

Pearson, Mike, 'Theatre/Archaeology', *Drama Review* 38: 4 (Winter 1994).

Pearson, Mike and Michael Shanks, *Theatre/Archaeology*, London: Routledge, 2001.

Pepper, David, *Modern Environmentalism: An Introduction*, London: Routledge, 1996.

Phelan, Peggy, *Unmarked: The Politics of Performance*, London: Routledge, 1993.
Mourning Sex, London: Routledge, 1997.

Phelan, Peggy and Jill Lane (eds.), *The Ends of Performance*, New York University Press, 1998.

Pick, John, *The West End: Mismanagement and Snobbery*, London: John Offord, 1983.

Pick, John (ed.), *The State and the Arts*, Eastbourne: John Offord, 1980.

Plant, Sadie, *The Most Radical Gesture: The Situationist International in a Postmodern Age*, London: Routledge, 1992.

Plumwood, Val, *Feminism and the Mastery of Nature*, London: Routledge, 1993.

Postlewait, Thomas and Bruce A. McConachie (eds.), *Interpreting the Theatrical Past: Essays on the Historiography of Performance*, University of Iowa Press, 1989.

Povinelli, Daniel J., *Folk Physics for Apes: The Chimpanzee's Theory of How the World Works*, Oxford University Press, 2000.

Priest, Graham, *In Contradiction: A Study of the Transconsistent*, Dordrecht: Nijhoff, 1987.

Rabillard, Sheila, '*Fen* and the Production of an Ecofeminist Theatre', *Theater* 25: 1 (Spring/Summer 1994).

Rebellato, Dan, *1956 And All That: The Making of Modern British Drama*, London: Routledge, 1999.

Rebelo, Pedro, 'Haptic Sensation and Instrumental Transgression', *Contemporary Music Review* 25: 1–2 (February–April 2006).

Rees-Mogg, William, *The Political Economy of Art*, London: Arts Council of Great Britain, 1985.

Reinelt, Janelle G. and Joseph R. Roach (eds.), *Critical Theory and Performance*, Ann Arbor: University of Michigan Press, 1992.

Ricoeuer, Paul, *Memory, History, Forgetting*, trans. Kathleen Blamey and David Pellauer, University of Chicago Press, 2004.

Ridout, Nicholas, 'Animal Labour in the Theatrical Economy', *Theatre Research International* 29: 1 (2004).

Stage Fright, Animals and other Theatrical Problems (Cambridge University Press, 2006).

Rittner, Luke, 'Secretary General's Report' in Arts Council of Great Britain, *43rd Annual Report and Accounts*, London: Arts Council of Great Britain, 1988.

Roach, Joseph R., *The Player's Passion: Studies in the Science of Acting*, Ann Arbor: University of Michigan Press, 1993.

Roach, Joseph, *Cities of the Dead: Circum-Atlantic Performance*, New York: Columbia University Press, 1996.

Roberts, Philip, *The Royal Court Theatre and the Modern Stage*, Cambridge University Press, 1999.

Rokem, Freddie, 'Theatrical and Transgressive Energies', in *Performance: Critical Concepts in Literary and Cultural Studies*, vol. 1, ed. Philip Auslander, London: Routledge, 2003.

Performing History: Theatrical Representations of the Past in Contemporary Theatre, University of Iowa Press, 2000.

Rowell, George and Anthony Jackson, *The Repertory Theatre Movement: A History of Regional Theatre in Britain*, Cambridge University Press, 1987.

Sainsbury, R. M., *Paradoxes*, Cambridge University Press, 1995.

Samuel, Raphael, *Theatres of Memory* – vol. 1: *Past and Present in Contemporary Culture*, London: Verso, 1994.

Scarry, Elaine, *The Body in Pain: The Making and Unmaking of the World*, Oxford University Press, 1985.

Schechner, Richard, *Performative Circumstances from the Avant-Garde to Ramlila*, Calcutta: Seagull Books, 1983.

'A New Paradigm for Theatre in the Academy', *Drama Review* 36: 4 (1992).

The Future of Ritual, London: Routledge, 1993.

Performance Theory, rev. edn, London: Routledge, 1998.

Performance Studies: An Introduction, London: Routledge, 2002; 2nd edn, 2006.

Schnitzler, Arthur, *Flight into Darkness*, trans. William A. Darke, New York: Simon and Schuster, 1931.

Schrum, Stephen A. (ed.), *Theatre in Cyberspace: Issues in Teaching, Acting, and Directing*, New York: Peter Lang, 1999.

Schweitzer, Pam, 'Dramatizing Reminiscences', in *Reminiscence Reviewed: Perspectives, Evaluations, Achievements*, ed. Joanna Bornat, London: Taylor & Francis, 1994.

Reminiscence Theatre: Making Theatre from Memories, London: Jessica King, 2006.

Selwood, Sara (ed.), 'The Performing Arts', *Cultural Trends, 1995: Cultural Trends in the '90s, Part 2* 26 (1995).

Shakespeare, William, *The Tragedy of King Lear*, ed. Alfred Harbage, Baltimore, Md: Penguin, 1967.

Henry V, ed. A. R. Humphries, Harmondsworth: Penguin, 1968.

Mr. William Shakespeare's comedies, histories & tragedies: a facsimile of the first folio, 1623, intro. Doug Moston, London: Routledge, 1998.

Shaw, Roy, *The Arts and the People*, London: Jonathan Cape, 1987.

Shellard, Dominic, *British Theatre Since the War*, New Haven and London: Yale University Press, 1999.

Shepherd, Simon and Peter Womack, *English Drama: A Cultural History*, Oxford: Blackwell, 1996.

Shepherd, Simon and Mick Wallis, *Drama/Theatre/Performance*, London: Routledge, 2004.

Sherrin, Ned, *Ned Sherrin's Theatrical Anecdotes: A Connoisseur's Collection of Legends, Stories and Gossip*, London: Virgin, 1992.

Shiva, Vandana, *Staying Alive: Women, Ecology and Development*, London: Zed Books, 1989.

Shorter Oxford English Dictionary, 3rd edn, Oxford University Press, 1970.

Shorter Oxford English Dictionary, 5th edn, vol. I, Oxford University Press, 2002.

Sierz, Aleks, 'Cool Britannia? "In-Yer-Face" Writing in the British Theatre Today', *New Theatre Quarterly* 14: 4 (November 1998).

In-yer-face Theatre: British Drama Today, London: Faber and Faber, 2001.

Sked, Alan and Chris Cook, *Post-War Britain: A Political History*, 2nd edn, Harmondsworth: Penguin, 1984.

Smith, Anthony, *Software for the Self: Culture and Technology*, London: Faber and Faber, 1996.

Smith, Chris, *Creative Britain*, London: Faber and Faber, 1998.

Smith, Marquard (ed.), *Stelarc: The Monograph*, Cambridge, Mass.: MIT Press, 2005.

Sorensen, Roy, *Thought Experiments*, Oxford University Press, 1992.

A Brief History of the Paradox: Philosophy and the Labyrinths of the Mind, Oxford University Press, 2005.

States, Bert, 'The Phenomenological Attitude', in *Critical Theory and Performance*, ed. Janelle G. Reinelt and Joseph R. Roach, Ann Arbor: University of Michigan Press, 1992.

Stelarc and James D. Paffrath (eds.), *Obsolete Body/Suspensions/Stelarc*, Davis, Calif.: JP Publications, 1984.

Stewart, Susan, *On Longing: Narratives of the Miniature, the Gigantic, the Souvenir, the Collection*, Durham and London: Duke University Press, 1999.

Stoppard, Tom, *Rosencrantz and Guildenstern Are Dead*, London: Faber and Faber, 1968.

Striff, Erin (ed.), *Performance Studies*, London: Palgrave Macmillan, 2003.

Szerszynski, Bronislaw, 'Ecological Rites: Ritual Action in Environmental Protest Events', *Theory, Culture and Society* 19: 3 (June 2002).

Szerszynski, Bronislaw, Wallace Heim and Claire Waterton (eds.), *Nature Performed: Environment, Culture and Performance*, Oxford: Blackwell, 2003.

Talbot, Colin, *The Paradoxical Primate*, Exeter: Imprint Academic, 2005.

Thomas, Keith, *Man and the Natural World: Changing Attitudes in England 1500–1800*, Harmondsworth: Penguin, 1984.

Thompson, D'Arcy Wentworth, *On Growth and Form*, ed. John Tyler Bonner, Cambridge University Press, 1966.

Thompson, Paul, *The Voice of the Past: Oral History*, Oxford University Press, 1978.

Thrift, Nigel, 'Steps to an Ecology of Place', in *Human Geography Today*, ed. Doreen Massey, John Allen and Phillip Sarre. Polity Press: Cambridge, 1999.

Tillyard E. M. W., *The Elizabethan World Picture*, Harmondsworth: Penguin, 1963.

Trussler, Simon, *Cambridge Illustrated History of British Theatre*, Cambridge University Press, 1994.

Turner, Nancy J., Iain J. Davidson-Hunt and Michael O'Flaherty, 'Living on the Edge: Ecological and Cultural Edges as Sources of Diversity for Social–Ecological Resilience', *Human Ecology* 31: 3 (September 2003).

Urry, John, *The Tourist Gaze: Leisure and Travel in Contemporary Societies*, London: Sage, 1990.

Vale, V. and Andrea Juno (eds.), *Pranks!*, San Francisco: V/Search Publications, 1987.

van Lawick-Goodall, Jane, *My Friends the Wild Chimpanzees*, Washington, D. C.: National Geographic Society, 1967.

Vanden Heuvel, Michael, *Performing Drama/Dramatizing Performance: Alternative Theatre and the Dramatic Text*, Ann Arbor: University of Michigan Press, 1993.

Various authors, 'Art/Environment/Ecology', *High Perfomance* 10: 4 (1987).

Wallace, Leonard, 'Introducing George Formby', *Film Weekly* (6 November 1937).

Wardle, Irving, *The Theatres of George Devine*, London: Eyre Methuen, 1978.

Warr, Tracey, 'Sleeper', *Performance Research* 1: 2 (Summer 1996).

Watzlawick, Paul, Janet Helmick Beavin and Don D. Jackson, *Pragmatics of Human Communication: A Study of Interactional Patterns, Pathologies, and Paradoxes*, New York: Norton, 1967.

White, Daniel R., *Postmodern Ecology: Communication, Evolution, and Play*, University of New York Press, 1998.

White, Mike, 'Resources for a Journey of Hope: the Work of Welfare State International', *New Theatre Quarterly* 4: 15 (August 1988).

Whittaker's Almanac, 'Theatre', London: Whittaker and Sons, 1996/7.

Wickstrom, Maurya, 'Commodities, Mimesis, and *The Lion King*: Retail Theatre for the 1990s', *Theatre Journal* 51: 3 (October 1999).

Performing Consumers: Global Capital and its Theatrical Seductions, London: Routledge, 2006.

Wiggershaus, Rolf, *The Frankfurt School: Its History, Theories and Political Significance*, Cambridge, Mass.: MIT Press, 1995.

Williams, Raymond, *Border Country*, Harmondsworth: Penguin, 1960.

Writing in Society, London: Verso, 1991.

Willis, Susan, *A Primer for Daily Life*, London: Routledge, 1991.

Worthen, W. B., 'Introduction: Theorising Practice', in *Theorising Practice: Redefining Theatre History*, ed. W. B. Worthen with Peter Holland, Basingstoke: Palgrave Macmillan, 2003.

Yanni, Carla, *Nature's Museums: Victorian Science and the Architecture of Display*, London: Athlone Press, 1999.

Zarrilli, Phillip B. (ed.), *Acting (Re)Considered*, London: Routledge, 1995.

Žižek, Slavoj, *The Sublime Object of Ideology*, London: Verso, 1989.

Enjoy Your Symptom, London: Routledge, 1992.

Welcome to the Desert of the Real, London: Verso, 2002.

MULTIMEDIA

Formby, George, *Formby Favourites* (2000) CD, Spectrum Music.

George Formby: When I'm Cleaning Windows (2002) CD, Pickwick Group Ltd.

Kershaw, Baz and PARIP, *Mnemosyne Dreams: An Interactive Document and Investigative Research Resource* (2004) DVD, Bristol: PARIP, University of Bristol.

Kershaw, Baz, performance as research projects (2000–5) *The Iron Ship*, ss *Great Britain*, Bristol Docks, 2000; *Mnemosyne Dreams*, ss *Great Britain*, Bristol Docks, 2002; *Green Shade*, Wickham Theatre, University of Bristol, 2004; *Being in Between*, Bristol Zoological Gardens, 2005.

Microsoft Encarta Digital Encyclopaedia (1998) – 'Energy' – 'Free Radicals' – 'Lightning'.

Microsoft Encarta World English Dictionary (2006) – 'Afford'.

WEBSITES

American Society for Theatre Research, Cost of Taste: www.astr.umd.edu/conference2004/Seminars/Cost_of_Taste.pdf (15.09.2006).

Ashden Directory, The: www.ashdendirectory.org.uk (26.08.2006).

Association for the Study of Play, The (TASP) – www.csuchico.edu/kine/tasp/ (03.06.2007).

Australian Aboriginals: http//:cals.arizona.edu/OALS/ALN/aln50/kimberpart1. html (06.10.2006).
BBC News Online: http://news.bbc.co.uk/2/hi/science/nature/4955398.stm (5.09.2006).
BBC Radio 4: www.bbc.co.uk/radio4/atoz/index.shtml#f (20.11.2006).
Biosphere II: www.biospherics.org/ (25.01.07); www.bio2.com/ (25.01.07).
Bookchin, Murray, 'What is Social Ecology?': http://dwardmac.pitzer.edu/ Anarchist_Archives/bookchin/socecol.html (01.10.2006).
Bowers, John, 'Improvising Machines: Ethnographically Informed Design for Improvised Electro-acoustic Music': www.ariada.uea.ac.uk/ariadate390/ ariada4/index4.html (04.11.2006).
Carbon cycle: http://earthobservatory.nasa.gov/Library/CarbonCycle/carbon_ cycle4.html (10.11.2006).
Centre for the Study of Environmental Change: http://csec.lancs.ac.uk (20.11.2006).
de Quincey, Tess, 'Bodyweather': www.bodyweather.net (06.10.2006).
de Quincey, Tess, 'Triple Alice': www.triplealice.net/informain.html (12.01.2007).
Eden Project: www.edenproject.com/ (20.11.2006).
FM2030: www.fm2030.com/bio-page.cfm (20.11.2006).
Forbes, 'Lists': www.forbes.com/ (03.10.2006).
Ford, Henry: www.answers.com/topic/henry-ford (24.07.2006).
Formby Flashback: www.georgeformby.co.uk/ (30.08.2006).
Foundation for Science and Technology: www.foundation.org.uk/events/pdf/ 20021031_summary.pdf (20.11.2006).
George Formby Society: www.georgeformby.co.uk/ (27.08.2006).
Gómez–Peña, Guillermo: www.pochanostra.com/ (18.11.2006).
Greenpeace: www.greenpeace.org/international/about/history/the-brent-spar (07.10.2006).
Mass Observation: www.sussex.ac.uk/library/massobs/ (30.08.2006).
McAuley, Gay, 'Bodyweather': www.bodyweather.net/gm_firt_2000.pdf (02.07.2007).
Orlan: www.orlan.net (03.10.06).
PARIP Website: www.bris.ac.uk/parip/ (01.09.2006).
Ping Body (Stelarc): www.stelarc.va.com.au/pingbody/index.html (01.10.2006).
PLATFORM: www.platformlondon.org (12.10.2006).
Population clock: www.census.gov/main/www/popclock.html (20.11.2006).
Population growth: www.globalchange.umich.edu/globalchange2/current/lectures/ human_pop/human_pop.html (20.11.2006).
Stelarc: www.stelarc.va.com.au/index2.html (01.10.2006).
Stelarc, 'Suspensions': www.stelarc.va.com.au/suspens/suspens.html (01.10.2006).
Topics in Functional and Ecological Vertebrate Morphology: http://webhost.ua. ac.be/funmorph/publications/Aerts_et_al_2002_Topics.pdf (20.11.2006).
Tristan, Bernard: www.Bloomsbury.com/ARC/detail.asp?entryid=118251&bid=3 (10.06.2006).
Wikipedia, 'Black Holes': http://we.wikipedia.org/wiki/Black_holes (07.10.2006).

Wikipedia, 'Ecology': http://en.wikipedia.org/wiki/Ecology (20.11.2006).

Wikipedia, 'Energy': http://en.wikipedia.ord/wiki/Energies (10.11.2006).

Wikipedia, 'Esfandiary': http://en.wikipedia.org/wiki/F.M._Esfandiary (03.10.2006).

Wikipedia, 'Fulgurite': http://en.wikipedia.org/wiki/Fulgurite (02.11.2006).

Wikipedia, 'Lightning': http://en.wikipedia.org/wiki/Lightning (03.10.2006).

Wikipedia, 'Radical (chemistry)':http://en.wikipedia.org/wiki/Radical_%
28chemistry%29 (28.08.2006).

Index